D0440266

HOW TO PAINT AND DRAW

HOW TO
PAINT AND DRAW

Bodo W. Jaxtheimer

**With 300 illustrations in colour and
150 in black-and-white**

Thames and Hudson

Any copy of this book issued by the publisher as a paperback
is sold subject to the condition that it shall not by way of
trade or otherwise be lent, re-sold, hired out or otherwise
circulated, without the publisher's prior consent, in any form
of binding or cover other than that in which it is published,
and without a similar condition, including these words
being imposed on a subsequent purchaser

All rights reserved. No part of this publication may be
reproduced or transmitted in any form or by any means,
electronic or mechanical, including photocopy, recording or
any information storage and retrieval system, without
permission in writing from the Publisher

This edition © 1962 by Thames and Hudson Limited, London
Eighth impression 1978
First paperback edition 1982
Translated from Knaurs Mal- und Zeichenbuch
© 1961 by Droemersche Verlagsanstalt Munich/Zurich
Printed and bound in the German Democratic Republic

CONTENTS

PART II: PAINTING

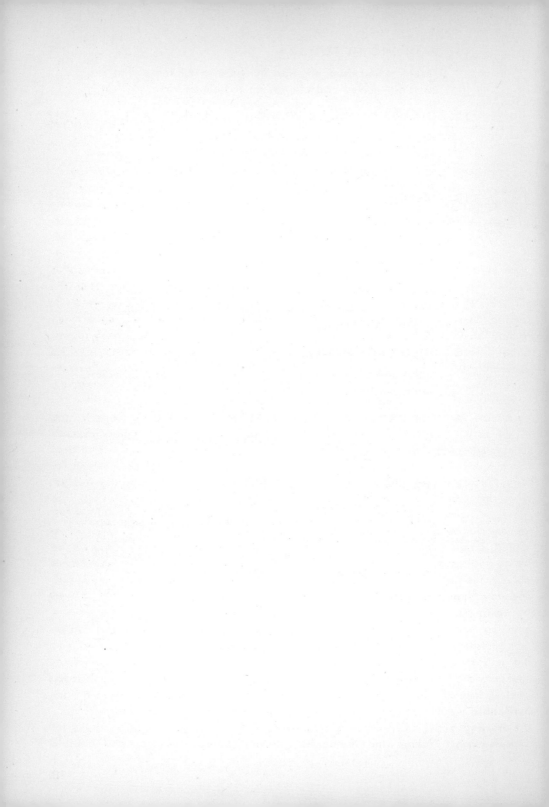

Everything which can be seen or touched is originally experienced as something plastic in space. If you wish to formulate the experience of these two senses for yourself, or to communicate it to others, you note down what you have seen; you draw points, lines, and areas in contrasting colors onto a flat surface. The image thus created gives an illusion reproducing the experience; it may be stronger or weaker than or equal in force to the original experience, according to your ability and to the material you use.

The most direct representation of volume is, of course, sculpture, or modeling in three dimensions. A sphere can be held, whereas a drawn circle representing a sphere cannot. Thus, the picture is an illusion, which in life is often much more significant than what is easily tangible. But even sculpture can show only volume, not space. If the object represented is significant and expressive only by its position in space relative to other objects, then a sculpture of it is no more complete than a drawing.

The desire to formulate and to communicate an experience is as old as humanity itself. It may even be that drawing and modeling are older than the spoken word, in any event older than poetry. It is conceivable that before the perishable word there was the picture, the drawing, by which even the mute can express himself. Things which are hardly describable in words at all can be understood at a glance from a picture, although, conversely, words can describe feelings which cannot be expressed pictorially except in abstract pictures. This aside, a verbal description of an experience is always much more related to consciousness and the intellect than the pictorial description, which achieves its strongest impact when dealing with visions and ideas not explicable by logical formulation. This "inner" vision may be so strong that it can be reproduced as directly as something which is objectively present to the sight.

The vision, on the other hand, may detach itself completely from the memory of recognizable objects, abstracting from the external form, which is universally recognizable at all times, inner, subjective processes and reactions which are actually unreal and do not correspond to a common vision or feeling. These abstract representations may thus not be universally comprehensible; then words and explanations are again needed to guide the response of the beholder to the point from which the painter started. Without them, quite contradictory interpretations can be read into abstract pictures, as in a game of ink-blot reading. Properly, a picture should need no captions; its true nature is to create an unequivocal effect without words.

The first efforts of human beings to set down pictorially the visible and tangible

Introduction

world were aimed at achieving the closest imitation of the object with means precluding any misunderstanding or ambiguity. The most unequivocal of these means is an area of color. If a child is given the most varied materials for drawing and painting, he will always choose color and make colored areas. The image on the retina of the human eye is composed of these colored areas. The lines which we think we see are only the boundaries we feel between two colors. This would not need saying if we were not educated (or miseducated) from childhood by the example of others and by our own efforts to set down everything we see primarily as outlines.

The line is in itself a considerable abstraction of immediate experience. If the child does not want just to daub, but to "paint" something definite, he first draws the outlines of the areas and then fills them in with color. The practiced painter does essentially the same thing—he can do nothing else. He must first set down the outline without which no area can emerge, and every pictorial representation is made up of areas. When the outline has served its purpose it can be eliminated and covered over with gradual transitions of color. This is the characteristic method of painting. If the outline remains and its inner area is only shaded in or left without filling at all,

Dürer, Schelde Harbor, Antwerp. Line drawing of great purity

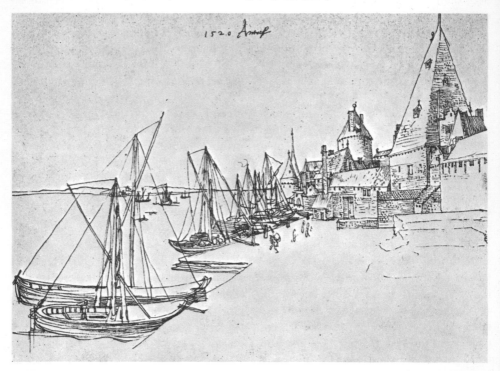

14

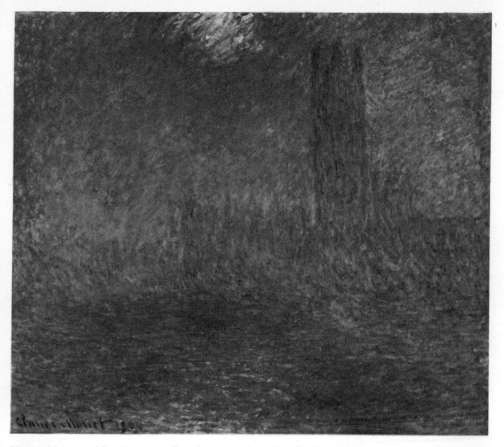

Monet, Houses of Parliament in Fog. Pure painting. Overlapping colors cause shapes to dissolve

the picture is called a drawing.

There is, in fact, no need to choose between the two alternatives. There is an infinite variety of intermediary stages between a pure outline drawing and a painting composed exclusively of areas of color merging and overlapping each other; hence, no clear division can be made between drawing and painting.

Pure painting, as opposed to drawing with color, did not in fact begin to develop until the discovery in the Italian Renaissance that many objects in nature cannot be separated clearly from their environment; that smoke and vapor, flickering or dappled light, cloud and darkness make areas merge inconspicuously into each other. Thus, the shapes of the areas are more felt than seen. Later this discovery led to a closer definition and separation of the concepts of drawing and painting. Thus, to compensate for the narrowing of the term "drawing" to "line drawing" the Greek word "graphic" is sometimes used as a more general word. Its precise meaning is "written," and there is, a very close relationship between writing and drawing.

15

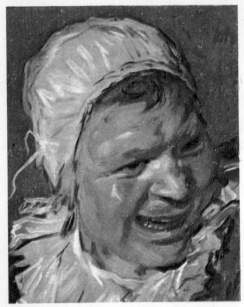

Hals, Malle Babbe (detail). Painting with gently overlapping colors. A foretaste of Impressionism. Oil

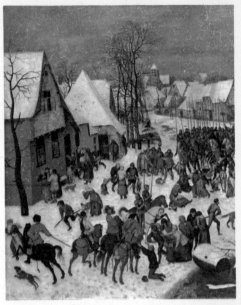

P. Breughel the Elder, Massacre of the Innocents in Bethlehem (detail). Painting which is very nearly colored drawing. Oil and tempera

Writing has developed from simplified drawings of objects representing certain definite concepts. Symbols were derived from these drawings and from the symbols signs or letters, which now retain only the meaning of single sounds. Letters are made by combinations of lines. The term "graphic art" is now applied to all kinds of representations which accept the principle of an abstracting line. This principle can be expressed in a reduction of everything visible to black and white, sometimes extended to include intermediate ranges of gray. It is still graphic art if colors are used, provided that they are kept clearly separate, either with an enclosing line or by the avoidance of any over-painting.

Thus, it is wrong to describe a picture as a painting because it is in color. It is equally wrong to make painting dependent on the brush, which can be used both for painting and drawing, as can colored pencils. The pen is the only exclusively graphic instrument, for it cannot be disassociated from the principle of the line. This explains, too, how wrong it is to use the word "painting" for those techniques which are entirely graphic in character: mosaic, stained glass pictures, batik, and sgraffito. If you examine an Egyptian wall painting you will see at once that it is not painting but graphic art.

There is, however, no precise boundary between graphic art and painting. The range of examples shows every gradation between them. An unceasing war

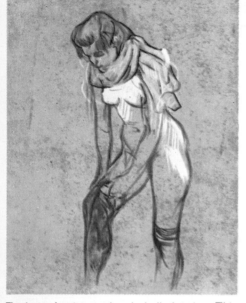

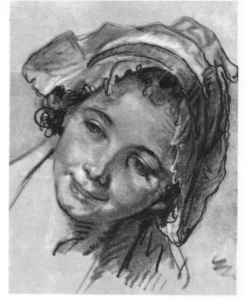

Toulouse-Lautrec, colored chalk drawing. This is still drawing, but painterly in intention

Greuze, black chalk, lightened with white. The illusion of color is reinforced by the use of red chalk for lips and shadows

can be waged by pedants for exact terminology, but it is unimportant. No one wishes to produce mongrel work in any sphere, but what is important is the effect of the picture itself, not its category. Categories can be left for the pedants, whose theorizings need not spoil our enjoyment of a picture nor impede the pleasure of trying to make one. These pleasures can be increased by a closer study of the development of pictorial representation.

This begins about 30,000 years ago in the Old Stone Age, and with something of a flourish—with colored cave paintings. A dispute as to whether line drawing or graphic coloring came first seems totally irrelevant as we admire these first, highly artistic creations of the human imagination. As we have shown, areas

of color can hardly be set down without an outline, and the line drawing must have originated simultaneously with the graphic coloring. The outline is not there as an end in itself but as a starting point. A pure line drawing may be equivocal, the area it encloses may be either substance or space. For example, if you draw a circle no one can tell whether it indicates a hole, a raised plane, a column seen from above, or a sphere. A simple outline, even when it is unequivocal, makes greater demands on the imagination of the beholder than a shaded or colored representation, or one drawn in perspective. A picture which has all these elements is the least demanding.

At least until the second half of the last century one of the foremost aims of

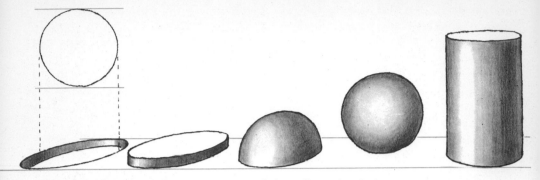

Seen from above, a circle may represent a hole, a disc, a hemisphere, a sphere, a cylinder

the student of painting and drawing was to create a perfect illusion of the impression derived from nature. In every age there were other no less important problems and aims, but teaching was based on the assumption that the true reproduction of nature was the aim of the accomplished artist, and that this formed the basis of his creative activity. Apelles, who worked as court painter to Alexander the Great, was the most famous painter in Antiquity. Among the many anecdotes concerning him is one illustrating this high regard for perfect naturalism. He once engaged in a public competition with a colleague; each was to paint a picture. Apelles' contemporary produced a picture of grapes which looked so real that the birds came to eat them. After due admiration of this feat the audience called on Apelles to unveil his picture. This he could not do, for the veil was all he had painted. Thus, Apelles succeeded in deceiving even the human eye.

The anecdote is, of course, apocryphal, and since no work by Apelles has survived it is impossible to know how closely naturalistic his painting was.

A few decades ago there were still theatre curtains which had to be studied for some time, before one could decide whether they were of draped material or merely painted linen.

Naturalistic representation ceased to be generally admired only with the advent of photography, when first black-and-white and then color photographs surpassed any drawing or painting in naturalism. Against this new invention painters and draftsmen had only one trump card, but it outplayed anything photography could do: even the best photograph is powerless against the artist's creative interpretation, against his intensified reformulation of his experience of reality. This does not imply that there was nothing more than unquestioning naturalistic reproduction in art until the advent of photography; the great artists have never been satisfied with that. If we study the bison painted (along with many other animals) in the cave of Altamira in northern Spain, perhaps 30,000 years ago, we can see such closeness to nature that the photograph could tell us little more of the animal's anatomy or proportions or of any im-

portant details; yet the drawing tells us something essentially more important even than this from the strong broad concept of the form. It is this which makes it impressive and imparts the menacing effect of the size and weight of the beast without any comparison with man or plant to give it relative scale. The drawing is by no means a mechanical, naturalistic reproduction but an all-embracing representation of its subject.

It would be interesting to know the circumstances which gave rise to this picture which is even today unsurpassed in its power and impact. There is no evidence remaining, but much can be deduced. It is certainly not painted from life. Apart from the impossibility of keeping the creature still while the artist drew it, the position in which it is depicted is composite and is not literally

possible. Yet the picture is not untrue. Evidently the artist frequently watched these beasts in this and other poses and studied dead ones for all the details. Then, his mind full of all these impressions, he created the picture out of his head. This is in great measure why these pictures are so magnificent. An artist who always draws from a model cannot draw freely. The faculty of memory is not as objective as a camera, but it is truer in its ability to sift away the unessential, omitting incidental and fortuitous characteristics and revealing only the typical.

The traditional method of the classical Chinese and Japanese painters indicates, even prescribes, the way in which to arrive at a meditated, condensed representation which distills the utmost from its subject. We are repeatedly told in

Bison. Pastel on wall rock, Altamira Caves, Spain. Paleolithic Age, c. 30,000 to 12,000 B.C.

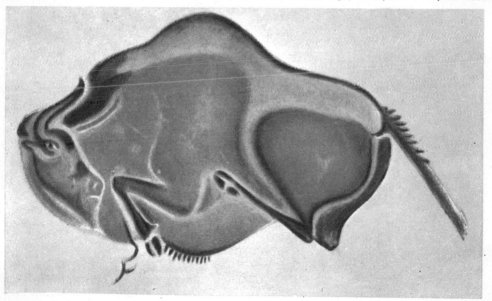

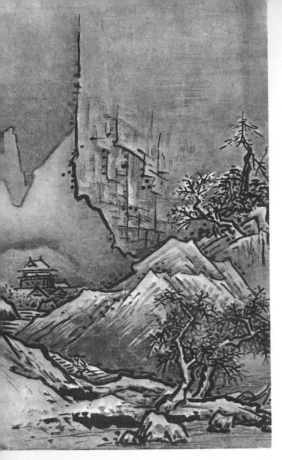

Sesshu (1420-1506, regarded as the greatest Japanese painter), Winter Landscape, India ink on paper. Clearly drawn from memory. Natural forms are made to appear crystalline (ice crystals)

written records how these painters wandered about in the countryside, deep in contemplation; and how only when returning home did they seize the brush and depict on the silk what had impressed them. Every triviality was forgotten, and a force more unconscious than conscious intensified the expression of the natural form to give it the subjective impact which the painter had received from the subject itself.

You can test how far a subjective impression differs from an "objective" re-

production by drawing a landscape, first from memory, then directly from nature, and lastly by photographing it from the same viewpoint. You will be surprised at how flat and insignificant the photograph appears against your drawing from nature, even when you have employed all possible mechanical aids for insuring an accurate record. This experiment does not apply when you put in clear detail and there is less space in the picture. Photograph and drawing then approximate more and more closely.

If we follow the historical development of pictorial art from the point of view of naturalistic representation we find two influences repeatedly at work against it. One is the human tendency to emphasize and exaggerate certain aspects, expressing itself in the form as well as in the content of the picture; the other is variations in ability.

Stylistic emphasis is most apparent in unusual proportions. Large eyes, heads, and hands are the most telling means of expressing the spiritual in Romanesque art. In the Gothic style they are elongated and narrowed. The Baroque expresses sensual enjoyment with colossal bodies; in the Rococo this robustness is transformed into an almost sickly sweetness, with the body acquiring an expression of languid decadence. Alternating with these periods are times when body and spirit achieve a harmony: the classical Greek and Roman, its rebirth in the Renaissance, and a later attempt at a revival of classicism. These three periods were concerned with the perfect proportion of all things and achieved varying success both in general concept and in particular example.

Greek vase (details). Example of well proportioned classical figure

Ability ebbs and flows to its own rhythm alongside these changes of style, generally expressing itself at the beginning of a period with monumental strength, reaching a perfection of balance at the zenith, and ending in decadence and decline, although at this final stage it often brings forth the most beautiful works of the entire cycle, like overripe, choice fruits from the last days of harvest.

Naturalistic representation reached its last and most trivial stage at the time of the advent of photography. The less gifted resorted to aids invented in an earlier time to obtain an "exact" replica of a model: the artist looked through a squared glass and mechanically transferred onto squared paper whatever lines filled each square; or used Lavater's silhouette maker, a piece of paper in a frame onto the back of which a candle threw the shadow of the model so that it could be simply traced around.

Meanwhile, everything which was known about pictorial representation was compiled into a categorical syllabus, and students in art academies were tormented to the brink of despair with the copying of plaster casts, both whole and in detail, for a minimum of two years. In this way all their imaginative powers were completely numbed or destroyed for the rest of their lives. Many whose temperaments could not endure this stultification were dismissed from the academies as incompetent and went away to become important painters.

There may sometimes have been a few exceptions, and the author must beg indulgence for his sweeping generalization. At all events, the opposition of a full-blooded temperament to the fossilized, or better, "plasterfied," activities of the academies engendered something quite new: a painting direct from nature, but one in which the momentary impression was immediately transposed and interpreted. To put it crudely, the painter screwed up his eyes and painted only

Rape of the Daughters of Leukippos (detail). Baroque exaggeration of human proportions

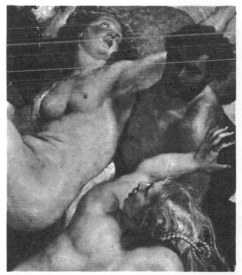

Introduction

the strongest colors which penetrated his sight. It was just this immediacy, rather than clarity of form, which inspired him. He saw significance only in the general impression which triumphed over the whirling mass of incidental detail.

In 1872 Claude Monet painted a sunset on the Seine at Le Havre; two years later he exhibited it under the title **Impression.** The influential art critic Leroy was incensed at this and other similar paintings and dubbed all the new daubers "Impressionists." Little did he know that he had coined the name for a style which now ranks among the highest in art.

The impressionist way of seeing and transposing was not entirely new. There are signs of it, as we have seen, in the Renaissance in the **sfumato** technique used by Leonardo, in which the air's haze is expressed by obscuring the unessential. This artificial haziness, in effect not unlike the work of the retoucher in photography, evolved increasingly into a sense of natural air, which is normally palpable in Rembrandt, still more enveloping in

Watteau, and with the Impressionists a mass uniting all things and beings.

This type of painting increasingly showed the atmosphere as a visible substance and added the new technique of color perspective to the already well-established linear perspective. Linear perspective as a set of mathematical formulae and rules was not discovered until the early fifteenth century in Italy, when it was immediately used in painting; but appreciably earlier there are suggestions of spatial perspective derived simply from observation. In fact, perspective appears wherever single objects overlap each other in a picture and thus show graduation in depth, and when objects in the background appear smaller than those in the foreground.

Perspective is also a means of making the illusion of space and volume more realistic. It is not essential to this illusion, for whatever one sees in a picture is unconsciously related to the aggregate of impressions seen in daily life. For example, there is not the slightest hint of perspective in the prehistoric drawing of

Leonardo da Vinci, background study to Adoration of the Magi. Construction based on middle perspective underlies this picture, to reappear in more austere form in Leonardo's Last Supper

22

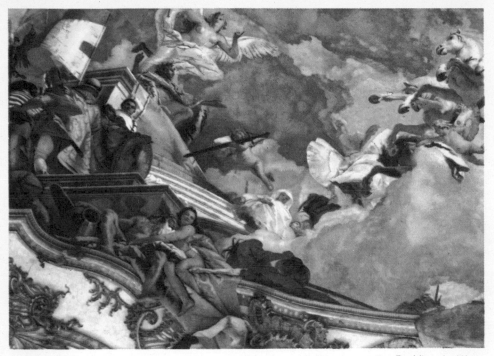

Tiepolo, detail from the fresco on the ceiling of the imperial chamber at the Residenz in Würzburg. The bold perspective succeeds only from certain angles. From others, for example bottom left, it takes on a stucco effect

the bison, yet one feels that the head and legs are nearer than the body and not on the same plane. In Egyptian wall paintings, too, in spite of the characteristic combined view, part frontal and part profile, which takes no account whatever of perspective, there are foreshortenings of circles and spatial relationships which indicate perspective. In the later styles of ancient Greek art many elements of perspective had become a matter of course.

Giotto, the greatest painting technician of the fourteenth century, paved the way for the development of true perspective by his sheer artistic mastery of form in space; and by the time of Leonardo da Vinci perspective is often used according to established rules as one of the major constituents of painting. This new scientific acquisition stimulated tremendous enthusiasm among painters for several centuries to come, but it has never been able to increase the spiritual value of a picture. Ultimately the beholder is much more affected by the mysterious charm of a pervasive and perceptible plane in the picture from which depth or modeling seems to emerge momentarily. A plane broken by perspective has no more mystery and tends to distract from the sense of a concentrated visual experience.

Baroque and Rococo ceiling frescoes

23

Signac, Venice, Santa Maria della Salute (detail). The intended effect is achieved only by standing some way back from the picture. The artist makes use of a knowledge of light physics with regard to the additive and subtractive mixing of colors (See chapter on colors)

are examples of the extreme use of perspective. It is often impossible to see whether they are painted or moulded. This is intentional; the painters aimed at imitating the much more expensive work of moulding and at extending what plaster work was already there by painting moulded forms. Painted moulding looks completely chaotic when it is seen from the wrong angle; and the plastic moulding continuing on from it projects from the wall without any logic.

Lastly came the discovery and use of color perspective. There are no rules for its use, only a few principles which are always being questioned; thus it is difficult to say where and when it first appeared. Its first great triumph, however, was in Impressionism. Today the perspective-building qualities of colors are used for the most varied purposes. The many Post-Impressionist painters used them, for example, to bring back linear perspective into two dimensions and combined them with a conscious use of the psychological effects of color.

However exact and conclusive they may be, the facts of science are not

absolutely indispensable to artistic creation. When they are used consciously, they operate as foreign bodies in art and obscure the artist's clarity of vision. They need first to be deposited like earth in muddy water to make a firm foundation in the artist's mind. Perspective founded on science was at first given an exaggerated importance and had a damaging effect on the work of many painters. The same is true of the speculations of Dr. Gall (1758-1828) on skull formation as an indication of character—which turned out, as it happened, to be untrue—and of the more correct theories on physiognomy of Lavater (1741-1801). In the same way the attempt of the Pointillists among the later Impressionists to work scientifically according to the physical properties of light soon came to an end.

Documentary naturalism lost its **raison d'être** with the development of photography. It had never in fact possessed one, artistically speaking, since it could never reproduce exactly what is seen. Before modern art turned sharply away from the directly recognizable, objective world it had already developed something which, though not contrary to naturalism, implied a critical attitude towards it. This was the stylization of accidental form into the typical. Here a very

human desire is at work: to survey and fit the surrounding world into a framework of the most generalized and simplified patterns and formulae possible; in other words the desire to see the species as an average and highly simplified form, a type, rather than as a multitude of individuals each with his own personal and different form. This desire has its parallel in other spheres: omnipotent nature is not concerned with the fate of the individual, but with the survival of the species.

Every stylization is simply the recognition of a common form behind many fortuitous related forms and the reduction of it to a geometric principle. This common form remains in the mind, making it easier to work back to its many individual variations. Once you have realized, for example, that the profile of a bellflower can be transcribed as a parabola, the frontal view of the human head as an ellipse, the contour of a young fir tree as a triangle, it will always be easy to start from these geometric shapes and to draw individual deviations from memory. Graphic abstraction from fortuitous natural shapes has led, among other things, to two independent offshoots of the art of drawing: ornamental pattern and writing.

Ornamental pattern, when it is fully

developed, always reflects some vital force of nature which is perpetually at work.

Perhaps the author may be allowed to describe an experience which relates to one of the most widespread of ornamental motifs: the meander, which is also called "wave-pattern," and sometimes "running dog." Meander was the name of a winding river, now called the Great Menderes, in West Anatolia. The term "wave pattern" recalls the profile of overturning waves at a shore; but "running dog"? One morning I looked out of my window onto a park covered with thick snow and saw a visitor approaching, a St. Bernard dog. Not seeing me behind the window, he ran across the snow and then lay down. Still I did not show myself, so he ran further and again lay down to wait. In the end he went away. Suddenly I saw how his tracks had made a perfect "running dog" pattern in the snow. The spiral curves each began and ended at the points where he had lain down. Then I began to understand something of the nature of this pattern: the symbol of the ever-repeated movements of a blind force perpetually running against an obstacle, like constant drops of water, the rhythm of day and night, birth and death. The ability to extract meaning from a representation which has been reduced to a pattern or symbol and associate it in a flash with a whole chain of thoughts and feelings is very human. Writing is the most impressive example of this. While we read, we no longer think how the individual letters arose, even though the process is known by which they developed from representations of something in nature to fixed symbols. Besides the two branches of drawing which have taken on an independent existence, pattern and writing, every pictorial representation begins with a simplification, whether it aims at a naturalistic portrayal or at complete independence from the objective world. In short, it begins with a sketch.

We all know that frequently a sketch is more effective and impressive than a finished picture. This results in part from the simplification of shape and the absence of distracting detail. The most beautiful and splendid picture may at times leave the beholder unmoved at a superficial glance; he turns away with the feeling that demands are being made on him to concentrate his attention, to give himself up. The sketch holds him more easily, it invites him to linger. This is because a sketch leaves so much open to him; it stimulates him to complete in imagination what is fleeting and unexpressed; it is full of mystery. And mystery, as everyone knows, is always attractive. The fleeting, interrupted strokes that fade into the plane of the picture

Irish manuscript, decorative animal motif. Example of almost abstract art, drawing on animal life for stimulus (eyes and beaks)

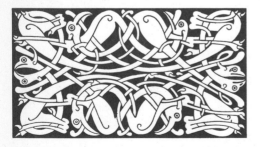

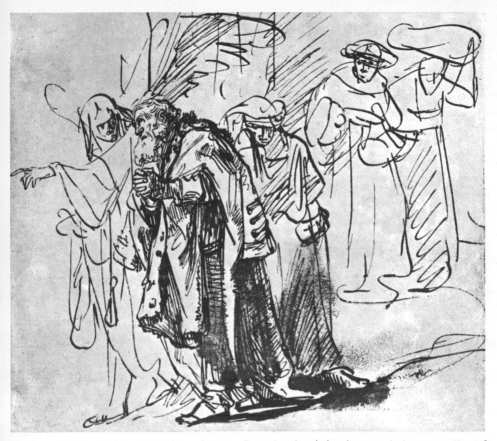

Rembrandt, The Flight of Lot from Sodom. Pen sketch, obviously executed in a matter of minutes

are continued in the mind, an activity of which one never tires.

Another charm of the sketch is that one can see how it came into being and can follow the work of its creation. Everyone enjoys watching work being done, whether or not he himself could do it. It is often said that art should conceal art, and it is true enough that signs of the effort of creation can oppress or disturb the beholder's enjoyment. But in most sketches everything seems easy, since it arose without obligation, and everyone prefers a suggestion to a command.

Gradually a new conception was introduced into the visual arts, that of a work which has the nature of a sketch, which implies rather than formulates precisely, intended not as a sketch or study but as the finished work. This vagueness and evanescence brought yet another quality into the work of art: the idea of movement.

Until the beginnings of Impressionism it had not been possible, other than in sketches, to represent anything but a fixed moment of movement, like a still from a motion picture. But a strong gesture interrupted and frozen was less and less felt to be satisfactory. It is tolerable only when it is represented just before or after its climax. Lessing tried to develop from the Laocoön group a theory of the right moment of representation which would give the noblest expression of the inner event, but it had no practical outcome. Lessing's deductions could only be regarded by detached painters as a restriction of theme. The Impressionists, however, found an inspired solution to the problem of movement in the suggestiveness of the sketch.

The Impressionists also introduced a measure of movement into the principles of composition, which were gradually becoming ossified. By composition we mean the dividing up of the area of the picture. Composition began to develop as soon as an artificial and clearly defined area replaced the natural rock surface as the field of the picture: first the wall and later the support of wood or canvas, silk or paper. Even when a modern mural is freely placed on an empty surface its position is always re-

Above: Plan showing a selective composition based on self-portrait by Gauguin (Page 65). The slightest alteration in the selected field would destroy the composition

Left: Plan showing composition with a wide field of vision, based on self-portrait by Rembrandt (Page 65). This field could be somewhat extended or reduced without appreciably altering the effect of the picture

Right: Plan showing inharmonious composition, based on Van Gogh's picture Field with Fence. The spectator has an involuntary urge to move the frame upwards and to the left

lated to the edges of that surface, most closely, of course, when the picture occupies it completely.

Just as, before Impressionism, a depicted movement always seems checked, and rarely communicates the illusion of being inherent, so composition was fixed in a balanced arrangement, in a frozen, self-contained moment from life, employing the interplay of movement and rest, the forces and centers of gravity. To create the sense that movement is in progress involves an entirely different compositional idea. At first sight the harmony is missing which until then was usual inside the bounds of the picture. A dissonance has been introduced into the picture plane, requiring an alteration of the placing of the subject, a displacement of the conventional centering of balance. There seems to be an excess of unused space at the expense of the significant part which is the center of interest. The tension of movement in Impressionist composition (which, of course, continued in the following periods) is comparable to that in classical oriental paintings. In the latter the empty space is introduced, to a large extent,

as a field for movement, although these compositions are always harmoniously conceived.

It would certainly be wrong to regard Impressionism as a break in the development of art, although it contradicted so much that had gone before, including the tradition, vacillating but constant, which had aimed at naturalism. Impressionism is better regarded as the apex of a symmetrical curve which begins by turning away from naturalism. Impressionism is an end, a climax, and a beginning as well.

A considerable distance has been traveled since then, but the path seems to be leading into the desert. The objective world is more and more seen as a thematic and formal source, which then becomes a schematic memory, until even this memory vanishes. This is not to be seen only in finished works, for in many instances even instruction in painting and drawing is also turning away from the objective. One may ask what remains when the objective world is not used even for study and practice? Were there any other subject material it would not matter, but we have now to await the results of a pedagogic effort which causes the student to represent a horse so that a layman, after much puzzling, thinks it may be a squashed liver sausage. The question arises whether we can call training that which uses as a beginning what a few individuals found as the highly personal climax of their pictorial expression, a climax which cannot possibly be accepted as a universally valid starting point. Such training arrives at what it most wanted to avoid: academic restriction. It is a restriction greater

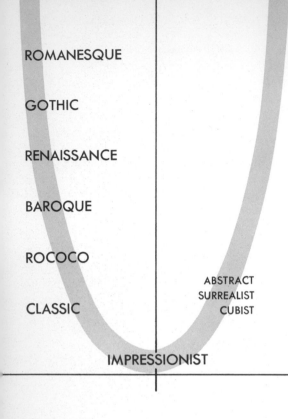

ROMANESQUE

GOTHIC

RENAISSANCE

BAROQUE

ROCOCO

CLASSIC

ABSTRACT
SURREALIST
CUBIST

IMPRESSIONIST

painting technician, to be neither necessary nor durable. These are produced because they are in constant demand by the ignorant. The beginner is helpless in all this. He is guided by what he picks up by chance here and there; he has to rely on a few dusty old manuals which contain a mass of antiquated information, not to mention the plethora of wretched small tracts. At the same time there has been for many years no difficulty in reviewing and judging painting and drawing materials and their technical use.

Nowadays everything which has shown itself to be suitable over the centuries is used as support, from natural rock and wood to cloth, paper, and now artificial fibers. In the early history of painting the powdery pigment was transferred to the support by first making it into sticks; also, once the color was mixed with a binder so that it could be spread, the brush came into early use. Both of these processes have persisted. Only recently palette knife and airbrush have been added, although spraying is seldom used outside of commercial art.

The following sections of this book are written with the conviction that painters and draftsmen should be masters of their trade. We will deal, then, with the resources surveyed so far and attempt to explain a little their fluctuating importance in picture making over the centuries. This explanation should make a beginning possible for those who have as yet no clear idea of all the different factors involved in the making of a picture. They should then be able to see more easily which things they can themselves use most effectively.

than any yet if "abstract art" is the only admitted foundation and also the starting point.

This being so, it is not surprising that the material side of painting and drawing is so much neglected in the schools. Numbers of painters and draftsmen have no idea of the nature of the materials they constantly use, and this at a time when all materials have been thoroughly investigated and analyzed in their composition and qualities, their technical and artistic possibilites. Institutes and technical periodicals can give exact information, and manufacturers can supply materials of a quality never surpassed. Yet materials are ordered which the manufacturer knows, better than any

PART I: DRAWING

1. IN THE BEGINNING IS THE LINE

If conversation turns to judging a picture which is finally dismissed as worthless, one often hears at the end of the clever talk, "Well, anyway, I couldn't do it. I can't even draw a straight line."

The speaker, humbly sympathetic and respectful of the painter's ability, is usually speaking from a quite unfounded sense of his own incompetence. Even if he does not mean a literally "straight" line, the layman often credits the practiced painter with a mass of secret gifts, particularly the mysterious gift of "talent" for drawing. This awe is quite unjustified. The average person at school and at work is assumed to have much greater ability to perform in several directions than what is needed simply to draw what he sees. Of course, **some** guidance is needed to acquire this ability, just as it is for writing, building, or cooking. A professional painter or draftsman naturally needs education and practice, just as does any craftsman, doctor, or administrator. Only very outstanding accomplishment is a matter of talent.

The famous straight line cannot be drawn without a ruler even by the great-

Left: Accompanying drawing magnified 12 times (left bell-tower). Right: ¼ actual size, pen

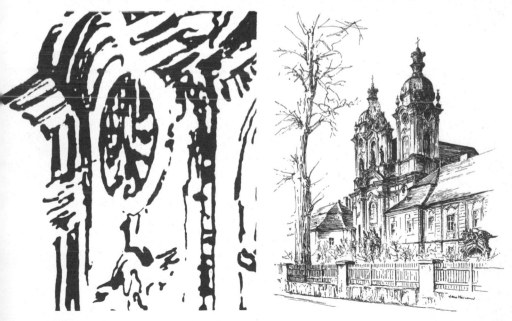

C. D. Friedrich, Monastery Burial Ground in the Snow (detail), illustrating use of set-square for architectural drawing

est artist. If you test the lines in the drawings of great masters with a ruler you will see at once that no line is perfectly straight, that lines that seem parallel are not always, and that verticals are very rarely truly vertical. This is the case even with pictures of buildings which were themselves made with plumb line and level, and seem to be so in the free, unconstrained drawing, in spite of its demonstrably crooked and wavy lines.

In this connection let us see where truly straight lines are to be found in nature. There is, in fact, only one example: the sun's rays when they are made visible by the moisture in the atmosphere. Another example, the line of the horizon on the sea, does not generally appear straight because shadows and reflections are often concentrated near the horizon. They cause an optical curve, up or down, of the line.

One of the first rules of all picture making is to draw not what you know, but what you **see** at the moment. This is equally true of external sight and of interior vision, the "inner eye."

The straight rays of the sun, the only straight lines in nature, are often drawn with a ruler, which makes a delightful and natural contrast to an otherwise free representation. Apart from this, truly straight lines occur only in man-made structures, in architecture. Sometimes in a painting, buildings also are sketched in with the aid of ruler and protractor. But many artists are enraged at the mere mention of the ruler. In this matter you must not be influenced by the expression of other peoples' feelings, but do what you feel is right for you in your own work.

Straight lines also help in the construction of spatial perspective, but the artist will seldom use a ruler to make them; in any case he will eliminate them once they have served as controls, or scaffolding, for his structure.

Generally, a free drawing of a building by a practiced draftsman looks more natural and competent than the constructional drawing of an architect. No one can say with scientific accuracy why this should be so, since the mysteries of the human organism of sight are involved here. The way the human eye combines the impressions it receives is understood to some degree, but the significance the brain attaches to these combined impressions is a matter of psychology. Nothing differs so much from one individual to an-

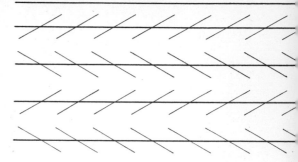

other as the eye's judgment, the ability to evaluate and judge measurements, angles, horizontals, and verticals. People do not react equally to the influence of optical illusion. These peculiarities of the process of sight, though not universally identical, have, like all other human senses, a constant tendency to equalize themselves, to work towards an average. This explains why, in the classic experiment we have illustrated, the heavier lines are seen to be true horizontals and parallel to each other only when one screws up one's eyes until the weaker sloping lines cannot be clearly seen. You may have noticed how painters often screw up their eyes while they are working. They do this in order to shut out confusing, peripheral impressions and isolate the essential effect, of color as much as of form.

We have explained from several points of view how every line is an abstraction. Scientifically speaking, a line exists only in the imagination, since it has no depth or width, and thus cannot be visible. Everything seen consists entirely of surfaces; they may be exceptionally narrow, but they remain surfaces. Pictures, however, are not concerned with mathe-

matical reality but with practical vision, which accepts the convention that even a broad line exists only in the dimension of length. The mathematician, as well, must ultimately accept this convention, since he has to see his figures.

Nonetheless, the draftsman should never forget that a line is an abstraction, primarily the representation of a sensed but invisible boundary between two surfaces. The line thus becomes part of the mental equipment of the draftsman. It is irrelevant that he sometimes sees surfaces which can, with the best of intentions, only be felt as lines, such as telegraph wires, the highlighted edge of a table, the outlines of roof tiles — there are endless examples. In theory every abstraction is reversible, and there-

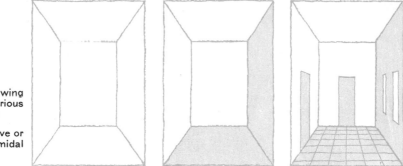

Left: Line drawing capable of various interpretations

Center: Concave or convex pyramidal frustum

Right: Unambiguous spatial effect

Rock engraving from Font de Gaume. Paleolithic age. Clarity achieved by repeating the outline several times; also by the nature of the subject

linear perspective is always ambiguous, indicating either space or volume until other elements give it definition.

The moment that the outline is doubled, not too closely, or the line itself evokes the illusion of shading and perspective by swelling and diminishing in width, all ambiguity disappears. This is equally true when the line is drawn not in one continuous stroke, but with numbers of small strokes. Either this produces an illusion of space or volume by implying perspective, or the line, especially if it is drawn with many strokes, is the beginning of surface texture which separates substance from emptiness and even leads to perspective.

fore ambiguous: the mathematical equation $(y = x^2)$, the wisdom learned from living (Where there is much light there is also much shadow), and equally so an outline. The ambiguity of the circle in the space which we invoked earlier (p. 17) can be applied further: for instance,

Optical illusion makes one sometimes see a long, horizontal, straight line as though it had a downward curve. The idea of gravity is linked with it quite unconsciously, as though it were a rope which always sags slightly however tightly it is stretched. This fact was known

The white spaces on the left are equal to the black on the right, but the white look bigger

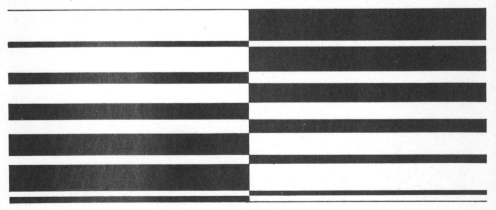

even in ancient Greece, and with interesting consequences, as the following example shows.

It was for long a scientific puzzle why the broad steps in ancient Greek architecture were not made with exactly horizontal edges and treads, but showed a slight curve upwards to the center. Practical comparison gives the answer: absolutely straight steps, when they are very wide, give the impression of curving downwards. The reason for this is that part of the tread, being above eye level, is not at first visible; only the edge can be seen. Being so long it appears to dip. When the treads are visible the light falls more strongly on them than on the risers. For the person climbing, the light is strongest ahead of him, and this is generally in the middle of the stairway. Here arises another phenomenon of optical illusion: a light line on a dark surface seems broader than an equally broad dark line on a light surface. Light stimulates the retina to spread its effect to a greater or lesser extent over the surrounding darkness. This makes the visible tread of the step seem to be broader in the middle. If it were absolutely horizontal it would seem to be worn away. For both of these reasons the steps were given a slight upward curve, imperceptible to the eye, which sees the steps as absolutely straight.

This effect of sagging is even more apparent if the straight lines are punctuated with something resting on them, like a pillar or a figure. Again an upward curve will set this to rights and go unnoticed. This is an adjustment which only the freehand draftsman can make. The technical draftsman would very soon

upset his whole construction if he attempted it. Now you can begin to see why it is that a freehand drawing of architecture can give a better effect of solidity and unity than an architect's drawing.

The man who protests "I cannot draw a straight line" naturally implies having to draw a relatively long line. Experience teaches that the longer the line, the wavier it becomes, and the humble protester thinks he should be able to draw a continuous, uninterrupted line by hand right across the surface of the picture. This is a task which no one can perform to perfection. It is a different matter to

Grossmann, Oswald Spengler (detail). The rhythmical lines heighten perspective and plasticity, and also add shadows

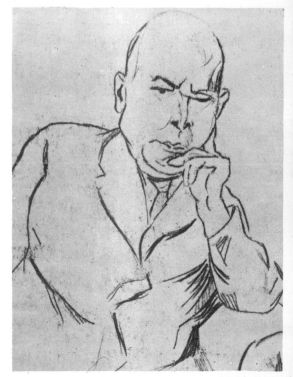

Freehand pen strokes. From top to bottom: 1. Drawn in one continuous line 2. Strokes joined to give continuous line 3. Interrupted 4. Succession of short strokes 5. Line drawn with a ruler Compare this with freehand line

lay the edge of your hand down on the drawing board and draw only part of the line with a movement of the fingers, then move the hand and start a new bit. The junction of the bits requires a sure aim, which is always hazardous; thus, it is better to leave the joints frankly visible. Such a composite line is drawn with greater control, and besides being straighter in fact, it looks straighter, which is the most important factor in freehand drawing. Furthermore, it looks easy and sure.

The little imperfections at the breaks are attractive in themselves. Anything unfinished encourages co-operation and creative activity. This may sound some-what high-flown, but the creative fantasy is fundamental to all men, and it is always satisfying to give it an outlet. Most children are much more quickly tired by a technically perfect toy than by one which does no more than stimulate them to imagine technical perfection. The imagination, too, is constantly changing its ground.

The ruler-straight line is only an ideal; the single-stroke straight line drawn freehand is a natural copy. Only the broken, composite, or repeated line can convey form. The idea of form can sometimes be heightened by letting the line extend beyond the outline of the figure. The artist can take his cue here from the tech-

Freehand drawing of building over plan drawn with ruler. The lines project at the edges

Constructive treatment of continuous and projecting vanishing and proportion lines

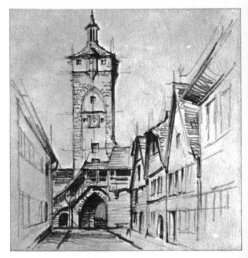

nical drawing, in which it is practical to fix angles more precisely by letting lines cross, for measurements, for instance, or to use compasses. This approach gives even technical drawings an indefinable charm, making them seem easy, almost sketchy. This charm is even more apparent in freehand drawings.

The artistic draftsman can carry the practice of working with overshot lines further, for in his first blocking out of the planes and masses he likes to find consistent combinations of lines which help in establishing and checking correct proportions. They are primarily guide lines, sections of which are then thickened where they form the outline of the surface to be depicted. This use of the line (drawn quick as lightning, not slowly and gropingly) comes from that positive attitude to the surrounding world and that manner of seeing it which may be called "constructive vision." Its opposite is naive impressionism, and between the

two extremes there are innumerable intermediate stages and styles.

The analytical, constructive way of seeing is directed primarily by knowledge and thought and a desire to see and understand the nature of things from the inside, to grasp reaity from within. Impressionistic vision, on the other hand, is entirely concerned with external form and surfaces, the inner structure is unimportant. It is essentially a painter's way of seeing. This does not mean that only painting results from it; a drawing, too, can be made in which every form is naively rendered. The impressionistic painter or draftsman is not concerned with understanding what he is representing at the moment, but only with catching the exact shapes of the various surfaces which compose the picture on the retina of his eye. From this may arise a mosaic of surfaces which need looking at for some time before the represented object emerges.

Preliminary drawing given additional detail by means of· superficial sectional treatment

Use of geometric figures to reproduce the proportions of a restless model

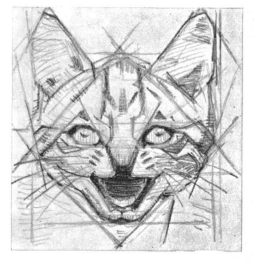

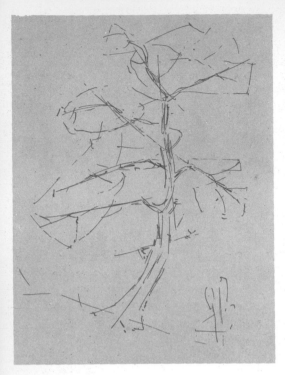

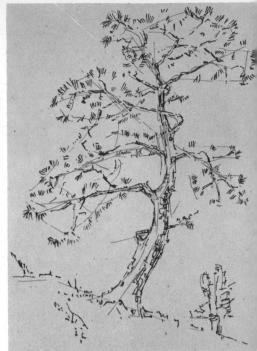

1. Impressionistic division of main surface, with little detail

2. Effect of solidity obtained by means of tinted surfaces, while shadows and individual shapes are outlined with restraint

3. The structural effect intensified and shadows heightened (chalk—medium and soft)

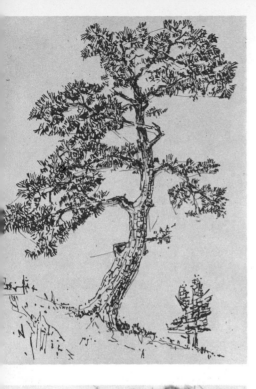

1. Preliminary drawing of constructive type, taking the shape of the tree trunk and branches as its starting point. Directional lines

2. Sketch showing which way the needles grow and the structural development of the bark

3. Final version, in which the shadows are lightly stressed by means of denser lines. (Pen; the preliminary sketch might be made with an erasable lead pencil)

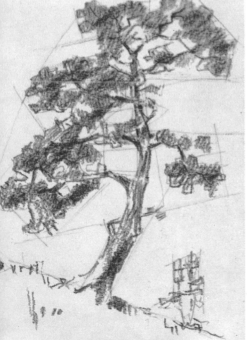

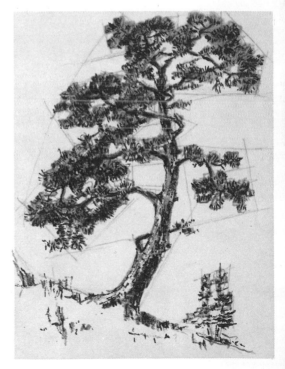

1. Preliminary constructive drawing with perpendicular and vanishing lines as starting point. (The building's horizontal lines all lead to vanishing points on the horizon at sea)

2. and 3. Elaboration (Pen)

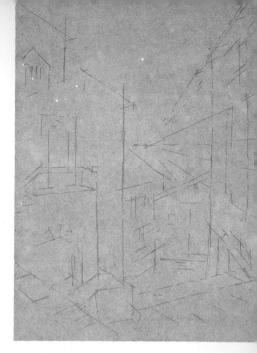

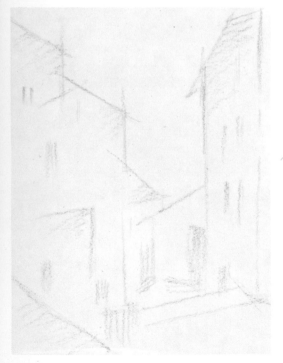

1. Impressionistic outline treatment of main areas of the background detail and architecture

2. and 3. Elaboration. The large areas already drawn serve as support for the elaboration of further proportions (Chalk—medium and soft)

1. Outline areas and proportion points

2. Outline with shadows and hair lightly hatched in

3. Darker areas treated as a whole using a combination of broad stroke, modeling, and detailed working

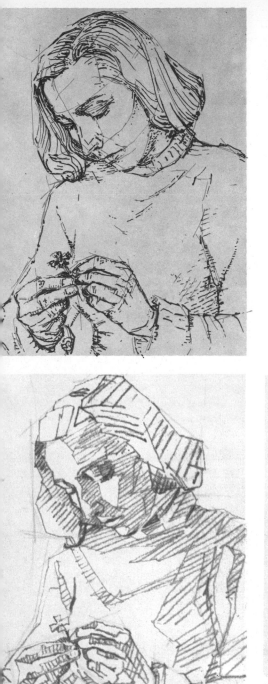

1. Here the posture and plasticity of the subject are set down by means of perspective and directional lines

2. and 3. Detailed work built up on Stage 1 (Pen)

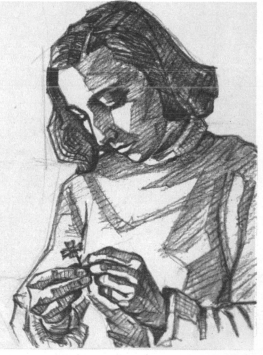

The serious student will progress most rapidly if in his practice he pursues both these extremes of vision to the utmost. He will then achieve confidence and certainty in seeing and reproducing and find most quickly his own personal means of expression. It is always wrong for a beginner to start with a one-sided program, with a preconceived notion of how to see and how to reproduce. It is equally wrong for the teacher to force his own individuality onto his students.

We have shown how in first attempting to make the ambiguous outline into an unambiguous representation, it is often the tone value that gives a thing substance. Tone value can also indicate the kind of material the subject is made of. The beholder always likes to know if he is looking at stone, wood, or cloth, whether the material is rough or smooth, soft or hard, dense or loosely assembled, etc. Lines, or strokes, can indicate material. Although it is not always ideal, the relatively stubborn "stroke" can give a peculiarly attractive rendering of material. However, color may sometimes seem a more suitable means of communicating fluid and other uniform surfaces. The simplest representation of a surface is made with parallel strokes, or hatching. But because a surface is seldom depicted parallel to the plane of the picture, parallel hatching will often throw the picture out of alignment. The lines of the hatching, like any strokes, tend to indicate a direction which is unconsciously associated with the vanishing point of spatial perspective. Either the hatching must take this into account or a different method of indicating surface must replace it: one conveying texture. Texture is essentially a means of representing a surface without implying any direction. The methods are innumerable. Even crosshatching loses any definite sense of direction, since it consists of four different directions, one pair perpendicular to the other.

It is possible to represent almost every material with textures of dots and lines. This can be practiced at every turn. **Once you can fill in textures, you progress to** drawing the textured areas without any outline. At first you need a guide: a thin pencil outline which is erased after the texture has been filled in with pen and ink. In time you will be able to achieve directly, without a guiding outline, the striking effect of textured areas which touch without outlines. These are the means of expression of impressionistic vision, of things seen as surfaces.

A uniform texture of equal tone value can be easily developed into one with gradations of tone which fades away. It can then be used for the representa-

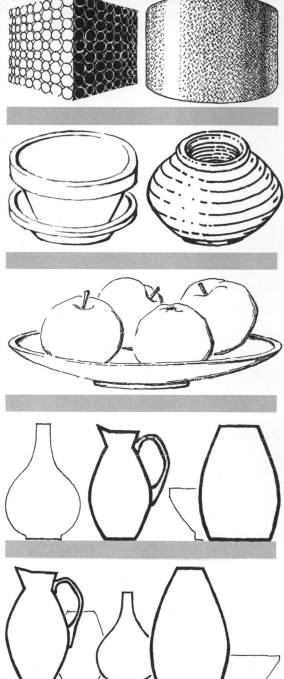

tion both of receding perspective and of modeling in the round.

When talking of the sketch, we were constantly referring to broken and incomplete strokes. They do not generally end abruptly, but are faded out, either becoming narrower or lighter in tone, or both, according to the material used for drawing. If you use a pen which does not respond to alterations of pressure, the line disappears in dashes or dots. In the same way that gradations in the weight of the texture produce an effect of volume or of distance, so a heavier or lighter line can give the illusion of space or volume, even if the line is used only as a contour. It can raise the outlined object out of the picture plane clearly enough to make shading or complete rendering of the material by texture unnecessary. Thickening of the line conveys shadow or nearness to the beholder; a faint line betokens light or distance. In the strongest light, the line can disappear altogether.

If objects of equal size are placed side by side the one with the fainter outline will seem farther away. If you make the objects overlap so that the more faintly drawn ones are partly covered you have started creating the illusion of recession in space. This illusion can be considerably increased by reducing the size of the partly hidden objects.

1. Light and shade construction (positive-negative) Rhythmical construction
2. Use of line of variable thickness and broken line to indicate curve
3. Use of broken line to indicate curve in light; and line drawn several times over to indicate curve in shade
4. Foreground and background shown by use of heavy and faint outlines
5. Differences in size used in combination with heavy and faint outline to indicate perspective

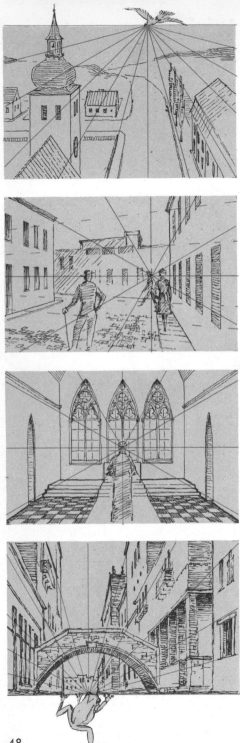

All these factors, heavy, light, and fading lines and dark, light, and fading areas, are the external media of perspective, of the art of conveying space and volume. This "art" rests on clear mathematical rules which make it possible to construct exact perspective. Every painter and draftsman should be acquainted with at least the main features of the construction of perspective. Even if in practice he does not wish to carry out these constructions exactly, he must support his subjective picture with constructional guiding lines if he is to avoid gross errors.

The easiest way to grasp the essentials of perspective is to look through a square of glass held directly in front of one eye, and copy onto it all visible outlines. If you then examine the lines, you will see that all the surfaces with rectangular outlines running parallel with the glass have parallel horizontal and vertical outlines on the glass. All lines leading into the distance, if they run perpendicular to your glass, meet like rays at one point. The outlines of surfaces which stand at an angle to the glass collect at other points. These points are called vanishing points. However many there are, these points all meet on a horizontal line, the horizon. This applies only to horizontal and vertical planes. If the planes are sloping, their vanishing points lie above or below the horizon. This horizon is always on eye level and is fixed. When one speaks of worm's or bird's eye view the eye level is simply unusually low or high.

1. Bird's eye view — 2. View with vanishing point in the perspective plane — 3. Central view — 4. Bottom view

If you stand in the center of a room which stretches in front of you with parallel and vertical walls, the vanishing point will lie on the central vertical line of your glass, and also of your picture. This is central perspective, frequently used for ceremonial and sacred pictures. You should now work from nature without a glass, transferring what you see directly onto your picture. This is easiest when you hold your drawing so that you can see above it, and your eye always meets it at a perpendicular, exactly as it did the glass.

Begin with a group of buildings whose receding lines are all parallel. You then have only one horizon line to find and two vanishing points. You find the horizon line by seeking architectural elements, such as window sills and ridges, which lie on a horizontal line right across the view. Put these horizontals, which are synonymous with the horizon, down on your paper, and from them fix the placing of the verticals. At first you will find it helpful to use a viewer, a frame of stiff gray board through which you can isolate any part of the subject, holding it closer or farther from your eye according to the scale of the subject matter in your picture.

In all these manipulations, especially when using a viewer, you should look only with one eye. If you use both eyes, you see the viewer double, since the separation of the eyes which is adapted to giving stereoscopic vision, presents a

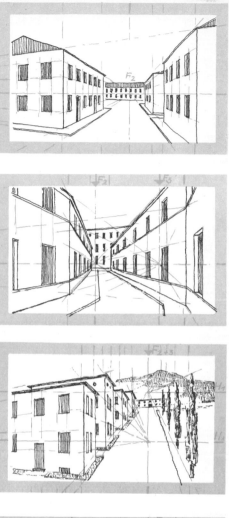

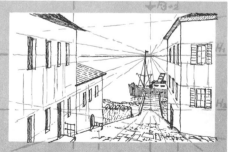

Use of a viewing frame:
1. Two vanishing points — 2. Three vanishing points — 3. Uphill = three vanishing points, two points on the horizon — 4. Downhill = three vanishing points, two points on the horizon

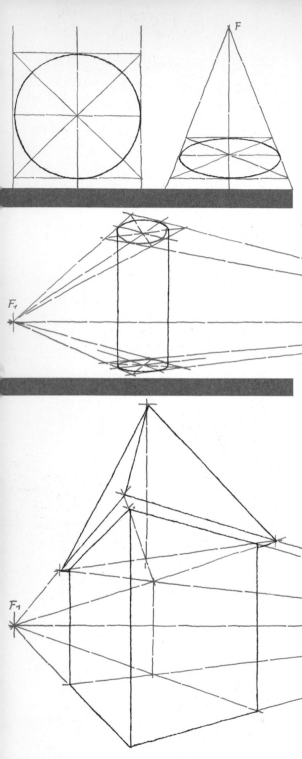

clear vision of near and far at the same time. Looking with one eye is thus better for seeing surfaces in one plane. Besides helping you to select your subject matter to the best advantage, the vertical edges of the viewer divide up the horizon, and you can transfer this important check on proportion onto your drawing. You must then find the vanishing points. Take several related receding lines, as steep as possible, and carry them as far as the horizon. They must all come together at one point. To find the vanishing point, you need only one receding line, but it is safer to check with several.

The second vanishing point is found in a similar way, but it often lies outside the area of the picture, as in the illustrated example with vanishing lines drawn in. Since it is not practical to extend the size of the drawing, the slope of the lines vanishing beyond the edge must be judged. Separate vanishing points have to be worked out for streets sloping up or down. If a sloping street runs parallel to one of the receding lines of a building, its vanishing point will lie on a perpendicular dropped from the appropriate vanishing point of the building. Then all that needs determining is its height above or below the eye-level horizon.

So far, perspective is fairly simple, but every perspective problem has difficulties which need special consideration and guiding lines for its solution. The per-

1. Circle and supporting figure. Aerial view and central view
2. Cylinder with two vanishing points
3. Slab with jutting pyramidal apex. Two vanishing points

spective of round or protruding or receding objects, for example, has its particular problems, and there are others in the rendering of reflections in water.

In the treatment of the perspective of round bodies, the sphere always remains a circle. A circular surface, however, has to be altered according to the same laws of perspective as employed elsewhere. Its alteration is best determined by surrounding it with a square. First draw the alteration in the square. Then join the center of the circle, which is also the center of the square, to the two vanishing points of the plane in which the circle lies. The two lines to these points will quarter both square and circle. They are thus diameters, which meet the tangents now to be made. These are each formed from two further vanishing lines which form the quartered square. From this it is not very difficult to draw in the foreshortened circle. It must always be an ellipse in the geometric sense and not the kind of egg shape which often appears! Mistakes are most easily spotted by tracing off the ellipse and examining it without its guide lines.

If you have to draw a pillar, imagine it to be transparent, and first draw the base and top surfaces before putting in the vertical joining lines. This is the best method for ridges too, such as the overhanging eaves on a house. It is best to imagine the main cube as transparent and draw the two diagonals onto the

1. Reflection in the water, starting from the surface of the water

2. Reflection of a building raised above the surface of the water

51

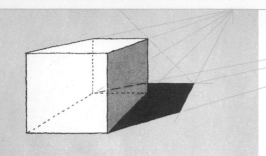

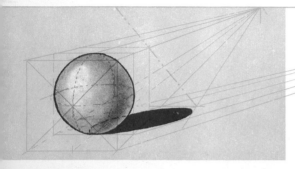

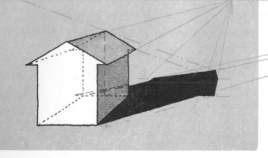

Above: Shadow perspectives (daytime) showing one vanishing point for the object and another for the shadow

Opposite page: Shadows in beam of artificial light (seen from above and side):

1. Cube in elliptic pool of light
2. Prism in parabolic pool of light with clearly defined shadows
3. Spherical objects in hyperbolic pool of light with parabolic shadow to infinity

wall, since you have to intersect the protruding corners. When you have judged the distance of the edge of the eave from the corner of the house, you find the points of the remaining corners with vanishing lines. The intersection of the diagonals is also the base line of the perpendicular to the center of the roof; for example, the apex of a tent roof or a steeple.

Reflections in water are always much admired by the layman and considered the mark of very great skill. Yet mirror perspective in a landscape is easily mastered with a little thought, since the reflecting water is always horizontal. Sloping mirrors, such as those hanging from a wall, make matters such more complicated from the constructional point of view, and require very close observation. Water reflections can easily be finished at home once the real object is taken from nature. The house in the author's drawing stands slightly above the level of the water, which you can then imagine as lying below the house. You continue the lines of the corners of the house to the water level and from there draw downwards the corner lines of the reflected house. In reflections all mirrored points lie vertically under the thing reflected, and the vanishing lines of the objects run to vanishing points which correspond with those of the reflection. The only difficulty is in judging the height of the building, or whatever the subject is, above the water surface, as there are rarely any definite control points.

Shadow perspective deserves a chapter to itself. Is is complicated for the

beginner because it introduces two new sets of perspective lines, those of the angle of incidence of light and those of the direction of its radiation. There are few problems with sunlight, which consists of parallel rays. On the other hand, artificial light radiating from a virtual source point onto a nearby object is always radial or cone shaped. Furthermore, its strength diminishes the farther the illuminated surface lies from the source of light. Although the effect of shadows is simple enough to portray from observation and comparison with other lines of perspective, the phenomenon can only be rightly understood after a closer study of how it arises and how it can be constructed.

There are two kinds of shadows: the object's **own** shadow, in which any surface of the object lies that is turned away from the light, and the shadow **cast** by the object. Cast shadow is supposed to be always darker than the other, but this is not necessarily the case. A surface in its own shadow is generally lightened by reflected light; the cast shadow less so; the latter also looks darker by contrast, being surrounded by illuminated areas. These differences in tone can make an interesting contribution to perspective. The effect of depth is less if both shadows are of the same tone, which may well happen under certain lighting conditions.

The angle of incidence of daylight determines the breadth of a shadow, which always stands in a constant relationship to the surface throwing the shadow. One of its edges always runs parallel to the surface, and thus has the

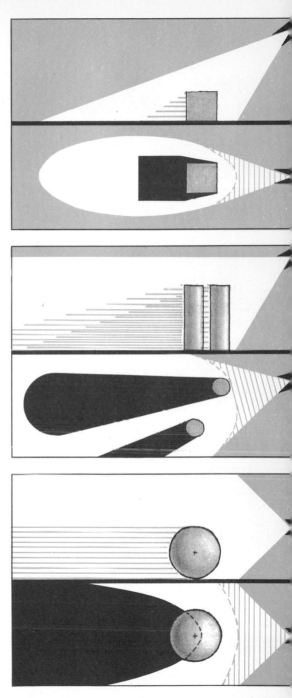

53

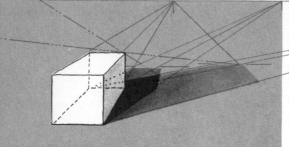

Slab with one vanishing point, two light sources, and two shadow vanishing points

same vanishing point. The other edge runs parallel with the line of incidence of the sunlight, and thus has its own vanishing point. It does not coincide with any other vanishing point of the perspective, except by chance. All the effects of daylight shadow are built up from its vanishing points and the angle of incidence of the light taken from the point of view of the draftsman.

Both circular surfaces and spheres always throw relatively circular, elliptical shadow. The general rule for other bodies or surfaces is that in daylight, they throw a shadow of a similar shape, geometrically speaking. Both the surface which throws and that which receives the shadow can be considered as the sections of a column with one common edge. This rule is of assistance when the light comes from an artificial source, that is to say, radiates from a point. It always throws an area of shadow corresponding to a conic section. The profile of this cone is determined by what shadow-throwing surfaces it meets.

The shadows made by artificial sources of light often have very strange shapes.

The best way to understand them is to study the sections of every type of conic profile. Circles and ellipses illuminated from a concentrated source will always throw shadows corresponding to the known stereometric curves of conic sections: circle, ellipse, parabola, hyperbola.

So far we have discussed light from a single source only. There is also diffused light, which can come as well from several directions as from one; for instance, in a room from several windows. Diffused light throws shadows as much as direct light. Generally, the shadows are weaker and their edges less clearly defined, and if the light comes from several different directions, there will be several shadows spread like a fan from each object with gradations in their density.

Shading to indicate rotundity was mentioned when discussing the filling-in of surfaces with fading texture. Spherical volume can be conveyed only by shading. An unshaded circle looks like a disc; a shadow on one side darkening to the periphery gives the impression of a hemisphere. The only way to create the illusion of a full sphere is to make a shadow running into a lighter band of reflected light near the circumference. This is very important for drawing and painting because natural shapes are generally rounded and do not have the sharp corners of cubes and rectangles. If a head or body, or a tree trunk, is to look convincingly three-dimensional the shading should never, except in a few extreme cases, be brought right to the edge of the outline, unless the effect is to be one of high relief.

54

2. AREAS, SURFACES, AND PLANES

First let us repeat: volume and space are registered by the human retina as a mosaic of surfaces. Every pictorial representation is concerned with arranging surfaces on a plane. The manifold means of perspective can recreate the illusion that these flat surfaces enclose bodies or that they surround space. Lines, in the mathematical sense, are invisible. Properly speaking, even the finest stroke is an unusually narrow surface. It is, however, felt as a line and can serve either as a means of delimiting the surface before it is given substance with pencil or paint, or as an outline which stimulates the beholder to imagine the substance of the surface.

The flat surface is thus the foundation of all pictorial art. Disregard of foundations always leads to catastrophe or to cheating. It would be reasonably consistent to consider as cheating those Baroque and Rococo frescoes which pretend to be plastic modeling. As you already know from working with a viewer, a picture can reproduce only the impression received by one eye. If we look with both eyes, their different viewpoints give us the feeling that we can see slightly around to the right and left of objects. This phenomenon is repeated in a stereoscopic photograph, which takes the appropriate picture for each eye. It is impossible for a painter or draftsman to reproduce this sensation. He draws as a one-eyed man sees. Hence, no picture

assumes depth of space or a sense of volume until it is looked at from some distance. The stereoscopic photograph, too, shows two practically identical pictures when the object photographed lies so far away that the difference in position of the two eyes or viewpoints is insignificant.

If you look at a wide landscape in which a telegraph pole stands about 15 feet away from you, and look at it alternately with one eye and then the other, the pole will seem to move back and forth against the background. If you move 100 yards from the pole and repeat the experiment it will move much less, and at greater distances it will not move at all. Thus, at great distances we do not see things in the round. It is only constant experience which gives us the impression of space, and it can give it equally when we look at a picture.

In pictures which are seen close up—near in comparison to the distance, say, of a ceiling fresco—the illusion of depth is most stimulating when the plane of the picture is not too drastically broken up. This breaking up is the result of a strong use of spatial shadow-and-color perspective, heavy dark areas which look like holes and light areas that jump out. If these resources are used only very sparsely so that they merely make suggestions to the beholder's imagination, then the almost unruffled plane of the picture does not distract from its con-

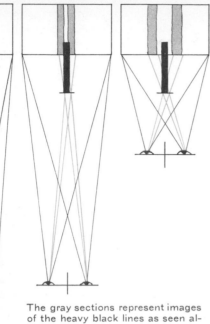

The gray sections represent images of the heavy black lines as seen alternately with the left eye and the right

as a phenomenon to be reckoned with. Even if the beholder is concerned primarily with naturalistic representation and responds first to the illusion of space and depth, he will be unconsciously aware of the picture plane. Excessive naturalism and the illusory depiction of what is known not to be there very soon becomes tasteless and tedious. Moreover, it is rare to find spiritual richness combined with exceeding virtuosity.

Emphasis of the picture plane is obtained by a number of so-called "artistic" means. The epithet is justified, for it is not enough here to follow the technical recipes unless they be combined with the extra "something" of real talent. The talent, however, can find no outlet without a mastery of the technical means. This is the precondition for any kind of art, if it is not to look amateur. How the means are mastered, whether in school or self taught, is a matter of little importance. Talent alone is **not** enough to produce a work of art.

The most important way of establishing the picture plane is by means of texture. It makes the surface felt as a uniform, tangible material. It is irrelevant whether this texture is achieved by means of drawing or painting, or arises from the substance of the picture's surface itself. Smooth white paper has no texture, nor has a smooth, polished, shiny painting surface, or smooth fresco plaster, whereas coarse paper, rough canvas and plaster have. If a textured material is available there is no need to trouble with graphic means of creating texture. On smooth surfaces, however, texture **has** to be created with appropriate pencil or brush strokes. Even the simple expedient

tent or theme. If, in addition, the plane of the picture is deliberately emphasized, it will, at a cursory, unconcentrated glance, seem devoid of any depth and arrest all the dynamic of color and movement. But if you really submerge yourself into a picture of this kind it can assume depth and volume as if by magic and perhaps only then be really understood. It would be interesting for physiologists and psychologists to study why this is so. For the practice of painting and drawing it must be simply accepted

of interrupting the line indicates that it is not intended to cut up the surface of the picture, but rather to work over it as though stitching a thread into the basic material of the picture.

Van Gogh in the course of his development as a painter, achieved the most uniform strokes possible for textural effect. With him it was certainly not a device, not an external matter. His pencil and brush strokes wind like eyeless serpents over the whole picture, an expression of the dreadful unseeing battle of all living things against each other. The texture gives exceptional emphasis to the surface, an impression which is again heightened by "false" perspective and a flattening of solid forms.

Flattening of solids and distances can also be used to transform all things depicted into a scheme of geometric figures. There is something of this in almost every sketch in which the artist has begun by linking up lines and shapes, seeking the way one curve or rhythm leads to another. This net of fine lines builds up into the effect of an expanding cobweb.

A uniform texture creates the quietest effect. But it can be carried too far, appearing mannered and so insistent that the subject of the picture becomes of secondary importance. A consistent texture is most effective on a rough surface. The original support may possess this, or it can be obtained with a thick application of paint from brush or palette knife. The rough surface gives

Left: Rough watercolor paper — Center: Canvas for painting — Right: Fine-grain sgraffito plaster

shadow effects, like a fine network of lines spread over all parts of the painted or shaded surface. A rough surface can also give a broken texture to a light, rapid brush stroke so that the basic color shines through everywhere, again emphasizing the picture plane.

Wherever a material creates a strong effect of texture or color by its substance, such as knotted carpet, tapestry, or varnished wood, it will give a strong suggestion of plane. Even the most brightly colored mosaic is absolutely flat in effect. Old book illustrations where the colors are outlined in black have the same flat look as stained glass with its black lead outlines.

Drawing with flat bristle brush (greatly reduced)

In all these different techniques, mosaic, colored drawing with black contours, and stained glass, the coarse net of irregular lines, which is both technically necessary and which determines the form, creates an effect of flatness.

If you look through a coarse-meshed net or curtain, its texture will hold the space behind it in its own plane, as long as you take care to look at both net and background together. If you look only at the distance, the net becomes blurred, and if you focus upon the net, you see it against a blurred background. This experiment can be repeated in front of a picture painted on coarse canvas; it shows how a picture can at the same time give an effect of flat surface and of living depth.

Besides the contour, which functions strictly as an articulation or outline, there is another method which is effective in stressing the plane of the picture: the black, cut-out silhouette. Black-and-white sgraffito (p. 212) has the same effect, although, unlike the silhouette, it can convey perspective. The effect of perspective is, however, reduced by the texture of the plaster. In fact, every method of drawing and painting can emphasize the picture plane simply by abandoning any kind of perspective, such as vanishing lines, cast shadows, or color dynamic. This results in the furthest remove from naturalistic representation. This approach is almost always seen in children's drawings, which are genuine, if naive, abstracts. Even an entirely naturalistic linear perspective can leave the picture all in one plane if the strokes used are very severe and uniform.

Line construction (subsidiary outlines erased)

brought into relationship with a second surface. The same thing occurs between volume and space, between two colors, or in life between two people. If more than two such entities or people are brought together, the dynamic of relationships becomes greater in number and more complex. The simplest demonstration of this is the fact that a white surface on a black ground always appears larger than the reverse, when they are placed side by side. This can be put in another way: light surfaces, or those with colors approximating to light and warmth (yellow and red), radiate and

K. H. Waggerl, Thistle (scissor cut-out)

This acceptance and emphasis of the picture plane is the artist's most important foundation, and out of it arises one of the most expressive factors in his work, the dynamic of the various separate surfaces or areas within the picture plane. A white or monochrome ground does not possess this dynamic, but it is created thereon with a single gray, black, or colored mark. This tension, relation, or discord, whatever you may like to call the dynamic between the mark and the picture surface, increases as more marks are added to build up areas of definite shape. It ceases if the entire surface of the picture is covered with identically shaped areas which make the whole into a texture plane.

Modern epistemology very aptly speaks of the "Gestik" which emanates from every surface as soon as it can be

Van Gogh, Cypress Trees Beneath the Moon (Pen)

seem to grow, while surfaces related to the blue of shadow and distance seem to shrink. All darks and black belong with these latter. This rule does not hold when strong colors are brought together with dull ones, a radiant blue against a dull red, for instance. But color dynamic is a chapter to itself.

At present we are discussing the formation of areas. The most important element is the relation in size of two or more areas, both to each other and to the area of the picture. Naturally, a large area develops more power than a small one, yet a small, light dot can have a very penetrating psychological effect on a dark picture surface. This shows that surface "Gestik" is more a material circumstance or indication of what is being expressed by what the small dot represents.

Another factor is the shapes of the

areas. Regular figures of rectangular or circular contour show no tendency to movement, compared with shapes that are elongated or point to one side.

If two or more areas lie in the picture plane, a tension is built up between them. This magnetic field is an entity which creates its own relationship with the picture plane. It is destroyed if one of the areas has a shape that implies a direction—such as a very sharp triangle or a surface that contracts in perspective.

All relations between areas or magnetic fields and the picture plane are more insistent when the main point of interest is not in the center of the picture but moves away from it. If the composition is built symmetrically around the center line of the picture, the effect is always lifeless, peaceful, or solemnly ceremonial. Central perspective or a pyramidal composition has, thus, always been preferred for sacred pictures. The choice nowadays of emphatically asym-

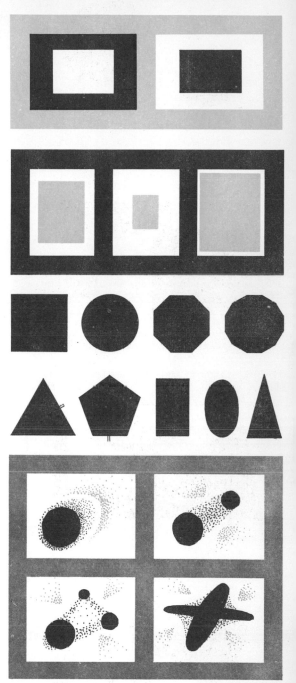

1. The area shown in black on the left is exactly equal to that shown in white
2. Left: These areas are equal
Center: The colored area is overwhelmed by the white area—or given added prominence
3. Shape without direction
4. Equilateral triangle and pentagon derive a sense of direction from the small stem. The rectangle and ellipse are two-directional vertically. The isosceles triangle has a single direction
5. Scattered dots in color indicate the direction of the white area; black dots, that of the black area (magnetic fields)

metrical arrangements expresses a desire to see Divinity more human and close to us. Symmetry, and especially central perspective, removes the Deity to the furthest imaginable distance.

You can now see how closely all matters relating to surfaces and areas are bound up with the composition of a picture. The illustrations given here are a modest attempt to encourage you to play, aimlessly at first, with areas and their shapes and arrangements, so that you understand something of the tensions and dynamics of their relationships before using them purposively to compose a picture. It is a serious, though frequent, mistake to compose only with pencil lines. If you cut out the appropriate shapes in paper and arrange them on the background you will have a much closer and clearer idea of how you want to compose your painting or drawing and what it will look like.

Experiments with balanced arrangement of plane on surface:
1. Two planes. No direction
2. Three planes. Both a pronounced and weak sense of direction
3. Three planes. Three different directions
4. Four planes, all of differing directions, sizes, and tone values. The placing of the equilateral triangle helps support the movement upwards and to the left

3. RHYTHM, COMPOSITION AND MOVEMENT

Rhythm in pictures results from spacing the lines and arranging the surfaces. Its possibilities are quite varied. Symmetrical, uniform spacing is monotonous and overemphasizes the plane of the picture, while a spacing which closes in or opens out leads out of the plane and evokes the illusion of flowing movement.

The rhythm of regular, parallel hatching is monotonous and inevitably stresses the frontal plane. If it swells and diminishes in the same stroke, it immediately suggests rotundity. If it does only one or the other it sets up a movement in one direction which seems to increase in speed where the rhythmic accents follow closer upon each other. The opposite effect may be felt also, depending on the sense of the whole composition.

If the accents giving the rhythm, here for the sake of simplicity portrayed simply by strokes, are made smaller as well as closer together, the effect of perspective gives a corresponding movement in depth. If the frequency is disproportionately increased, the movement seems to increase, and conversely it slows down

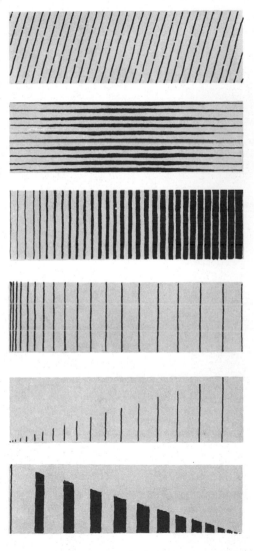

1. Monotonous rhythm and restful surface
2. Parallel lines of variable thickness, thickening in the center
3. Lines graduated in thickness, used to model a curve
4. Lines of equal thickness placed at intervals of increasing frequency create a speeding or a crooked effect
5. and 6. Lines graduated in size create perspective

Design for textile print

from pictorial representation, which is our theme in this book; yet both draftsman and painter should understand the nature of ornamental design, since it carries the elements of plane, rhythm, and composition to their ultimate conclusion. Composition begins to exist only when the area of the picture is clearly defined. The rock wall used by the prehistoric artist did not possess this defined limit. Once it exists, on the man-made wall or on canvas or panel, the artist has to show his mastery within this limitation and work out a strict utilization of space. The composition of a picture, however, unlike that of pattern, is not confined to a monotonous filling out of the available space. Contained by the edges of the picture area, it also strives towards a center of interest and a concentration of the essential, generally in a broadly geometric framework. Two or more geometric figures, acting as balancing weights, may be used to compose a picture; or one may act as a counterweight to the main center, with some sort of tension between them; or the figures may interpenetrate and overlap. None of this, though, is unambiguous, and the different solutions cannot be held to be universally applicable, for new answers to the problem of composition are always arising. Furthermore, a picture may begin either as a very tightly packed composition, a filled frame, or as a space in which the pictorial incident is the center of gravity but does not fill the whole area included within the frame. Just as we have defined two extremes of vision, the intellectual, constructive vision and the naive, impressionistic, we can define two extremes of composition. One is the

as the frequency of the accents diminishes. It is also possible to give a curved effect. The flattest effect is obtained from the rhythmic repetition of an ornamental pattern, on printed textiles or on carpets, for example, although the very movement of the eye itself gives some sense of pictorial movement as it unconsciously moves from one accent to the next, as though to make sure that the same unit is being repeated. If a cloth printed in a large, definite pattern is compared with a plain colored one, everyone will agree that the printed one is more lively; and that, conversely, it is peaceful in comparison with one that has a woven pattern or damask in it. Ornamental pattern, as we have already said, is quite different

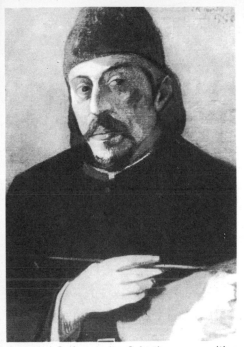

Gauguin, Self-portrait. Selective composition

ined things. In any case, the isolated subject cannot prevent the beholder asking what happens beyond its borders. However full the composition and however detailed the rendering, however much it aims at being a slice of reality, it can give only a part, perhaps the essential part, of the incident it portrays but never the whole of it. On the other hand, a drawing may be placed in an empty space without arousing curiosity in the beholder, if there is nothing to awaken it.

It does not matter whether the picture is a drawing on white paper, grows in color out of a tinted ground, or, as so often happens in the work of Rembrandt, emerges as light against a dark ground; what is important is how the subject is placed in the "empty" space. This is for the most part the basis of composition in

Rembrandt, Self-portrait

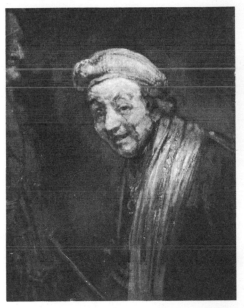

"isolating" or "detail" composition, the other is "central" composition, which works from the center of gravity outwards. There are as many intermediate stages and links between the two as exist between pure seeing and pure understanding, since composition no less than vision is engendered by artistic feeling alone and scarcely depends at all on logical or technical considerations.

The subject isolated by the viewing frame is the most passive type of composition. The photographer has no other starting point, however much he may alter the aspect of the subject with the refinements of optical instruments. But the draftsman is not tied to an irrevocably inclusive subject; he can leave things out or introduce distant or imag-

Cimabue, Madonna and Angels. Pyramid composition

Apart from a few rare aberrations, the shape of pictures has always remained one of three regular geometrical figures: rectangle, circle, or ellipse. The center of gravity of these areas, the geographical center, is virtually never the right center of gravity for the pictorial composition, since it constitutes an indifferent balance. A hanging picture requires a stable equilibrium, which necessitates raising the center of gravity above the center point. It then forms the beginning of a symmetrical composition rather like the summit of the "figura pyramidale" so beloved in the Italian Renaissance. Central and symmetrical composition underlines ceremonial, sacred themes. It is often supported by a central perspective. Art historians have made great efforts to formulate a series of schemes of composition from the famous masterpieces, assiduously drawing diagonals and triangles, circles, ellipses, and arcs, not noticing in their zeal that linear construction alone can never fully render the effects of areas. Even if such analyses are carried out more realistically, nothing more emerges than certain similarities in the arrangement of areas which are hardly capable of explaining the individual peculiarities of the com-

modern murals which no longer fill the whole wall inside the architectural framework but leave large areas untouched inside these limits. On very large areas a small mural painting will act only as a center of gravity. The subject itself cannot then use the emptiness of the surface as a supporting field but must free itself from it.

Construction based on a stable focal point, both in the picture plane and central composition

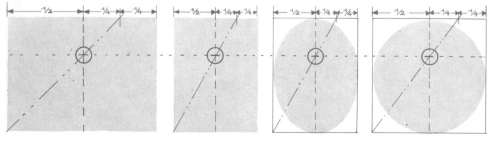

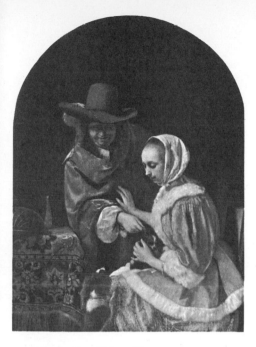

von Mieris the Elder, The painter and His Wife. The glances passing between the two figures and the dog form a triangle

seeks really to interpret a composition one almost needs a model in the round. Weight, movement, and projecting or receding effects of color cannot be understood through drawn lines and areas. The essence of a composition cannot be reduced to the formal arrangement of the plane of a picture, which is something very superficial. It is much more concerned with the dynamic of depth. The position and expression of the eye, for instance, is the only way of depicting which way a figure is looking. The path of the look cannot be represented, but, compared with the small dot representing the eye, it has a tremendous pull in the composition. This is proved by the well-tried rule that there must be much more free space within the field of a figure's vision than outside it. Perspective has the same pull, so do light and shadow.

Leibl, La Cocotte. Diagonal composition

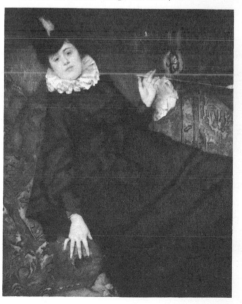

positions. The artist can build only a very trite composition by constructing in this way. His feeling works more correctly and, in a higher sense, more logically for him. Besides, there are other centers in the composition that cannot be traced with areas and lines at all, such as, for instance, the empty space that takes up the turn of a body or a head which would otherwise jump out of the plane of the picture, or the high, wide expanse of sky which can express nobility, burden, menace, and many other sensations, according to what else is happening in the picture. The classical painters of the Far East were past masters in the art of using this empty space. When we discuss composition in color (p. 358) it will be seen that when one

Rhythm, Composition, and Movement

A flight of perspective can lead the beholder's eye to an imaginary point which is not represented but which nonetheless works as the center of gravity of the picture or as a counterweight to some clearly portrayed center. Light, again, does not make its only effect by the small patch represented but often by a path which may be merely indicated only by a few illuminated points rather than a continuous shaft. These are just a few samples of the endless possibilities. Another is shadow with its contribution of dark areas and indications of direction.

An entirely new concept of composition arose with Impressionism. Hitherto, the weight and stress of the composition had always been confined within the edges of the picture. Now there arose a disharmony between the incident in the picture and its borders. The beholder feels the urge to pull the subject back into position, and since he is unable to do this his interest is excited and held. It is the same sensation as that given by a piece of music ending on a discord.

Every picture conveys the feeling, often aroused by the composition itself, that at any moment some movement may begin. A simple experiment will show what this means. The illustration shows three identical male heads, schematically represented; yet, from left to right, the heads express first, active resolution on some reaction; next, moderation, patience, and self-possession; lastly, resignation to what is apparently seen. This is not the author's interpretation, but the opinion, formulated more or less exactly, of eleven out of fourteen people (two saw no difference, one thought they were three different heads). This makes it clear that the placing of the subject, that is to say the composition of the picture, can have a vital influence on its effect and character. It is equally revealing to tilt the subject instead of moving it from side to side; as the head is held at different angles, its expression alters. Expression is always made up of gesture and pose; both can be properly conveyed only by a relation to the hori-

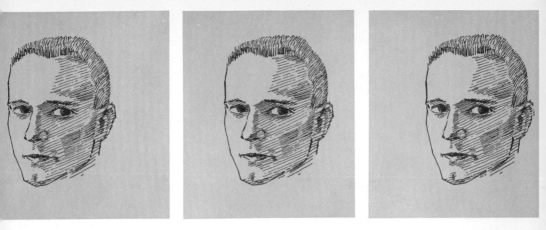

zontal and vertical axes, which are determined by the borders of the picture. The object's relation to the vertical and horizontal is the main indication of whether it is represented in movement or at rest. The determinant is the supposed line of gravity, which is always vertical; the base line is less important. An object can give a firm impression of rest even with a sloping base.

All bodies, which in pictures means all surfaces, fall down if their vertical axes fall beyond their base lines. The posture must express either helpless loss of balance or a willed movement. Whenever the line of gravity signifies a movement in progress, the picture gives the impression of arrested action, like the sudden stopping of a moving film. Sooner or later it becomes ridiculous unless some static rest can be felt; in other words, the figure should be able to remain in this position, at least momentarily, in reality.

This is a simple fact, easily proved. Here is an example taken at random. If you wish to represent a ball thrown up high, the only moment for represent-

ing it which is not ridiculous is when the ball has reached its highest point and for a fraction of a second stays there before it begins to fall. This is called the moment of rest. This rule applies equally to depicting a dancer, a discus thrower, or someone stepping forward. This is how Hodler represented his woodcutter: the axe has just reached the point of rest between swinging back and coming forward (p. 70).

If you look at the figure for a long time you can even imagine that the axe has passed the moment of rest. In an internal combustion engine it would be the moment of late firing (after the moment of rest), known to give more power than early firing (before the moment of rest), which is better for acceleration. This analogy fits the depiction of a movement exactly. The sense of speed is greatest if the movement is seized just before its completion; just after the moment of rest gives the sensation of greatest impending impetus. But to catch precisely the moment of rest itself may arrest all sense of movement.

Hodler, The Woodcutter (Charcoal). Movement frozen at top dead center

The woodman would seem to be hanging by his axe handle, not swinging it.

The beholder likes to feel impending movement more than to see it, just as he likes to feel the depth and modeling of a picture grow on him and not have it thrust at him at first glance. If a stroke is given enough space to run on, you will feel that it has not only moved to a certain point but that it will move on or is already moving again. If you give it space at either end, the stroke seems to swing. In this way movement can be represented which really seems, for a few seconds, to be going on in the picture. It is a trick, if you like; but this is not a degradation of means. Every craft has its tricks and dodges. This trick for depicting movement was first used intentionally by the Impressionists, although it existed earlier. There is, for example, the famous, mysterious smile of Leonardo's **Mona Lisa**. The mouth, or, more precisely, the corners of the mouth, seems to be moving, which has never ceased to be impressive and astonishing. It is this sensation that gives the smile its expressive power. The trick resides in the vague **sfumato** painting of the corners of the mouth, which are given space to move up or down or outwards, and seem really to do so. How quickly, in contrast, one tires of a fixed, full smile which has no possibilities of altering! Mystery is the universal trick of all pictures which move us. The problem is how to achieve it. There is no doubt that in most cases it comes by chance. The artist's genius resides in his recognition of it, and in his not trying to alter or improve it. There is real art in omission, in implication, rather than complete statement.

We usually become acquainted with lead pencils in early childhood when we experience some of our earliest graphic pleasures in making lines with them. As we continue to use pencils we learn that the marks made with soft lead, although they cover paper well, smear and come off unless we are very careful. We learn, too, that hard pencils yield sharp, clear marks that hardly rub away at all. Why? We do not ask, really, because we have become so accustomed to these common tools for jotting down notes and making sketches that we hardly so much as think about the technical processes behind them.

If we were to give thought to these questions, the very term "lead" pencil might occasion some bewilderment, since ordinary pencils no longer have a trace of metallic lead. Since the fourteenth century, metallic lead—which can be used for drawing if pure enough—has come to be replaced by a crystalline form of carbon called graphite. In its pure form graphite is too soft for efficient use—although originally it was used pure. For the last 175 years, clay (a common earth formed chiefly of a mixture of oxides of silica and aluminum) has been mixed with it in order to make it harder. Before then, efforts were made to develop graphite sticks and blocks in which powdered graphite

was held together by glue-like binders; results were less than satisfactory.

Pencil "leads" contain between 30 and 70 per cent of clay, according to grade of hardness. The clay is ground fine, mixed with the graphite, and formed under pressure into cylindrical rods. Such rods are extremely fragile and, therefore, are clinched between two pieces of wood glued together; in this way they can be held in the hand comfortably and sharpened easily. Cedar, a dark, smooth, aromatic wood, is used in the best quality pencils. There are 15 degrees of drawing pencils. The harder spectrum ranges from 10H, the hardest, to H, the least hard; F and HB are, respectively, hard-medium and soft-medium; and the softer spectrum ranges from B, the least soft, to 7B, the softest. Artists rarely use pencils harder than 6H or softer than 6B. HB is the most popular degree for ordinary use. Soft leads are thicker and more fragile than hard leads. A knife and piece of sandpaper are more satisfactory than a mechanical pencil sharpener for pointing them.

I recommend the increasingly favored practice of using refill instead of wood-clinched pencils, buying the different degrees of leads in boxes of a half dozen. Colored leads and chalks may be bought the same way.

So-called "chalks" have even thicker leads than soft graphite pencils, about one-eighth inch in diameter; they include all colors and carbon. The word "chalk" is misleading here, for the leads are not natural products, like charcoal, but materials artificially compressed like pastels, only more finely ground and purified. The leads of real chalks of natural derivation are, unfortunately, made only in black, from amorphous carbon, white, from a mixture of clay and baryta white, and red, or sanguine, from a clay reddened naturally by iron oxide. There are three grades of hardness: hard, medium, and soft, each differentiated by the admixture to the very soft raw material of corresponding quantities of binder instead of clay. If the chalks are thick or tough enough they can be used without a wooden or refill case; this is true particularly with the comparatively resistant Conté crayon and compressed charcoal.

You will remember from your school days how fragile chalk is. Binder must be used very sparingly or the color will not come off. White blackboard chalk consists of real chalk, or carbonate of lime, deposited as a sediment in the Cretaceous geological period by myriads of minute sea creatures. The chalk powder is obtained by grinding and then washing the chalk in water so that the particles which are still too large for use settle on the bottom. Prehistoric cave arists used chalk, presumably in its natural lump state. For black they used charcoal, a carbonized, not burnt, wood, the same used today for charcoal drawing. Charcoal sticks are made from thin, peeled twigs of the lime tree, which are made to glow without free access of air until they are completely carbonized. Lime wood, or willow, is best, as it is very soft and free of resin and gives a very even color. Charcoal made of hardwood is more uneven. Resinous pines and firs produce vegetable tar when carbonized, which would smear in drawing.

Colored earths are obtainable in red, yellow, brown, and dull green. The prehistoric artists evidently did not know the greens, but they used all the others. Colored earths are not found naturally in lumps, like natural chalks, which can be used as they are for drawing; and archeologists could not at first explain how the paleolithic artists applied their colors, for there is no trace of brush or pencil stroke in their cave paintings. All that could be found were pieces of hollow bone, the tibias of animals, containing traces of color on the inside. This discovery gave rise to the ingenious explanation that prehistoric man had blown colored powder onto the walls of the cave through these bone tubes. Presumably these archeologists had heard of spray painting, but it did not occur to one of them to try out this method which they had offered with such finality.

The experiment would be entertaining: someone takes a large marrow bone, scrapes out the marrow, sprinkles colored powder into it, and blows hard into one end. After the dust cloud has settled, a few grains of powder may be seen on the wall, but no one will be able to recognize any shape or form. To be effective, spray painting requires a strong blast of air through a narrow pipe which sucks thin fluid color from

a second pipe and atomizes it in a cone. The only way to produce a definite shape with a spray it to use a stencil. Also, it would be impossible to make a satisfactory atomizer out of a marrow bone, which could function only as a very crude spray.

In the author's opinion, prehistoric man discovered and used a much simpler and more effective method: the color was ground between two stones and mixed to a dough-like paste with water and some binder—the sticky juice of spurge-like plants, milk, blood serum, or egg white—and then pressed into the hollow bones. The filled bone was put to dry in the sun or in warm ashes until a finished drawing pastel fell out. The damp mixture would not stick to the inside of the bone because the marrow would have left a lining of fat, and the

1. Charcoal — 2. Conté crayon — 3. Red chalk pencil — 4. Pastel chalk — 5. Graphite pencil — 6. Crayon holder for 6H to 2B leads — 7. Crayon holder for 3B leads and chalks (actual size)

Charcoal and chalk pencil holder

evaporation of the water in the mixture would make the paste contract as it dried so that it fell easily out of the bone holder.

There is no proof that this is the method used in prehistoric times, but anyone can make pastels in this way and draw with them. The applied color can be rubbed and spread with the fingers so that no trace of the strokes remains.

Modern pastels are made in exactly the same way. Gum tragacanth is used as a light binder, and instead of the marrow bone, metal or wood moulds are used. Color paste can also be prepared on a board and then rolled into shape by hand before it dries. In the section on Painting, techniques for which it is advisable to make one's own color sticks will be suggested. In general, pastels are more a painter's than a draftsman's material. However, if only one pastel color is used, such as red or sepia, or another discreet dark tone, the result is generally conceded to be a drawing. This, at any rate, used to be the rule. When the artist uses an additional color or two, the strict division between a drawing and a painting may become uncertain, as in some pastel works by Degas or Toulouse-Lautrec. However, painting is usually thought to begin when several colors are applied and overlap or merge.

Refill pencils are made to hold leads

up to a thickness of only about one-fifth inch, and a special chalk holder or "porte-crayon" is made for charcoal and pastels, since they are so fragile. The holder makes it possible to use short ends, and it is even more comfortable with longer, unbroken chalks. Three or four springy blades protrude from a handle, and a ring passes over them to hold them close around the chalk.

The drawing materials enumerated so far, lead or graphite pencils, chalks, charcoal, and pastel, constitute a group, as they are all erasable. The softer they are the more easily they rub out. Hard pencil is the least erasable; it has to be pressed quite hard onto the paper before it makes any mark, and even so the mark is never more than dark gray. Only the very softest graphite gives anything approaching a black line or mark, and there are some solid graphite pencils available nearly four-tenths of an inch

Lead pencil in four degrees of hardness, together with graphite pencil

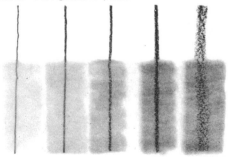

thick which can be used like pastels without a holder. They are useful for large-scale drawing and for the application of large areas of shading and for almost brush-like effects.

Some white, red, and black chalk leads are made which are nearly as hard as soft graphite pencils and give almost as firm a line. If a stroke is made in pencil or chalk with sufficient pressure it cannot be completely erased. Charcoal is different. It is so soft that the stroke can be wiped away completely into a gray smudge. Most pastels are the same, although their hardness varies. The factory aims at producing pastels with as near uniform hardness as possible, but some colors harden with time so that ultimately they will hardly mark at all unless the surface is very rough and hard, like wall plaster, or is primed with marble or pumice dust and size.

A drawn line is made by the surface mechanically rubbing something off the drawing instrument. The surface of even quite "smooth" paper is rough enough for drawing pencils and chalks, although it is much weaker than rough paper or the sandpaper used for sharpening

points. The rubbed-off particles of the pencil are held weakly and mechanically to the drawing surface. Only a few particles penetrate into the pores from pressure or rubbing. The smaller the particles the deeper they penetrate and the less easily they smudge or rub out. A rubber eraser is adequate to remove pencil marks from a firm paper which is not fluffy or fibrous. It removes the graphite particles which have penetrated the paper mechanically, but it always rubs away some of the paper, although a soft rubber does it less than a hard one. Plastic rubber, on the other hand, lifts up the particles of color by sticking to them. It is not made of rubber, but of just the right mixture of clay and vaseline to be malleable and not to leave either clay or vaseline when pressed onto the paper, and yet be sticky enough to pick up particles of graphite dust. Fresh bread crumb is even stickier and does not affect the paper; however, it must, of course, be completely free of fat or grease. It is the ideal cleaning material for restoring work, since it does not damage even the most delicate paper.

Chalk in three degrees of hardness, Conté crayon, charcoal

Soft and hard pastel chalks, with fine and broad points

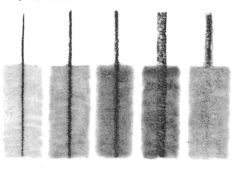

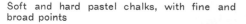

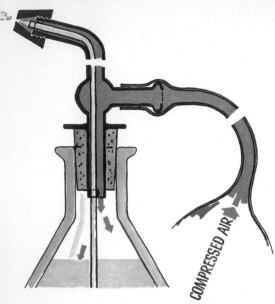

Spray attachment with rubber bulb

All pencil and chalk drawings are made without the third, binding element essential to a durable picture. Binder is therefore sprayed onto the paper after the drawing is finished, fixing the more or less loosely attached particles of color to the ground. All binders used in this way are called fixatives. In general, any adhesive material can be used as a fixative; the choice depends on the colors and ground.

The most usual, universal fixative is made from a two per cent solution of shellac in alcohol, as sold commercially. The basis of shellac is the resin of East Indian fig trees, which is extracted by punctures from plant lice, the **hemiptera** or **semi-aphides**. The resin contains some of the wax secretion from the insect, which reduces the brittleness of the resin. The wax is dissolved only in the alcohol

under heat, although the resin itself remains solid. If you wish to prepare shellac fixative yourself, you must warm the bottle of shellac and alcohol carefully in a water bath from between 140 and 158 degrees F. The bottle must not be more than half full, for some of the alcohol evaporates and could cause an explosion as it expands.

A simple blow pipe works quite well for spraying the fixative. If the drawing is large it is best to make a spray with a cork and rubber bulb. The spout and ascension pipe get encrusted in time with shellac; they can be cleaned with a thin steel wire and rinsed out by squirting a few times with pure spirits. It would be quite possible, theoretically, to brush on the fixative, but even the finest hair brushes rub off some of the particles of color and smudge the drawing.

Loose pigments used to be fixed in the following way: before drawing, the support was first primed with reversible glue, such as gum arabic, gum tragacanth, or carpenters glue. After the priming had dried, the drawing was done as though on ordinary paper and then steamed, so that the glue softened and fixed the particles of pigment onto the page from underneath. The advantage of this method is that the pigments are not embedded in the binder as they are when covered with a spray, and their surface is unaffected. The disadvantage is that the glue is sensitive to damp. This, though, is a disadvantage shared by all painting which contains glue, including all watercolors. Some experience is necessary to ensure the correct thickness of the glue; if it is too

thin it will not hold the pigments sufficiently, and if too thick it tends to crack and scale off.

Colored pencils containing oil or wax and similar pencils are not erasable. They consist in principle of pigments mixed with oil and wax and a solvent which evaporates once it is exposed to the air in a thin layer. There are also non-greasy colored pencils which can be brushed with water after drawing. None of these is very pleasant in consistency or effect. They may have some justification for taking notes in sketching, but have nowhere near the beauty of the erasable colors.

Copying pencils are totally useless. Their coloring matter is aniline dye and ink which combines chemically to some degree with the fiber of the paper when it is at all damp. There is always some dampness in all "dry" paper, so that, practically speaking, precipitation always occurs. Direct moistening with water makes the drawing run and blot.

Ball-point inks are made on the same principle; their rather viscous fluid is not composed of particles. The color is a soap-like solution colored with aniline dye. The solution dries out very quickly by evaporation, leaving an indelible mark. These inks are very sensitive to alcohol and ethereal oils like benzine and benzole, and they run and fade if they come into contact with them. This can happen even if there are gases from these oils in the air.

Apart from this disadvantage, the ball point pen can be an excellent instrument for small sketches and can make very delicate marks on paper,

Blow-pipe for fixative

producing an effect like a pen drawing. It does not seem suitable for finished work, since the color appears not to be completely durable. If drawing inks, true inks, or liquid paints are used for drawing, pens or brushes are needed to transfer them to the ground. The classic liquid "color" for drawings is black drawing ink. We shall return in the section on Painting to deal thoroughly with the term "color," but we must here point out the many uses of the word. All attempts so far to find more precise terms and usages have failed.

Color means, first, that which is contrasted to black, white, and gray. Secondly, it can mean a pigment or coloring substance; this can include black, white, and gray. It also means pigment ready prepared for painting and drawing, either liquid in the form of a paint, or dry in the form of a pencil or chalk; and here, too, black, white, and gray are

included. Thus, one can speak of black watercolor or white tempera color.

Watercolor is also a vague term. Literally it should include all paints which have water as a medium. This would include tempera, distemper, gouache, and ink. In fact, it is used only to describe colors which have a gum binder and are transparent.

Watercolor is, technically speaking, halfway between paint and ink. The latter, being a true solution of organic substances in water, is quite different chemically and physically. Ink makes a chemical precipitation on the fibers of the paper and is virtually irremovable; it can, however, be chemically changed, on the paper, into something colorless and hence invisible. Watercolor differs from ink in that the fine particles of pigment can be filtered out of the water, whereas in a true ink the coloring matter is in molecular form and passes through a filter as well as the water.

Drawing ink consists of very finely ground carbon suspended colloidally in pure water, with a binder. When brought into contact with paper or cloth, the carbon coagulates into larger particles and adheres to the surface indissolubly.

The binder used in ordinary commercially prepared liquid drawing ink, or India ink, is a mixture of shellac and borax, which cannot be dissolved in water once it has dried, but which will dissolve in caustic soda. The carbon used is not ground to the infinitesimal fineness at which colloids begin, even in the finest makes. Carbon as used in genuine Chinese ink, which is a more complex mixture than the more popular India ink, is a very fine soot obtained

by the incomplete burning of camphor oil. This soot is ground in water, a trace of glue, and various other materials of which the secret is not divulged, and pressed into a cake. The cake is pressed flat, ground down, and pressed again. This tedious process, rather like making flaky pastry, is repeated several times until finally the cake, still in a malleable condition, is pressed into oiled moulds, which often have appropriate characters carved into them. Lastly, the moulded cakes are dried very slowly until they are as hard as stone and absolutely durable. They are often covered with real gold leaf and are much prized by collectors and command high prices, particularly those of great age—perhaps nearly a thousand years old.

In use, the cake is rubbed down with water in a fine porcelain dish, an extremely tedious operation. The ink thus obtained must be used immediately before it thickens in the water. It is a much more expressive medium than ink bought ready prepared in liquid form.

It is worthwhile rubbing down real Chinese ink if one's first preference lies in brush drawing, and there are now small electrical machines to grind it down. Chinese ink cannot be used with steel nibs, as it begins to harden on the nib, but a reed pen can be used. The water must be distilled.

The brush is the most expressive instrument for ink drawing. It is erroneous to imagine that it cannot produce very fine lines; with the best brushes, both broad and hair-thin lines can be drawn, smoother and finer, perhaps, than with the finest nib.

The best brushes are of squirrel, ichneumon, or red sable (kolinsky) hair. They are round and must run to a needle point when wet. It is a professional touch when buying brushes to ask for water to test the point. It may look even more professional to lick the hairs to see if they form a firm point, but it is not very dainty and is no more effective. It is not enough simply to rely on well-known trade names when buying

Left: 1. Non-waterproof Chinese ink — 2. and 3. India ink — 4. Chinese stick ink, with glass pestle and distilled water Right: 1. and 2. Pan and tube, artists' watercolor black — 3. Opaque black — 4. Casein black

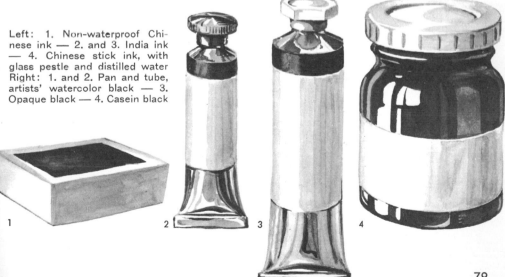

1 2 3 4

brushes; even with the best of intentions brushes cannot be identical. A further indication of quality besides price and name is that the best brushes always have seamless ferrules. The brush size is measured in numbers, beginning at 0 and going up to about 20 or more. It is valuable to train oneself from the first to work with the thickest possible brushes. One works more quickly and with more expressiveness, and with the best quality, thick brushes it is perfectly possible to make fine lines. Thick brushes hold a great quantity of color, so there is no need to dip so frequently into the paint as with a fine brush. One can draw with fine strokes for much longer without the brush drying. Thin brushes under No. 6 are really suitable only for closely detailed work and corrections.

You will soon learn to judge and value a good brush if you try working with a poor one! There are some of badger and cow hair which are far from poor, but—you must ty for yourself and see the difference! Most brushes imported from China are of wolf's hair. They are certainly no better than sable hair brushes but perhaps more resistant. India ink and its soap solvent affects them all severely, and they soon become brittle. Perpetual rinsing is tiresome when one is at work and it does not help much. The caustic attacks the hairs as soon as they are wet. Rinsing in vinegar and water after use is helpful, as it neutralizes the alkali.

Genuine Chinese ink does not damage the brush, apart from the gradual mechanical wear inevitable for any brush. If it is not essential that the drawing be waterproof, black watercolor can also be used. It is much more pleasant to work with and a more expressive medium than India ink, and it does not damage the brushes.

There is a paint based on casein which is waterproof. It can be thinned with water, but once dry, it is not water-soluble. Casein is one of the nonreversible glues. Glues are called reversible if they can be dissolved again after they have set. Casein is soluble only in a caustic, however, and this damages the brushes. These waterproof colors are best used opaque, without making them transparent by thinning. They have a compact consistency which can be very attractive. Their black pigment is a fine soot.

All liquid paints can be used with a pen, as long as they are mixed to the right consistency. This requires experimentation. Ready-made inks naturally flow better from a pen and behave like writing ink.

Nowadays the draftsman is not bothered with sharpening his goose quill with a penknife. Steel nibs are sold in every thickness and degree of hardness, and there is a wide choice to suit all tastes. The most individual line, swelling and thinning as the pressure alters, is made with a soft nib specially designed for this purpose. Ball-points are primarily for regular, even lines without any appreciable differentiation from pressure. A wide nib gives two thicknesses of line according to the angle at which it is held. Other nibs are made for writing and do not produce a sufficiently sensitive line for drawing. Yet there are

draftsmen who prefer these. There are people, too, who swear that there is nothing like an old goose quill or reed pen. Made from ordinary reed, the latter lasts only a few strokes. Chinese reed pens, however, are made of more suitable and durable material.

A drawing instrument with felt nibs has come into vogue recently. It is suitable only for very coarse and large-scale drawing. The color flows directly from a container located in the handle onto the felt tip. A practical reservoir pen for drawing ink has long been sought. Nothing so far has succeeded, for drawing ink is not strictly an ink but a mixed pigment which very easily blocks and encrusts the tubes leading to the nib, not to mention the nib itself. Reservoir pens with changeable nibs have been put on the market, however, but not everyone finds them satisfactory.

Color pens rather similar to ball-points are an improvement on this, and there are special colors made for them, but the lines do not respond to pressure. The special inks can be obtained either waterproof or water soluble. The waterproof ones require some hours to dry before they become indelible.

The author's advice at the end of this review of pens is first to take a perfectly ordinary writing or drawing nib and see if there is really anything which can improve on it.

All the pencils, brushes, pens, and colors so far dealt with are for work on ordinary unprepared drawing paper.

Round hair brushes Nos. 3, 6, 12; flat hair brush No. 18 (actual size)

Drawing Materials

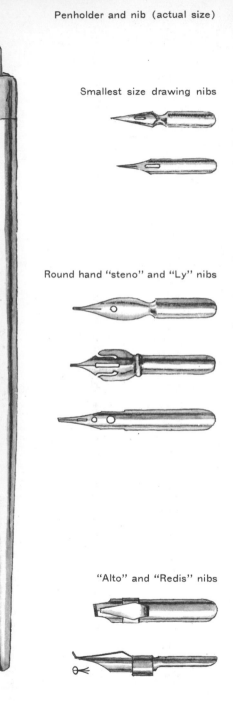

Penholder and nib (actual size)

Smallest size drawing nibs

Round hand "steno" and "Ly" nibs

"Alto" and "Redis" nibs

Prepared paper is needed for only one type of drawing: silverpoint. Pure silver is, like pure lead or tin, very soft, but it makes a barely perceptible mark on good drawing paper. Rag paper is not hard enough and must be given a ground. Bone meal used to be employed exclusively for this purpose. The best was said to be from the wing bones of capons. The bones were heated red-hot until they became bleached and could be ground to a very fine powder. The powder was also used for polishing parchment. Enough of the powder remained in the pores to cause the silver to rub off. On paper, the bone ash has to be applied very thinly with a solution of glue. A very fine chalk paste, not too soft, mixed with gum arabic is equally effective.

Silverpoint, which is like a very hard, sharp pencil, shows hardly any difference in tone or fluctuation in the thickness of line. Heavier tones and values have to be made by closer spaced strokes. Silverpoint line produces a silver-gray effect, which by oxidation soon turns to a dark brown.

Silverpoint has a very individual character, suitable mostly for small-scale drawings. It is the medium for a real craftsman who is after very fine detail. A silverpoint instrument used to be made by soldering a silver wire onto an iron or bronze handle and then sharpening it. The silver wears away very little. It is also possible to take a piece of fine silver wire about an inch and a half long and of the thickness of a pencil lead, notch the top end with a knife, and fit it into a refill pencil. The notches will make it hold.

There are many kinds of drawing paper on the market. They are not, unfortunately, always everything they are said to be. It is frustrating when paper expressly sold for pen drawing is so weakly sized that the ink runs. Handmade mulberry-leaf paper, which is entirely free of wood, is still the best. Rather absorbent papers can be used for brush drawing, especially with genuine Chinese ink, for which they should not be too heavily sized. The Chinese even primed their papers with alum in order to make the surface soak up the coagulating ink particles to some extent. It is quite easy to prepare a two per cent solution of alum, carefully cover the paper with it, and leave it to dry. The steeped paper is then thoroughly rinsed and allowed to dry again before the drawing is begun.

Japanese papers with prominent rice-straw fibers are very popular. They are especially attractive to the beginner, as their texture gives a good emphasis to the picture plane. But in time one tires of the effect, which can underline the bad as well as the good qualities of the drawing.

Good painting paper is always suitable for drawing, but the reverse is not true; a paper which is suitable for pencil or pen drawing may contain alkaline or acid ingredients which will affect certain sensitive pigments.

Mandarin injector with interchangeable nibs

Spare nibs, 2 types

Small mandarin tube injector

5. DRAWING TECHNIQUE

After reviewing the materials available and the various uses to which they are best suited, the next step is the manipulation of the materials in order to produce a workmanlike drawing.

The first need is to provide a firm backing for the paper. The simplest way, of course, is to buy a drawing block which has the pages attached either at one side or all around. These blocks, however, are not made for all types of drawing paper, and the shape of the block dictates the format of every drawing; so it is better to buy the paper in separate, large sheets. The artist gets quite a different feeling for the paper if he is able to see and handle it on both sides, and

Drawing board, seen from above, front, and side

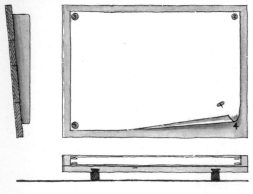

the financial outlay for individual sheets is not so great as for a series of blocks, some of which may not prove to his taste when he starts using them. It is much more interesting to choose one sheet each of different kinds of paper in a good shop. The make, specification, and price can be marked on the back of each, if there is no imprint or watermark by which to refer to it. It is useful to make one's own pattern book with cuttings, marking down comments on each example as it is tested, so that one becomes a real connoisseur.

A drawing board provides a good backing for paper. It should not be too large to begin with, about 2 by 3 feet. This will comfortably take imperial size sheets. The board should be of poplar wood, which, being one of the softest woods, makes it easy to pull out the drawing pins to remove the paper. It should have a hardwood border, which is intended to prevent its warping; however, it is advisable to make sure that the surface is quite flat before buying it.

Architects' drawing pins are the best. They are sold on cards instead of in boxes. These special pins have carefully turned, conical points and are easy to pull out of the board. If one of the points breaks off in the board in the

course of time, a small pair of flat pliers should be used to pull it out. It is clumsy to hammer the point in to flatten it, as this inevitably makes dents in the board, which renders it useless for many types of drawing.

It is often better to use bands of adhesive tape instead of pins. If this is done, a board covered on both sides with white or light gray plastic can be used instead of the wooden drawing board, as it allows for greater ease in adhering and removing the tape. Care should be taken again to see that it is perfectly flat. These boards have the advantage of being completely resistant to water and India ink.

However the paper is mounted, the corners should always be fixed diagonally so that it lies quite flat: the paper is smoothed from one fixed corner, either with the edge of the hand or, better, with a dry clean cloth, down to the opposite corner before fixing it there.

It is important not to touch the surface of the paper any more than necessary, for even the cleanest hand leaves some grease, which can prevent watercolors from flowing evenly and also affect chalks. If there is any doubt about the cleanliness of the surface, it can be rubbed over just before work with diluted oxgall to remove any grease. This product is sold ready prepared in good art shops. The dry surface should also be brushed with a small clean brush, for no speck of dust must interfere with the strokes of the pencil, pen, or paint brush. The brush is also needed after using the eraser.

Paper should be quite dry, but not too dry, as it may be if it has lain too long

Adjustable table easel and working armchair

in an overheated room. If the sheets of paper have become too dry, they should be hung up with clothes pins in a cool atmosphere near an open window and left for a day or two so that they can slowly absorb the necessary moisture from the air. It is difficult to flatten paper when it has been wet, except by fixing it in a horizontal frame so that the air can reach it from both sides.

The paper must always be carefully placed with its edges parallel to the sides of the board so that in working you do not lose the sense of horizontal and perpendicular. From the beginning the habit should be formed of keeping the

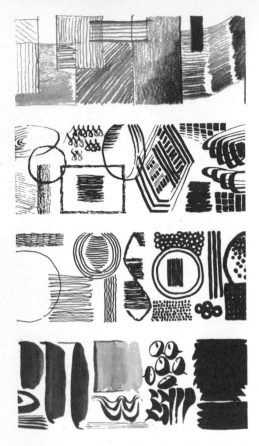

Results obtained by using (from top to bottom): 1. Lead pencils 4H to 6B — 2. Different size nibs — 3. Regular drawing nib — 4. Brush

can be raised to a slope. The whole table surface should not be sloping or there will be nowhere to put the drawing materials and eraser. The table must not be too high, about three feet is convenient If it is not at the right height for use with ordinary chairs, a revolving chair or stool that can be raised or lowered should be used, as it is important to sit correctly. The ideal chair to encourage both concentration and relaxation has a horizontal, not-too-deep seat, flat and relatively hard upholstery, and a very upright back.

Before the reader starts work, let us review the proper way to hold pencils, pens, and brushes. Most people manage more or less correctly, but many difficulties are due solely to a wrong grip. Pencils, pens, and brushes can be used in many different ways to express different things, but full freedom of expression is allowed only by a correct grasp.

Pencils and chalks are in themselves technically capable of a great variety of strokes, darker or lighter according to the amount of pressure with which they are used. The thickness of line can also be controlled to a lesser extent

Nibs filled with drawing ink do not allow any alteration of tone, but according to the kind of nib enormous differences of thickness can be obtained by different pressures. Ball-points and pens with a rigid, circular point are the only ones that give a completely uniform line, whatever the pressure.

The most expressive variation of stroke is obtained with the brush, and by diminishing the amount of liquid it holds, it can also be made to lighten the tone, an ef-

board still while working; it should never be turned around. Soon this becomes second nature. The stability of the subject is lost at once when the board is not kept in the same position.

It is usually best to set the board at an angle when working, rather than have it flat or upright. Most people who work at home need a table on which a board

fect otherwise created by diluting the liquid. The brush, together with pencil and chalk, is best for filling in areas of color, a tedious business with a pen.

The variety of expression possible with the brush led the Chinese, and, hence, the Japanese, to adopt it for their writing. This use entailed the development of a very precise and disciplined system of hand movements which could be used equally effectively for drawing. It is natural that the brush became the classical drawing instrument in the Far East, for every literate Chinese who underwent the rigorous training in using the brush required to learn to write found himself in possession of a most expressive drawing technique as well.

In the West, brush drawing has always been purely a matter of personal choice, and with the absence of a traditional discipline it has never been used to much effect.

In the West the original close relationship of writing and drawing vanished long ago; nothing but the word "graphic" remains to remind us of it. It would be ridiculous here to try to use our writing as the basis of our drawing. Even the way a writer holds his hand is much too limiting and cramped for the draftsman. The edge of the writer's hand rests on the paper, while the pencil or pen is moved almost solely with the thumb and first two fingers. This position of the hand does not allow the writing

Japanese brush work, writing and designs

Japanese manner of holding paint brush

strokes downwards, one to the left, the other to the right. These eight strokes are composed of combinations of eight different movements of the hand: laying on, lifting, drawing, lingering, pressing, turning, returning, and finishing. The beginning and the ending of each stroke are especially important, for much of the personality of the stroke depends on them.

In the West no one has ever thought of working out a system of this kind, not even to the extent of devising a system of hand positions and movements. This is regrettable, for after the usual cursory instruction everyone has to fumble for himself, struggling with all the inadequacies and mistakes which have made trouble for even the most proficient of his predecessors. There are, of course, countless and immensely varied examples of their finished work, but without copying them exactly every student has to start from the beginning for himself. The Chinese draftsman, on the other hand, starts with an ancient tradition which has evolved to the greatest perfection and simplification. This tradition is based on the script. No one would be considered capable of drawing a good picture before he had developed a good hand in writing. This is understandable, for the same movements that are used for parts of characters are also used for depicting, for example, bamboo leaves, waves by the shore, pine branches, grass under snow, and meadows in morning mist. One could continue indefinitely to enumerate what can be done with the eight hand movements with their eight strokes, all with the one hand position.

even to flow; the hand has to be moved along after every few words. This primitive hand position is adequate only because our script is legible without any subtlety of line. Only with the introduction of modern shorthand have definite differences of thick and thin strokes produced a graphic symbol which functions in much the same way as the Chinese ideograph.

In oriental character writing the brush makes eight different marks: a dot, a horizontal stroke to the left and one to the right, a vertical stroke upwards and one downwards, a hook, and two short

This position has been so skillfully devised to use every subtlety of which the human hand is capable that all draftsmen would be well advised to try it. The thumb is turned slightly upwards and supports the handle of the brush against the first two fingers, which point slightly downwards. These three hold the brush. The nail of the third finger and the tip of the fourth finger guide the more delicate movements. The hand is suspended freely, and the brush always points vertically onto the horizontal paper or silk. Only the elbow is supported, and the forearm and wrist make the larger brush movements. The vertical position of the brush makes possible the finest subtleties of movement. When the brush is held at a slope, as is usual in the West, the resultant stroke is much less controlled and sure. Chinese classical painting countenances only this single hand position, and it cannot be improved upon.

Our constricted position for the writing hand permits several kinds of drawing strokes, but a flowing, broad drawing demands several other hand positions, which permit greater freedom of movement and free the hand from the drawing surface so that it is easier to see what it is doing. A child who has had no instruction in drawing will always squeeze his fingers around the point of the pencil and bend the first finger. When he draws, in little jerks, he can see nothing of what he is doing, and, as inspiration grows, misfortune soon comes: the point breaks and tears of frustration follow. The first rule then for all drawing is to watch the intended path of the line. This rule can be obeyed only if the drawing instrument is held as far away from its point as possible, and if the hand is held free. This makes it possible to obey the second rule as well, which is to draw lightly. If the pencil is held at the far end it is almost impossible to press hard and rigidly. A drawing should always be begun with light strokes, whether one starts with outlining surfaces or building structures. The first lines are a tentative groping towards the final ones.

The beginner is often not so careful. To give himself confidence, or to look confident to others, he haphazardly sets down a thick line, corrects it with an eraser, and as likely as not continues this alternation with growing discouragement. He is likely to enjoy his work more if he dispenses entirely with the eraser. Then every line he draws must be left; consequently, they must be laid

Wrong way to hold pencil, resulting in cramped handwriting

Ways to hold pencil for
bold, easy sketching

like a breath, like gossamer, onto the
paper. Once a few correct lines have
been strengthened, the others do not
matter. They are hardly noticeable, and
do no more than make an attractive fine
texture on the white emptiness of the
paper.

Competent draftsmen use the eraser
sometimes to remove guiding lines if they
are going to work later in another mate-
rial—for instance, using watercolor or
ink over a pencil sketch. Any other use
of the eraser destroys the directness of
the stroke. It is just this spontaneity
which charms the beholder and arouses
his imagination—not corrected, though
absolutely "correct," lines.

There are two hand positions suitable
for a light sketching stroke. With the
first, the end of the pencil or brush points
into the palm of the hand; with the
second, the handle points past the edge
of the hand while it is held by the tips of
all the fingers. The latter is the typical
grip for charcoal and bare chalks. The
hand can use them on their sides, flat,
without a change of grip, for putting in a
surface in one stroke. The area covered
depends on how steeply the pencil is
held to the paper.

A stroke of stronger and more certain
effect is obtained by holding the pencil
closer to the point, either with the writ-
ing grip or the one described above for
charcoal. The pencil must never be held
so short that it obstructs sight of the line.
A loose, long line is drawn from the
shoulder and elbow, almost entirely
without wrist movement. Strong and
very sure strokes need a support for the
forearm, wrist, or even the edge of the
hand. Then the wrist can make the move-
ment for the stroke. Very short strokes
are made by the fingers alone. In this
way one can draw with heavy pressure,
as far as the firmness of the paper and
the strength of the leads allow.

The question of strong pressure does
not arise when using the brush. Only
hair brushes are used for drawing, and
they are so soft that it is almost impos-
sible to tell with the eyes shut when the
point touches the paper. The smallest
touch with a filled brush makes a dot or
a thin stroke. Greater pressure will give
broader lines or areas. The finest and
most regular stroke comes from a brush
held perpendicular to the paper. The

Way to hold charcoal
and chalk

The fist grip of pencil or brush, which, of course, is held loosely and not like a murderer clutching his dagger, is surest for horizontal and vertical lines. It leads directly to "building," that is, to a Cubist interpretation, however insistent curves and slopes may be. Extensive use of the fist grip is liable to become an affectation, but at least it forces the student to draw with broad, bold strokes. It should be practiced with discretion. A hand position is as indicative of character as is handwriting, and any affectation is betrayed in the finished work.

Without a traditional technique for holding the instruments and forming strokes, such as the Chinese learn, the Western student has to set about finding and developing his own personal technique as early as possible. It would be wrong to search out something quite new for the sake of originality alone, but it may be valuable to study the drawings of famous masters for an appropriate style of expression. Much of the individ-

hand needs support for fine brush strokes, using either the edge of the hand or the outstretched point of the little finger.

There is another grip which produces strokes of great individuality: the thumb points straight down the pencil or brush, while the fingers curl above it almost into the fist. This grip requires the use of a flat brush, and here we pass over the borderline from drawing into painting. Also, an almost upright surface is essential for this grip, whether using pencil or brush. With the other grips the slope of the surface was immaterial, except for the Chinese brush grip, which must have a horizontal surface.

Way to hold pens, pencils,
and brushes when precise
strokes are required

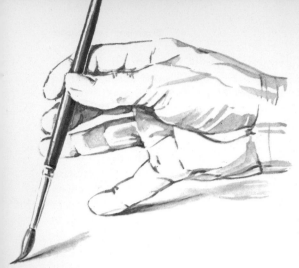

Way to make long strokes

dividual temperament. One artist may concentrate immediately on some detail, then add a second, then others, and carefully draw in the final lines, quite unconcerned about the "correctness" of the whole. He will see more cosmic significance in a grain of seed than in a tree or a whole forest.

To work from the small form to the large one certainly requires a touch and vision different from the reverse process. These suggestions are to indicate that the most suitable approach for a drawing is not consciously determined, but something which grows out of the artist's nature.

The development of technique is naturally closely concerned with a personal preference for certain drawing materials. This is a matter of individual sensuousness, which develops quite unconsciously.

uality of a work depends on the way the strokes are made. It is instructive to try to imitate the kinds of strokes in a chosen model. By this is not meant a true copy of a particular drawing, but a use of the other's manner in one's own drawing. An analysis of something perfect of its kind is a rapid means to self-discovery.

This, however, is not enough: the same motif should be drawn in different techniques. Especially valuable are those which the student does not like. His prejudice often turns out to have been misplaced, and he finds increased expression by mastering a new method. If not, he is reassured that he is already working along the right lines.

The mode of vision determines to some extent the way the strokes are made. Until now we have spoken of only two ways of seeing: an impressionistic and a constructive, or structural, mode. There are others, which differ according to in-

Way to hold brush for fine detailed work

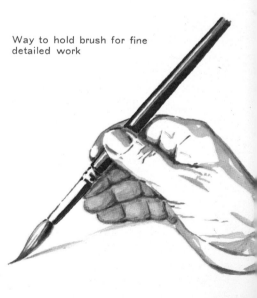

Dürer, with his fine, precise lines, thought out everything in advance to the last detail. Kathe Köllwitz was more spontaneous; her broad, soft touch brings the deepest human qualities to light directly from her response to her subject. To draw a line with charcoal across smooth paper—some people cannot even endure the noise it makes—certainly evokes different feelings from drawing with pencil, pen, or brush. There is nothing to be gained from resisting or ignoring these physical stimuli and preferences, even though they seem to contradict the Chinese dictum, "When you take ink you should not be taken by the ink, and when you use the brush, the brush should not use you."

The beginner is not alone in being open to the temptation of filling in surfaces, especially shadows. Everyone has a natural desire for completeness, which is frustrated by empty spaces between wiry lines. It is as difficult to draw with pure lines alone as it is to paint a perfect watercolor. When drawing with a pen, the only way to fill in a surface is by hatching. You have to abstract once more, as you did with the line: you see contours which are in reality only boundaries between different colored areas. If the beginner uses charcoal or chalk, he is at once inspired by the softness of the material. He can rub and wipe with his finger to fill in surface and achieve wonderful gradations and the softest, smoothest rounding. But he should beware: this is only a hair's breadth from vulgarity.

The beginner must discipline himself firmly against mannerisms of this sort, or he will blind himself with cheap effects, which he seeks only because they are easy. Perhaps it will open his eyes if he attempts the same motif twice in the same material, once rubbed soft and once using more or less gentle strokes.

Above all, let the stroke be gentle! There is no difficulty in pressing hard and dashing down wild lines; this is not really the measure of a creative temperament. A better ideal is strength restrained by gentleness. A thoroughbred horse cannot be tamed by muscular strength, but by gentle guidance, behind which he can feel the iron will.

Drawing Technique

We do not wish to disguise the fact that problems arise when drawing a surface which appears more or less uniform. "Surface" refers not only to a smooth, paved road or a plastered wall, but to the surface of a field, the silhouette of a mass of foliage, mountains, water, sky, or a patch of dark shadow. It is all very well, say, in a pen drawing to deal with the problem of surface with parallel hatching. Suppose there are a rocky cliff, a field, and the sky as three different surfaces in the same picture. The three surfaces will have to be differen-

Design illustrating use of pen in landscape picture

tiated from each other and, further, should awaken in the beholder the illusion of the substances of which they consist. The answer to this problem has already been touched on: texture can replace a mechanical copying of minute particles of the surface with a more impressionistic reproduction of the general effect. This gives as much, often more, than an "exact" picture.

The reason for this can be illustrated as follows: if a collection of various tree barks was shown to a group of people of average education, most of them would be able to tell the difference between a pine, a poplar, and a beech tree. But if these people were asked to draw the barks from memory, even just after looking at them, it is unlikely that they could do so. A general impression is much more important than individual details, and a texture can give this just as effectively as a painstaking copy. This is the principle behind oriental painting; which has a convention of textures to render different materials. Not only is it unnecessary for the draftsman to put in individual details instead of a texture, it is tedious both for him and the beholder if the texture fills the whole area. A mass of people need not be depicted by dozens of portraits, even though a texture of heads side by side is liable to be mistaken for a field of cabbages. The common spirit which has brought the crowd together can be expressed in one or two faces which merge into a massed sea of faces, each indicated by a few rapid strokes. Pictorially it is adequate, and, moreover, more attractive, to put in the texture fully over some parts of the

area and let it fade off and disappear in others. The eye of the draftsman will see only the texture of a roof surface where his attention is concentrated. The rest of the surface he will see more as an indefinite patch of color, or in a drawing as an area of a certain tone. Thus, the whole area of the surface can simply be given a tone value, out of which the textural drawing appears at a few places or even at one place, in the direct path of the eye, on shadowed areas, or on the illuminated parts. If, for instance, the paving of a market place in sunlight is laid in with gray tone, and the bright patches where the light is reflected are left white, the texture of paving stones could perhaps be indicated in the bright patches. Though the picture is drawn in detail only in these places, which merge into the surrounding gray tone, the impression will be that the whole place is paved. The important thing is to find an appropriate way of making this tone.

Only one kind of tone should be used for brush drawing; it is laid on with the brush loaded with diluted color or ink. Chalk and pencil can make tone with broad, soft lines or by rubbing over the lines with the finger or stump. For ink drawing, one can make a wash of tone by brushing over the strokes with water, provided the ink previously used is water soluble. Sepia ink, once so popular, is water soluble; it comes from the ink bag of the cuttle fish. It is, however, notoriously sensitive to light, in contrast to modern materials which derive their coloring matter from pure carbon.

With the use of tone we are leaving the realm of pure line drawing. Tone

Tiled roof, repetitious design covering whole surface (brush)

Plaster, design in light and shade

Crowd, broken lines (chalk)

95

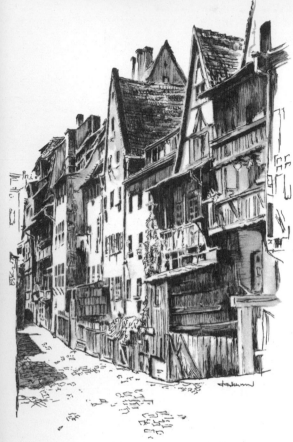

Drawing in non-waterproof Chinese ink applied with a mandarin injector

ter whether the line drawing or the wash is done first; but if soluble watercolor is used, the wash would dissolve and smudge what should remain as line drawing. Dark stroke accents cannot be put in until the end, and work must progress from soft lines and washes towards the dark values. This is always the correct mode of procedure for work on white paper, which, for this and other technical reasons is best for watercolor.

When working with pencil, chalk, or charcoal, it may be necessary to use the above-mentioned rubbing technique to make a toned surface, although very soft strokes done one on top of the other or with a broad point will always give a sharper effect. If the rubbed tone is preceded by a finished and strongly formulated line drawing it provides the material for stumping. Working in this order it is easier to decide where tone will enhance the picture and where it is unnecessary. Starting in the reverse order, with patches of tone which are afterwards defined with accents and contours, requires greater certainty, for there is no scaffold or framework from which to work towards the final idea. Whichever approach is used, tone or modeling must never show labor or anxiety. Its nature is to be flowing and easy, and it is better done with the fingers than with fine-pointed stumps, which carefully fill in every corner. Tone must show spontaneity. It is a very severe and impartial indicator of competence.

A drawing loses its freshness if it is fixed each time after work on it in order to avoid smudging. A drawing should never be fixed until it is finished. Eraser

increases the realism and plastic quality of the picture. Its use is a matter of choice, for it is impossible to say whether a tone drawing is "better" in principle than a line drawng, or vice versa.

Some forethought is necessary if tone is to be used. If one is working with insoluble, fast-drying ink, it does not mat-

and bread crumb should be left well alone, particularly when using chalks. With charcoal some final erasing and touching up can be done. Because it is so soft, charcoal has a very loose contact with the paper anyway, and it produces rather imprecise lines, which match the uncertain traces of the eraser.

A line and wash drawing on white paper is built up in the same way as a watercolor: working from light to dark. Starting with the wash and finishing with the accent strokes is more in keeping with an impressionistic vision. If the constructive approach is preferred, the reverse order is appropiate. It is possible, of course, to do both simultaneously, just as both modes of vision can be used together.

Black or white chalk drawing on colored paper is comparable to opaque color or oil painting. The artist works from the background color into the darks and puts in the lights at the end. This way of drawing is best done with lines alone; washing or stumping does not give good results. White strokes are best done with white pastel, not white pencil, which is too transparent on most papers. The greatest precision is obtained with a fine brush line of opaque white.

We have already shown why readymade, bright colored paper is unsuitable for any drawing other than an explanatory sketch or a poster. It has more important artistic arguments against it, for the exact tone of color used is exceedingly important to the whole effect. Color laid on by hand can produce an exact tone and besides has an attractive surface quality. The background color has to

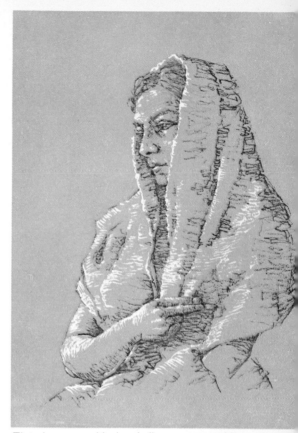

Tinted paper, black chalk, opaque white strokes inserted with a brush

combine well with the material used for the drawing, either by affinity or contrast. Some "black" inks have a brown tinge when diluted, others are colder, bluish or violet. It is rare to find a black that dilutes to a neutral gray, and when it does it is affected by the color of the paper and gives all kinds of nuances from the effects of color relationship. Even when undiluted, pure black inks do

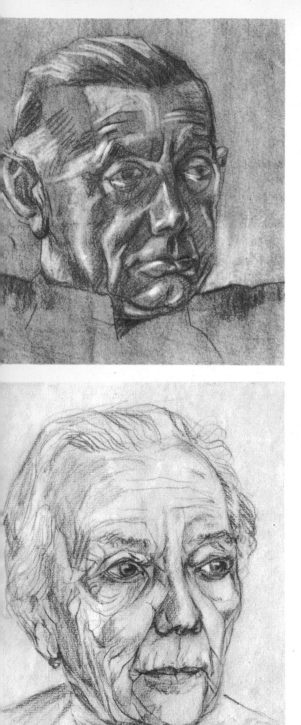

the same. This must be kept in mind to avoid unexpected results. The Chinese, who are the greatest authorities on ink, used its hidden color qualities deliberately. More will be said on color relationships in the section on Color (p. 251). Without a close study, it is impossible to control effects with colored paper.

Despite the numerous varieties of colored paper produced since their manufacture began, the best artists have always tinted their papers themselves, aiming at an optical, colored gray by the exploitation of color relationships. Dürer laid a mat green over red ochre to make a sensitive brown or greenish gray. Sometimes he made a tone verging on violet and blue grays. But gray was always aimed at, not strong colors which are too noticeable, distracting from the drawing and the theme. Those who incline too much to strong colors should remember this.

Tinting of paper is best done with transparent watercolor. Opaque colors, besides looking dead, often make the ink stroke run because of their opacity, although they are tolerable for pencil or chalk. Even then the "heightening," as white shading for high lights is called, is unattractive on them. It is

Above: Rough white drawing paper, black chalk. A broad first application of Conté crayon is rubbed over flat; then more detail is inserted, and finally high lights are picked out with a soft rubber eraser
Below: White French Ingres paper, red crayon. The original line drawing is tinted in places by moving the pencil point lightly over the paper

thus advisable to keep to a thin glaze of watercolor; the whiteness of the paper behind it imparts a brilliance even to dark tints.

Corrections cannot be made on ink drawings on colored paper without spoiling the tint. Opaque white, too, cannot be corrected or washed off without smudging the ground. If pencil is used, then only opaque white can be used for heightening because white chalk does not combine satisfactorily except with black chalk or charcoal.

A drawing heightened with white pencil or opaque white cannot, thus, be attempted without some experience and competence. There is an easier technique on colored or gray tinted paper. It is, in the author's opinion, much safer, as it rests on uniformity of material. An eraser is all that is necessary; the rubbed out ground gives the high lights, as follows:

The light paper is colored all over with ground chalk, but not fixed. The drawing is then done in black or red chalk as required, as though onto white paper. A soft, pointed eraser is then used to take out all the high lights from the ground. It is possible then, if necessary, to deepen the darks with the chalk, or put in more detail.

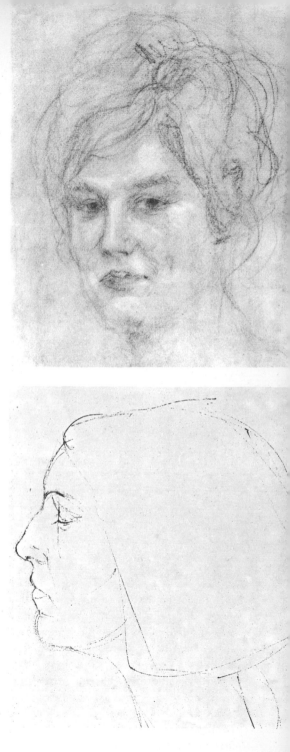

Above: White French Ingres paper, red crayon. A soft drawing achieved by rubbing over the entire surface several times with a wad of cloth and finishing off with shadows added with a blunt crayon
Below: Light gray Ingres paper. 1mm. Rex nib used the wrong way round. A preliminary study for a portrait (no preliminary drawing). In one hour six sketches were done in this way

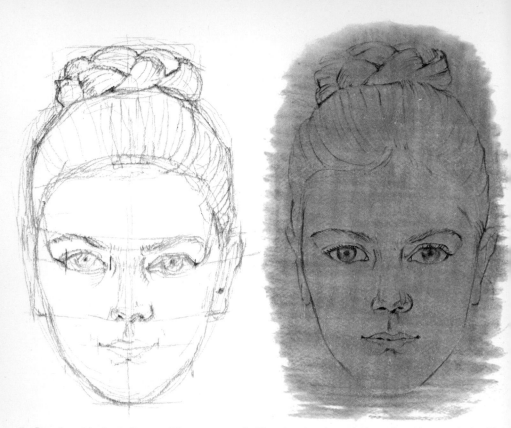

1. Drawing, black chalk on white paper — 2. The drawing traced through and corrected with red crayon rubbed over the wrong side — 3. The lines to be retained are pressed through onto

Another method is to draw with black chalk on white paper, almost without any shading. The drawing is then fixed so that it can be wiped and the tinting rubbed in, taking out the high lights again immediately with an eraser. The work can then be continued with the black chalk. This method has the advantage that all the thinner lines of the first sketching in are obliterated by the tinting, and the stronger ones are softened and gain in quality from the color of the chalk overlay. Subsequent working with black may stand out rather too much, however, unless all the lines are gone over again.

A technique used with immense success by Hans Holbein the Younger is almost unknown nowadays, although it requires a minimum of means. It em-

French Ingres paper with a hard pencil; this is then lightly tinted by pressing with a stump, then a few final touches are added directly onto the third sheet of paper (using a red crayon). Work carried out entirely in the presence of the model

ploys a tracing technique to eliminate every unnecessary or uncertain stroke, working down to the essential contours. All the work is done from the model. After the first sketching in, the back of the paper is rubbed over with powdered color and laid, right-side-up, over a second sheet. The correct lines are pressed onto the second sheet with a hard pencil or stick. This sheet is then worked on and again colored on the back and traced through. This process can be repeated indefinitely, until the drawing is quite perfect. The lower sheet picks up some of the color from the top sheet, especially where it is pressed deliberately, perhaps with a rounded stick, the back of a finger nail, or whatever seems appropriate. The soft, lightly spreading lines from the tracing give a very tender

Thin watercolors are used, then light gray opaque color is thickly applied. The whole is then covered with sweeping strokes of Chinese ink and bleached out under water

and subtle modeling. The powder used on the back of the paper must, of course, be of the same material as the drawing, red or lead pencil or black chalk.

Nowadays tracing paper could make the process simpler, white paper being needed only for the first and last drafts. The intermediate stages would not be pressed through, but traced onto the transparent paper.

Lastly, we shall describe a new procedure. It uses drawing ink which is indelible on paper once it has dried, but which cannot penetrate a thickish layer of glue-bound paint. Any thick drawing paper or board can be used. All the surfaces and lines which are to appear white are painted in with ordinary poster white, preferably after a preliminary pencil sketch. This is not very easy, as the white paint does not show up well on the white paper, but unless it spoils the final effect the white can be tinted with color or black.

When the paint has dried, the whole page is covered with ink, using a broad hair brush, and left to dry again. The page is then laid flat in cold water, and the ink is washed off where it lay over the white paint. Then, the paper is held under running water and sponged or brushed with a bristle brush to remove all the white and whatever ink remains on it. Only the black ink and the exposed white lines and areas remain.

Most people enjoy this process immensely. All sorts of chance effects are produced by the varying thicknesses of the white layer, which in some places lets the ink through a little. Wherever the ink has got through it is held fast. The work looks like the most delicate brush drawing, and even quite clumsy work looks effective. Professionals who do not know the technique are often puzzled by what seem to be negative brush strokes, as though some mysterious substance had etched away the ink at these places.

This process can be elaborated in many ways; for instance, instead of white, opaque colors can be used, which by reason of their colloidal composition leave a hint of color behind on the paper when they are washed off. Colored waterproof inks or paints and even strongly diluted ink can be used instead

of pure black ink. Again, it is possible to start by covering some areas with waterproof colors (casein colors, for example), draw over them with soluble white when they are dry, and then paint over that with ink or casein color; this will wash out where it covers the soluble white, producing a multi-colored effect. The design or picture still remains a drawing, since it is held together by a graphic texture, as in batik or mosaic.

A similar process, known as resist dying) has been used for centuries on textiles. Using wooden blocks, a design is printed in wax or paste onto the raw cloth, which is then dyed. The wax prevents the dye from taking on the printed areas.

How to enlarge a square grid. The colored lines indicate the procedure

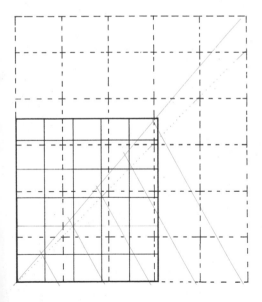

This review of drawing techniques does not exhaust the possibilities, and much can also be done with combinations of different techniques. Some materials do not go well together, such as pencil and chalk, nor is it possible to use a wash over charcoal. It is better, however, to experiment with the chance of finding interesting new combinations than to be too strictly confined by cramping rules as to what is "correct" or "allowed."

Drawing technique includes a knowledge of the purely mechanical processes of enlarging and reducing. Every draftsman and painter must at some time or other alter the size of a sketch or drawing to fit another format. The simplest method, which can be used even by quite an inexperienced draftsman, employs a network of squares.

The original drawing is conveniently squared up into a grid pattern, and correspondingly larger or smaller squares are laid over the paper onto which it is to be reproduced for the enlargement or reduction. It is comparatively simple to copy the lines in each square of the original onto the corresponding squares of the reproduction.

It is best to draw the new squares onto tracing paper, for once the new drawing is done, they are not wanted. The back of the tracing paper should be colored and the new drawing traced onto its paper. The flat side of a pastel is the best thing for this, for then the tracing can be uniformly wiped out. Carbon paper is not good because the "carbon," being generally an aniline dye, is indelible. Paper which has been rubbed over with chalk is suitable.

The pantograph is hardly ever used in freehand drawing, but a new copying instrument called a Bell Optican (anti-scope) is very useful. It works on the principle of the epidiascope, but with greater precision. It reflects a well-illuminated image or drawing and projects it through an enlarging lens onto a surface placed at right angles to the original. Usually it does not enlarge anything above about six inches square, and cannot make above a six-fold linear enlargement. If the original is larger than six inches square, the enlarging has to be done piecemeal, which requires some practice and skill; and if an enlargement greater than six fold is wanted, the process has to be repeated in stages. This is liable to produce error, so that squaring up is really more satisfactory. The Bell Optican can also be used with a lens that reduces the size of the original, but

its scope is rather limited. This machine should, of course, not be used for copying other people's drawings, which would be pure theft. Nor is it much less objectionable to use photographs as models for a drawing which could never be made freehand. Its use is quite justified however to bring up one's own small sketch to the required size or to enlarge a part of it to make a picture. Work can be continued on the enlargement, improving and adding, and being all one's own work there is no moral objection to it. Etchers, engravers, and miniaturists have used the reducing glass ever since it was invented; no one accuses them of dishonesty or lack of artistry for doing so. Art is not a game which must be played according to rules to make it more difficult. The purpose of technique is to remove material hindrances from the free expression of the spirit.

Anyone who does much drawing in a professional way and makes use of ruler and set square should consider investing

Diagram illustrating working of a Bell Optican (antiscope)

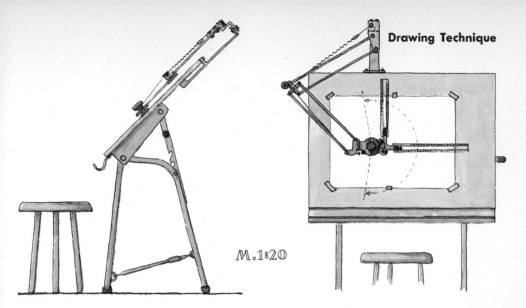

M.1820

Small drawing machine with adjustable board about 28 x 40 inches and hair-spring counterbalance seen from side and above

in a "drafting machine." It consists of a set square held in equilibrium by weights or springs, which can be moved all over the board without altering its angle. It is firmly mounted on a board and made in many sizes, from simple flat boards that lie on the table to the largest drawing boards which move by balancing weights or even hydraulic pressure. This elegant apparatus is intended for architects and technical draftsmen, but it makes work a pleasure for artists working on a large scale who use rule and square for guiding lines and need exact measurements, even though they work in freehand.

FORM

The following sections treat of the artist's subject matter from two points of view; first, investigating how natural and artificial forms have arisen and developed, reviewing the principles of growth and construction, and, secondly, indicating how these forms can be understood visually and transcribed onto paper. This artistic activity may involve leaving out some unessentials in order to stress the essential. The essential in turn is sometimes further enhanced by exaggeration, simplification, or elaboration.

It is clearly necessary to have a correct understanding of an object before reproducing it. Even deeper understanding is needed if the work departs from the external form, in an abstract representation, than if it is done from a model present in the flesh or in previous sketches and studies. To draw well we must be acquainted with the skeleton and surface anatomy of the human body and of animals, the principles of growth in plants, the methods of construction used in buildings, and the factors underlying the phenomena of landscape. Without this knowledge gross mistakes are inevitable. Even if we intend to draw what we see and feel rather than what we know, we need a basis of objective knowledge to give it significance. There is no need to cling helplessly to this knowledge, but without it we can never penetrate far into the nature of things.

The works of the old masters are full of distortions or alterations of form and shape, deviations from what the eye actually sees, but they are never biologically or structurally wrong. A beginner usually draws a movement incorrectly unless he has some idea of the anatomical structure of the body. It is not so much detailed information which is necessary as a comprehensive understanding of the biological or, in architecture, the structural, principles which constantly recur. These enable the artist to put onto paper forms taken either from nature or from his imagination. Whether in the constructive or impressionist style, a figure drawing is always begun in a different way from a landscape. The following pages aim at providing the basic knowledge from which an individual style of drawing can be developed.

The skeleton determines the proportions of the human body, especially its length. The bones are for the most part joined flexibly to each other. From this fact arises the mobility of the body and the changes in its shape.

The movement and position of the bones and joints are directed by muscles, which also affect the breadth of the body: a person with weak muscles is thinner than one with well-developed muscles. Muscles, too, determine to a large extent the contours and shape of the body.

Skin and the fatty tissues under the skin level off these contours, rather as a firm chalk drawing is leveled off by stumping. The fatty tissues have sometimes more effect on the breadth of the body than the muscles. For instance, if someone fifty years old has a waist measurement half as much again as that of someone of twenty five, it is due to the increase of fat tissue; the skeletal measurements of both ages are practically the same.

BONES AND JOINTS

Bones are rigid and unalterable in shape. According to a person's constitution some parts of the bones can be seen more or less clearly modeled under the skin. These places are where the artist starts fixing the proportions of the body. The shape and function of the whole bone must be understood in order to understand the shape of the body where it comes to the surface. Bones also determine the posture of the body, which is evident when the functions of the bones and their relations to each other are known.

The formal structure of a joint is unimportant for the artist; its **function** is what interests him. The simplest joints occur where two cartilaginous ends of bone meet without crossing and are held together with the fibrous cap which covers all joints. The most visible example is where the collar bone is attached to the breast bone. The cushioning discs between the vertebrae also allow a measure of movement to each bone against its neighbor. The spine as a whole is like a rod which can bend in every direction and twist around on itself. The ribs, with their cartilages and ligaments joining them to the breast bone and spine, build up the rib cage, which, thanks partly to the flexibility of the rib bones themselves, is a very elastic structure. The elbows and knee joints and finger and toe knuckles are like mechanical hinge joints, but, being organic structures, they are more elastic than rigid mechanical hinges. The knee joint as it bends also permits a twist to the lower leg down its long axis. The radius and ulna rotate against each other along the length of the forearm.

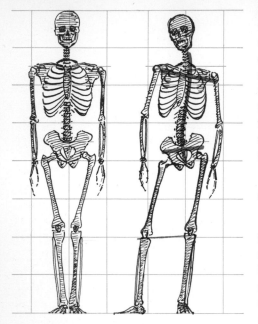

Chart showing alteration in axial skeleton in level upright position when weight is shifted to one leg only

ball of the hip joint that is to take the weight, and the resting leg has to move away; the spine bends to find a stable equilibrium and thereby causes an asymmetrical movement of the ribs. Shoulder and arm joints also unconsciously adjust themselves more or less visibly to maintain a balance. This will naturally involve a corresponding reaction of the muscles.

MUSCLES

The surface relief of the body is determined mainly by the muscles which are attached to the skeleton and move it and partly by the subcutaneous fat tissues. The muscles constitute the flesh of the body. There are also the vascular and intestinal muscles which are not externally visible and do not belong to surface anatomy. Every muscle is composed of small fibers which are bound together with tissue. Nervous stimulation causes the fibers to contract and this makes the muscle change its shape. If the nervous stimulation ceases so does the contraction of the fibers, and the muscle ceases to work. According to the demands on it the muscle grows in size or diminishes.

Muscles are attached very firmly to the bones by tendons. These are composed of strong, inelastic fibers, which can be seen and felt on the surface of the body when the muscles are tensed, for instance at the sides of the hollow of the throat, between the muscles of the forearm, wrist, and fingers, between the shin and toes, and at the sides of the kneecap when the knee is bent. The tendons running between the forearm and fingers and between the

The shoulder and hip joints are comparable to mechanical ball-and-socket joints. The shoulder can also rise and fall as a whole, and the entire shoulder girdle comprising collar bone and shoulder blade is attached to the chest in a way that allows some movement.

The hands and feet are composed of manifold systems of hinge joints and articulations. As units they can rotate at wrist and ankle with the mobility of ball and socket joints.

The movement of a large joint results in a series of movements in the smaller joints; for example, for you to stand on one leg, the pelvis must drop around the

shin and toes are appreciably longer than the corresponding muscles. Tendons, especially the largest, the Achilles tendon, which builds the contour of the heel, can easily be mistaken for bone, for they are tightly stretched and feel hard.

Except in sleep, the muscle fibers are always held slightly tensed, even when they are not working. They are like engines ticking over. This rest tension is called "tone." It influences the whole appearance of a person, and if the tone is too slack he looks, and probably is, slack, tired, or ill.

Every muscle can contract or relax either in jerks or very gradually. As long as there is any contraction the muscle is working, for there is no mechanism for maintaining it at a constant tension. If the muscle stops working, the limb which was held or moved by its power falls by force of gravity back to a position of rest.

Muscles only pull, they cannot push, and every muscle has its counterpart working in the opposite direction. If the extensor muscles of an elbow were cut, the arm would still be able to lift something towards the body by tension of the flexor, but, except by force of gravity, it would be unable to put it down again. Usually only the most important functions of muscles are given in anatomy books, but it is interesting to note that some muscles, particularly in the chest, back, and shoulders, have subsidiary functions; when a joint is bent to its fullest extent the direction of a muscle's "pull" may be changed and its function as flexor or extensor altered as well.

PROPORTIONS

Attempts have been made ever since Antiquity to submit the proportions of the human body to a canon or formula. In comparatively recent times Dürer made an exhaustive study of bodily proportions which is still valid as a point of reference for modern research. Since no two bodies grow to the same proportions, the search must start with an average of many measurements. From this it is relatively simple to find the individual character of a real body.

All research on this subject has concluded that the human body is constructed by and large according to the proportions of the golden mean. This proportion is a division of a given dis-

The area indicated in red is that part of the larger gluteal muscle which serves to move the hip

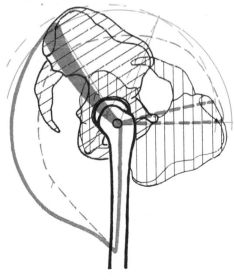

tance so that the smaller section stands in the same relation to the larger as the larger does to the whole. The algebraic formula is $m:M = M:(m+M)$; where $m =$ minor, smaller section, $M =$ major, larger section. This division can be exactly found only in a geometric construction, but it yields an approximate figure of 0.618, which serves as multiplier for the value of the distance to be divided. The result gives the value of the larger section with sufficient exactitude.

This theory ought to be understood; though, since calculations and geometric figures are out of place in a freehand drawing, it is enough to judge by eye or to use the simplest measurements, with folded strips of paper or a pencil held out to mark off distances. This technique should be mastered, for it is essential to be able to divide distances. More

From the left, the divisions of the colored vertical stripe are measured exactly, according to the golden section, while from the right the eighths are drawn freehand

theory: the Fibonacci series in which each succeeding number is the sum of the two preceding ones yields increasingly close approximations to the golden section: (1:1, 1:2) 2:3, 3:5, 5:8, 8:13, 13:21 and so on. It is close enough to stop at the proportion 3:5, according to which 8 (3+5) can be divided easily according to the golden section. If a length is 176 inches, an eighth is 22 inches ($\frac{5}{8} = 110'' + \frac{3}{8} = 66''$).

Of course, no figure drawing is started by making a series of measurements. All we need to do is to mark down the height from the standing line to the crown, and then to halve it. These divisions are halved again, and yet again until the height is divided into eighths. The third and fifth sections divide the whole height by golden section. Ever since Antiquity the following rules have been valid: the human head, measured from the under edge of the chin to the top of the crown without hair is an eighth the length of the whole height of the body. The navel is at five-eighths of the height of the body from the ground. If this distance is again divided according to the golden section in a relation of 3:2 it meets important lines of proportion on the shin. The diagrams show how divisions into eighths mark out other important points on the body.

The proportion 3:5 is not far advanced in the Lame series and is, therefore, not very exact. A multiplication of 176 by the index 0.618 arrives at 108.7. This makes a difference from the division into eighths of 1.4. The practical effect is that the navel has to come very slightly lower than the five-eighths line, a correction which can be made by eye.

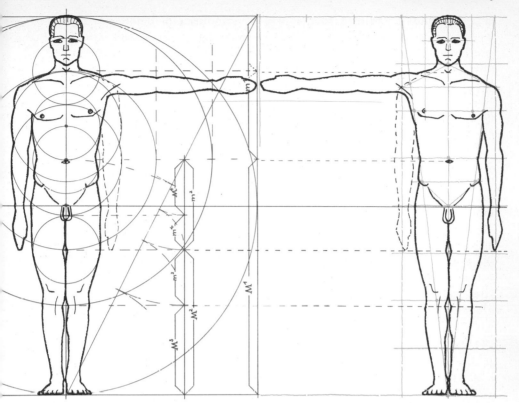

The radii are used to measure off sections according to the golden section. The circles then approximate to various body measurements. The hachures indicate the difference between constructive design and exact division into eighths

The drawings illustrated side by side show a comparison of the exact and rough schemes, demonstrating that the latter is perfectly adequate for freehand drawing. The exact scheme can be arrived at only with compass and set square, and these have no place in an artist's equipment. The difference is so small that a scaffold of 16 squares is perfectly satisfactory. It is quite sufficient to draw this scaffold freehand and by eye.

Some other measurements are of use. The two diagonals from the standing point to the corners of the complete double rectangle have been found to touch important points, though they bear no relation to the golden mean. Neither do the two outside lines of a rectangle formed by one eighth squares on either side of the center axis; but these are easy to find and give useful indications for the breadth of the body. If the upper four squares are divided into sixteenths, the lines are valuable for finding the proportions of the head as a basis for the shoulder triangle and for the distance between the breasts. Another division

into sixteenths in the fifth squares will give the triangle of the pelvis. Unlike many other guiding lines this one is not altered by movements of the body, as the pelvis is rigid within its own bone structure. No guiding lines can do more than give points of reference for comparing with the model.

The only generalization to be made about the adult human body, in view of the extraordinary differences of proportions from one individual to another, is that all healthy bodies are consistent: a thickset trunk has thickset head and limbs; short armed people generally have short legs as well. This harmony persists in the soft parts, too: the musculature, fat and skin tissues. There are, broadly speaking, three general types into which all the multifarious individuals can be divided:

1. The leptosome or slender type, tall and thin and long limbed, with a long, narrow trunk and correspondingly narrow shoulders and a long, narrow skull.

2. The athletic type with broad shoulders, a high solid skull, powerful trunk with large chest, firm abdominal muscles, little fat tissue, making the muscle contours clearly visible attached to large bones. The body has an overall wedge shape.

3. The pyknic or compact, thickset type, of medium height, with round skull, short neck, and a deep chest. A tendency to grow fat tissue inclines to make the muscle contours even out; the face is soft and plump and the body paunchy. This type loses its harmonious proportions if, through hunger or diet cures, an attempt is made to approximate it to an irrational ideal.

Fundamental differences between the male, female, and child's body structures also exist alongside individual differences. The male body is generally used for the study of anatomy as it shows the bones and muscles most clearly. Male and female differences are to be explained through their difference in biological function, the male being more adapted to work and the female to the demands of reproduction—hence, for instance, the greater breadth of the female pelvis. This in turn causes a strong curve inwards of the upper leg bones, which is why women tend to be knock-kneed. The pronounced narrowing of the female waist is in part due to the broader pelvis and in part to its stronger turn forward. The female rib cage is generally longer, deeper, and narrower than the male, and more rounded off at the top. The shoulders drop correspondingly lower and tend to be more rounded and sloping; sometimes the neck, too, seems longer and more slender.

On the female body the chest muscles are almost completely hidden by the breasts, which very enormously in shape with individuals. There is no biological nor aesthetic norm to be found for them.

The canons of earlier times maintained that on the whole the female body is smaller and gentler, shorter legged and armed, and with proportionately smaller hands and feet. A comparison of earlier representations of the female body, until the latter half of the nineteenth century, with photographs of modern sportswomen shows plainly how little these canons apply to the average modern woman. Rather do we see now that the

proportions of the female body are not so different from those of the male, a reflection of the changed role which women play in social life. Sloping shoulders have become much rarer in women. A long leg is now the ideal of female beauty, and nowadays it is unusual to see such breadth of hip as used to be taken for normal in the old days.

It is biologically impossible that the skeleton should have altered so much in a century; the change can be explained only by the social tendencies of the modern age: women now hold themselves more upright and walk with more freedom and self confidence. Muscle tone, influenced by these factors, can disguise much and make the anatomy seem very different from what it really is, implying that there is still some mysterious chameleon-like quality in us that can even alter the shape of our soft tissues. Sport and uninhibited movement in sun and air with a minimum of clothing have become as usual for girls as for boys, and thus girls, too, develop their muscles at the expense of the fat tissues. Some medical opinion attributes a tendency to greater stature directly to the influence of sunlight on the body, particularly in early childhood.

It can be seen from the diagram of physical growth from birth to maturity how different parts of the body grow at different rates. In linear measurement the head, for example, only increases from between a half and a third, whereas the shin is four times as long in a man as in a newborn baby. All the other parts of the body increase in different proportions within these extremes. The five stages illustrated are not taken at regular intervals of age. Generally, a person grows most quickly between the fourteenth and sixteenth years, and often reaches full stature during this period. It is clear how important it is to observe the characteristic proportions when drawing children.

The oblique blue lines show the growth of individual parts of the body between 0 and 21 years

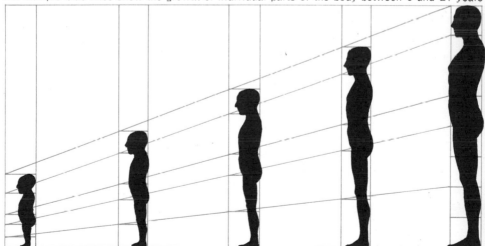

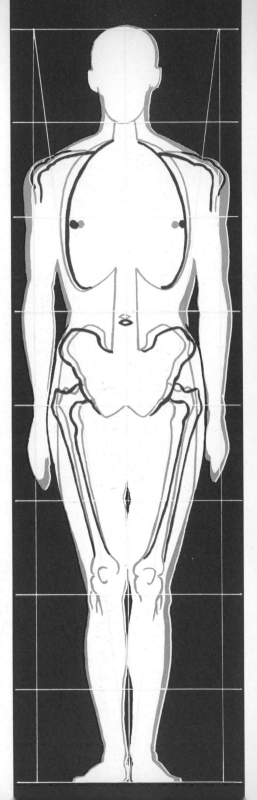

The white areas indicate the outline of the female body compared with a male of the same size. The red lines show the female skeleton, and the blue lines the male

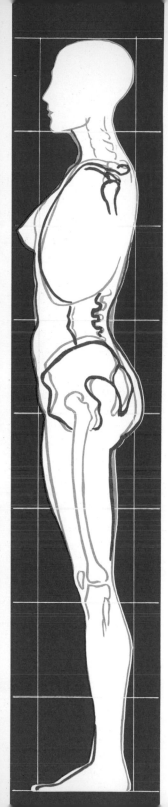
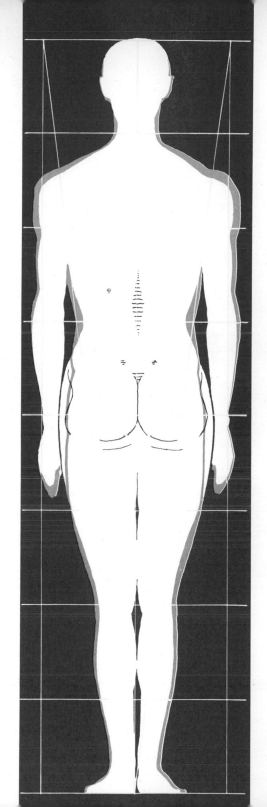

Skeleton and Superficial Muscles—Front View

Sternomastoid 27

1	Cervical vertebrae (7)	
2	Coracoid process	
3	Collar-bone	Shoulder-girdle
4	Greater tubercle	
5	Shoulder-blade	
6	Sternum	

Coicoid cartilage 28
Clavicular fossa 29
Acromion process 30
Collar-bone 31
Deltoid 32
Pectoralis major 33

7 Ribs (12)
8 Humerus

Nipple 34
Serratus anterior 35
Biceps 36
Rectus abdominis 37
Radio-ulnar angle 38

9 Lumbar vertebrae (5)

Cubital fossa 39

Obliquus abdominis externus 40
10 Radius
11 Ulna
12 Iliac crest
13 Anterior Superior spine of the ilium
14 Iliac fossa
15 Head of femur

Extensor carpi radialis 41
Brachio radialis 42
(same as 13) 43
Inguinal ligament 44
Mons pubis 45
Tensor fasciae latae 46

16 Greater trochanter
17 Neck of femur
18 Pubic bone
19 Femur

Femoral triangle 47
Sartorius 48
Gracilis 49
Quadriceps 50

20 Kneecap (patella)

Medial epicondyle 51

21 Head of fibula
22 Anterior fibial tuberosity
23 Fibula
24 Tibia

Patellar tendon 52
Gastrocnemius 53
Tibialis anterior 54
Anterior crest of the tibia 55

25 Medial malleolus
26 Lateral malleolus

Soleus 56
Malleolar angle 57

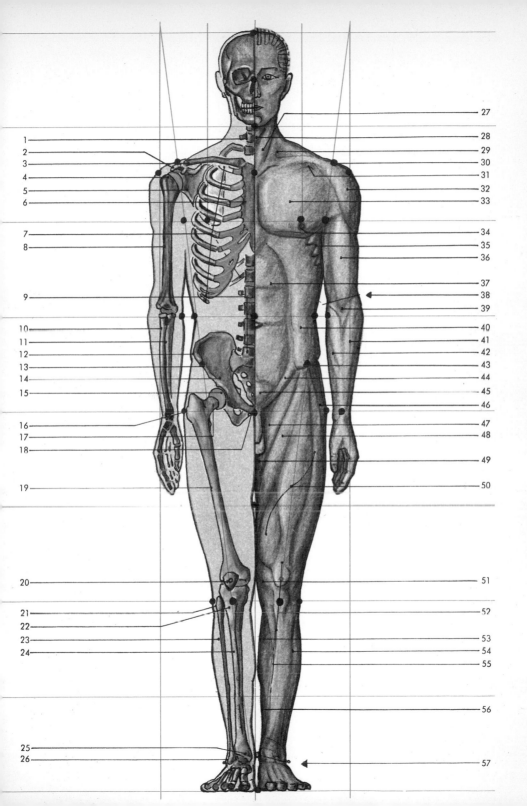

1

2

3

4

5

6

7

8

9

10

11

12

13

14

15

16

17

18

19

20

21

22

23

24

25

26

27

28

29

30

31

32

33

34

35

36

37

38

39

40

41

42

43

44

45

46

47

48

49

50

51

52

53

54

55

56

57

Skeleton and Superficial Muscles—Side and Back View

1	Clavicle	10	Cervical vertebrae (7)	Sternomastoid 31
2	Coracoid process	11	Spine of scapula	Acromion process 32
3	(Sternum)	12	Head of humerus	Trapezius 33
		13	Blade of Scapula	Infraspinatus 34
		14	Humerus	

4	True ribs (7)	15	Thoracic vertebrae (12)	Triceps 35
	(rib cage)	16	Floating ribs (2)	Latissimus dorsi 36
		17	Lumbar vertebrae (5)	Radio-ulnar angle 37

		18	Ulna	Obliquus externus 38
5	Iliac crest	19	Radius	Flexor carpi ulnaris 39
6	Anterior spine of	20	Ilium	Extensor carpi ulnaris 40
	the ilium	21	Sacrum	Tensor fasciae latae 41
7	Pubic bone	22	Head of femur	Gluteus maximus 42
		23	Ischial spine	

	24	Ischium	Adductor magnus and gracilis 43	
	25	Greater trochanter	Vastus lateralis 44	
	26	Lesser trochanter		

27	Femur	Flexor muscles of the knee 45

8	Patella	
9	Tibial tuberosity	Popliteal fossa 46

28	Fibula	Calf muscles 47
29	Tibia	

		Achilles tendon 48
30	Heel-bone (calcaneus)	Malleolar angle 49

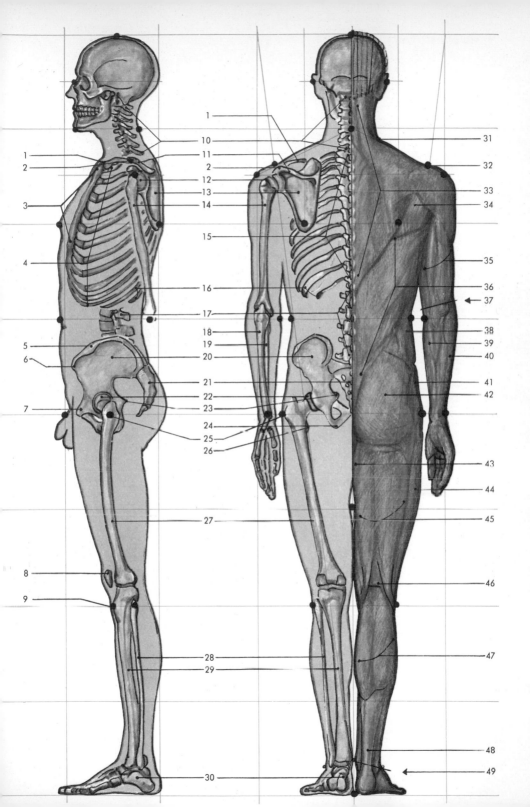

1 Sternomastoid	Sternohyoid muscle 31
2 Trapezius	Levator scapulae 32
3 Deltoid	Subscapularis 33
4 Pectoralis major	Pectoralis minor 34

5 Triceps brachii (long head)
6 Latissimus dorsi
7 Serratus lateralis
8 Biceps brachii
9 Triceps brachii
10 Obliquus abdominis externus

Brachialis internus 35
Brachialis 36
Obliquus abdominis externus }37
(course shown schematically) {38

Obliquus abdominis internus 39
(broken lines show origin and insertion)

11 Brachioradialis
12 Flexor antebrachii superficialis
13 Rectus abdominis
14 Iliacus
15 Tensor fasciae latae

Flexor carpi ulnaris 41
Flexor carpi radialis 42
Pyramidalis 43
Gluteus minimus 44

16 Pectineus
17 Sartorius
18 Adductor longus
19 Gracilis
20 Quadriceps (rectus femoris)
21 Vastus lateralis

Adductor femoris 45
Quadriceps 46

22 Vastus medialis
23 Patella
24 Sartorius aponeurosis

25 }
26 } Gastrocnemius
27 Tibialis anterior
28 Soleus

Extensor digitorum 47

29 Extensor digitorum longus
30 Cruciate ligament

Extensor hallucis longus 48

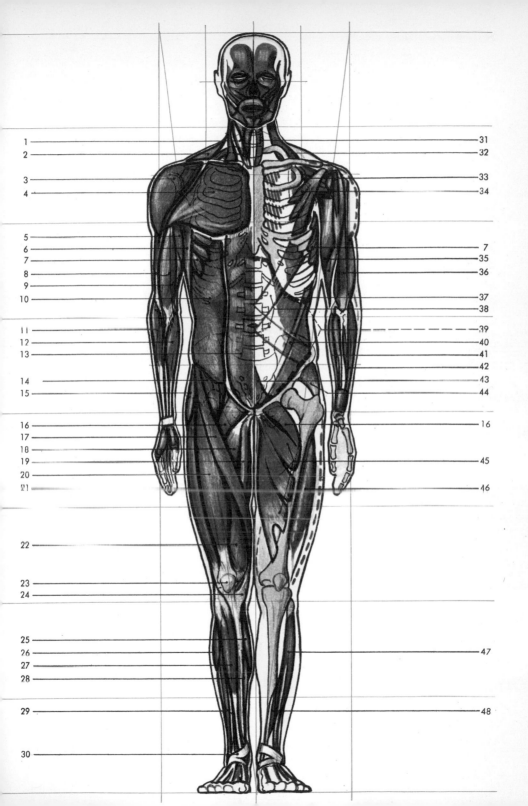

1
2

3
4

5
6
7
8
9
10

11
12
13

14
15

16
17
18
19
20
21

22

23
24

25
26
27
28

29

30

31
32

33
34

7
35
36

37
38

39
40
41
42
43
44

16

45

46

47

48

Musculature—Side and Back View

| | | 16 Occipitalis | Splenius capitia 33 |

1	Sternocleidomastoid	17 Trapezius	Levator scapulae 34
2	Pectoralis major	18 Deltoid	Lesser rhomboid 35
		19 Teres major	Infraspinatus 36

3	Serratus lateralis	20 Greater rhomboid	Long head 37
4	Obliquus abdominis	21 Triceps brachii	Lateral head 38
	externus	22 Latissimus dorsi	Triceps brachii 39
5	Rectus abdominis		Intercostal muscles 40
			Longissimus dorsi 41
			Extensor carpi radialis longus 42
			Obliquus abdominis externus 43

6	Tensor fasciae latae	23 Extensor carpi radialis	Anconaeus 44
7	Sartorius	24 Flexor carpi radialis	Flexor carpi ulnaris 45
		25 Gluteus maximus	Deep muscles of the hip 46

8	} Quadriceps femoris	26 Greater trochanter	Quadratus femoris 47
10		27 Gracilis	Adductor 48
9	Fascia lata	28 Biceps femoris	

11	Kneecap	29 Semitendinosus	Semimembranosus 49
			Popliteus 50

12	Tibialis anterior	30 Triceps surae	Flexor digitorum longus 51
13	Peronaeus longus		Flexor hallucis longus 52
14	Peronaeus brevis		

		31 Triceps surae	
15	Tendons of the extensor digitorum longus	32 Cruciate coural ligament	

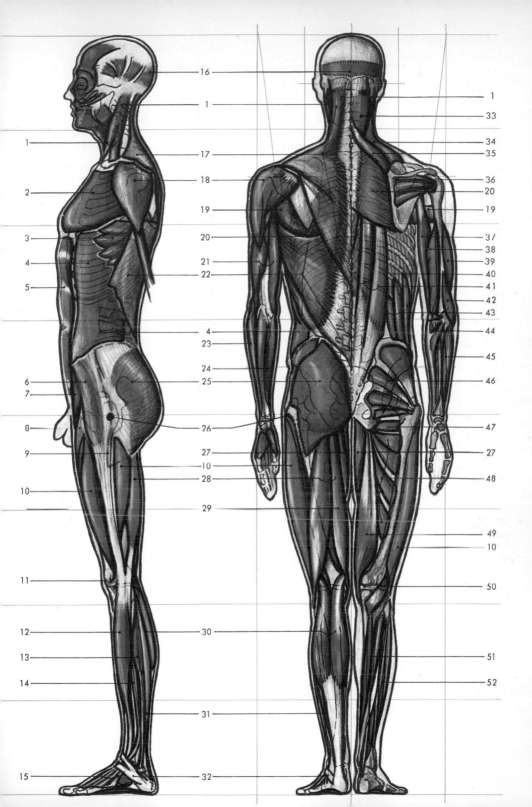

To make this review simpler, we have separated the anatomy of head, hands, and feet from the rest. Attempts have often been made to find scientific correlations between the shape of the skull, nose, and ear and the temperament or psychological characteristics of a person. The hand, too, has been studied in this light, and chiromancy even claims to read the individual's past and future fate from the lines on the palm. Science dismisses all these speculations; a sharp, aquiline nose reveals no more good of a person than a bulbous or flat one; an ear which according to our views is beautifully shaped is no more proof of musicality than one which has what looks like criminal characteristics. To think that joined eyebrows mean an unnatural death is a ridiculous superstition. The painting by Titian, however, which is only one of numerous possible examples, shows how much can nevertheless be learned of the mind and soul from the face and hands.

THE HEAD

The shape of the head is determined first of all by the structure of the bones of the cranium. They can also indicate racial origins. The average shape of the long skull is enclosed frontally in a rectangle. Its height is an eighth of the whole height of the body of a full-grown man. The breadth is two-sevenths smaller than the height. The same head in profile fits into a square with sides corresponding to the height of the frontal rectangle, one-eighth of the total height. The muscles of the head have primarily technical functions; they open and shut the mouth and eyelids; they move the lower jaw for chewing and biting. For blowing, sucking, and speaking the mouth muscles regulate the flow of air.

The facial muscles, however, react to psychological stimuli as well, so much so that even small children and animals can understand clearly the momentary changes of mood of the person they are with from his face. Laughter, weeping, anger, and sorrow are universally understood expressions. They are all facial movements caused by muscular activity.

Titian, Tribute Money

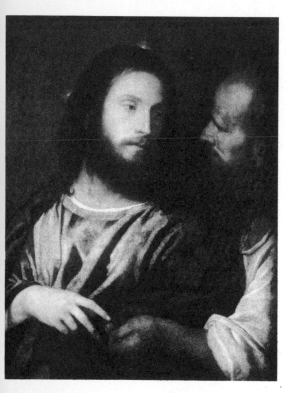

If certain stimuli are repeated frequently they become more and more impressed into the contours of the face, mainly by folds and lines in the skin. Constant cheerfulness or resentment, discontent, obstinacy, reserve or self-control create facial expression through the muscles of the face. A person's reaction to circumstances, rather than the circumstances themselves, determine the character of a face. Passing violent moods leave no trace.

As can be seen in the diagrams, there are few facial muscles, but an infinite variety of effects results from their interplay, providing all the changes of expression—even as the thirteen notes of the well-tempered scale can combine in every possible way to form the whole range of musical expression. The laughing muscles, for instance, are also the principal ones used in crying, but the difference is established by the intervention of the chin-raising muscle and the muscle in the brow. The eyes, even to the color of the iris, are fundamentally the same in all people, and of practically the same size, but their apparent size is considerably altered by the opening of the lids, which in turn is influenced by the formation of the upper lid and the cushion of fat surrounding the eyes at

Above: The face divided vertically into seven. Center: The chin tip and the tip of the nose, nose and eyebrows, eyebrows and start of the hair are all an equal distance apart. Geometrically speaking, the central point of the skull lies on the diagonal and perpendicular lines, crossing the ear cavity.
Below: Head seen from above

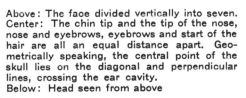

the back. Fritz Lange, professor of orthopedics ("Die Sprache des menschlichen Antlitzes"), has distinguished six basic types of lid formation, a formulation which is of great use in portrait painting. The general tone of a person is often indicated by the eyelids. The eyes can be made large at will, but if the lids are usually rather dropped it is a sign of weak tone. The upper lid may, of course, relax momentarily with anyone—for instance, in moments of strong and passive sensual excitement, listening to music, or breathing in intense perfumes. Wide eyes have always been associated with a deep spiritual life, and there is a constant tendency to portray eyes larger than normal in relation to the rest of the face and body.

The width of the space between the lids does not differ much between individuals, but there is a much larger difference in the space between the two inner corners of the eyes. Here again the constitution is as much responsible as the position of the eye sockets in the skull. Deep-set eyes generally lie close together. The normal distance between the two inner corners of the eyes corresponds to the breadth of the visible eyeball.

The most important thing in drawing an eye is to establish the position of the eyeball from the placing of the iris and its pupil. The iris is immovable behind the cornea; the eyeball is moved by six muscles. The circular iris has a concentric circular opening in the middle, the pupil, which can be enlarged and reduced by muscular action to regulate the amount of light penetrating the eye. Emotion as well as light affects the size of the pupil. Depression, anger, and

Ear and nose, side and front view

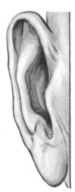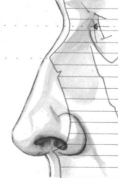

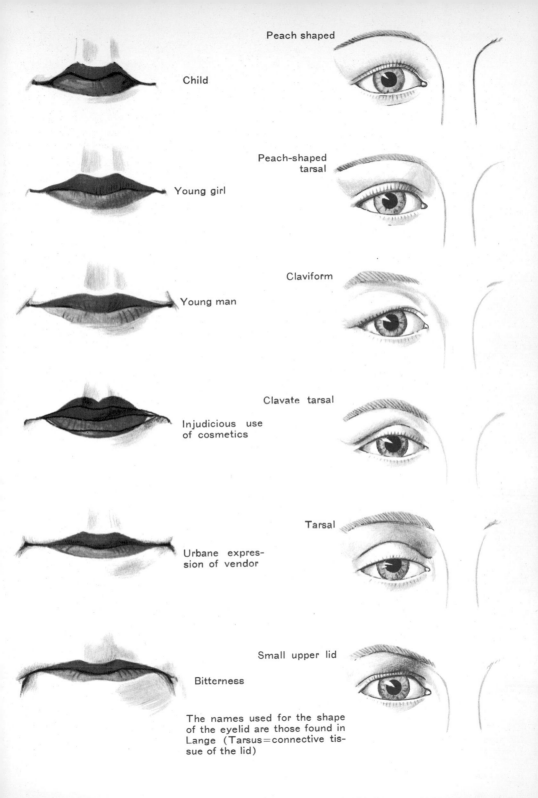

Peach shaped

Child

Peach-shaped
tarsal

Young girl

Claviform

Young man

Clavate tarsal

Injudicious use
of cosmetics

Tarsal

Urbane expres-
sion of vendor

Small upper lid

Bitterness

The names used for the shape
of the eyelid are those found in
Lange (Tarsus=connective tis-
sue of the lid)

POSITIVE EMOTIONS

Smiles

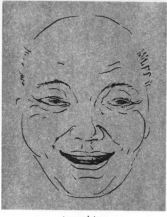

Laughter

sorrow make it larger so that objective vision is disturbed by excessive penetration of light. "To see things in a false light" is an apt figure of speech. Animation reduces the size of the pupil.

Focusing is operated by a lens lying behind the iris and moved by the ciliar muscle. The changes in it cannot be seen directly; yet it is always possible to know if someone is looking at an object or through it, or seeing in a "visionary" manner. There are no rules to help in drawing this; close observation is the only way. Shading and high lights, the

Worry

Tears

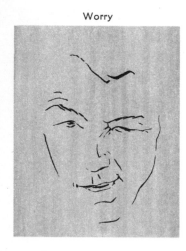

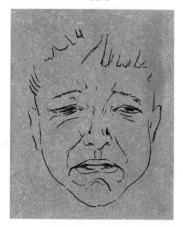

NEGATIVE EMOTIONS

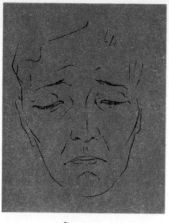

Sorrow

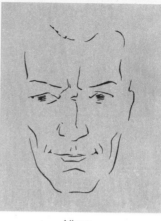

Vigor

path of the look of each eye, and their combined direction, which is parallel only when looking into the far distance, are the things to notice. The much admired portait which seems to look at the beholder from whichever direction it is viewed is achieved by the trick of making both eyes look straight out of the picture perpendicular to the picture plane. The color of the iris has no connection with character. The permanent expression of the eyes is related to the position of the iris in the eyeball and the position and shape of the lids. The "expression" of

Bitterness

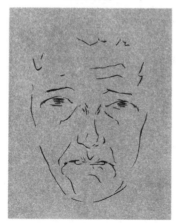

Brutality

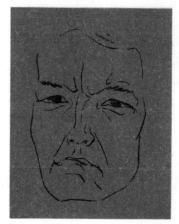

HEAD MUSCLES

No.	NAME	FUNCTION	POSITIVE EXPRESSIONS	NEGATIVE EXPRESSIONS
9	Frontalis	Wrinkles forehead, raises eyebrows, helps raise upper eyelid	Joy, attentiveness, surprise, meditation	Doubt, painful effort, resignation
10	Corrugator supercilii	Knits brows	Attentiveness, concentration	Indignation, anger, rage
11/24	Orbicularis palpebrarum	Closes eyelids (11 = upper, 24 = lower)	Powerful movement indicates all positive qualities (open eyes). Blinking: reflection, sailors' and painters' eyes	Open: stupidity, limp: fatigue, intoxication, sexual and other affectation. Blinking: cunning
13	Levator nasalis	Turns up and puckers nose	Criticism	Dissatisfaction, grumbling
14/15	Zygomatic muscles	Draw corners of mouth up and out, hard	Open laughter	Tears, disgust
18	Risorius	Draws corners of mouth up and out, gently	Gentle smiles	Tears
19	Triangularis	Draws corners of mouth downwards	Pain and sorrow	Bitterness, resignation, ill humor
20	Quadratus labii inferiorum	Depresses the under-lip		Vexation, disgust
22	Corrugator glabellae	As 9 and 10	As 9 and 10	As 9 and 10
23	Procerus nasi	Puckers the nose crosswise	Energy	Brutality
25	Nasalis	Depresses tip of nose	Pugnacity, energy	Irony
26	Caninus	Draws corners of mouth backwards	As 14 and 15	As 14 and 15
27	Buccinator	Draws corners of mouth outwards	Laughter between closed lips; obliging smiles. Self-control	Tears, resignation, exasperation. Insincerity obstinacy
28	Masseter	Used in chewing	Energy, self-possession (clenched teeth)	Doggedness, rage, repulsion, gluttony
29	Orbicularis oris	Closes and puckers mouth (as in whistling and kissing)	Self-possession, energy. Repressed tears	Resignation, rage, scorn, derision, sulking
30	Mentalis	Pulls up skin over chin (as in pouting)		Threats, anger, rage, brutality, contempt
31	Levator nasi et labii	Lifts nose and lips		Tears, disgust

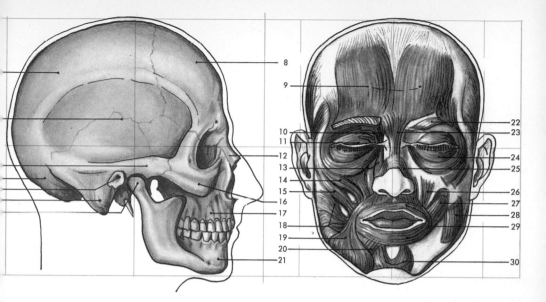

Bones of the skull:

1. Parietal — 2. Temporal — 3. Zygomatic arch — 4. Occipital — 5. External auditory — 6. Mastoid — 7. Ramus of the Mandible — 8. Frontal — 12. Nasal — 16. Malar bone — 17. Maxilla — 21. Mandible

Muscles of the head and neck with no power over facial expression

32. The Platysma — 33. Temporal — 34. Occipital — 35. Posterior auditory muscles — 36. Trapezius — 37. Splenius Capitis — 38. Levator Anguli Scapuli — 39. Annuent muscle

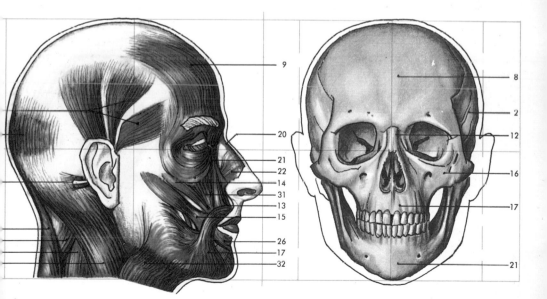

the eyes is, in fact, the general facial expression. Tears, or an increase of tear fluid, make the eyes shine more.

The original shape of the mouth is rarely to be found in older people. The movements of the mouth muscles affect the shape of lips and corners from childhood, for the mouth is the first feature to be moved by any change of feeling. In general, outward expressions of temperament make the lips turn out, while feelings held in and experience passively received make the mouth turn in and become narrower. A typical painter's mouth seems to belong to anyone—temporarily, at least, to anyone who looks, observes, and then reacts creatively to what he has seen. Purely receptive or acquisitive people, on the other hand, tend to have narrow, pulled-in mouths with regular, downward folds at the corners, the wrinkles of bitterness. Combinations of facial movement are a fascinating revelation of character, but there is always a harmony of expression even in melancholy people who are inwardly torn. Women's make-up is liable to substitute a mask for this harmony, inventing a new line of brow and broadening the lips to make a pretence of great sensuality; for portraits it is important only to let make-up underline the natural forms with color.

The folds of the cheek from nose to mouth corners run in about the same direction as the folds of a pulled-down mouth. They may, however, be due to heredity, and are sometimes seen, though not as lines, in children, as quite unrelated to their character. They are caused by smiling and weeping and by strain or discontent and are only exceptional if they look strange in the total build of the face, betokening some passion which is uncontrolled and not assimilated in the general character of the person. Lines of discontent are caused by the frequent puckering of the muscle which lifts the nose. Bellicosity causes a line to appear in the same way, one which is to be seen on the faces of almost all the great fighters of history. It does not appear on a face where the nose runs into the brow without an inward curve. Active concentration and combative effort may evoke activity of the frowning muscle, pulling the inner ends of the brows downwards and inwards and forming the so-called lines of thought. The middle part of the forehead muscle works against this frowning muscle, raising the inner ends of the eyebrows to give the expression of pathetic pain, the "Laocoön brow." This movement of the brows is rarely involuntary, it has to be practiced and studied and is a powerful means of expression for the actor.

A wrinkling of the whole brow, making vertical folds, is a natural movement and leaves its mark on all older faces, but it does not imply very much, for only someone who is controlled to the point of impassibility has none. Every passive effort uses it, astonishment, reflection, attention, and pomposity, too. The forehead muscles can replace those that lift the eyelids to some extent, if these are weak or do not function. Thus, folds on the brow have to be studied along with other expressions to be correctly understood.

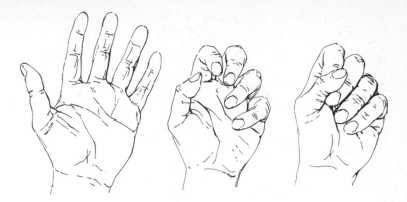

THE HAND

The length of the hand is equal to one-tenth of the length of the body. Its width is roughly in the relation of m:M of the golden section, measured with the fingers together, although it varies according to one's constitution. Women's hands are often less than one-tenth the length of the body, and correspondingly narrower.

The skeleton of the hand is composed of three sections: the carpals, metacarpals, and fingerbones, with three corresponding groups of joints. The wrist joint rotates against the radius (the ulna is too short to reach the wrist). The metacarpal joint lies between the carpals and metacarpals. It is not very mobile and serves simply to increase the elasticity of the palm. The two hand joints are moved by five muscles: ulna and radius flexor, ulna extensor, and one short and one long radius extensor. The fingers really begin with the four metacarpal bones, which are joined together in the carpas, or palm, by articulating muscles between them and by ligaments and skin. The separate fingers are formed

each of three bones continuing from the metacarpals. Between the finger bones are knuckle joints, which are moved by long tendons from the flexor and extensor muscles attached to the upper and lower arm. The first finger joint also allows rotation, which is worked together with a stretching apart of the fingers by the muscles between the bones.

The thumb turns the hand from a clamp into a holder. It is held opposite the fingers by a rotating joint between the wrist and the root of the thumb. It has a series of muscles, especially around the lowest thumb bone, to give it a strong counterpresssure to the fingers. The outstretched fingers move with an increased

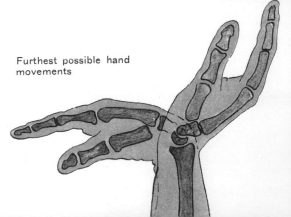

Furthest possible hand movements

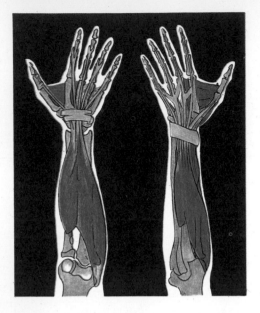

Muscles most used in flexion and extension of hand and fingers. Left: Left arm with flexors (palm of the hand). Right: Right arm with extensors (back of the hand)

fist, like a claw with concentrically approaching points. This movement is the key to many seemingly complicated positions of the hand. Its many bones and different muscles and tendons of different lengths make it into a splendidly sensitive instrument. Small wonder that it can reveal much about the nature of the person, with its gestures and positions, much of which can be reproduced by the artist. Often, characteristics such as grace, nobility, avarice, rapacity, or brutality are more easily seen in the hand than on the face. The reproduction of Titian's portrait should be examined once again in this light! A coarse hand should not immediately be accepted as a sign of coarseness, however. Quite often hands which look clumsy and ugly belong to sensitive and manually dexterous people. The author himself underwent an extremely painful examination of a wound by a doctor whose hands were classically beautiful; she was so unsuccessful in her search, however, that she handed it over to her senior, a surgeon whose thick, coarse, peasant-like fingers did all that was necessary without causing a twinge.

bend towards the end, as though to hold a sphere the size of a soccer ball. If fingers and thumb bend further the imagined sphere grows smaller and the finger ends begin to move. They can curl up until they are tight against the

Furthest possible hand movements

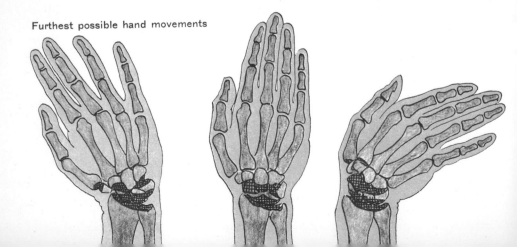

THE FOOT

The length of a man's foot is about one-sixth, of a woman's about one-eighth, the length of the body. Its widest part is about the same width as the widest part of the hand. A comparison of the structure of the foot with that of the hand is the best way of understanding it. It is built on the same principle as the hand, but it is placed at right angles to the shin instead of being a continuation of it; and the big toe, which corresponds to the thumb, does not stand in opposition to the other toes, so that the toes can only be used for grasping, not holding or manipulating. The foot has become exclusively adapted for walking and standing.

In this connection the foot has developed as a very efficient shock absorber. If one suffers a loss of this function—from too much motor driving, for example—considerable damage can result to the vertebrae and inner organs. The structure of the skeleton of the foot shows this function. Both lengthways and across, the bones are like conical vaulting stones, joined together into arches; but being organic, they are more flexible than stones and more like strongly bent springs. The sole of the foot is further cushioned with flexing muscles, fat, and skin tissue. This enlarges the tread area of the foot, but the double arch is still discernible in the characteristic print of the naked foot. These arches are higher if the foot is turned inwards, and sink if the foot turns outwards or after long periods of standing.

The ankle, like the wrist, can rotate, being worked partly by the muscles from the fibula and tibia, and more strongly by the largest extensor of the foot, the threefold peroneal muscle which works through the Achilles' tendon on the heel bone. Without this tendon it is impossible to walk or to stand. Its name refers to the Greek hero who was vulnerable only on his heel. Both flexors and extensors must be intact even for standing at rest, for a joint can be held firm only by the intertension of both sets of muscles.

The build of the third shin muscle, the soleus, together with that of the Achilles' tendon, determines the shape of the foot: the shorter the heel bone the shorter and thicker the shin musculature. Negroes, who have very long heel bones, have shin muscles extending long and thin almost to the heel.

The mobility of the foot is governed by the activity of the upper and lower ankle joint. The upper connects the ankle bone and tibia (the fibula, like the ulna, is not attached to the joint); the lower connects the ankle and heel bones. It is arranged so that it is bent inwards however far the toes point outwards: the typical position of dancers and jumpers. The toes, again like the fingers, are moved by long tendons which can be seen plainly when the right muscles are tensed. As in the hand, these tendons are held in their curving path by cross bands and projections of bone.

It is in walking that the continual and versatile co-operation of all parts of the body in the act of balancing becomes most manifest, since the foot has a relatively small bearing surface. In walking

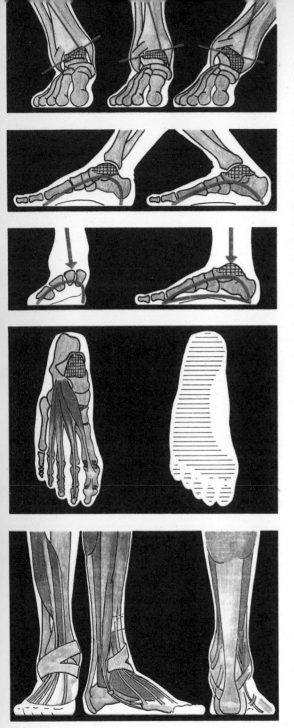

and in keeping one's balance, not only do the muscles of legs and trunk play their part, but the swinging of the arms also helps towards an easy gait. Thus, the swing of the arms is always opposed to the leg movements. If one side of the body is carrying a heavy weight, the arm on the other side instinctively lifts away from the body, but without discontinuing the swinging movement. Similar actions can be observed in athletics—javelin-throwing, for example, or the discus, or shot putting—where an explosively sudden weight shift has to be achieved.

Movement also shows up a person's general physical condition. Strenuous exertion of almost all muscles (even facial muscles are distorted in conditions of stress) presumes normal tone. One who is in poor condition betrays this by a dragging gait. And one's general condition depends to some extent on one's state of mind: you can see people walking along in bright and cheerful mood, self-assured and full of confidence, or sadly, with a depressed or care-worn slouch. If the foot is injured, even if only slightly, the gait becomes a painful limp; chronically unsound feet will permanently destroy the beauty of an upright gait, the most "human" of all man's movements.

1. (Right foot) Left: Outward tilt of the shank, showing flattening of the arch. Center: Normal upright stance. Right: Inward tilt of the shank, showing arching of the foot
2. Left: Extension of the foot, showing raised arch. Right: Flexion of the foot, showing flattening of the arch
3. Arch of the foot, cross-section and longitudinal section
4. Skeleton of the foot showing extensions of the toe, silhouette and normal foot print, seen from above
5. Formation of the most important adjuncts of the flexor and extensor muscles of the foot

THE NUDE

In portraying the nude figure, the principal requirement is a sound grasp of the plastic aspects of the anatomy and proportions of the human body. In teaching these proportions, a simple system of diagrams has been evolved, and these can be of practical assistance in drawing. Their use is largely restricted to the portrayal of the upright, motionless nude figure. Nonetheless, some adaptation to the needs of movement is possible. Generally speaking, nude and figure drawing become much more interesting when the body is portrayed in some position other than merely upright. The first task must be to establish whether the figure is at rest or in motion. Not only is this important to you, the artist; the spectator, too, will want to know whether your drawing relates to a completed movement or not. The use of a perpendicular line will clear up this point for you. Let us suppose that the subject is standing on one leg. In this case, the perpendicular will start just inside the leg which takes the body weight. If you find that the volume is evenly distributed on either side of the perpendicular, you will know that the body is at rest. If, on the other hand, it is unevenly distributed, the body is moving in the direction where the volume is greater. Draw in or visualize this perpendicular, and you will soon ascertain whether your drawing is accurate, or whether the figure you have drawn in motion is in fact in repose; or if the subject you have shown at rest is in fact in motion.

Whichever it is, at rest or in motion, you will always find directional lines which will plainly show where a movement begins, which way it points, where most weight is placed, its balance, counterbalance and rhythm. External outlines and variations due to the plasticity of the subject are indicated by means of directional lines touching each other. An example of this is to be seen in the variety of trunk postures which may arise from movements of the spine and shoulder. Two figures of great assistance in this respect have already been shown. The first is the pelvic triangle, which never alters; the second is the shoulder triangle, which may vary. In practice, yet another set of tangential lines will be found of help where the subject has his or her back to the artist. This is the triangle formed by the buttocks. Although the proportions of this triangle

will vary among individuals, it is unaffected by movement, owing to pelvic support. This triangle can be expanded to form a square, should the exigencies of the perspective plane so require.

The safest way to determine the positioning of this triangle or square is to follow the cleft between the two buttocks, as this invariably divides both types of figure in half. This is a line reaching from the edge of the iliac blade at the top, right down to the larger upper thigh muscle when stretched.

If, as is often the case, one side is

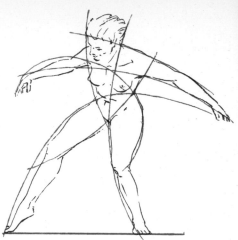

relaxed, then the tensed side should be used as the guiding line. Both sides can be relaxed only when the body is hanging or lying. The sides of the rectangle come where the buttock muscles are attached. The rectangle, or square, reveals two facts about the body, one relating to the bending and turning of the pelvis in against the middle trunk, the other about its constitution; one a matter of perspective in the picture, the other of its actual shape. Basically it is a rectangle lying on its side. In slender bodies it may become a square, and only in very thin ones an upright rectangle. Female bodies always have a wider rectangle because the pelvis is broader in women than men and there is a greater amount of fat tissue. A correct structure of all the guiding lines and figures provides a sure scaffold as a preliminary to drawing all poses, and the various strategic points and lines of proportion can afterwards be added to it without difficulty. Even a crouching pose which does not allow the height of the body to be gauged can be helped by a division into eighths. In the illustration only the arm can be seen

spective, by treating them as though they were transparent. This trick is the easiest way of making clear the relative positions of the parts of the body. It is usual to insist on the beginner's using cuboid figures for the human body delineated with a harsh, angular line, making him avoid sweet and soft, rounded contours.

This method has the disadvantage of making the artist turn people into robots, thereby losing his feeling for the roundness of the body. Severity of line is a discipline that can be practiced in other ways.

Exercise in perspective has taught us that the variety of vanishing points increases with the diversity of the shapes

at full length, but the face and shin are sloping in the same direction and thus have the same small degree of foreshortening. The length of the arms, shin, and head can be satisfactorily coordinated, and then the shoulder breadth, of which the foreshortening is rather restricted, can be fitted to it.

The more the body is turned away from a frontal view the stronger the foreshortening in perspective, which must be rendered with the help of geometric figures, not a linear scheme. If an arm is stretched out towards the artist, he needs to be very experienced to interpret it correctly at sight. The inexperienced artist should proceed by encasing the upper arm in a cylinder, the forearm in a truncated cone, the joints in conic sections, and the hand in a slightly curved rectangle with small truncated cones for the fingers. The same can be done with all other parts of the body: the head becomes an egg shape with meridians to indicate the features and the trunk a barrel describing an oval section.

It is a useful exercise to study these figures, with their foreshortenings in per-

Supplementary lines are used here to illustrate the division of the body into eighths, with and without foreshortening

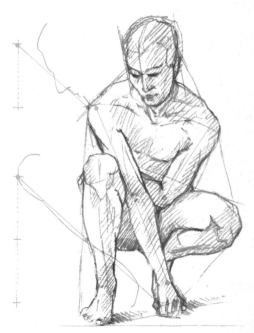

of the individual bodies. The same applies to the guiding figures used now in life drawing. It is not appropriate to work out a large series of constructions for this work. Architectural studies are the best means of developing a feeling for perspectival relationships, and this feeling should be sufficient in life drawing. Architecture is closely allied to the structure of the human body. Nowhere else is man so much the measure of all things as in architecture, which is, therefore, at its best when based on the proportions of the golden mean.

Drawing architecture is useful for developing the sense of stability so necessary in life drawing. An understanding of the containment of space in architecture also develops a feeling for the space in which the body is contained. The only way of establishing the position of the body in relation to the artist is by enclosing it in a cubic structure. He imagines it in a glass box, the walls of which touch the outermost points of the body. This approach clarifies the foreshortenings and ambiguities caused by perspective. If this boxed man is approaching the artist, the reduction in size of the hinder parts of the body can be worked out from vanishing lines. The horizon and positions of the vanishing points provide a useful check on the direction and stability of the walking figure.

This imaginary guide is used not only by beginners but even by the greatest artists from time to time.

Life drawing should not be done at first from a posed model; it is much more instructive to make the first attempts in chance, natural surroundings, while watching sports or swimming, for example. If the artist is serious he will always find someone to hold a chance pose long enough for him to make a quick sketch. It is advisable not to plague this kind person by long searching after the perfect pose; better to flatter him by saying how delightful his momentary position is, and then he will stand like a statue. The advantage here is that awkward poses are avoided—poses which are too difficult to draw at first, and when once mastered are found undesirable.

At first, it will suffice to draw an outline of the whole figure, concentrating on correct proportions. Details are needed only where they are particularly obvious on the model. It is more impor-

Diagram of human body to help with the accompanying nude study

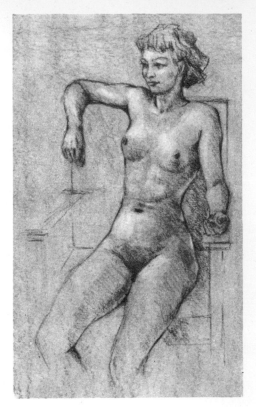

tant at first simply to gain assurance than to attempt a complete nude drawing. Enough experience should be gained before this attempt to impart individuality to the model, to give it the telling characterization that is half the charm and success of a drawing. It does not matter if your model is not an Aphrodite or Adonis. Even an "ugly" body can be beautiful if it expresses something, and this it will do only in a natural position. The dusty old academy poses, using horse tamers, bell ringers, amphora bearers, and such like, may be useful for showing anatomy but are no more desirable as a final picture than the silly affectations of mannequins or the well-tried repertory of pin-up girl poses.

Thus, it is important to know why, beyond the necessities of training, we draw figures. Two main reasons can be found: one is the purely formal beauty of the body, the other is its human expressiveness, although it seems that for many years beauty has caused distress in figurative art, and it is hard indeed to find a beautiful body in many modern exhibitions. Do all ugly poses really express something so essential? Would it not be a fine task to rediscover the beautiful body for pictorial art?

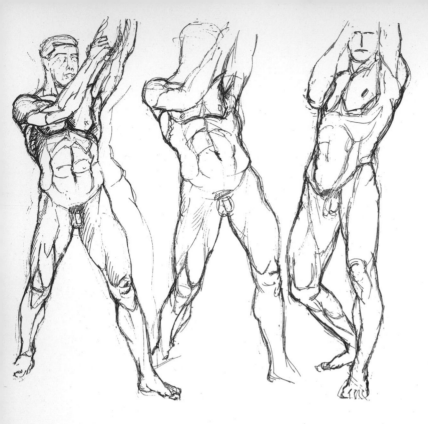

Nude studies from the studio

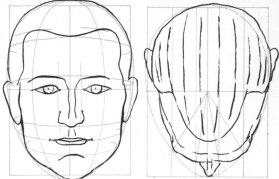

PORTRAIT DRAWING

In the section on the anatomy of the head we showed that non-physical factors like mood, temperament, and character are more important than biological functions in moulding the forms of the face and giving it individuality. These factors are thus at least as important to the draftsman as a correct rendering of physical proportions. A portrait must reproduce the personal character of the sitter's face and not just show a type of head. Nothing in the living world lends itself so easily to abstract drawing as a face. All our lives we read human faces into all kinds of living creatures, and indeed into inanimate things having nothing to do with people—in the graining of wood, flowers, the contours of hills. These phenomena can give as deep an impression of personality as the real faces of people and animals. There is great scope here for artistic expres-

sion, but this book is concerned only with the foundations of naturalistic representation as the basis for every kind of artistic interpretation. We learn drawing as we learn to write at school; how and what we write later is no concern of the teacher.

When fitting the parts of the body into a geometric scheme, we likened the head to an oval. This oval, like a bird's egg, can vary greatly in shape, from long and narrow to almost spherical.

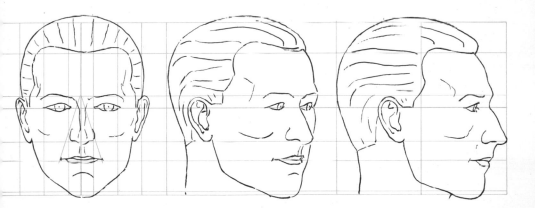

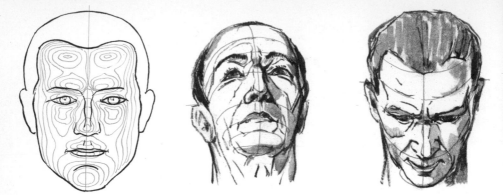

Facial contours. The middle line is shown foreshortened when the head is raised or inclined

The head is never a cuboid structure. The ever-present tendency to abstraction, a tendency quite independent of a deliberate stylization like cubism, often makes people forget this.

Students are often astonished, looking at a head for the first time from above, to notice that there is not a single flat frontal surface to be seen. Observed from above, the face, so often depicted far too flat, falls sharply away to the sides of the head, and the crown and brow build yet another oval. Awareness of this is an important step forward. For a deeper understanding of the shape of the head, and particularly of the face, it is useful to draw the chosen view as a relief map with contour lines. It is equally valuable to draw the head in many varieties of profile, both held erect and at various angles. All this helps to make the student more aware of the roundness of the head.

Apart from an external, formal resemblance to the sitter, a portrait is concerned primarily with finding a characteristic and consistent expression. There is no rule for achieving this, but it is helpful to know that the more the nonessentials are left out, the stronger and more determined is the expression.

A portrait drawing begins systematically from the linear scheme, from the relation of height and breadth in which the oval is contained. The slightest turn or bend of the head curves the straight lines into meridians, foreshortened by perspective: through the corners of the eyes, below the nose, through the meeting of the lips, the fold of the chin, through the eyebrows, and the beginning of the hairline on the brow. Into this scaffold of elliptical lines further points of measurement are marked: the width of eyes and mouth, the fold of the chin, the beginning of the hairline, the setting

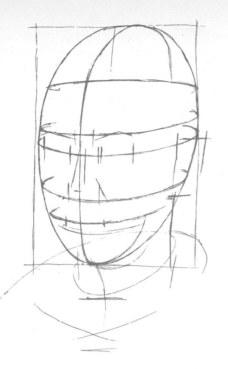
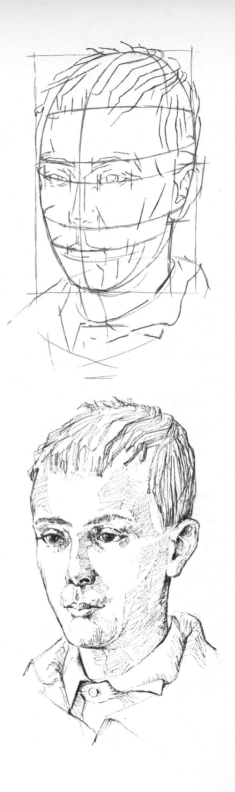
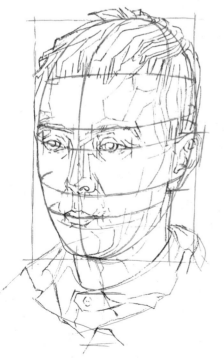

of the root of the nose, the nostrils and the breadth of its bridge, then the ear, its position and outline. The first working can also indicate the line of the eyebrows and the folds of nose, lips, and corners of the mouth.

The second phase of work starts with the main shapes in the regions of the eyes and mouth, and the lay of the hair. Ear, cheek surfaces, and temple can receive the broader details.

The third phase turns to greater detail, particularly the exact outlines which give individuality—but with the gentlest possible drawing. Preliminary softness in drawing the lines allows the fourth phase to pick out what is essential and characteristic until the portrait is worked up to the desired degree of finish.

This is the disciplined and scholarly way, and the way most certain of success in setting about to reach a "likeness," that desired goal which commands so much respect and which causes so much alarm among the inexperienced. It is a mistake to try to find the likeness right at the beginning instead of allowing it to grow out of the exact pursuit of the individual shapes and lines. However, this close attention to the individual shape must not become a routine which makes all the portraits from the same hand look as though the sitters were all relatives, a danger run by many professional portraitists. There is no need to treat every portrait as a first beginning, which would inevitably produce an academic aspect. Academic discipline is only a means to an end, which, with experience, should lead to a personal form of expression, in the same way that a personal handwriting grows from the school copybook.

The well-worn critical comment that much has been "put in" a portrait is misleading. A human face is much more significant than a cast and nothing needs or should be put in it, rather much should be taken out in order to emphasize what is essential and particular. The choice of what remains depends on the maturity of the artist and his temperament, his perception and ability to assess the significance of facial features.

The most easily accessible model is the artist's own reflection in a mirror. For study purposes it is quite unimportant that it is seen in reverse. But if one wants to make a true portrait, it is quite possible to train oneself to make a mechanical reversal of the reflection, altering the coordination of hand and eye to produce a mirror image.

Rembrandt, one of the greatest painters of all time, repeatedly studied his own reflection. He did not do this from vanity—he was by no means a handsome man. He painted himself because the sitter was always available, and he did it uncritically, for he was entirely preoccupied with the problem of light and shade. Over one hundred of his self-portraits survive and are among the most compelling ever painted.

Animal anatomy is best understood by a comparison with human anatomy, working from the idea that animals have adapted the structure of the human body to their own needs of existence. For artists, the idea that man is the measure of all things is always correct. The point of view of exact science would enforce him to be continuously rethinking instead of reacting primarily to his faculty of vision. The understanding of visible form is basically a matter of comparison, and for the human being the most accessible object of comparison is the human body, if he is trying to understand the structure of other living bodies.

We shall concern ourselves here only with vertebrates, and of these only those most conducive to pictorial representation: quadrupeds and birds. Their physical structure is very close to the human. It is composed of the spine, skull, thorax and shoulder girdle, pelvis, and four limbs.

QUADRUPEDS

The shape of the spine in quadrupeds is the first deviation from human anatomy because of the difference of posture. Its shape resembles a slightly curved arch, between the pelvis and shoulder girdle, and is not, like the human spine, S-shaped to balance the erect gait. Only the S-curve of the neck, composed with very few exceptions of seven vertebrae, is repeated in quadrupeds. The sometimes considerable length of neck, in the giraffe, for instance, is due solely to the length of each vertabra. The vertebrae are never plastically noticeable in the neck, unlike those in the tail, which are a continuation of the spine beyond the pelvis. In human anatomy five vertebrae have grown together to form the os sacrum, but in most quadrupeds the more numerous vertebrae (many reptiles have up to 40) have remained mobile. The number of vertebrae in the back is greater in a number of animals; therefore the trunk is proportionately longer in animals than in humans.

It is important to study from the skeleton the line of the spine along the back in different animals in order to understand the arrangement and function of the pelvic and shoulder girdles. Unlike those of the human, their chest and loin vertebrae have very high projections. Thus, the outline of the back of an animal appears slightly S-shaped as it lifts over these projections at either end of the spinal arch. In felines this outline has a downward curve, like a span roof, which turns where the projections change in slope. The turn of this curve is again marked on the skeleton by a very short vertical projection. The peculiar alternation of slope in these projections prevents a reverse bend of the spine and gives a powerful spring mechanism to the back for jumping, worked by strong, straight muscles.

The typical conformation of the vertebral column in quadrupeds. Illustrated is the skeleton of a wolfhound

The fore- and hind legs of quadrupeds have different functions. The hind legs give the impetus and power to move forward; the forelegs primarily provide the main support for the greatest weight of the body, two thirds of which in the horse, for instance, rests on the forelegs. The mechanism of forward and backward movement in quadrupeds can be likened to a motor car with rear-wheel drive. Every quadruped begins a forward move-ment with a hind leg and immediately afterwards, almost simultaneously when running, moves the opposite foreleg forward to offset the change in gravity. A few animals move differently: the camel, for example, goes forward with both legs, first those of one side, then the other. This gait can be taught to horses in dressage, but is not natural to them.

The stance of animals at rest and mov-

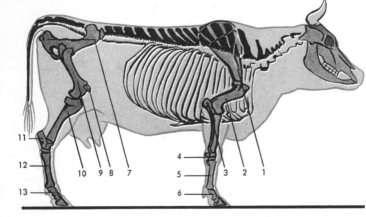

1. Scapula — 2. Upper arm — 3. Forearm — 4. Carpus — 5. Metacarpus — 6. Digit — 7. Pelvis — 8. Patella — 9. Thigh — 10. Shank — 11. Heel-bone — 12. Metarsus — 13. Toe

Typical position of the spinous process in hoofed animals. Illustrated is the skeleton of a cow

ing is best understood by taking two lines of gravity, one running down the fore- and one down the hind leg—a system different from that of men and birds. Held for any length of time, it is unnatural if the two lines of gravity coincide. A horse's levade or a dog's upright stance is a matter of training, but a horse that bucks or rears or a cat that stands up gives a momentary push to increase the weight of recoil against an obstacle which is thereby overthrown and whose resistance should, therefore, be taken into consideration as part of the equilibrium of the maneuver.

The position and build of the skeleton is naturally affected by the four-legged gait. Most quadrupeds walk on their toes, in contrast to humans, who walk on the soles of their feet, thus requiring a larger ground surface for balancing. It is an advantage for quadrupeds to touch the ground with the smallest possible area, as this enables them to move off more quickly. Bears and monkeys walk on the soles of their feet and are much slower. The instep, affected by

this gait, has grown into a single bone. This, and the necessity to be always ready to jump in self-defense, has brought about the manifold bends, particularly noticeable in the hind legs, which exist even in a position of rest. A sudden, powerful movement forward can be provided only by stretching the leg joints. A runner who needs to make a quick start waits in a crouched position for the starting gun. A frightened deer can give a bound from a position of rest. The beast of prey crouches for its leap, as will any cornered animal.

The bends in the foreleg are less visible from outside. At rest they are present only between the shoulder blade, short upper arm, and forearm. The upper arm lies inside the skin of the trunk, and the bends of the joints can be understood only by a study of the skeleton. Drawings of animals often come to grief at this point. Elasticity of movement is much helped by the curve of the upper arm, which is much more flexibly attached to the trunk than the human arm, which, being used for work, re-

Typical position of the spinous process in animals of the cat family. Illustrated is the skeleton of a lioness

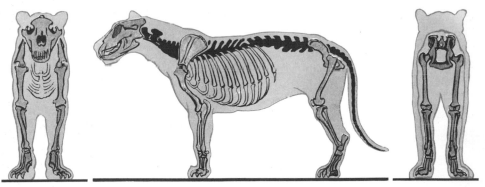

quires a stronger hold. The shoulder girdle in humans is still joined flexibly to the rib cage by the collar bone, but with very little mobility. Quadrupeds have no collar bone, which means that the shoulder blades are much more mobile. This is plainly visible in cats; at each step when they walk the shoulder blade rises as high as the withers. The collar bone is replaced by cords of sinewy muscle which are very supple and can act as brakes, like the springs of a shock absorber. Only animals which use their forelegs more for work than running have collar bones: monkeys, which climb, moles, which dig, and the kangaroo are among the few.

Where the forearm is more firmly attached with a collar bone, the joint of the limb is always more mobile, especially so in man. Quadrupeds who use the foreleg mainly for running and jumping do not need the rotary action of hip and shoulder; it would only require extra muscles to strengthen the scissor movement while they were running. Their shoulder and hip muscles work like hinge joints, and the limbs cannot move much sideways. This alters the structure of the pelvis. Herbivorous animals, which need to be able to run far, have a pelvis proportionately as wide as humans. Carnivores, which catch their prey by jumping, have a very narrow pelvis. The widest point is at the socket joints of the thigh bones. In horses and cattle the thigh sockets and hip bone knobs stand out equally. Beasts of prey also have much shorter necks than herbivores, which feed while walking and so are always bending their necks downwards.

In human anatomy we learned how a joint is held solely by muscular activity. It is tiring to stand for long, and even more so to remain with knees half bent. Quadrupeds, however, are in a position of rest with their knees half bent. Two other factors contribute to the tension of their joints: there are ligaments which hold them taut, and there is a slight

Left: Body balance shown by use of single plumb line

Right: Two plumb lines each with a different weight

150

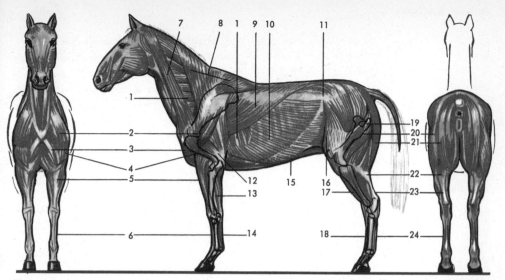

The most important muscles in a horse. In principle the same holds good for all quadrupeds. M = muscle.
1. Latero-serrak M — 2. Deltoid M — 3. Chest M — 4. Biceps — 5. Forearm (extensor) M — 6. Toe extensor tendon — 7. Annuent M — 8. Trapezius M — 9. Latissimus dorsi M — 10. Oblique abdominal M — 11. Anterior spine of the ilium — 12. Triceps — 13. Forearm (flexor) M — 14. Toe flexor — 15. Rectus abdominis — 16. Quadriceps extensor of the cannon — 17. Toe (foot) extensor — 18. Toe extensor tendon — 19. Greater trochanter — 20. Greater gluteal M — 21. Quadriceps flexor of the cannon — 22. Gastrocnemial M (triceps) — 23. Achilles' tendon — 24. Toe flexor

hollow on one side of the joint surfaces, and a corresponding convexity on the other, so that the two parts can rest against each other. The joints are held close by tendons, which are stretched only by muscular activity, causing the joint to move. This is why horses can stand all day without tiring, and why full-grown animals need never lie down and can even sleep standing up.

All animals, especially those with long necks, use the neck and head as a counterweight when walking. A horse nods its head constantly while it runs, both up and down and slightly sideways. The movement occurs mainly between the skull and the highest neck vertebra, although the whole neck is brought into play to some extent. The tail also is used for balancing, although it is mainly a sort of rudder against wind resistance and serves horses and cattle as a fly whisk. Animals also give unconscious expression to their feelings with the tail. Dogs wag their tails when they are pleased, stick them up when they are aggressive, as do cats, and put them between their legs when they are afraid.

The pelvis of the elephant and giraffe falls steeply away from the horizontal backbone. It is flatter in the horse and flatter still in cattle. The drawings of skeletons show the differences of proportion and position of leg bones peculiar

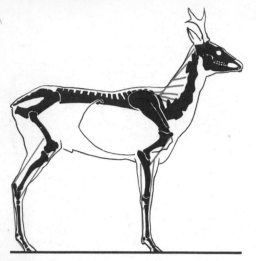

Skeleton of a roebuck. Example of braced tendons in extremities and neck

are in other respects similar to human feet. The soles of bears' feet are rough and grip the ground well, while monkeys' feet, which are adapted to tree climbing, developed like hands. The carnivore has to grip its prey; it developed thick pads which allow a quiet tread and protect the sharp claws from wearing away.

The front foot developed in a similar way. Only where there is some reason for the forepaw to twist around do the humerus and ulna exist and rotate around each other, as, for instance, in cats, which can give short side pushes. They can turn around only one eighth as much as the human forearm.

The human head rests its weight on the spine; relatively little muscular strength is needed to hold it in this upright position. But if the muscles are not working, the head drops to one side, as can be seen if someone falls asleep in a chair. In animals the head and neck must always be held stretched out, and this would entail vigorous activity and eventual fatigue if left to muscles alone. The head and neck are, therefore, held by a supple tendon running from the projections on the vertebrae of the chest to the back of the head. A plate of sinew runs from this tendon down to the neck vertebrae. If the animal bends its head down, it has to stetch the neck sinew by working the muscles; if it stops this muscular activity, the head springs back into its stretched out position. Old, work-worn horses sometimes hang their heads all the time because the sinew has lost some of its elasticity.

The shape of the skull is determined primarily by the relation between the

to each animal. In some animals the kneecap is grown together with the upper thighbone. Sometimes the shinbone has disappeared in part or completely. Both kneecap and shinbone are needed in humans for the twisting of the thighbone along its long axis. Where this is unnecessary in animals, these alterations, if we regard the human skeleton as the norm, take place.

In all toe-walkers the instep bones and heel bone have grown together or joined up, more completely in hoofed animals than in felines. The toes, too, have become one in hoofed animals, and a double hoof in cloven-footed animals. Carnivores still have all their toes. The double arch of the foot does not exist in any animals, not even in those which walk on their soles and whose feet

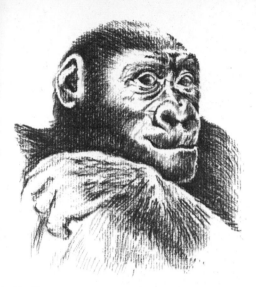

Gorilla

a profile line than in humans. The lower jaw has to adapt itself to the changed shape, and altogether the skull presents a profile roughly comparable to a pair of tongs. Animal skull shapes are widely varied according to their habits, particularly their manner of feeding. The position of the eyes is important. Monkeys and carnivores look straight ahead like humans. It can almost be said that the more defenseless the animal, the further its eyes are set to the side to enlarge the field of vision. A man, if he is concentrating, can see movement and color within a cone of about 90 degrees. He can see clearly only within an angle of 30 degrees. A rabbit when it rears up can see for 360 degrees—a complete circle.

brain case and the face, both in humans and animals. The brain case is relatively small in animals, and brow, nose, and upper jaw are in much less continuous

The aspect of an animal's head is much affected by the structure of its outer ear, and in some, too, by the formation of horns or antlers. The outer ear in

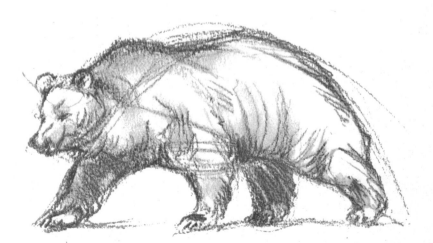

Brown bear

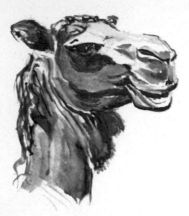
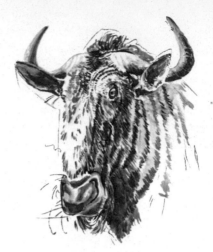

Head studies: Camel and striped gnu

humans and monkeys lies against the skull; most other animals have pointed, upright ears, although elephants, pigs, and some dogs have hanging ears. All outer ears are made of cartilage, but, unlike the human ear, they are very mobile. The ears of lynxes and squirrels have an added tuft of hair which makes them seem bigger.

Animals are far too different from each other to make a practicable scheme of proportions. The example given of the musculature of the horse can help the student to work out that of other animals. Parallels between human and animal skeletons and musculature should make understanding easier, for basically they are very similar, and a knowledge of their different requirements and habits explains the differences.

To draw an animal it is best to make a constructional sketch first, fixing the position of the backbone, leg bones, neck sinew, and skull, marking in the recognizable points of proportion: os sacrum, wither, knee and elbow, heel and foot. Next come the contours of the thorax and the straight stomach muscle, the hind leg, tail, and lower line of the neck. The sketch is finally developed with a more detailed outline of the head with the positions of the eyes and ears and the positions of nostrils and mouth, and, lastly, with a closer rendering of the structure and position of the feet (claws or hoofs).

Most animals are covered by a thick and relatively long fur, and unless the artist has an intimate and inborn knowledge of the animal's anatomy he will not

get far using a purely impressionistic vision. The animal's coat should be described with texture-like strokes, unless paint is used, but even then the strokes should be made in the direction of the hair growth to give a realistic impression. The growth of the hairs is determined by the need for water to run off the animal as quickly as possible and to create the least wind resistance. In some places there are whirls and ridges or crests where the hair growth lies in different directions or meets.

The drawing and painting of animals has always been a subject of special interest, in the same way as portrait or flower painting. Even in modern art animals often occur and are frequently more attractive than other subjects treated. Perhaps the emphasis on the type in animal subjects has an appeal greater than the unnecessarily individual character of many other subjects.

Siamese cat

With modern zoological gardens, aquariums, and now underwater observation of animal life, the themes have increased in number. One group, however, seems to have been almost forgotten: birds.

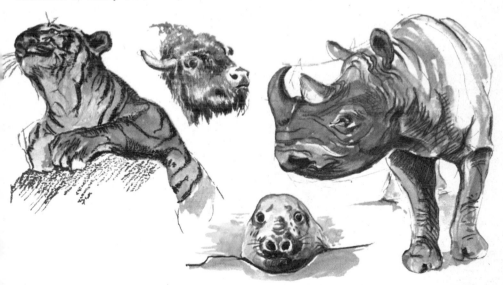

Bengal tiger Bison Sea-elephant Rhinoceros

Grecian tortoise

Young gorilla

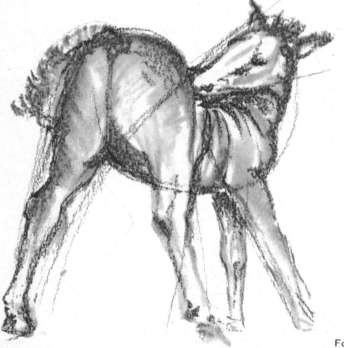

Foal

BIRDS

The body of the bird, having only two legs, rests on a single line of gravity. The external shape of a bird is very different from that of its skeleton and soft anatomy, which make up its weight. Nevertheless, the external form has to be understood from the skeleton. The feathers are as important for flight as they are for a warm covering, and the wing and tail feathers, which serve to vary the weight distribution of the soft parts of the body to assist flight, do not follow the soft parts in their modeling as do the smaller down and covering feathers. The wing and tail feathers serve to continue the tensions of the thin muscles and tendons; hence the difficulty in reconciling the shapes of a live and a plucked bird. Only the beak, eyes, and legs are uncovered by feathers.

The usual mistakes made by children and beginners when drawing birds are due to the difficulty of seeing the position of the trunk, spine, and leg bones when they are all covered with feathers. In fact, the human skeleton is closer to the bird's than the quadruped's. The rest position of the bird is closely approximate to that of the human crouching on tiptoe, holding his arms close and bent, so that the hands are at the level of the armpits and hanging down. A bird's flight position can be imagined by the human spreading out his arms and pushing the edges of the hands backwards; a strong downward pull of the arms corresponds to a beat of the wings. Raising the arms is harder, but a bird is helped by air resistance against the fall of the body. A turn of the arms shows how the bird folds its wings.

The crouching position illustrated shows how the vertebrae, rib cage, and pelvis have become a single, though very elastic, bone structure in the bird. It does not need the flexible spine or shoulder girdle of the human skeleton, for the heavy work of the wings is better served by a firm support, and the strong beat downwards needs to lift the body as directly as possible, so that it is best rigid. The collar bones have become the solid forked wishbone, which has either grown into a single unit with the breastbone or is joined to it with strong sinew. The shoulder blades have become a narrow saber-shaped bone which often reaches as far back as the pelvis and is thus much restricted in movement. The breast muscles, the motors of flight, weigh as much in birds of flight as all the other muscles together. They are

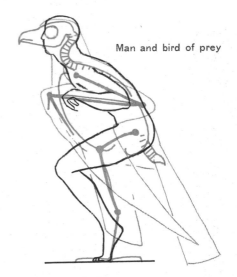

Man and bird of prey

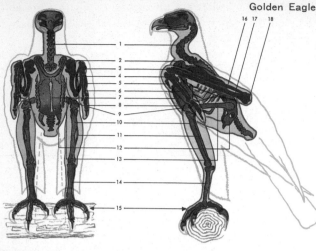

Golden Eagle

1. Atlas — 2. Furcula (collarbones) — 3. Carpus — 4. Upper arm — 5. Pollex — 6. metacarpus — 7. Sternal rib — 8. Forefinger — 9. Patella — 10. Tibia — 11. Fibula — 12. Pelvis — 13. Upper thigh — 14. Metatarsus — 15. Digits — 16. Radius — 17. Ulna — 18. Elbow joint

attached to a strongly protuberant piece of the breastbone, which is not present in birds which do not fly and which is smaller in swimming birds. All muscles other than those of the breast are very thin and model the trunk to an oval or teardrop shape which offers the minimum of wind resistance. The tail vertebrae do not need much mobility. The last of them have formed a flat plate to which the tail-steering feathers are attached, which, on the whole, point straight backwards. They, like all the feathers, are moved by skin muscles.

The neck vertebrae need greater mobility than in quadrupeds and humans. This is because the eyeballs are almost immobile in their sockets, and because of feeding habits. The number of vertebrae is greater: doves have 12, hens, ducks and birds of prey 13 or 14, geese up to 18, and swans sometimes have 25.

The vertebrae of the neck are surrounded by strong muscles, as those who eat game birds well know. The neck and head are not held with sinews, as in quadrupeds, but with muscles. This is why birds bend their necks in sleep or tuck their heads under their wings, so that the muscles are completely relaxed.

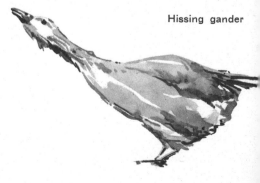

Hissing gander

The skull of the bird is unlike that of the quadruped or human. It consists mainly of eyes and beak. If a man had eyes of the same proportionate size as those of an eagle, they would be as large as tangerines; and of the great horned owl, even larger.

Bird's legs differ in the same way from human's as hoofed animals; only the toes remain. The very small thighbone when at rest is almost at right angles to the lower thighbone, and the shinbone is almost nonexistent. The instep has become a single bone, the bird's "leg." Generally, it has four toes attached to it, one of which points backwards. Climbing birds, like parrots, have two toes pointing backwards; in water birds they all point forwards. Many birds have only two toes; the African ostrich has three. The number of knuckles also varies. The toe pointing backwards has two, the inner, forward toe three, the second four, and the outer toe five. Whereas all the leg joints function like hinge joints, the two outer, forward toes have rotary joints, enabling them to be pulled towards the inner one.

The hip joint is still a ball joint, but it is so stiffened with tendons that an inward movement of the leg is possible to bring the leg under the line of gravity of the body, and in stepping forward the body can be moved in a straight line. More broadly built water birds cannot do this; they have to waddle, with inturned toes.

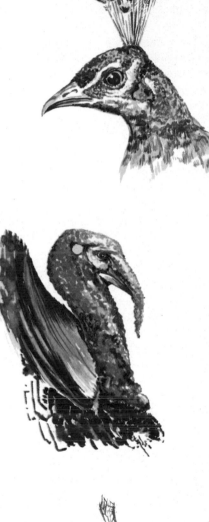

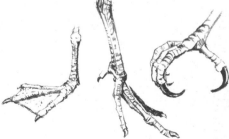

Head of peacock and turkey cock
Foot of webfooted bird, game bird, and song bird

The "arm" bones of the bird have been completely adapted for flight, but they still resemble human arms very closely, and even human hands. The humerus and ulna, however, have grown together at the ends and cannot rotate around each other but form a strong plate to which the arm pinions are attached. The wrist and finger bones have dwindled or disappeared completely, except for two extended bones of the first finger, which hold the hand pinions attached by a hinge joint which prevents the wing from bending too far either up or down.

The feathers present the draftsman and painter with a difficult problem if he does not wish to copy every detail naively and exactly. Basically, the feathers are a mass which, like a tiled roof, could be done with a texture; but this does not work, for the texture has to cover a relatively complex underlying form, and the difference of the feather's shape and its function must be made clear in places. There are two main types of feathers: the small, soft down feathers, which are indefinite in shape, and the covering, tail, and wing feathers, which are harder and clearer in shape. Down feathers, which provide warmth, correspond to the coat of quadrupeds. The covering feathers lie over the down and are more of a mechanical protection. Their size and definite shape make a clearly marked scaling which has to be reproduced lying correctly.

Every feather is composed of a quill and the feathering, which is made up of numerous small branches standing out flat to left and right of the upper part of the quill—symmetrically in the tail, covering, and down feathers, and asymmetrically in the wing pinions. The feathering of down is soft and curly, but on the others it is harder and cleverly toothed to form airproof plates. The narrower feathering of the wing pinions

Golden eagle in flight, showing disposition of feathers, seen from below. Feet omitted to make picture clearer. 1. Pinion — 2. Rudder-feather — 3. Down feather

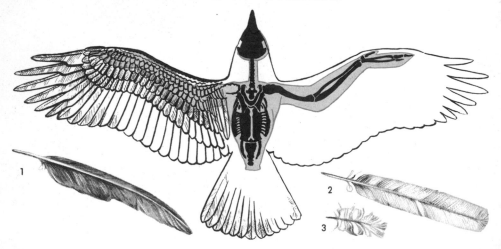

Bird of prey about to swoop

always points away from the body and overlaps like roof tiles, looking at the bird's back as a roof ridge. When the wing beats down, this layering causes the air to press the feathers together, and when the wing is lifted, they are opened, like the slats of a Venetian blind.

The wing and tail feathers serve to increase considerably the area of the bird's body when it is flying, without adding much to its weight. The shape of the bird when flying cannot be deduced from its bodily structure, but must be studied carefully in each case. Almost every bird has its characteristic flying shape.

The feathers are stuck at an angle into the skin at the lower end of the round quill and, like beak and claws, are extensions of the skin. They are moved by numerous small skin muscles, which can ruffle them and guide the movements of tail and wing feathers for steering.

Lastly, we should mention the decorative growth of feathers, crests, and unusually long tail feathers. They serve no practical purpose, but rather tend to restrict freedom of movement and flight. Other decorative skin forms are the strange combs and throat flaps on some birds.

Birds in all their variety of species have been used more than any other animals for ornamental stylization, especially emblems. The most interesting examples of naturalistic representation of birds are those of the ancient Egyptians, who solved the problem of reproducing feathers by drawing the most important tail and wing quills very exactly and leaving the others out, giving only the modeling or contour, but again putting in carefully observed details of eye, beak, and gait. Egyptian and Chinese wall paintings are full of fascinating, closely observed pictures of flight. In the Baroque and Rococo periods artists began to take an interest in the beauty of different species of birds and made delightful colored copper plate pictures of them, which are still the source of many lovely bird books. Might it not be a stimulating change from the eternal still lifes and bathing nudes to work on pictures of birds?

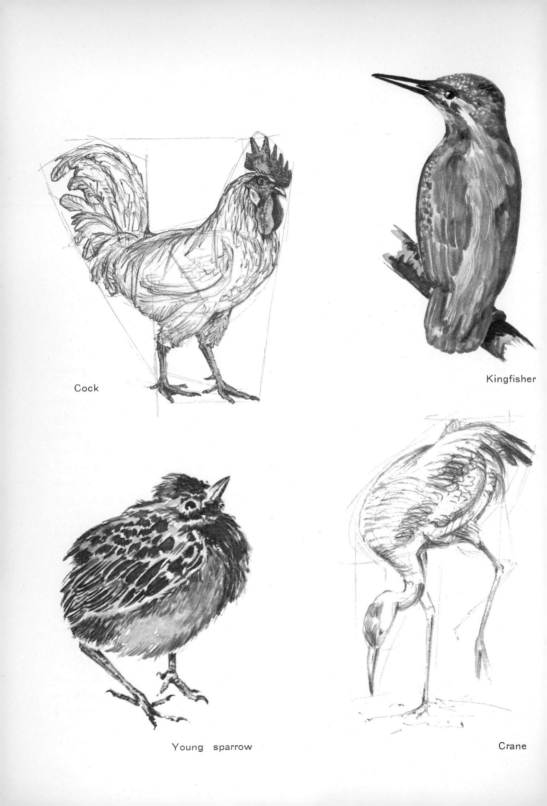

Cock

Kingfisher

Young sparrow

Crane

In drawing any plant, the principle of its growth must be understood in order to grasp the character of its outer form. No view of the whole is obtained from botanical analysis or the classification of small details, whatever wonders of nature these details disclose. In drawing a plant the most important thing is the first impression—what is seen at first glance—and the correct rendering of this characteristic appearance, whether it corresponds to a type-form or deviates individually from the type. Individual deviations are more quickly understood if the typical growths have been closely studied. This, of course, is most easily done with the largest plant structures, trees, rather than with the small ones. The principles of growth learned from the large plants are easily transferred to smaller ones, be they grass, flower tendril, or single leaf or petal. Thus, the artist, unlike the botanist, is concerned first with the large, immediately obvious form.

If we transpose our concepts of human anatomy to plants, then in trees and bushes the trunk, branches, and twigs correspond to the skeleton, and the leaves and flowers to the soft parts. The longer one considers this comparison the more fruitful it seems; the tree in leaf, like the human body, shows the shape of its skeleton only in part, although the peculiarities of its growth, called in plants "habitus," all derive from it. However, the foliage can alter the aspect of a tree much less than the soft tissues can change the appearance of a human. No tree suddenly becomes fatter or thinner; in a fixed position with a virtually constant climate and nourishment it will grow in the same way year after year, either strongly or poorly.

Yet, as always, comparisons should cease when they become lame, and principles should not be made too rigid. The life of plants follows rules different from those that govern mobile creatures. Their soft parts are organs, not muscles; their "skeleton" consists of vessels which have grown more or less rigid. These vessels naturally continue right into the organs, leaves and flowers, and they often repeat the same pattern of growth as the stem and its branches. The leaf simplifies this pattern to some extent and makes it an obvious ornament in a drawing. It is no wonder that leaves and flowers (which, in essence, are also made up of leaves) should have been so frequently used as subjects for decorative ornament. The type of leaf used often characterizes a whole style of ornament: acanthus for the Corinthian, vine and ivy leaves for the Gothic, and the water lily with its long, wavy stem for Art Nouveau. These are only a few examples, all of which used mainly graphic forms, even though they were carried out in relief. Plant forms were, of course, also used in the round; the most impres-

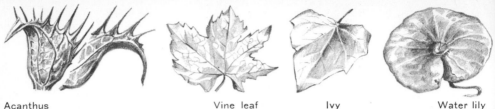

Acanthus Vine leaf Ivy Water lily

sive example is, perhaps, the columbine shape used in the Renaissance.

The branch formation of a plant can be seen in a simplified, two-dimensional form in the veining of its leaf. The skeleton of a leaf is very similar in design to a bare tree, or to flowers and grasses which are stripped of their green. These general types of growth formation should be understood by the artist before he studies individual forms. Without this understanding two mistakes often occur: either both typical and individual shapes are bungled and what should be a tree looks like a birch broom standing upright decked out with cotton wool, or so much

attention is given to the type-form each time that the characteristics of the particular plant being drawn are overlooked. In either case the result looks amateurish.

Drawing a tree means, up to a point, drawing its portrait, and the surest way to success is the "constructive," not the impressionistic, approach. First, there is the general line of the central trunk below the branches. As soon as a major limb branches off, however, the whole trunk usually changes its direction slightly. It bends away from the branch, just as the human body bends to adjust its equilibrium if the weight is put on one side. This is the rule for all trees with alternating branches, apart from a few individual exceptions, or where conditions of growth force a deviation from the rule. The majority of trees in the European and American landscapes grow to this pattern. The zig-zag growth of the trunk with alternating branches is always seen in saplings and is repeated in the leaf arrangement. The twigs do not grow on a plane with the bough or trunk but are grouped spirally around it.

As the tree ages and becomes thicker, the zig-zag tendency becomes less noticeable. Twigs break off or grow irregularly, so that a static symmetry is no longer necessary. As the trunk thickens, the distance between the offshoots

Tree silhouettes

Copper beech

Fir trees

becomes smaller. Sometimes, too, the horizontal ground level develops a slope, and the trunk has to go with it; the upper part will tend towards the vertical again and give a general curve to the trunk. It may be that continuous washing away of soil around the roots makes the tree grow crooked from the beginning, and the weight of the trunk and branches prevents its righting itself to the vertical. This condition is often seen beside water, particularly in willows, some species of which have an additional tendency to grow strange bends and curves in trunk and boughs. If the main trunk is broken off while the tree is young, two or more main stems generally form, and it looks as though several trees were growing from one thick trunk. Through such ob-

servations much can be learned of the history of a tree from its growth and deviations from the normal habitus; it has to grow in situ, whatever changes occur in its environment, and adapt itself to these changes.

Among the commoners trees in Europe, only the maple, horse chestnut, and oak have paired branches, and, of course, the conifers, which each year produce a new whorl of twigs at the top of the main stem. For obvious reasons these trees all grow straight, especially the conifers. Their branches always remain relatively small compared to the main stem, whereas the oak, consistent with its compact shape and slower growth, forms branches hardly thinner than the trunk, and when the tree is full grown it

View of pine wood

cannot spread out, and there is not light enough for their leaves. If one of these trees remains standing when a wood has been cut down, it looks most unnatural. Constant strong winds from the same direction can also make a tree look unnatural, with branches growing only to the leeward side. This happens mostly near or on the tops of mountains or where the wind has a long unbroken run.

Even if trees are thickly covered in leaves, their trunks and branches are discernible to some extent. A general impression of a tree in leaf is best caught on paper by following through the branches where they can be seen. It is their growth that fixes the "likeness," for in a picture of a whole tree it will rarely be possible to reproduce the individual leaf shape of the various species. To help the student we have illustrated a few schematic renderings of particularly characteristic tree shapes. An understanding of how trees grow, be-

is often impossible to distinguish the trunk amid the maze of branches at the top. Another reason for this is that the main stem of a young oak breaks very easily; this is also the case with fir trees. As a rule the oak does not grow so straight as it gets older; also the trunk gets thicker, and the branches tend to grow more strongly than the trunk.

A thick wood is the best environment for straight, regular growth. The need for light makes the stem grow as vertically as possible, and as the top grows higher the lower branches die off. They

Japanese quince

sides preventing elementary mistakes in drawing them, will give the student a better sense of the character of a land-scape. A tree, unlike a single flower, is hardly a subject which calls for isolated depiction apart from its surroundings.

Leaves or conifer needles can be seen only as a mass, best reproduced with a suitable texture. Both leaf shape and density of foliage are characteristic of a tree. An oak with its notched leaves is very different from a beech with elliptical leaf shapes, but both have dense foliage, in contrast to birch or willow.

It is very interesting to work out a texture suitable for leaves in varying light conditions. Photographs can be traced lightly by the beginner to help him see his way into the problem, although he should always devote most of his time to studies from life. As with all textures which render a mass of living or organic detail in three dimensions, it is best to use

Maple

Apple tree

the "trick" of picking out a few areas for exact delineation and merging them into a general toned surface. The beholder unconsciously associates the whole back-ground texture with the part that is de-tailed. The bark is another area where texture is important. As with the texture for leaves, it must arise from individual observation, and once worked out is more effective if most of the area is merely indicated by shading rather than filled in pedantically in every corner. However, bark must be carefully observed; a vague, lifeless impression is not sufficient.

Lime tree

Grasses

As in politics and everyday life, the greater the understanding, the less the necessity for a display of knowledge. In drawing this is realized by a knowledge of the shapes and a mastery of expression. A quiet, discreet word with the authority of knowledge behind it is always more impressive than a full-scale explanation. Even if a wood is depicted as a whole it is well worthwhile putting in here and there a carefully observed leaf or patch of bark to give precision to the total effect. It is this approach which will make the larch wood seem satin soft, or the greenery of a pine wood clearing scrubby and prickly, so that the beholder will almost hear the wind in the tops of the trees, the rustle of birch leaves, or the sighing of the wind in the willows by the stream. This can come about only if the artist's intention is precise. How this intention is communicated does not matter; it may be in terms of complete abstraction. Whatever the means, they are most effective when they are discreet and simple—they should never tell a tale of laborious toil. It will require a great deal of time for the student to make leaf textures like the Chinese with their thousand-year-old brush technique.

After studying trees, there will not be many problems in drawing bushes and shrubs. Many trees exist in the form of bushes, and other true shrubs, except for the difference in the proportion of branches to leaves, are like miniature trees or tree tops. To show the difference, a larger leaf texture is drawn on finer branches, emphasizing the smaller size of the plant.

Thorn apple

Oak

Artists have always paid much attention to the shapes of flowers and leaves. They should not be copied unthinkingly; each type should be studied for its basic form, especially in order to understand and interpret the perspective and foreshortening correctly. This is much more important with small plants seen at close range than with trees, which, at the distance necessary to see them, appear much more as silhouettes. If, for example, a drawing is made of a bluebell or a sunflower, it should not resemble a botanical study, which would display as much detail as possible frontally, but instead be a living picture characterizing the personality of the plant with all the grace peculiar to its nature.

It is not usual to draw flowers in their natural surroundings, unless, like Dürer's columbines and grasses, they are dug up in a great clump of earth. Then, the results seem less like pictures than botanical studies, even more so if the flower is left in its environment and rendered as a detail against surroundings which are represented by a texture. Photographers do this by showing a flower in its habitat and blurring the surroundings to emphasize the subject. To leave everything in focus would make the whole picture too dazzling. The eye itself looking at real flowers selects one on which to focus.

If a student is interested in flower drawing or painting he cannot do better

Martagon

Chrysanthemum

than take the Chinese as his model. He will learn from them how to give himself up completely to the particular individual form after having mastered the basic form of the type. There is an anecdote about a Chinese chrysanthemum grower which should be pondered in this connection: the Emperor heard of a famous garden and announced that he would visit it. When he arrived the garden had been flattened to a smooth gravel surface. But in the gardener's house, in a precious porcelain vase, stood one single chrysanthemum, the most beautiful out of the whole garden.

Unfortunately, there are many flower pictures which remind one of the dictum of Grünhagen, a tireless and delightful painter of the changing seasons: "Three primroses in a glass are shapely beings, spreading an aura of mystery, but three hundred are nothing but an amorphous blur."

Ever since man began to theorize about art he has assumed that the man-made dwelling place first made conscious artistic activity possible. This is true, for although the cave paintings were made at a time when men did **not** build dwelling places, prehistoric cave art is a solitary phenomenon. All pictorial and plastic arts are nowadays connected in some way with the man-built dwelling house.

Architecture forms a part of the subject matter of the great majority of paintings and drawings. More than this, a whole branch of painting has adopted the building itself as its subject. Although it had originally no other object than to reproduce the impression of splendor given by a town (splendid in comparison with untouched nature, then considered "raw"), the prominent architectural painters also included much of the atmosphere of contemporary life in their pictures. Today, architectural painting has been almost entirely replaced by photography.

Some knowledge of building technique is indispensable for anyone who depicts architecture, whether as a primary subject or as a background for figures, just as he needs a knowledge of the surface anatomy of human, animal, and plant life if he is to understand the forms he observes and reproduce them intelligently.

Architecture deals with man-made structures, but its methods are based on natural laws and natural conditions, in particular the laws of gravity and the nature of the materials used. The measurements are man made, adapted to man's size and ways of movement. Thus, ancient classical architecture was based on the golden mean.

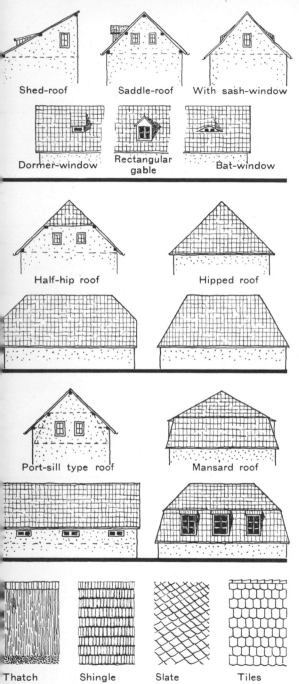

Shed-roof Saddle-roof With sash-window

Dormer-window Rectangular gable Bat-window

Half-hip roof Hipped roof

Port-sill type roof Mansard roof

Thatch Shingle Slate Tiles

When drawing buildings the human scale must be considered, or the figures will appear gigantic like Gulliver in Lilliput or minute like Gulliver in Brobdingnag. A few basic measurements should be remembered to prevent elementary mistakes; or, rather than relying on numerical figures, it may be easier to retain in the memory a scheme like the one illustrated as a reference to scale. If these few proportions are borne in mind, the building will turn out properly as a whole.

The building material by its nature dictates certain proportions. A wooden beam cannot extend farther than twelve or fifteen feet unsupported; beyond that it would bend or even break. Used as a pillar, wood must have a certain thickness in relation to its length or it will bend in. Other materials dictate other uses, but their peculiarities are much more obtrusive than those of the ideal building material, wood. Stone has a stronger resistance to pressure, but little tensile strength, and reinforced concrete is now used instead. Concrete gives resistance to pressure, and steel reinforcement adds resistance to strain. The material used also dictates the construction technique. The opposed diagrams in the illustrations show how each material must be used according to its nature. The roof needs special consideration; it is often drawn quite incorrectly. Naive observation is not always enough. When the main structural forms are understood, it will be easier to understand the peculiarities of an unusual roof or to follow the logic of its construction.

The general structure of a building is determined, according to the laws of

gravity, by horizontals and verticals. A building with leaning walls must fall sooner or later. The eye feels this unconsciously and seeks out horizontal and vertical relations, even when they are not structurally necessary. The eye derives satisfaction if the axes of the windows lie vertically one above the other and the sills and lintels run in horizontal lines. If an architect disregards this convention he must introduce other optical lines of relationship to emphasize stability—for example, lines running right across the wall.

A building corresponds better with the laws of gravity if it narrows towards the top and the walls press together inwards rather than pulling apart outwards. This is also a matter of construction, for walls are built thinner as they get higher, as they have less weight to bear at the top, and also thus reducing the weight on the lower walls. This is seen clearly on towers and other high buildings. Another way of reducing the weight is to make larger or more windows on upper stories. On Gothic towers the roof-like spires become exquisite pierced filigree.

Much of the pleasure we derive from the best drawings and paintings of architecture is due to the workmanlike knowledge of the artists, who have not considered it beneath them to study the craft as well as the aesthetics of building. The views of towns by Bernardo Belotto (1720-1780), nephew and pupil of Canaletto and court painter to the King of Poland, are fully satisfying artistically, and, furthermore, they were technically adequate to be used alone for the rebuilding of some of the historic buildings of Warsaw, the plans having disappeared.

RIGHT WRONG

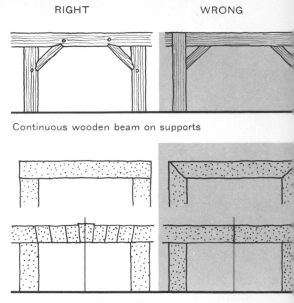

Continuous wooden beam on supports

Window or door frame of stone

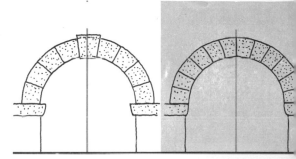

Round arch of beveled stone

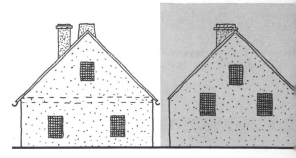

Arrangement of chimney stack and windows

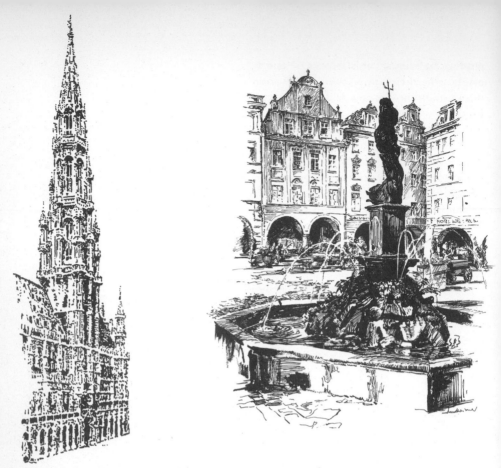

Impressionistic effect obtained by applying Chinese ink with injector

Pen and brush

Of course the representation of a building as a picture has a purpose different from an architect's drawing. The picture need only create the illusion of the complete building, whereas an architect's scale drawing sacrifices illusion for exact detail and precise indication of forms. A picture will reproduce exactly only here and there, being concerned with an over-all impression; just as when we look at a building, even with great concentration, we do not see every detail with the same precision. The volute of a capital or the profile of a moulding or a gateway can merge into vagueness while the effect of precision remains. If the study were rendered in every detail, the general effect would be lessened, for the beholder can work out details in his imagination far more harmoniously than it could be done in fact.

Generally, old buildings are chosen for pictures which are primarily architectural in subject, but the picturesque appeal of

modern buildings, cubist blocks of apartments with their bright colors and clean lines, should not be rejected out of hand. Surely the spirit of our time is fully expressed in these buildings. There is no dreamy atmosphere of contemplation, no coziness, but a challenging background to a life of restlessness, change, and activity. Yet modern forms have a charm of their own: driving through a town in a car as dusk falls on a wet November evening, the streets lie in a blue haze, the first bright lights are reflected in the wet asphalt, sulphurous clouds dissolve into the pink and gray haze of the horizon, and the car is nothing but an atom in all the bustle of the town. Here, surely, is an experience which can inspire the artist.

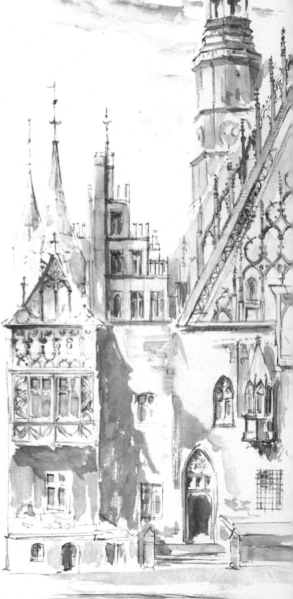

Architectural lead pencil study with touches of watercolor added

10. LANDSCAPE

In a landscape all the subjects we have studied in isolation are brought together: plants and animals, people and buildings; but the determining factors in a landscape are the form of the earth's surface, and the sky above it with its colors, clouds, mists and stars.

As with all solid things, the form of the earth can be made intelligible only through the medium of perspective. Linear perspective is the principal means, with its reduction in the scale of things as they approach the horizon. But a straight path with its sides running to a vanishing point indicates space and distance whether the land is rising or falling away. As in drawing buildings it must be related to other lines running parallel to it (cf. p. 49). If the path winds or rises and falls alternately it implies the rise and fall of the surrounding land. If it disappears and rises again the reduction in its breadth when it reappears shows how far away it has now run from the beholder, how far the landscape stretches. Fields and patches of woodland are useful in the same way because of the deviation from normal perspective caused by the undulations in the ground.

If a small tree is drawn near to a large one of the same kind, the effect will be to imply distance between them, although in fact trees of the same species can vary greatly in size. To make the real difference in size clear, the foliage of both trees must be given with the same texture and shown to be of the same size, for the size of leaves does not vary with the size of the tree.

Relative size modified by use of figures (duck, fishing vessel)

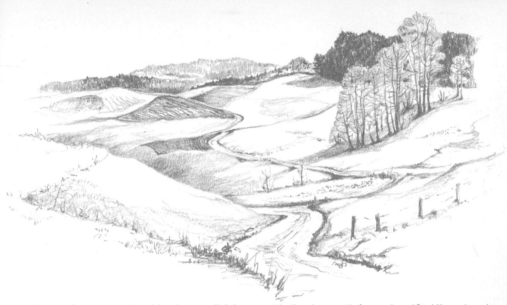

Landscape showing road and landscape divisions and indicating earth formation (Stabilo colored crayon)

Even though all the usual methods of perspective can be used to give an illusion of space and distance—gradations of size, heavy drawing against faint, dark areas against light—it is impossible for the earth formation by itself to give an indication of the scale of the scene. Even trees, as has just been shown, cannot always serve to do this. Only accessories of clearly defined size can perform this function unequivocally, such as people and animals, or buildings, which are always related to the human scale by the size of their windows and doors. Very often figures are added to a picture at the end to give the scale of the landscape. It is amusing to recall how in the Baroque period many landscape painters had to employ specialists to put in the figures for them, as they could not manage them themselves. Two examples in the illustration show the same earth formation with a different scale indicated by a single feature, the duck in one, reducing it, and the boat in the other, enlarging it.

Shadow perspective can also be ambiguous in a landscape. Cloud shadows are deceptive, and towards the horizon the haze of the atmosphere completely eliminates the modeling of mountain, tree or building. A mountain mass of great depth looks like a wall, trees become as flat as stage scenery, and the sea of houses in a distant town is nothing more than a flat silhouette. But the outline of a silhouette is sharpened by distance and the illusion of recession in space is associated with it. The same impression arises whenever these outlines

177

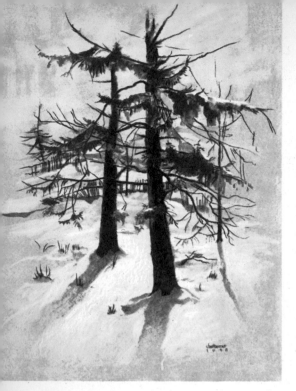

Misty winter's morning, paste and watercolor

though it were on a steep slope facing the artist across a steep valley, but this is not what we mean! The artist should embrace the whole hill or tree in his mind just as he holds a vase or jug on the table, sensing its three-dimensional shape. Then when he draws his landscape with a normal position for the horizon he can better understand the implications. There must be a sense of space between the near and far objects. This is helped, for instance, by breaking the outline that joins something near and something far together on the sky-line or nearer, either simply by broken lines in the drawing or by a color contrast. This may seem like a trick, and admittedly it is one. It is a trick used most often by the greatest of all landscape painters, the Chinese. There is all the difference between a trick used as a formula, and one which expresses a thought, or rather which is occasioned by a feeling—here the feeling of space. Space is the foundation of the landscape's being, just as a flat surface is that of a picture's, and once the artist has really felt the space in his landscape he can use well-tried conventions like those suggested without becoming mechanical; they will be something very different in his hands from an imitated trick.

The most intense way to experience a landscape is to walk alone and quietly, stopping whenever the eye is caught by something and noting it without any particular picture in mind, perhaps just memorizing it, like the classical Chinese and Japanese painters. Most of the great landscape painters of the pre-Impressionist era, such as Turner or the great German Romantic, Caspar David Friedrich, painted their landscapes in the

become less clear, as through a mist or flickering light.

Color perspective in a landscape is much more reliable. What we have said so far applies principally to the graphic reproduction of landscape. Colors can give it a sense of breadth or of being closed in, without either figures to give a scale or vanishing points (color perspective p. 353). Usually, however, both linear and color perspective are used in a colored rendering of a landscape, as in all other types of painting.

To make the formation of the land in the picture really convincing it helps to imagine it first without foreshortening, spread out as in an aerial view. Children drawing an imaginary landscape do this, making the whole picture appear as

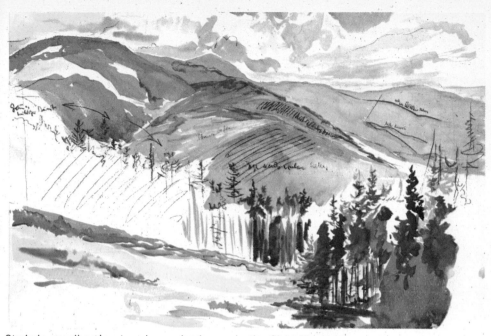

Study in pencil and watercolors, a landscape in the Giant Mountains

studio from quick notes made on the spot. These notes, made in pencil, chalk, or wash, did not attempt to render color or atmosphere; for this the artist relied on his memory. Though their landscapes are usually given exact topographical titles, none of the places is rendered literally; yet, as portraits of the landscape one feels that they are closer in "likeness" and atmosphere than if they had been copied exactly. The author has spent most of his life in the Riesengebirge in Sudetenland where Caspar David Friedrich worked, and although hardly a line tallies exactly, he can vouch for the atmosphere of the district in the pictures being unmistakable, and the impact of the pictures as strong as the landscape itself. For landscape in its highest artistic form expresses in the most absolute way a psychological condition, a mood,

closely comparable to the feelings experienced in hearing music. It hardly needs saying that this experience need not be "romantic" in character, a much abused word which has thus come into some disrepute. When Kokoschka painted Hamburg, or Monet painted the Houses of Parliament at Westminster the result is no less "romantic" an interpretation than that produced by painters who work more from their imagination, or in a romantic style (such as Friedrich in his **Die Sieben Gründe** of the Bohemian Riesengebirge).

The author used to live near a wild parkland which was a famous beauty spot. From early spring to late in the autumn painters could be met there. They set out on the day after their arrival looking for "subjects," stopping every

few yards to find pleasing or striking views. They churned out whole series of pictures, often very able impressions of the subject, then hurried back to town and handed the paintings over with the paint hardly dry on them to the greedily waiting dealers, who, as the painters boasted without shame, sold them "like hot cakes." The pictures filled up empty spaces on the walls of the "best" houses, whose owners could then boast of having a "Nowak" or a "Vollmer," or whatever the name of the painter in vogue at the time might be. (In the same way they "went to the opera," never to Tosca or the Magic Flute.) This ham stuff was hardly more than enlarged picture postcards, copied views, with nothing in them of a creative vision, of impressions drawn from a real feeling into the landscape.

What a difference from Breughel's **Winter Scene** or Van Gogh's **Cornfield!**

It is strange, in this period of experiment and exploration of new subjects which lie beyond the boundaries of pictorial representation, that so few artists have attempted aerial views of landscape. Many people see it much more frequently today from the air than they do from walking in it. Nothing can be seen from a motor car, since the road ahead has to be stared at, and from a train it is rarely possible to achieve the quiet enjoyment that an airplane provides. From a height, the most broken landscape is flattened into a carpet; the picture plane is there already. Surely the airplane provides a great source of unexplored subjects, all strange and dreamlike.

Aerial view, chalk and red crayon

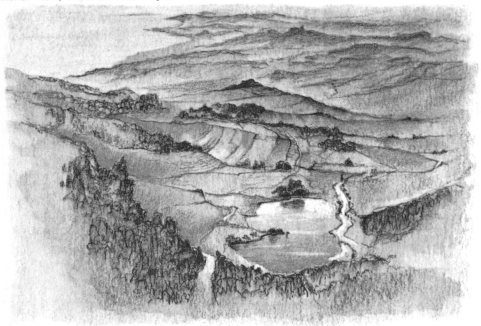

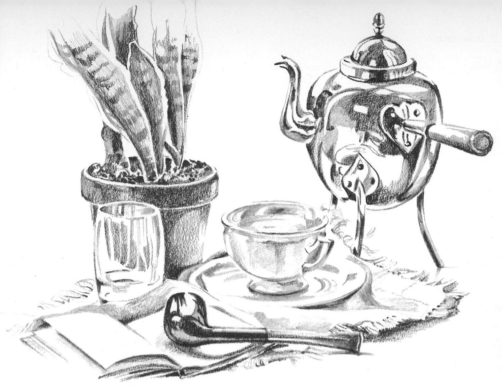

Pencil study of varied objects and shapes

11. STILL LIFE

Again in still life we bring together subjects which have already been treated separately: plants, animals, and objects. As in landscape, the separate objects are not there for themselves; the significance of a still life lies in their combination. The usual combinations of subjects in a still life are of interest primarily to painters, not draftsmen. The concept must be extended to include all the obviously chance combinations which are of constant interest to draftsmen, such as dented metal jugs in a corner, a hole in the ground, a dead bird.

The difference between the painter's still life and the draftsman's consists, without any inner reason, in the difference between the deliberate combination and the chance find.

Here arises the problem of the purpose of a still life. The French call it **nature morte**, which is less telling than the English concept of still, secret, and outwardly unmoving life. The term is derived from the Dutch **Stilleven** and was adopted by art historians in the eighteenth century. A still life is concerned with, one might say, the helpless, unconscious existence of things, whether they are really dead material or partake of the continuous life of a flower, a fruit, and, if we see more closely, of a dead animal, too.

The classical still life painting, pictures of flowers, hunting trophies, or fruit pieces, as they are called in dealer's parlance, arise from the painter's delight in his ability, his technical self-satisfac-

tion. It is a piece of virtuosity, like elaborate compositions played by virtuoso pianists and violinists, or the florid passages sung by a coloratura, with nothing particular outside itself to communicate. In such pieces the artist at last finds the opportunity to show off his brilliant technique. It is no different with the purely painterly charm of the still lifes of the seventeenth and eighteenth centuries: a complete contrast to the **Piece of Lawn** of Dürer or the **Sunflowers** of Van Gogh, where all thought of the technique of the master is forgotten in sympathetic contemplation of the existence of these small things.

A composed still life is a useful way of practicing composition and studying painterly effects, different materials, the changes of color in light and shade, and their use for harmony or dissonance, and trying out combinations of different strong colors or emphasizing one dominant color with subordinate or complementary tones. Sometimes under the hand of a great master these technical exercises produce works of art.

The still life based on the chance find is something else. A pair of old shoes thrown away and forgotten may cause the artist to seize his pencil; and while the open seam, twisted leather, and torn soles may present interesting problems of form and interpretation, his imagination may be inspired by the amusing or tragic implications of the subject. The beholder of the drawing will certainly respond in this way. Thus, it is usually "ugly" things that interest the draftsman, what is forgotten and, for the former owner, long since dead. These things would probably mean nothing to the artist while they were bright and new with no patina of use and age. The charm comes not alone from what is picturesque, but also from a feeling for recording small things for their own sake,

Having thought of a still life in this way, the student may approach the incidental objects in a picture with a higher intention; in fact, a picture of quite a different subject often contains still life as an accessory. Dutch paintings of the seventeenth century should be examined for this. In the portrait of Georg Gisze by Holbein the loving inclusion of the many small still life objects enhances the extraordinary clarity of the face.

Same objects as in previous illustration, arranged for a study in color (glue colors)

Toulouse-Lautrec, Self-portrait (caricature)

12. CARICATURE

We have so far treated our aim in drawing as reproducing what we see as nearly as possible to nature. This is the only sure and secure foundation on which to branch out into exaggeration and distortion and on which to start artistic creation. This is a valid foundation for caricature as well, but here we have to move on to the second and last stage, that of creation.

First, we must explain what we mean by caricature. The word first brings to mind the witty drawing, which has so many uses: the illustration to a literary joke, social or political satire, advertisement. No academic training is necessary to produce this, as long as the drawing is not required to caricature a particular person. Many cartoonists, and by no means the worst, use the same figure again and again, of the kind that a child

could soon learn to copy. Here the talent of the draftsman lies less in manual dexterity than in the brilliance of his literary concept. Even the satirical drawings of men of great ability like Goya, Daumier, Chodowiecki or Doré are not really caricatures, but very representative and typical figures with portrait-like features.

What we mean here by caricature arises from the portrait of a definite individual, portrayed as a person and not as a general type. Portrait caricature of this type demands great ability; it is also the clearest example of how something can be created out of a carefully understood natural form by the power of the artist to see into the essential nature of the person.

Many paths can lead to this insight, but its pictorial presentation depends on

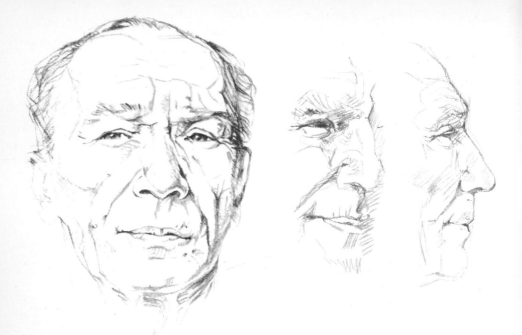

Portrait studies used in drawing the caricature on the right

two things: the most precise pinpointing of the characteristic forms of the face, and their exaggeration. Both of these can be emphasized with the pose and gesture of the whole figure. It can be approached from two extremes, as can nearly all artistic creation, either from the visual experience and impression of what is immediately seen, or from a knowledge of human peculiarities, weaknesses, and strengths, in short, an impression of the artist's psychological experience of the person. This portrait approach could arise without the artist ever having seen the person, and it is conceivable that a caricature could be made without ever having seen the subject, although it might then have to be provided with a title.

Here, however, we are dealing with a caricature portrait that can be recognized without a title. It is built on characteristic forms. If he starts from a visual impression, the artist will ask himself what this or that form or line signifies, whether this aspect is typical or not, whether the person's nature—helped here by his knowledge of anatomy and physiognomy—is to be found in this or that peculiarity, and what is essential, what subsidiary.

Starting from the psychological idea, the artist will seek formal structures which can express it. He must not alter forms consciously, but rather work with what is to be seen. His psychological impression will guide him in what he selects to emphasize and what he rejects. Usu-

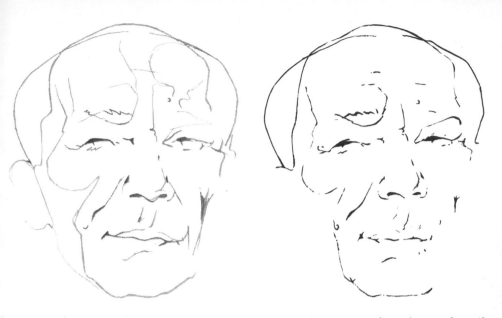

Successive stages in this caricature were obtained by tracing the portrait study seen from the front. It is that of an eminent surgeon. Like many great doctors, he employed sarcasm to ward off the absurdities of his patients

ally, of course, he will use both visual and psychological approaches. A significant caricature can arise only from an all-around idea, and it is irrelevant whether it appears immediately or grows slowly. This idea cannot be forced, but much can be done to help its growth.

Here the author illustrates a systematic reduction of a portrait to caricature as the idea takes shape. First comes a portrait study, or, better still, several. Over them he lays tracing paper and redraws the forms, already beginning to select and emphasize certain features. These tracings can be made again and again, or one can start at the beginning and draw a final caricature direct from the

model or from memory. Systematic work of this kind, which can be varied in a number of ways, is always of some value; it may result in a brilliant portrait or it may fail. Nothing can be won without trying, and systematic work is the best way to try. Even if the result is a failure, the practice is its own reward.

All this indicates that genuine caricature cannot be a sideline. It is a branch of fine art, demanding specialization and a grounding in straightforward portraiture which uncritically contains all that can be seen. Unless the artist can dominate nature, he will be unable to create, emphasize, or exaggerate.

13. LETTERING

Every artist must at some time or another come to grips with the problem of lettering, however little inclination he may feel for it. Lettering has little to do directly with artistic drawing, although, as we know, they were originally connected, since all writing derived from simplified pictures.

These pictures first signified whole words; they were then simplified and gradually came to represent abstract syllables, until in the final stage of development each individual letter represented only a sound. Apart from the Chinese, the writing of all civilizations has evolved in this way.

Roman capitals have been the basis for all writing in the Western world since about 500 A.D., at which time they were already over 1000 years old. They were used primarily for monument inscriptions which were incised into the stone after first being drawn on with a

SINEMATR

flat brush.

Alongside the Roman capital developed the faster and more flowing commercial hand. The small letters with their up and down projections (called "ascenders" and "descenders") evolved gradually from the habit of running the capitals together. The letters were sloped forwards to aid fluency, and the cursive script resulted.

The proportions of the Roman capital letter, the "capitalis quadrata," are based on a square. By turning the square into an upright quadrilateral the

porabat inmanib: fuis

"capitalis rustica," a narrow, cursive capital hand, was evolved. Numerous mixed alphabets grew out of these, which took on characteristic forms in different regions and countries. Among them was the special German or "black letter" alphabet which, following the usual Gothic stylization, broke up many of the curves

SUNTETSPIRITI

into angles, resulting in the Fraktur or "pointed" text. With the invention of printing, three basic ways of writing are differentiated: the printed alphabet composed of isolated metal letters, the drawn alphabet, and the written alpha-

Sctē Mihael archangele·De-

bet. The drawn is, of course, that which most concerns the artist and the one to which the other two owe their origin.

Every drawn alphabet derives from a group of geometric figures: a rectangle, which was originally always a square, a triangle, and a circle. The rectangle can vary a great deal in proportion, and the circle can become correspondingly elliptical, while the triangle also can vary

in shape. In all good lettering these geometric figures remain in a definite relation to each other and can be combined into a basic skeleton shape, which we may call the prototype figure. Each style or alphabet has its characteristic prototype figure (from which the key letters O, H, and V are immediately derived and to which the remaining letters relate).

The prototype figure, however, does no more than determine the shapes of the individual letters and does not affect the word or line formation. The arrangement of letters in words, and of words in lines, has to obey a certain rhythm. It must be as monotonous as possible in order to emphasize the evenness of the lettering and at the same time give a compact unity to the text. Monotony in word and line rhythm also prevents the reader from being distracted from his subject matter and makes reading easy and fluent. Above all, the forms of the individual letters must be clear and simple.

Clarity results automatically from the prototype, which is based on the shape of the rectangle. This, without going to extremes and producing a hardly legible text, can vary from a square to an upright rectangle with a 1:4 width-height relationship. If this proportion is expressed as 2:8, it is easier to divide the proportions of the letters by eye according to the golden mean, as we learned when drawing the human body. In lettering, the golden mean is, once again, the most satisfactory proportion. Here we can only outline the elements of letter construction. Writing and lettering is a special field in which expertness is gained only by much practice. Real

mastery is a special gift, which, like every talent, reveals itself through an unusual predilection for the subject.

To make this exercise easier it is advisable to use squared paper. First draw an upright rectangle of 5 x 8 units, and divide it diagonally in both directions; then, as illustrated, draw in the ellipse. This is the basic proportion, the prototype, for capitals, which gives the construction of C, L, N, O, Q, and Z. By quartering the figure we get E, F, H, T, K, and Y. (E and F seem disproportionately broad, but in certain technical alphabets, which must be constructed with ruler, set square, and compasses, they are allowed to remain so. In the next stage it will be seen that they are normally altered to a more pleasing proportion. These mechanically constructed alphabets do not even use the ellipse, but instead join half circles with straight lines.)

Lines joining the centers of the top and bottom of the rectangle diagonally to the opposite corners give the two triangles which make A and V; and, when doubled, M and W. The C is made by cutting the ellipse where it meets the diagonals, and the G is made in the same way, both letters thus not filling the rectangle completely. All the other letters are narrower still. The E, F, and T can now be given their correct widths. The D is half the ellipse, plus an additional eighth, with a vertical. The other letters are formed using circles and half circles with a diameter of four units. Better proportions can be given to the R and B if they, too, have at least one added width unit; otherwise they would appear too narrow.

At this stage we are moving well

beyond the scope of rigid mechanical construction; creative lettering is more than measuring and logic. Nevertheless, the skeleton, the proportion of the golden mean, must not be forgotten. As we develop a more sensitively designed letter, it will be found that many have a center that differs considerably from the geometric center of the rectangle. In B, D, F, G, H, P, and R, the central horizontal is slightly above the geometric center, the lower part of the letter thus being rather bigger than the upper to give greater stability.

In K and Y the juncture of the diagonals is similarly altered. In S and B the two half circles are of different diameters. There remain J and U, which are made respectively of a half and quarter circle across five units.

We now must decide whether to keep each letter as a schematic shape built up of uniform elements, or whether to consider each letter individually. Experience teaches that individually designed letters are more quickly and easily read than those built up schematically. The latter emphasize the regularity of the rhythm, but other artifices can be used to recover this so that in artistic lettering one is able to concentrate on the individual shape of each letter. W and M are the most obvious examples. They are much pleasanter and more legible if they are narrowed by making the two outer strokes tend more toward the vertical than the inner ones. Two very simple and legible forms can be drawn directly from the basic rectangle, but their shapes are not attractive. The illustrations show how to find satisfactory proportions from diagonals within the rectangle, and other values from divisions according to the

golden section. In the end we come to quite imponderable alterations, since no good . writing is made from uniformly very thin lines. Either we make block letters with uniform thick lines, or we use a flat brush or broad nib to combine thick and thin lines. Serifs can be added to these. All these resources change the balance of the letters, so that the artist's sensitivity must be brought into play as the deciding factor.

A 3 x 5 unit rectangle for the small letters, in printing called lower case, can be derived from the original 5 x 8 rectangle. Ascenders and descenders, such as the "tails" of p and d, stand in a 3:5 relation to the average height. The 5:3 relation has already been used for the horizontal line in capital A, and small letters use the 3:5 relation in the same way as the 5:8 principle was used for the capitals. If necessary, the descenders and ascenders can be reduced to two units. The relation would then still be within the golden mean, though at the primitive level of 3:2.

Numbers, as the illustration shows, are developed on the same principle as letters from the prototype figure, but with more opportunities for variation. Which style is chosen is a matter of taste, but it should be constant for both letters and numbers and not mixed.

One should always aim for a regular rhythm in the structure of word, line, or paragraph. To be absolutely regular it would of course have to be composed entirely of strokes at the same angle and of shapes exactly similar and with regular spacing. But since writing is composed of letters of varying shapes and compositions, the only way to produce a rhythmic uniformity is to find an optical

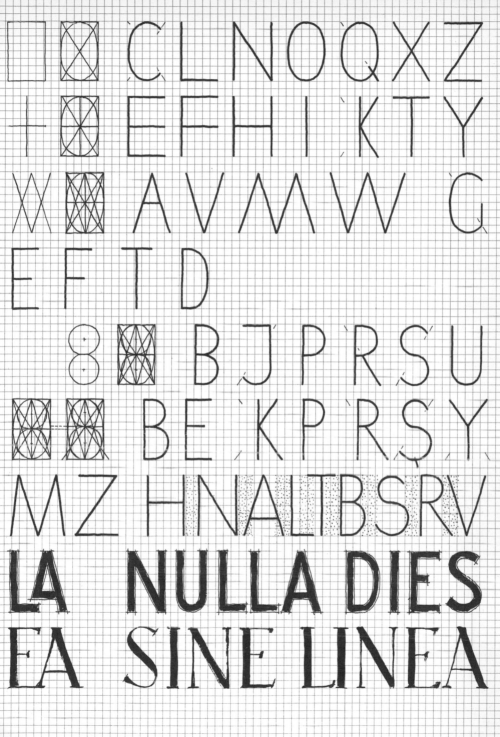

C L N O Q X Z

E F H I K T Y

A V M W G

E F T D

B J P R S U

B E K P R S Y

M Z H N A L T B S R U

LA NULLA DIES

EA SINE LINEA

t x y o abcdef

ghijklmnopqrs

tuvwxyz

bdef hi k mn st w

123456789038

Terra di Siena Odp.

regularity which will give the **impression** of a uniform amount of empty space between each letter. The shapes of these spaces vary enormously. There is a rectangle between H and N, a trapezium between N and A. The curves and openings which occur with most letters, such as E, C, and B, are seen mainly as part of the weight of the letter, and only partly as gaps between the letters. If L and T stand together, the free space seems to belong less to the letters than it does when L and N are side by side. In the seventh line of the illustrated development of capital letters the distance between the letters is dotted in at a constant two units. At a glance it is obvious that there is not enough space between T and B and between R and V, and that they should be set wider apart to make a satisfactory rhythm for the line.

It is a constant rule that, to make the text more legible, broad letters require close spacing and narrow letters broad. With a very narrow alphabet the separate letters are so compact that the spacing between the letters and the optical space can be regarded for practical purposes as identical.

The distance between words corresponds to the width of the letters; a two- or three-letter space between words is needed for clarity. The distance between the lines gives lettering its character. Generally, in a drawn block of text, a wide space between lines makes reading easier; a narrow one makes the block more compact. It is, thus, a matter to be decided according to the purpose of the text. In the block the spacing of the words must be determined line by line to fit them into the given length. Words can be crowded slightly if necessary, but it must not be noticeable or the unity of the block is destroyed. A drawn text should always look harmonious. The individual letters and their spacing must be built up on a consistent principle, so that their shapes are not more arresting than the content of the text. Mixed forms can be used, and sometimes even different prototypes can be combined. There are, for example, very attractive styles in which the letters are all narrow, except for the round shapes, which are drawn to a full circle instead of an ellipse. A mixture of ellipses and circles would destroy the harmony.

Many beginners try at once to develop a personal style of lettering. This is a mistake. As in drawing it is essential first to be able to control the stroke and learn to work in the usual styles with confidence and fluency. When this is accomplished, the student will generally find that he has, in fact, developed a personal style without having consciously sought it.

Really new alphabets arise from the unconscious work of many people and are always closely related to the style or taste of the period. All decisive developments in art arise from ideas which are much more objective and more a part of the whole spirit of the times than may at first appear.

Picasso, Woman on the Divan. This nude study, possibly drawn in the presence of the model, shows a trend toward a near-abstract design

14. ABSTRACT ART

The great artistic problem of our time is to come to terms with abstract drawing, painting, and sculpture. The experience of the abstract presupposes in the artist a particular mental or spiritual attitude which is fundamentally the same for all branches of the visual arts. Only the means of expression differ, and the nature of the experience is of a particular kind, often expressible equally well in drawing, painting, or sculpture, though in some cases limited to one of the three modes of expression. In this respect abstract art has not altered the traditional situation.

What in fact is meant by "abstract"? There is hardly a satisfactory answer to be found from anyone. The etymological meaning of this word of Latin derivation is, more or less, "drawn out or extracted (from objective reality), unreal, conceptual, only thought." One can also say only felt, as against really seen; yet this is not quite accurate, insofar as we, when

we set out to look for them, also "see" abstract forms and colors in the imagination. Painters and draftsmen must indeed do this, if they wish to reproduce abstract sensations.

This "seeing" is no more a deliberate thought process than the painter's poetic creative vision of impressions of real things. Part abstractions have always been associated with artistic vision. Medieval chimaeras and fabulous beasts which were never seen in reality in form or color express imaginary concepts, however naturalistically they are represented. They were the result of a desire to express some intangible, spiritual content of an imagined, or even of the visible, world. These attempts, which kept recurring, are the smallest and most remote rootlets of what has now become a rampant growth, spreading its tendrils over the whole of the objective world of the artist as "abstract art."

Böcklin represents the zenith of naturalistic representation of the imagined, and perhaps by self-suggestion, seen, world. He was about contemporary with Van Gogh, whose work represents what are basically the same natural forces; but while Böcklin was spinning out a mythological interpretation, Van Gogh saw more directly, more crudely, and his work speaks more forcefully: the dissolution of colors and forms into a seething blind mass of restless power. If we consider the work of Marc, we see that it is still concerned with realistic forms, but the color is not derived from the natural object, even though it may be thought and felt symbolically: blue horses' heads, and red horses. The colors here are by no means used with superficial decorative intent.

Thus we see that there have always been the means and the desire to represent in pictures feelings which are not

Klee, Flora of the South — an Echo. Watercolor. Klee's work often represents a preliminary step towards true abstraction

a part of the object, and to see in the things of the real world a second appearance which has no similarity to any recognizable object.

The intention of abstract art is to give pictorial form to feelings or sensations whether they arise from a mental concept or from an object. A program, one may say a dogmatic program, has been evolved which aims at drawing a clear division between objective and abstract representation. Michel Seuphor, one of the most outstanding interpreters of abstract art, defines the program in the following words: "I call abstract art every art that does not desire the memory or evocation of reality, in which it is irrelevant whether reality was the cause of the creative process."

There is also the common opinion that pure sensations independent of any known real object can be expressed only if the forms and colors of a picture are no longer associated with any recognizable object. If we hear the words "sorrow" or "joy" we many imagine situations from the past, but we do not undergo a direct experience of any definite shape or color, as we do if we say "spoon" or "house." A contradiction arises immediately in the pictorial reproduction of abstract visions: there are no abstract forms or colors in themselves. If we analyze an abstract picture we can always say that here we see a red triangle, this part looks like a blue rhododendron leaf, there the picture is reminiscent of a spiral nebula. It is only the combination of the forms which is unreal. We must also remember that there are no colors which we can imagine but cannot really see. What the human eye cannot perceive, like infra-red or ultra-violet, cannot be imagined either.

An abstract picture never gives the superficial likeness, even if it starts from a real object. It is trying, rather, to express how the painter felt as he looked at a thing, a person, or a scene. We all have these feelings, but we are not all inclined, or inwardly ready, to bring them to expression. Let us consider a few examples, which can, of course, elucidate

Klee, Human Weakness. Example of an illustration of an abstract conception which can yet be objectively comprehended

Gontscharowa, The Cats. This picture was clearly based on blinking cats' eyes

only the author's own sensations. It is certain that other people will feel quite differently, and it is precisely this difference or even opposition of sensations, natural among different people which explains why an abstract representation can never be generally understood.

If the author recites the days of the week he sees Sunday as orange-red, Monday as gray-blue, Tuesday as dark yellow, Wednesday white with gray shadows, Thursday violet, Friday gray-green, and Saturday a brassy yellow. He also see colors in numbers: one is white with gray, two is light yellow, three is blue, four is brown, five is light red, six light gray, seven orange, eight blue-green, nine red-brown, and zero is light blue. Combined numbers have yet other colors.

In these examples, which could be extended to include letters and even verbal concepts of feeling, the author reaches an abstraction only through color, and this seems natural: where there is abstract form or a concept which cannot be attached to a form, the abstraction can be expressed only in color. What awakens a sensation in these examples has already been formally abstracted. Numbers and letters consist of lines, and the line itself is, in drawing and painting and even in geometry, the abstraction of a surface. Where something is already abstract it cannot be abstracted further. How much the line is already an abstraction can be proved thus: there is no object which consists only of lines; it would have no substance. Objects are made up of surfaces, and

Jenkins, Solstice

Shinoda, Sorrow

surfaces in pictures are abstractions of the solid forms of which the whole universe consists.

Every artificially created form is an abstraction: a bottle, for example, but not a gourd or a pear. These latter growths clearly assume their form according to an ideal which could be expressed in universal terms by the outline of a white wine or champagne bottle. The formula for all these natural forms (let us refer to what was said at the beginning about aiding drawing from memory by using basic shapes) is, on a surface, a simple, symmetrical figure, described by continuous curves or straight lines, like the oval, parabola, or unequal triangle. Multiple symmetrical forms, like the circle, ellipse, or equilateral triangle, occur less often in the larger works of nature but are more frequent in flowers, fruit, or smaller, almost microscopic things.

Every pictorial representation has always to deal with two problems of abstraction, one of color and one of form. Even color by itself must have some form definition or it could not be seen. All abstractions must ultimately be dominated by form and color as their means of expression.

Suppose we hear, or say to ourselves, words like "tram" or "nude" or "winter morning." The very sounds of the words, or the sight of them if we are reading, evokes something pictorial. It usually derives from something remembered, sometimes from something dreamed. If we set about painting or drawing this pictorial impression the immediate memory fades. Then we begin to think: "What was it like?" or "What belongs to it?

What is the **essence** of a winter morning? Which winter morning?" This is not what is wanted here! As soon as we think and draw we seek the whole impression, the whole form of the object. With practice we can learn to fix the first idea without trying to complete it. This will produce something of the same effect we find in many of Picasso's pictures, an assemblage of fragments. Perhaps we first see a tram's buffer, the yellow of the seat, the knee of a passenger, the number plate on the outside, rails between paving stones. If we depict this assemblage it is still no abstraction; it is a stage towards it, in that we have learned to concentrate on what the memory unconsciously has retained from the whole. But abstraction also means selection.

We can look at it like this: we go a step further with our instant reaction to the word "tram" and retain only the colors; then, since the colors must have a shape, we put them down as square patches. We have continued our selection of impressions by eliminating all but the colors seen, which, although reduced to unmodulated patches, still have a relation to the objects. Blue and yellow can be expressed only by blue and yellow colors. If we were to put red, say, for yellow, and brown for blue, it would no longer be an abstraction, but just insanity.

If we study the reproduction of Klee's **Resonance of Southern Flora**, it is clear (with help from the title) that he made a selection on the basis of color, until nothing further could be transposed. The individual forms of the vegetation, unessential to the general impression, have been abstracted into a scheme of squares.

Let us imagine an ordinary brown enamelled milk jug. Milk is poured in and out of it. The milk flows into it in a line, spreads over the bottom of the jug, rises up and splashes out of the spout at the top. This we are doing, let us say, in a green tiled kitchen. We see the colors of the milk: yellowish and bluish. All this we see together at once, but this vision, although deriving from a natural-

Quentin, Composition. Example of a representational character often met with today

istic scene, is as illogical as the colors of numbers. It is this illogical, but clearly sensed "seeing" that we reproduce in a picture.

In this example the author confined himself to noting down what he "saw" with his eyes closed. He named the colors of the natural surroundings in order to show how much had vanished in his interior sight, although what remains is in accord with the color seen with the open eye. It is possible to give here an impression of the process in time, which can never be done in an objective picture. A single picture can give what a filmstrip has to render in a series; here the author gave the idea of a milk jug with a linear representation. There are many other possibilities for the student to try!

The Milk Jug

The impression could be reproduced, for instance, by color alone, without any clear, formal outline, for liquid has no definable shape, but depends on other factors: falling through the air it takes on a drop shape; on a surface it spreads out as far as its consistency and the nature of the surface allow; in a vessel it takes the shape of the hollow. The idea of milk can be expressed in color in any of these shapes, since it can take any of them. "Milk jug," on the other hand, is something different, for its form, color, and use are inseparable from it.

This simple example has been chosen deliberately to give an idea of the process involved in an abstraction. We also started out from an object, a tangible material, for how would it be possible to explain how to arrive at an abstraction taking as an example something like the working out of the concept "medieval poetry"? However, even a series of words only half understood (unless by chance our student is versed in Anglo-Saxon or Norman French) can leave an impression of shapes or colors. That, however, is an entirely subjective affair, **tot homines**. . . .

The second example begins with quite an ordinary acoustical experience, independent of any external natural forms or color impressions: rain falling on a roof at night. The author had here no need to investigate his "vision"; it came to him repeatedly on its own, and he noted it down as something valid only to himself which might one day be worked up into something.

We may read in the catalogue of an exhibition the titles **Solitary Walk** or **Sorrow** and wonder where the walk took

Rain at Night

things or the soul of something living the method is always the same: he must immerse himself in it until he feels something special about it, and then try to reproduce this feeling pictorially for others. The germ of it is in each one of us, but our training and upbringing does not direct most of us to function in this way. Two forms of art, music and dance, have always existed to prove that there are spiritual feelings in us to be expressed. We do not, of course, refer here to the infrequent naturalistic forms of these arts which imitate natural sounds or daily activities. Even with these it has never been attempted to identify specific emotions with definite scales or gestures and movements, except in the teaching of eurythmics, which has the admirable idea of expressing in dance emotions and musical sensations, words and sounds. In actual practice, however, this gets reduced to a sort of representational dumb language which can be understood perfectly objectively and is over-intellectualized.

The longer one considers the nature of abstraction and of abstract art the more one becomes convinced that it is the highest form of art. On the other hand, it offers every charlatan unimaginable prospects of success. There is the story of the unsuccessful painter who framed the portion of his friend's skirt where she had sat on his palette and called it **Chance**; he won first prize at an exhibition with his "painting." This story is far from abstract. Even today it can be successfully realized. The disadvantage of abstract art is that no one can recognize whether an inner necessity and

place, what kind of sorrow it was, or whether it was just sorrowing in itself. We cannot know, but sometimes there is someone who can feel himself into it and find a related experience. Or the picture may simply be called **No. 76.** We are left to find something in it that speaks to us, or not, and it is no matter whether what we feel is at all related to the experience or feelings of the painter. A true abstraction can come only from meditation, from a state of deep sinking into oneself. It is rather a listening inwards or, better, looking inwards to the color or formal reflection of an experience which was once linked with a person, a landscape, or the exterior and function of an object. All these things, it is often said, have a soul; at least we use this same metaphysical concept for what we cannot explain in "dead" things. If someone wishes to represent pictorially the individualities of

a genuine experience led to the abstract picture, or an intentional or playful invention. Judgment is rendered more difficult because there is no need of any technical, professional proficiency to produce an abstract painting or drawing. Even a child can make curves, hooks, stripes, and geometric figures.

We have not yet developed an eye for sifting the wheat from the chaff in abstract art. This situation is not new in the arts. For centuries the art of primitive peoples was a closed book, an art that, in fact, has many abstract features. Today it is appreciated even by the man in the street, who has no interest in artistic problems. He may not be able to say clever things about it (thank goodness, one may say), but he may have a genuine love of these things. This may one day be true with abstract art.

Efforts to come to grips with abstract art are often hopelessly misdirected, however, and have created great confusion in art schools. It even happens that very "modern" teachers categorically forbid any tackling of objective form. These teachers, who may well be thoroughly serious artists, might as well ask someone to describe the atmosphere inside a great building while forbidding him to enter it. Starting from objective reality, we can only get inside it from the outside, or, more concretely, no one can interpret the spiritual content of a form and its color unless he has really studied it. Perhaps Goethe spoke the most tellingly about penetrating into the nature of things: "Nothing is inside, nothing is outside, for what is within is without."

Of course, it is not necessary to plague students until they are unconscious (in the truest sense) from exercises in copying flower pots or muscles to a photographic accuracy. What is at first just play with colors and invented shapes is equally important and can lead to new and great visual ideas, but these ideas can be fulfilled only with concrete formal structure. Teaching which includes this freedom leaves the field open to the most complete abstraction but does not lose its firm basis, which must always be in the external forms of things, about which no misunderstandings are possible.

If the student has studied the preceding chapters carefully and practiced faithfully, he will be able to produce a competent drawing. He now knows about the materials he needs and the formal problems that beset him as a draftsman and as a painter. It would require a lifetime and more to penetrate fully the structure and significance of all the forms in nature, but by now he has mastered some branches of this study and is able to learn the rest as special occasion demands. Yet even what we think we have mastered continues to pose new problems with the years. To take an example: even when the student has an exact knowledge of human surface anatomy, he will find himself gradually, or sometimes suddenly, seeing the forms he knows well in quite a different light. He discovers that he is no longer concerned with anatomically correct form alone; on the contrary, thanks to his knowledge, he may feel free to ignore it deliberately without committing any gross errors. With this freedom, he can now concern himself only with the over-all gesture, which, in certain circumstances, can best be expressed by the flow of lines rather than a precise rendering of the contours. The latter method only weakens his expressive powers. We have already referred to this practice—in life drawing by emphasizing the over-all rhythm, in portraits and caricatures by showing how only a few lines can capture an expression or mood. The objective forms of animals, landscape, architecture, and still life can also be treated in the same way. But the artist must know where to look for the central structural problem of every natural form and be able to draw it exactly as the need arises.

If the artist knows what is essential to master and has a general idea of the most important problems in other fields and subjects, he can then work according to a plan; he will not just sketch at random but will make studies. In other words, he will pursue a definite purpose in his drawing. The sketch is simply a note or memorandum, either of an object seen or of an idea that the artist wishes to remember. A study, however, has a definite aim in view: the fixing of some aspect of a subject required to carry out the idea suggested by the sketch. While the sketch is generally a quick view of the whole, the study is systematic work on a detail that needs mastering. One must always keep the details in mind in order to have a definite view of the whole picture.

The artist should never be in doubt as to whether he is making a sketch or a study. The sketch is always rapid and suggestive and leaves plenty of play for the imagination—that is its charm and its value. The study, on the other hand, sets a limit to the imagination by thoroughly investigating the subject.

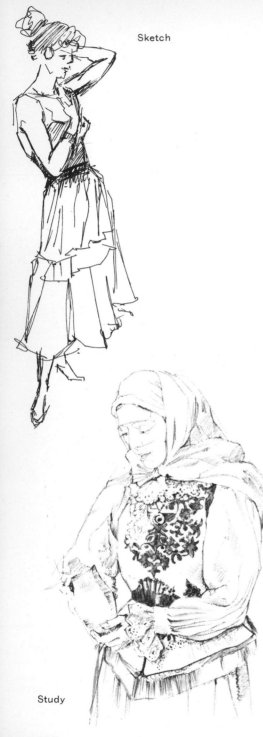

Sketch

Study

We will now take a single example of how to approach a drawing with a very limited and definite purpose. Our model is a color photograph, which must serve here as a substitute for direct nature. We will imagine that we are in Engadin and that we see the chapel on a low hill surrounded by mountains. Why we choose to make something of this particular spot we leave to the reader's imagination. Our task, however, is to make the chapel recognizable, to draw its portrait. Any distortion of what we see must be used only to emphasize the essential features of the subject.

Of the many possibilities available we shall select three: an illustration of a story, a reminder of an occasion, and an outline drawing which contents itself with the external formal structure, its rhythm, accent, harmony, and dissonance. The drawing is to be black and white. A color photograph is chosen as a substitute for nature because natural models are always colored. A black and white photograph would already have translated the subject into values of black, white, and gray, and this is one of the problems we are to solve for ourselves.

We do not begin with a sketch but with a study. The aim is first to render the subject almost photographically. There are two reasons for this: working this way we make our first acquaintance with the given forms and learn to know them individually; also such a sketch will provide us with an exact note in the event, when we return home, we should wish to recreate something of our experience, reproducing it as it appeared to us without having to rely heavily on memory. The comparison between the

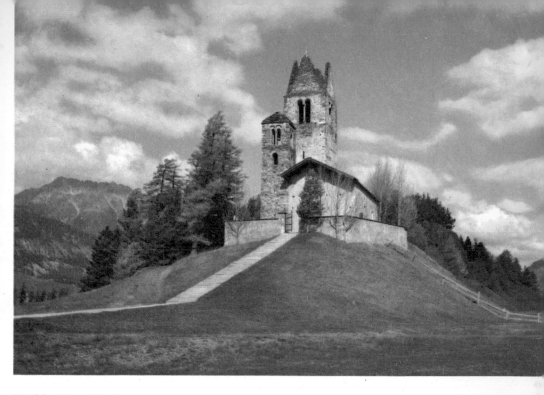

Motif for the set task

exact copy—the study—and the picture that we carry in our inner eye teaches us clearly what we can enhance or leave out. The alternative method would be to walk often by the subject and then to work only at home from memory. Nowadays, this is rarely possible.

As soon as we decide to draw a subject, we must determine how much of the surrounding area we wish to include. We can do this by shielding off what distracts us with our hands or by using a viewing frame, which is often a help to beginners. We quickly make our first decision, whether the shape will be a horizontal or vertical rectangle, or a square. It must include everything we think essential, not only the main object but all the accessories indicating place, position, space, and mood. We are not bound like the camera to a mechanical reproduction. We can crowd our motif or expand it, put in what is not there and leave distracting elements out. All of these considerations will influence the choice of format.

We are stimulated to draw this particular view largely because of the group of buildings, whose main attraction is their position on a hill among mountains. The left-hand group of trees seems rather fortuitous, but to leave it out would take away much of the charm of the view; moreover, the trees express an important movement toward the main subject.

The cast shadows show that it is a sunny day. If we wished to indicate that it were an autumnal landscape as well, we should have to use color or emphasize some accessories: for instance, half

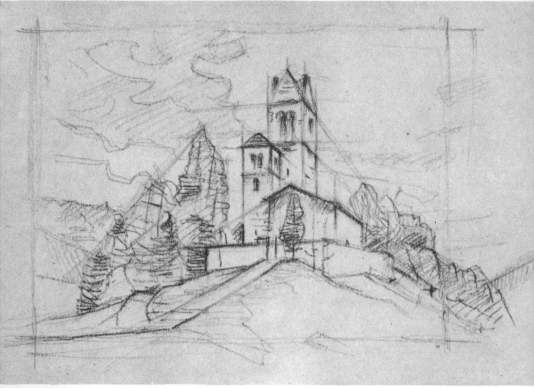

First study

or completely bare trees beside leafy ones. But since color is not available and more trees would greatly alter the aspect of the view, we will ignore the season.

In the background, the left-hand mountain mass gives the character of the location. On the right, enough of the surroundings should be included to show that the chapel is not standing on an isolated hill top. Below, there must be enough space to show that the steps do not continue downwards indefinitely. A patch of sky above the top of the tower will indicate the breadth of the landscape. All of these considerations bring

us to a slightly elongated square as our format.

Now we take pencil and paper. The paper should be large enough not to limit our intended format, especially as there is no stongly outlined area to dictate it. To have plenty of paper space affects also our method of seeing and working. It is best to begin with the group of buildings, leaving enough space all around to allow us to adjust the scope of the picture after we have rapidly sketched in the surroundings.

We begin with the vertical lines of the towers and chapel walls. The width of the left-hand tower can then serve as

a point of comparison for the various heights. We mark off this width by adjusting the distance of our thumb from the point of a pencil held toward the subject at arm's length. We can then determine how many width units make up the whole height of the building and how other elements, such as the bottom of the steps, the top edge of the breastwork of the wall, and the cornice lines of the towers, can be fixed against it. Once the width and height relation is secure, we fix the most important horizontal and vertical outlines with firmer lines. Putting in the window openings and some dark stones in the walls provides a further check on over-all proportions.

Next come the diagonals. The most insistent are those of the hillside, the steps, and the chapel roof. We hold the paper at arm's length, and gauging the slopes by sloping the extended pencil, we draw them in. The position of the right-hand vanishing point for the frontage of the building is found in the same way. The left-hand one is so far out to the left that we content ourselves with judging the slopes on the left. After this it is easy to find the correct angle for the slope of the tops of the towers and articulations of the walls. Another important diagonal leads to the highest tower along the tops of the left-hand group of trees. The main tree tops we already marked in at the beginning as vertical accents. Now they become the

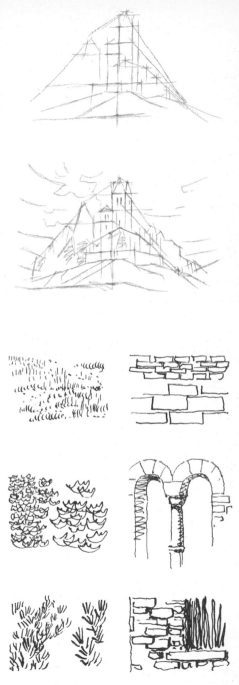

Above: First and second stages of study shown on left
Below: Attempts to delineate grass, masonry, and foliage; detailed study of window arches and breastwork

205

starting point for further lines of contact which outline the spaces between the trees.

We finish the play of lines with an allusion to the left-hand mountains, the outline of the surrounding walls to the right, and the background behind them. There could also be an indication of the lay of the clouds; often the direction and shape of clouds as they are blown by the wind is characteristic of a landscape.

A light diagonal hatching might tone in the building and the most important dark places, and a few last strokes can show the rough textures in the grass and the areas where details will be needed in the tree and mountain masses.

All this will have taken only a few moments. Now we must study our work from a distance and compare it with the original. We may, perhaps, make a correction or two with a heavier line and compare the drawing again with the landscape, this time through the viewing frame. Then, we finally decide where to cut off the picture with a penciled frame.

If the lines have been soft enough, the study can be given some sort of rounding off with stronger lines, behind

An essay in composition

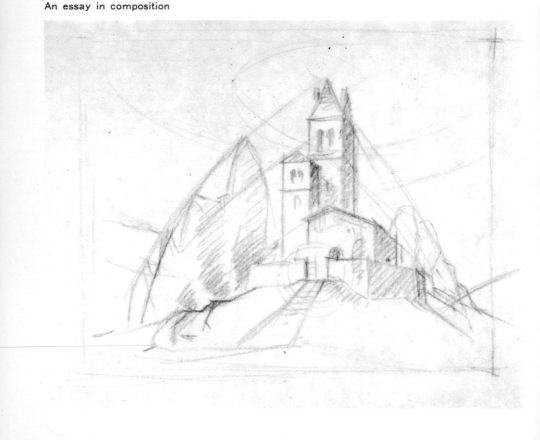

which the network of tentative strokes almost disappears. We now have before us an uncritical note. The closer it has come to the correct proportions, the better it is. If our practice and experience are adequate and the drawing large enough, we can now consider our preliminary work as done and go home with our study to work our information into the various final forms that will already have suggested themselves to us. Our aim should always be to keep the whole in mind and not get lost in detail too soon. A picture should grow altogether like a plant or a tree, so that whenever we stop work we should have reached some stage of completion.

When making this uncritical copy of the subject, we are certain here and there to have felt that something, either a detail or a more general area, seemed "awkward." The further we go with the drawing the clearer it becomes, until we gradually see how to enhance the character of the whole without giving it completely different features. In the final check to compare the model with the study, the viewing frame alone will show that we have made some unconscious exaggerations. Generally this is seen mainly in

Preliminary pen and wash drawing

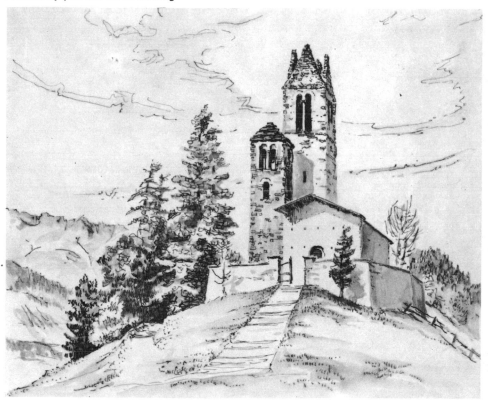

the diagonals: the steep ones made too steep, the flatter ones too flat. This subjective and unintentional distortion is the beginning of real artistic creation. The next step is deliberate distortion or alteration, and a critical analysis of the original "copy," which leads to a creative composition.

Again we take a sheet of paper which allows plenty of free space. The reduction of a colored landscape into a structure of lines and light and dark masses is made much simpler if we first find the focal point, the center of gravity of the picture. In our example it is concentrated on the entrance to the surrounding wall, where the top of the hill is centered; all the main lines and movements lead to it: the verticals of the towers, the outlines of the areas of grass, and the steps. Even the far lines of the mountains and sky curve towards this point or bend in its direction. The walls of the building stand over it like a resting pyramid, towards which the slope of the pyramids of trees moves with a rising rhythm.

If we play about with this idea using the softest possible strokes, we shall soon see how to enhance the general impression; for example, the hill could be made steeper, simply by taking a more frontal view of the steps. This means moving our viewpoint a little to the left. The logical consequence of this is useful: the right sides of the buildings are more foreshortened by the move, and the right-hand vanishing point comes further to the left, towards the center of gravity of the picture. We know from our study of central perspective that the center of gravity has the strongest effect when it coincides with one of the vanishing

points. This is not the case here, but the points are close enough for the beholder's eye to be stimulated by the possibility of bringing them together. If we continue a line upwards from the tops of the trees on the left, it will nearly touch the highest point of the tower. This is right for the composition only if the buildings and trees are to be seen as a whole. But our task is to stress the buildings alone; the trees are to be included only as a foil to the main theme. This should be emphasized by making the line of tree tops at the left steeper, and, thus, the last tree taller, and letting the line fall down steeply to the right over the highest tree top. This gives a stronger rising rhythm up to the pyramid of buildings. Nothing is altered in the character of the picture by doing this; it is merely clarified.

The same is true if we alter the incidence of light so that the right-hand side of the buildings is in shadow. This might well have been the case, for this alteration does not contradict the natural course of the sun. The shadows added by this change will decidedly enhance the impact of the picture by emphasizing the main subject, the buildings. The main movement rising up from the left is nicely terminated by the vertical shadows of various shapes and sizes which repeat the general rhythm of rise and fall in the picture and offer a slight counter movement to the strong upward thrust from the left. Both movements meet more or less at a point that could be joined in a rising line with the center of gravity and the vanishing point of the right-hand side of the buildings. Concentrating around the center of the picture's gravity, the movements and tensions gradually support each other and lead to a static

Black pastel on glossy paper. Mural study

rest, without which the composition would seem uncomfortable and unbalanced.

At this point in our work we again look at the drawing through the viewing frame to test the balance of the picture. One small detail: the fir tree to the right of the entrance in the wall hides the door into the chapel. Either the tree can be left out altogether, or it can be moved to the right to show the door, which will further emphasize the center of gravity of the picture.

Now the composition is finished, and we have to decide what we intend to do with our work.

To proceed further, we trace the outlines of the composition onto a new sheet. In this way we isolate the skeleton of the picture and turn to the representation of the materials of which it is composed. We have masonry, with tiles and ashlar, curling beech leaves, soaring conifers; the hill is covered with a prickly coat of short grass, and the far-off mountain range must be given its crevices and

The Drawing

Contour study

strips of woodland. Clouds can be made with a play of fine lines, and a horizontal texture sparkles up from the stairway. We cover our new page gradually with a mass of surface textures without worrying about the general effect, but determining with sketch and study how to convey the separate details.

This may be thought rather pedantic, but it is fruitful: anything studied is a permanent gain, and it is dangerous to try to find imaginative short cuts before we understand the full story.

Until now we have used only part of our drawing sheet, so that our composition would not be constricted and we would be free to put our final frame where we thought best. Now that the composition is settled, we shall work right to the edges, using the whole area of our paper. If we are not content with calculating the rest from a few important measurements, we can use the squaring-up process to transfer our drawing to a bigger scale. We shall do our final ver-

sion in ink; so we can draw in first with a sharp, soft pencil, which can later be erased. If our first drawing is small enough, it is convenient to use the lucida to enlarge it. If the format is not very large, it is a good idea to draw with water-soluble ink, so that the shadows and other dark areas can be graded with a wash. Too many textures on a small drawing make it heavy, and broad shading with charcoal or chalk would only produce an indefinable smear.

The technique of a wash needs both care and a fluid hand. It lightens the strokes which have been gone over with the wet brush without letting them run. The process can be repeated several times until we have achieved the desired depth of shading or, if we are clumsy, until we are faced with a patchwork of black blurs. Even then all is not lost: damp blotting paper can lighten the color considerably. It is best to remember the adage, "When it tastes best, stop eating."

Our picture now shows very little evidence of our toil and tears. It will also have very little of the charm of spontaneity. This is not to be expected when we have worked stolidly at our subject as an exercise from start to finish. Yet dull, worthy drawings of this kind were produced by even the greatest masters. It may well be that someone will see the drawing and find it neither particularly attractive, nor exciting, but there will surely be someone to say, "Well, I couldn't do it. I can't even draw a straight line."

Yes, the **line!** It lies at the beginning of all drawing and it remains its substance. We can all go on learning how

to use it better and more ably. First we struggled with a complete outline. Then we learned from sketching that there is more charm in an incomplete line. Now we leave out the line altogether around the large masses and let it be suggested by the mosaic of their textures; and even that is not required right to the edges of every surface. We know that the eye prefers to finish things off for itself; it is sufficient to start it off and support it here and there. The more we leave out, the better. In this way we reach back gradually to the picture plane, especially if we have some excuse to do without a window-like frame: drawing on a wall, for instance, or illustrating a book. A framing line would make a mural or book illustration unbearably rigid, cutting it off from the room or text. At any rate it seems so today. Perhaps we feel

this because human development, deliberately or unconsciously, is reaching out in every way, into every sphere, to extend space. The incentive to make this drawing came partly from the graphic interest of constructing the outlines. Let us therefore see what happens to the appearance of a picture if we do without any indication of material. This experiment means a new study, not this time to learn about the object, but to see how else to make a picture from it. Many painters close to the Impressionist school drew outline compositions (generally in blue) as a scaffold for their color surfaces. An example of this style is the picture by Gilman (p. 320).

16. SGRAFFITO, MOSAICS AND BATIK

Graphic art includes the techniques of sgraffito, mosaic, and batik. They are all three based on clear drawing. If color is used, it is in sharply defined areas without tonal gradations; the painter's way of merging and overrunning colors is technically impossible.

Each technique derives its particular charm from the effect of the material and the method of working it. In sgraffito it is wall plaster, in mosaic the small colored stones, or tesserae, in batik the cloth, generally real silk. Each of these materials has a pronounced texture which defines the picture plane strongly and, with sgraffito and mosaic, combines the design with the architecture. The **raison d'être** of both techniques is to decorate a wall, and batik, too, achieves its full effect only as a wall hanging.

All three techniques will succeed with anyone who can express a graphic idea clearly and simply on paper. These crafts can easily be learned and do not need much practice—much less than professional engraving or wood carving. Sgraffito and mosaic will, however, require the help of an experienced builder with the preparation of the plaster work. Useful hints can be picked up from watching his work, which may not be familiar from an acquaintance with only finished plaster. Batik, on the other hand, is a domestic occupation. The craft is easily learned if one knows a little about ironing and follows the simple directions for the use of cold dyes.

All three techniques require the design to be well thought out in advance. It is pointless to set to work with only a vague idea of what it should look like. Both design and procedure must be well planned.

Sgraffito

Sgraffito means "scored" or "scratched." The Italian term is always used in English.

The wall is prepared for sgraffito by giving it two or more coats of different colored plaster. The upper coat is either cut away to the shape of the design, or the design is scored out in line drawing which then shows up in the color of the under layer. The process can be easily understood by smearing a slate or other dark ground with a chalk paste (without a binder) and, after it has dried, drawing into the white surface with a metal or wooden point; this scrapes away the white, leaving a dark line. The earliest sgraffito designs were made in this way: the wall was first rendered with a coat of mortar mixed with soot, and this was then masked with a layer of whitewash. The design was scored into the white with a metal or wooden stylus. At first this procedure was practiced only by ordinary builders for simple ornamental decoration or imitations of stone blocks.

The first sgraffito design of any artistic

value dates from the thirteenth century and is in the cloisters of Magdeburg cathedral. Strictly speaking, it is only a drawing scratched into the plaster while it was soft, and presumably afterwards colored with a brush, since it would not otherwise have been visible unless seen with side lighting to throw shadows. Today only a few traces of color remain. This attractive sgraffito medium is no longer used, but it would be worthwhile reviving its practice.

Sgraffito into lime wash over mortar mixed with soot was used to greatest effect during the Renaissance. Bohemia has the largest number of examples. Prints and engravings by famous artists were the most popular models. Enlarged on walls to monumental proportions, they look like rough pen and ink drawings. In the same period artists hit upon the idea of using calcareous earth pigments instead of soot to color the mortar, covering it with a thin coat of plaster in a contrasting color instead of the lime wash. It is difficult to make close hatching in plaster, so shadows and dark areas were cut out in solid pieces. The thickness of the top layer made the edges of all scorings and cut-out areas stand out in relief. This technique was at first used almost exclusively for the ornamental decoration of paneling, but it is now commonly used in all sgraffito work. The reader will be able later to judge to what extent it is worth his aiming at a professional standard in the mastery of this technique and how artistically rewarding it can be. To form an idea of the technique, the student must at least have a theoretical understanding of the composition of wall renderings and the

Sgraffito tools: 2 spatulas, screwdriver, 2 wire loops, stylus, scraper (side and front view)

4-color sgraffito: dark green, red and blue plaster, a lime-washed sgraffito ground. Stage 1: Cutting through the drawing previously traced, scraping away the lime wash to the furthermost contour lines except where already cut deep. Stage 2: Provisional elaboration of the picture,

use of mortar or plaster as a wall covering. Its manufacture and application is, of course, the work of an experienced builder, but some acquaintance with the builder's work when he prepares the wall for an artist will give the beginner confidence, and make him feel less of an amateur.

Every mortar is a combination of three materials: sand, water, and a binding element. Lime, cement, or a mixture of both, serves as the binder, the choice depending entirely on the function of the rendering, which also determines the choice of the sand. Whatever its granulation, sand must be sharp and free of earth. Plaster, a harder preparation for

the top coat and containing more lime, is also a general term used for any wall coating.

The lime is obtained by heating broken-up limestone, such as marble, until it is red hot, and thus allowing the carbonic acid and water of crystallization to escape. When the burnt limestone is then brought into contact with water it generates great heat and forms a creamy paste which hardens immediately upon absorbing sufficient carbonic acid from the air. It never becomes as hard as the original limestone, however, and needs the addition of sand and grit to make it firm.

Cement is made in much the same way

working from top to bottom. The tools drawn in transparently are to be imagined vertical or at an angle of 30 degrees to the plaster surface

as lime, but clay, dross from smelting furnaces, and other materials are added in the heating; the product is then finely ground. Cement does not need carbonic acid from the air to harden it; it can set in an airless environment—under water, for instance. It is always harder than lime. If greater firmness is required, or there is likely to be insufficient air, cement is added to lime mortar, or replaces the lime entirely.

Besides making it harder, the additional material forms the main body of the mortar. The proportions vary between 1:5 and 1:3, the higher number being the sand content in relation to lime or cement, both measured dry.

"Fat" plaster has a lower sand content. In plastering a wall, the same principle applies as in oil painting: always put fat over thin, never the other way around. Water is added to give the right consistency. It does not require any special measuring, but plaster will not adhere to a wall if it is too wet. However, excess water evaporates. The mixture is too friable to take at all if it is not wet enough.

Even if he leaves all the plastering to the builder, the student must himself execute the actual work of scoring and carving. The plasterer would work in sgraffito with the same precision he has been trained to for cornices and mouldings;

215

The completed work

his training in the use of level and float would produce the same effect as a portrait drawn with ruler and compass. Even if at first the strange position close to the wall on a scaffold makes the student lose his sense of the vertical, and he has to use plummet and spirit level, he should put them aside after the first sketching in of the design. The cutting tools must be used freehand, except, perhaps, for work on large lettering.

A good outdoor wall plaster is composed basically of three layers. The first coat seals up any joints, cracks or seams in the wall and makes a rough but even surface, to which the second, finer coat can be keyed. The top coat forms a permanent texture and gives the wall the desired color. For sgraffito the colored layer is put in either as the second (middle) coat or as an extra coat above it. As each color requires a separate coat, it is technically impossible to do sgraffito in anything but a limited color scheme. If plaster is applied too thick to a wall it does not hold securely; it falls off of its own weight whenever frost or mechanical causes give it a chance. Polychrome designs are thus better carried out in a modified form of sgraffito, called plaster intarsia.

Sgraffito can be worked only while the plaster is soft enough to be easily cut and scored. If it has hardened so that it can be cut only with a mason's chisel and hammer, it makes lighter patches and the whole work will look faulty. The carving has to be done rapidly; there is no time to reconsider the design. Plaster is rarely in a condition suitable for sgraffito tools for longer than 24 hours, and then **only** if the under layer was well dampened before the application of the top coat, and the weather is dull or a screen of damp cloths protects the working surface from the sun. Hence, all preparation must be done beforehand so that the artist can concentrate on the technical execution of his design as soon as the top coat of plaster has been applied.

Like all work which is planned for a purpose, a sgraffito design begins with a preliminary sketch, which is gradually worked up into a working drawing. The technical demands of the medium dictate the first translation of the purely artistic idea into a suitable style. Besides using very definite lines and surfaces of uniform color, the shapes in the composition must be suitable for execution with a stylus and cutting spatula. Austere and angular drawing without much detail is the most effective, whether the work is done in the classical black and white or uses several colors. The cutting technique of sgraffito is best approached by making a cartoon from the first sketch, not with pencil or brush, but by building up the design from cut-out shapes of colored paper. This procedure is very useful for every kind of graphic decoration and will be dealt with more fully when we draft our batik design.

It is difficult to work out a well-balanced composition without fitting the sketched idea as soon as possible into a scale drawing of the whole facade. The scale may be chosen, according to the size of the proposed work, between 1:20, 1:10 and 1:5. The larger the proportion, the easier it will be to transfer the design to full size.

If several colors are used, it should be borne in mind that the strictness of the form makes each color much more insistent than in a painting. If a fresco on a facade were to be changed into a sgraffito, or a plaster intarsia, in as many colors, it could be done only by reducing many of the gradations and mergings, or overrunnings of tone, into one distinct color. This color would then stand out independently in its own right. To find a harmonious effect that does not break up the whole unity of the facade requires a thorough study of color problems, particularly as we are further restricted by the fact that many colors are not compatible with lime (see section on Painting).

To begin with, we are confined to a basis of one color, that of the top layer of plaster. In two-color sgraffito (a monochrome would be a colorless plaster-cut) the essential effect is the contrast with the top layer of plaster; in polychrome the combined effect of all the colors forms the contrast with the top coat. By attempting otherwise we risk the possibility of one predominant color destroying the unity of the design, unless the main color be used pervasively and more lineally.

It may be more enjoyable to color the sgraffito plaster oneself than to buy it ready-colored; however, ready-made

colored plaster saves trouble and is guaranteed durable. It can be chosen from a color card to a specified granulation and comes ready for the plasterer to add water and apply it. Buying ready-made plaster is considerably cheaper than preparing it oneself because one does not have at hand supplies of the various sands needed to give the plaster its basic color. It is easy to make a stronger color by adding a small amount of pigment, but good pigments are expensive and it takes a large amount to color white plaster. Pigment also works like earth in the plaster and in large quantities reduces the binding effect of lime and cement. Furthermore, a lot of drying tests will be needed, since damp plaster is always much darker and more strongly colored than dry.

Sgraffito coats are always applied so that the darkest layer is lowest and the brightest color is on top. Over it all comes the finishing coat that covers the whole building. It is tempting to apply very thick layers in order to obtain as plastic an effect as possible with strong shadow outlines. This may look well at first, but the process soon becomes tedious, quite apart from the fact that deep cutting endangers the permanency of the work and destroys the formal unity of the design. In the long run a sgraffito worked in thin coats is more effective and professional looking than one which looks like an appliqué of fretwork.

The general effect depends on a good texture for the top layer of plaster. The sgraffito coats are better made of a fine plaster with little texture effect. The coat must be applied according to the size of granulation and should be about double the thickness of the largest grain. Coarse granulation is thus possible only if there is to be no more than a single sgraffito layer. If the top layer of plaster is coarse, it is difficult to make subtle outlines; they will crumble, which looks unpleasant unless the design is done in very heavy drawing.

This consideration must be weighed against our desire for a coarse texture to stress the picture plane. It is particularly important in sgraffito to keep the design flat, as it must form part of the whole building. The sense of depth must embrace the whole architectural unit, not just the surfaces surrounding the design, and effects of perspective are totally out of place. At most, perspective should be confined to a simple arrangement of individual elements one behind the other as in a stage set, for which Egyptian wall paintings give the classical example.

There are three types of finish: one is

3-color sgraffito on the house of an employee at a large textile concern

rubbed flat with a float or felt, one is scraped, and one is thrown on. The strongest and most naturally varied texture is obtained with a float finish, mixing largish round pebbles into a relatively fine plaster. The pebbles make grooves and ridges and then fall off. It can be clearly seen how the float moved, in circles, up and down or horizontally.

The texture of scraped plaster is dependent entirely on the size of granulation. When the plaster is applied it is smoothed flat and then, when set hard, nearly scraped with a metal edge or a nailed board that works like a coarse brush. The result is uniform, without any direction in the texture, and is always darker in tone than a smoothed surface. The contrast is strong enough to be able to make a design recognizable if carried out in scraped against floated plaster.

If a finer plaster is smoothed with the trowel alone, not with a float, it falls into ridges and waves. This is certainly the most craftsmanlike of treatments. It has a mellow effect, especially on rural buildings when it is whitewashed every few years. After a time patches of earlier whitewash peel off leaving a natural looking relief patina. A two-color sgraffito looks very well in this technique, as long as the design does not get splashed with whitewash.

Thrown-on plaster, rough cast or wet dash, is the lowest grade of plastering and shows up—in contrast to a fine sgraffito layer—almost palpably for what it is, a thin skin covering the building. It is a comparatively coarse but watery plaster thrown on with a trowel, or more often squirted. It remains very rough and is rather fragile. While it is new it looks quite well, but it quickly accumulates dust.

Many cheap products have been developed in recent years to give a very smooth plaster finish. Any texture that

The light effects are obtained by leaving plaster unscraped with a smooth flat finish

Detail, taken with very oblique lighting. Top plaster is left to a depth of about $\frac{1}{10}$ inch

is put on them looks quite artificial and arbitrary. Sgraffito on these surfaces is reminiscent of an antimacassar on a plush chair.

The method of drawing out the design depends on the type of top coat. All plaster is exceedingly sensitive before it sets hard and retains indelibly any dust that falls on it or any lines used in blocking out the design. Fresco technique is, of course, based on this characteristic of plaster, but it has its dangers for sgraffito. Scraped plaster is the most convenient surface to work on. The surface is not scraped until after the work is finished, and unwanted lines and marks can be eliminated by it. What is often done is to make a full size cartoon of the outlines, lay it over the fresh plaster and press the lines through with a stylus, as for a fresco; but this is unnecessary. With sufficient experience of enlarging by squaring up, and a good feeling for the effects of engraving on a large scale, it is perfectly possible to work from a small drawing and draw directly onto the wall in freehand. It has the advantage that mistakes can be rectified at once, and sometimes an effect is very different on a wall from on paper. The freehand drawing does not lose spontaneity, as the traced one may well do.

Working on a surface which will later be scraped, it is possible to indicate the squares for enlarging onto the plaster by using string marks made with plumb line and level. If the top plaster is not to be touched afterwards, a lath frame can be hung up on hooks and a net of strong squares fixed to it. For rough cast the net must be hung on the scaffold so that it does not touch the plaster anywhere.

All the brass gravers and styluses and wire loops used by clay modelers can be used for cutting the lines and removing patches for the design, but the author has found screw drivers and spatulas of different breadths, some with sloping ends, to be more satisfactory. Lines can be begun very thin with a sharp steel screw driver and then thickened by turning the implement towards the flat side. The thickness of the line can be varied as it would be with a broad drawing nib. The outlines of the larger patches can be cut down first to just above the first sgraffito coat with a narrow, oblique spatula. They should be cut with a visible slope towards the surface. If the angle of the cut is too steep and is run along a ruler edge the effect is too metallic. All lines and outlines should be done freehand. It is better to make the patches too small at first rather than too big. It is easy enough to remove more plaster and make them bigger, but filling in is never wholly satisfactory and wastes a lot of precious time. The patches can be carefully removed with the flat of the spatula blade; generally the top layer comes away quite cleanly. Wire loops take much longer to lift out the plaster, and this is irritating because of the time factor, which makes the artist hasty and nervous. With a little practice the spatula can be used very neatly. A loop can never come cleanly to the edges and into corners, so that in any case the work will always have to be touched up with the spatula.

At first, the top coat should be removed only deep enough for the sgraffito layer to show through. Thus, one quickly gets an over-all impression of the whole

design and allows time for the freed surface to harden slowly. If the patches were scraped clean at once it would take longer to get an over-all impression of the design, and the damp under surface would get smeared, while the top coat was hardening in other places more than necessary to be worked. Thus, it is best to remove the top coat quickly all over, and then start on the final cleaning up.

The same method applies if there is more than one sgraffito layer. The whole design is first cut down to show up the first sgraffito layer. Then the surfaces that are to be in the second and subsequent colors are drawn into the first and all cut down nearly to the second. The process is continued for the third and any subsequent layers.

When all the lines and patches are cut, the plasterer will decide when it is time to scrape them clean, though in time the artist learns to judge for himself. If you use a spatula blade held perpendicular to the surface, the plaster should crumble off almost dry. If it smears it is not dry enough; the surface would form waves and too much of the colored layer would come away. No more should be scraped off than leaves the surface clean.

It is obvious that this must be done from the top downwards or dust would collect in what is already cleaned, and the lines would have to be cleared again. If the top coat is also to be scraped it should be left to the plasterer, who will do it together with the rest of the wall. Unless you are experienced, it is easy to miss patches on a large surface, which will show up lighter and spoil the whole facade. The sgraffito layers, however, should never be left to the plasterer, even for touching up, for his whole training compels him to straighten off all the edges.

The beginner can start practicing on a board. There are cemented, pressed boards made from wood pulp, which can be treated as a rendered wall. In a smaller format, it is possible without the plasterer's help to cover hardboard with a mixture of fine scouring sand, powder color, and a slow hardening gum of some sort; wallpaper paste is the best. Each coat should be about $\frac{1}{12}$ inch thick. A pocket knife serves quite well as the cutting tool, both for scoring lines and cutting out patches. The effect of this work can be rather like a mistaken "refinement" of the scraping technique, in which the finest residue of top layer is used to shade in a design on the undercoat. It is neither painterly nor graphic in effect and is entirely opposed both artistically and technically to sgraffito. The thin residue of plaster is very insecure and soon weathers away out-of-doors. It looks rather like a wall pastel, but, with its easy but pointlessly carved edges, carries none of the conviction of a pastel.

Sgraffito and plaster intarsia must be intelligently related to the character of the materials.

Following page: sgraffito design for an agricultural college. Green top plaster and reddish brown sgraffito layer. White obtained with opaque lime

Mosaics

Mosaic is technically a more expressive medium than sgraffito. The number of colors used is not limited, nor is it any more difficult to produce a work in polychrome than in black and white. Only the preparation of the design and full-size cartoon take longer with many colors than with few.

The strength of a mosaic is not affected by the number of colors, nor does it reduce the graphic effect. The network of divisions between the colored stones always looks like a drawn texture enclosing each small fleck of color. If this were not so, mosaic could become a painting with the softest transitions of color.

Classical mosaic is made from colored tesserae all of the same size, between $\frac{1}{3}$ and $\frac{3}{4}$ of an inch square. Only occasionally, for lines running to a point or very curved, are the small squares sloped off or split. As a rule, a variation in the width of the joins serves instead; it does not matter how the joins run.

The work begins by giving the wall a first coat of coarse plaster. This must be absolutely flat, but should not be too smooth, as it must give a good grip to the next coat. Into this upper layer of plaster, while soft, the tesserae are pressed. Unless it is quite flat the surface of the mosaic will be uneven. Its thickness depends on whether the tesserae are all of the same thickness or not. If they are uniform the bedding layer can be thinner than if it has to even out differences of thickness so that the mosaic surface remains flat. The average thickness of mosaic, bedding layer and undercoat together, comes to about $\frac{2}{3}$ of an inch. The plaster must be rather fat and very fine so that the tesserae can be pushed into it easily and lie as close as possible to each other. Only very fine plaster can press up into the narrow cracks and hold the tesserae fast. The cracks average about $\frac{1}{16}$ of an inch if the edges of the mosaic stones are parallel. Very little plaster comes up into the cracks from underneath; after the mosaic surface is complete it is washed over with fine watery plaster. The attractive textured effect of the joins between the stones comes from the slight projection of each individual stone, and this is achieved by brushing away the plaster applied from above for about $\frac{1}{12}$ inch down into the cracks, a process which cleans up the surface of the stones as well.

Mosaic is most attractive when each stone is fixed directly into the wall, showing the natural irregularities of work done by hand, as was done in the past, as long as 2,000 years ago. Recently various methods have been evolved which enable larger sections to be composed in the workshop and then applied to the wall. These all produce a very smooth and close-packed surface which is technically perfect, but which loses much aesthetically. The result is even more negative when the artist sends his cartoon to be carried out entirely by artisans in the workshop which supplies the tesserae. However accomplished and tasteful these artisans may be, they cannot be expected to interpret the intentions of the artist exactly.

Nor can the artist be expected to exploit all the expressive qualities of the medium unless he has practical mastery of it, which means that he must carry out most of the execution himself. It is different if the design is purely decorative in intention and needs complete technical precision for its execution, for instance a tesselated pavement which has to be absolutely flat, or over-all ornamental decoration of walls and pillars. For these purposes the workshop can provide larger and closely shaped stones which can be fixed with scarcely any space between them. This is very different from the Early Christian mosaics, whose expressive and tectonic texture is not conceived merely ornamentally. Their technical "imperfection" has much more personality than the smooth elegance of the precision work from a factory.

This "imperfection" is the same quality we required the artist to seek in sgraffito: work which bears the imprint of the artist's own hand, not the impersonal touch of the plasterer's. In mosaic it is also the constantly repeated building up of the design step by step to the final creation. No technique gives a clearer sense of finality than this composition of a picture stone by stone.

Before tackling our cartoon we must acquaint ourselves with the material. It is stimulating to play about with a collection of colored stones on a tray and arrange them in different ways and patterns. Mosaic tesserae may be artificially made from fired clay, either colored right through or glazed with color only on the top: or there are colored glass pastes which are transparent and give a radiance to the work, and some

with a layer of gold or silver leaf under glass. Many natural stones are used, cut to the right shape. Fragments of colored marble slabs and wall and flooring tiles of the right thickness are highly suitable. Even brightly colored pebbles from the seashore or the beds of streams can be used for a primitive, rather decorative style of mosaic.

The author once came upon a garden wall which was decorated with mosaics made from pebbles collected over the years. There were fishes, seagulls, wild boar and a series of other animals, an amusing record of the maker's holidays. He was entirely self-taught and had begun to collect the pebbles at random. Having decided on how to use them, he collected them more deliberately. Each year on his return from holiday he got a plasterer to cut out a space on the old wall surface about 3 x 5 feet in area and fill it in with a fresh, slightly prominent bed of plaster. He then worked from a rough drawing, pressing the stones, which he kept wet in a trough, into the plaster. The excess plaster was removed with a spoon and spatula and the stones wiped with a damp cloth. The plasterer gave a final touching up to the edges.

The stones looked very dull and pale when they dried, but once the plaster was quite dry and set they were brushed very lightly with hot linseed oil mixed with beeswax, taking care not to touch the plaster and mark it. The stones had first been heated with a blow torch so that the wax had time to penetrate the pores before setting. In a few days' time they were polished with a woolen cloth. This work had not, nor was it intended to have, any artistic pretensions; but far

and wide the plaster garden dwarfs found the taste of the neighborhood had become too good for them, and they disappeared without a trace.

There are essentially four different mosaic techniques: odd stones or broken slabs pressed into thick plaster; builder's mosaic with strings of pebbles laid in horizontal lines; the almost joinless industrial mosaic; and classical freehand mosaic. We can deduce the methods of the others from a knowledge of the classical process. When properly done they are all very durable.

Once the theme and the size of the mosaic is decided in relation to the building we start work on a sketch. It can, and, indeed, should, be very small, so that a certain monumental quality arises from enlargement alone. This is a trick that can be used to some extent in all pictorial art. Nothing is so damaging in mural work, particularly in mosaic, as to lose the broad and simple effect in a mass of detail.

The sketch should be carried out in poster colors on paper the color of the plaster, without at first taking the texture of the joins into account. When a simple colored sketch is ready we place over it a sheet of tracing paper and divide up the areas of color into squares corresponding to the size of stones which will be used. This need not be done exactly; the aim here is to get an idea of how the design will look in mosaic.

To let the idea develop properly it is best to make an intermediate drawing before the full-size cartoon, about a half or third full size, again painted in continuous colored surfaces. In parts, at least, this can be divided up into the tessera squares, using a soft pencil directly on the drawing. If we feel there is no essential correcting to be done we proceed to an exact drawing of the most important outlines on good tracing paper. This page is to be kept for reference, and no more work is done on it at present. We now take thick drawing paper and color it to match the surrounding plaster, trace on the outermost outline of the mosaic—if it is to stand free on the plaster surface, and wash inside this outline with a neutral gray waterproof color to represent the shadows of the joins. Unless waterproof, it may run when the colors of the design are put on. Onto this we trace all the outlines of the design, a process best done with white chalk.

We now need a flat hair brush, or several if possible, of a width rather less than that of a tessera. With this we paint in the tesserae as square flecks of color. The brush has to be smaller than the tesserae, as it always spreads a bit. It is safest to experiment, before starting, to find the right thickness. We then mix the basic colors, if possible again in waterproof paints, such as casein poster paint, and then fill in the tesserae, carefully but not too rigidly, fleck by fleck, as close as they will lie. In this way we have an approximate idea of what the design will look like. If necessary, corrections can be made by covering over a portion with gray and rebuilding the color structure.

This draft shows only a few uniform tones of color. It is only now time to contemplate transitional colors by laying in the mixed colored over the basic colored squares. There is no point in fussing

Preliminary design with some stone arrangement sketched in. The composition is not yet satisfactory

Design altered and somewhat enlarged. Right: detail of design in actual size. Final version 6 times magnified

with subtle mixtures of colors at the start. It is much more important to indicate the transitions broadly. Gradually as we work over the design again and again we shall achieve the desired subtlety. If we happen to blur some of the join lines in this process, they can be drawn in again in gray with a pointed brush, although this is necessary only if it is considered important to have an exact picture of the final effect. Next we see to the stones.

It is best to find out beforehand from the supplier what colors are available and which of them show up most clearly. We can now furnish the supplier with the design and ask him to put together the assortment of tesserae required. It is probably better to be present when the material is selected, for we are then better able to judge the possibilities open to us, and no doubt pick up a few good tips. It is worth finding out how the tesserae can be broken up and shaped, even if we intend to use them whole for the most part. One should always allow for a few more stones than the number that has been calculated, and a few of

the lighter and darker shades than those scheduled. These extra pieces will certainly come in very handy.

In preparing the next stage of the work we draw the outlines of the original onto stout transparent foil, such as acetate, for checking later. The same drawing is copied again on soft oiled or waxed paper, which will later be laid on the fresh plaster for the outlines to be pressed through. While the bottom layer of rendering is laid on the wall in pure cement, or cement and sand, and left to set for a few days, we can again see to the stones. To ensure that no grease adheres to them they are washed in small lots in dishwashing detergent, rinsed with clean water, and left to soak. This treatment is particularly important when the stones are unglazed, for their porous clay body absorbs a great deal of water, and were they left unsaturated, the stones would draw off from the plaster the water which is essential for its hardening. The same is true of natural stone; only glass or glazed material does not need to absorb more water.

The student is well advised to keep his first mosaic to a size which can be executed in a small space. The work will go something as follows: the first full-size drawing on transparent paper is placed on a board of suitable proportions; it is not needed for other purposes. It is covered with a sheet of thick transparent foil, and the colored original is hung up for convenient reference. Then the whole mosaic is set out on the transparent foil with the tesserae, using the underlying outline as guide. At a first attempt it will probably be necessary to

make a trial setting to see whether the sizes of the stones correspond to those assumed in the plan, or whether the plan has to be modified to accommodate the actual sizes of the pieces. In this preliminary setting some individual tesserae will be shaped with pincers and whetstone where it is absolutely necessary. The most important tool for setting is a pair of pincers, which can be conveniently used for changing over and moving the tesserae. One comes to realize that it is much more interesting to leave some accidentally set color as a means of enlivening the whole composition rather than to follow the model slavishly. Thus, there is no necessity at the start to root out from the assortment of stones the piece which fits exactly; it is better to get the forms approximately right in the first place and to revise them in detail afterwards. Of course, incorrect settings must not become too deliberate a habit.

Now the fun starts. The plasterer thoroughly wets the underlayer of plaster and puts in laths or screeds in order to spread a uniform bedding layer. Into this surface the tesserae are set, once the design on the oiled or waxed paper has been pressed or traced onto the plaster. The work is done from the bottom of the design upwards, a strong lath being inserted along the lower edge of the mosaic to support the first row of tesserae. If the design does not finish at the bottom in a horizontal line, the edge of the outline transferred from the oil paper drawing must be supported by a firm ridge of plaster. In this way the first line of tesserae is held firm from underneath and provides the necessary support for the stones above. The stones are picked up one by one and pressed by hand into the soft plaster. The best procedure is to start with the two or three lowest lines of tesserae from the composition and to set them complete, and then to continue to build upwards the main motif of the design, such as a figure in the middle of the picture. This enables us to follow the traced outlines and to check the progress of the composition against the outline tracing.

The setting of the stones should go forward as fast as possible so that the plaster is not given time to alter its consistency. Now and again, when a fairly large piece of the composition has been completed, the stones should be lightly tapped. A board about 6 x 12 inches, covered with thin felt or rubber, is laid over the mosaic and tapped or pressed with the hand to ensure an even surface.

This should be done as little as possible, for there is a danger of shaking the tesserae from their bed while the cement is still binding. In a mosaic built up in this fashion we do not aim at a completely even surface; with practice and experience the use of the board for flattening the mosaic can be given up. The irregularities which arise in the bedding of the stones by hand can be attractive in themselves.

Once we feel confident enough to undertake larger scale work, of the kind that is done on the front of a building from a scaffold, for example, it is no longer possible to transfer the pieces direct from a preliminary setting out. The method then is to divide the tesserae up in flat boxes of varied colors which are numbered conveniently so that the re-

quired color is easily found while working on the scaffold.

On large and complicated mosaics the plaster is likely to get too hard before the work is finished, and the stones will then not hold firmly. It is best in these cases to do only a section at a time, and where necessary to strip off the plaster and relay it, as has always been done with large frescoes.

If a mistake has been made and a few tesserae need replacing, it should be done at once. The tesserae must be carefully removed with the pincers, the space moistened slightly with a spray, the new stone given a touch of plaster on the bottom and pressed carefully into place. Corrections, however, should be avoided as far as possible.

Once the work is finished it is left until the plaster has hardened enough to give some hold to the stones. The ridge of plaster added to hold the bottom edge is cut away while it is soft enough to come off easily without shaking the whole composition. Once the stones are holding firmly, the whole mosaic is spread over with very fine watery plaster, which then is immediately wiped off the surface.

When this plaster is beginning to set in the joins the whole surface is brushed from top to bottom with a suitably hard nylon brush to clear the joins near the surface and let the separate stones stand out. Now the mosaic shows its characteristic texture for the first time. To finish off, each tessera is cleaned with a cloth moistened with an acid such as vinegar to remove the last traces of plaster from the surface.

Very old mosaics look now as though they had never been cemented from on top. The stones seem simply to have been fixed individually and to stand quite separate from each other. This relief texture is so attractive that we nowadays like to reproduce it, and it is possible to do so. In old mosaics the cracks are due to the decomposition of the lime plaster. This texture of empty cracks can be reproduced today by not placing the stones too close, and pressing them by hand into a very fine cement mortar without subsequently cementing them from above or pressing them smooth. It is the simplest process of all.

As a contrast we should mention how industrial mosaics are made. A mirror image of the design is drawn on sticky paper. The stones are arranged as close as possible onto this underlay with the top side down. The pieces are made to slope slightly in a cone shape towards the bottom edge, so that the plaster can run up higher and bind them firmer. The paper with the stones stuck on it is cut into convenient pieces which are set clean and flat into the plaster; the paper is stripped off when the plaster has set hard enough to bind the tesserae. A very fine plaster is smeared over the top into the thin cracks. This method is very efficient and sure, and is fully justified for floors and purely decorative purposes.

Second following page: Archbishop Maximian. Detail from mosaic in chancel of San Vitale, Ravenna. Example of great power of expression of portraiture in mosaic form

Batik

The word batik is a meaningless fragment of the Javanese word Ambatik, which signifies both writing and drawing. In a Javanese riddle describing the process of batik making, the answer contains the one special implement needed: the "tjanting."

A calyx with the beak of a bird of
 prey,
Five follow him across the empty field,
Wherever he goes he leaves his blood
 behind.

The answer to the riddle, the tjanting, is a small copper vessel, in shape rather like the calyx of a tulip. It has a thin curved spout which is likened in the riddle to a bird's beak. The five who follow it are the fingers which hold the vessel by a handle like that on a Turkish coffee pot. The fingers follow the jug as it moves over the uncolored cloth. In Java a smooth cotton is used, but we tend to prefer silk. Blood stands for the brownish yellow liquid wax which flows from the fine spout and leaves a trace of writing or drawing on the cloth.

What follows is quite mechanical: the cloth is dyed in a cold dip. After drying, it is ironed and the wax melts out, leaving a white design instead of the "traces of blood" against the colored ground. The wax prevents the dye from penetrating the cloth. This process is called "resist dyeing" and was used in the past for hand block printing, such as the famous Schwabian "blue printing," in which carved wooden blocks are dipped in a paste which does not dissolve in cold dye and pressed onto bleached linen, which is then soaked in a bath of dye. The places protected from the dye by the paste remain white.

The materials used in batik, then, are cloth and dye. We know that the pigments with which we paint or draw need a binder to fix them onto the ground. Textile dyes do not need this, since their coloring substance, which can also be called stain or ink, makes a true solution with water. That is to say, the inks are distributed in the water at a molecular fineness and cannot be separated by filtering. Seen through a microscope even the smallest particles of pigment are enormous, and they can be separated from water through ordinary filter paper. Being true solutions, textile dyes can penetrate the fibers of the yarn and often fix themselves there indissolubly. If this is so, the cloth will not discolor; the fastness of dyes can be increased by preliminary chemical treatment.

Unlike almost all painters' colors, cloth dyes are organic substances. They used to be extracted from plants, of which indigo and madder are the best known. Today the same substances—as well as a great many more, tens of thousands, that were not known as natural plant dyes—are obtained from coal tar in a chemically purer form. Their constant purity makes synthetically produced dyes much more reliable; that is to say, they are usually much purer colors and less liable to fade than vegetable dyes. Earlier, and often today as well, those dyes proved the fastest which do not evolve their true color until they have "developed" by combining with the acid in the air and setting fast in the cloth fibers as oxides. For instance, there is a

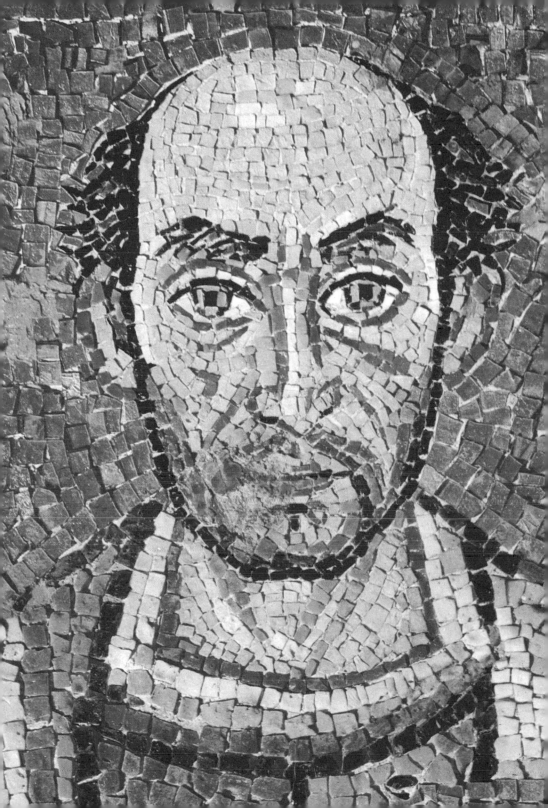

dye which comes out of the vat as yellowish green, and which turns to a lovely blue later when it has been in the air. A drastic example of how oxidation makes a dye fast is walnut juice on the fingers. A crushed green walnut gives off a pale green juice which soaks into the skin and after a few hours turns dark brown. The dye is so fast that it cannot be removed, and will grow out only as the skin scales off in the course of time. Skin is horn, like wool, and the same sort of substance as the fibroin of animal silks.

In dyeing, the difference between cloths made of animal and of vegetable fibers is important, as animal fibers resist acids better, and plant fibers resist alkalis. It is important to state which kind of cloth is to be used when buying dyes; some textile dyes are suitable for both.

Many cloth dyes take effect only in hot or even boiling water. These are, of course, unsuitable for batik work, as wax melts at well under boiling point. Cold dyeing produces, on the whole, much better colors on animal than on plant fibers. Animal fibers also hold the dye faster than vegetable ones with the primitive methods we are discussing. Wool is mostly too rough for batik; a smooth silk is the best choice, for the colors come out with greatest purity on silk, and its sheen and texture, especially if it has a linen weave, are added attractions. A great deal of work goes into a multicolored batik, which justifies the use of a good natural silk, even if other cloths are suitable.

Although today there is an inexhaustible selection of textile dyes with every imaginable nuance of color, the number of dyes that work out well under the primitive conditions of domestic dyeing is limited. Anyone intending to go in for batik should make a pattern book. It is important not to make the patterns too small, for colors look quite different on a large piece and on a small cutting. Different kinds of silk will need testing, so that the right weave is chosen for the right design. Taffeta weave is usually the most suitable; a delicate design should have the smoothest taffeta. This is woven from thread unwound from an undisturbed cocoon, unlike slub silk, which is taken from shed cocoons and cuttings, and thus consists of short fibers which have to be properly spun before they can be used. Slub silk is thus more fibrous and, like linen, has irregular thick knobs which are very attractive in the cloth, but which in batik make sharp line drawing impossible. Tussore silks look the same; they are wild silks taken from wild silkworms and are more difficult to dye. Silks are often dressed with metal salts to make them stiffer, and these, too, take dyes badly.

As we have said, batik is a process of resist dyeing. Only one color can be applied at a time, and when there are several colors everything which is to remain in the first color has to be treated with "resist" in the subsequent dips, while those exposed to the next must be protected afterwards from later colors. The more colors in the design the longer and more complicated the process. Some colors can, of course, overlap, so that every place where a later color is to come need not necessarily be covered every time, but some experience is needed to envisage the combinations of colors ahead. It is wise to make several

Tjanting as generally sold

test pieces of a given dye, say yellow, to test not only the pure color but also how it mixes with blue, red, and whatever other colors are to be used. Let us give a practical example: first we dye in yellow and cover everything which is later to be blue. For the second dip we cover everything that is to stay yellow, and dye blue; this will give blue where the wax was applied at the yellow dip, and green everywhere else. Thus two colors are given by one dip. If before or after the yellow there were a red dip, the blue could give not two, but three colors according to the waxing: blue, green, and purple.

It is not enough to know the theory of color combinations, every coloring substance reacts differently and must be tested in its combinations with cloth and other colors.

All this shows how important it is to prepare the work beforehand and not to make a first attempt with more than two or three dips. Even that can give five or six different colors. It should be borne in mind that overprinting always produces a darker tone than direct printing. In the example we discussed using blue and yellow, the blue will always be lighter in tone than the green. If the green is wanted as light or lighter than the blue it will have to be dipped in a separate green dye.

The graphic effect of batik is due equally to the manipulation of the tjanting and the fact that no gradual transitions of color are possible. As in sgraffito and mosaic each patch of color lies by the next without any modulation. To this is added a texture that cannot be either influenced or eliminated deliberately; it can at best be made closer or sparser. When the cloth is pressed into the dye the hardened wax breaks up and the dye, of course, penetrates into the cracks, making a fine veining of color. This is characteristic of batik, and in doubtful cases can determine the authenticity of the work. This texture emphasizes the picture plane in a very natural seeming way.

Another uncertainty must be reckoned with. After each dip it is practically always necessary to iron out all the wax; only rarely does the design allow one part to keep the wax through several dips. Thus, many of the lines and areas of the design are repeatedly waxed over, and it is unlikely that it will be done so exactly that the edges of the design remain sharp; a blurred effect is to be expected.

So far our cartoons have been made from a sketch, either in black or colors, using pencil or brush. For batik it is worth trying the method used by professional workers in many branches of ap-

233

plied art and one very suitable for sgraffito as well: the lines and surfaces of the design are cut out of colored paper and assembled. Whether this is first done directly full scale or smaller is a matter of patience. It should be remembered that small drafts are the best way of learning to make broad effects.

For the sake of simplicity we will assume here that we are working straight away with a full size cartoon. For simple batik the design is drawn against a single background color. Even if this is not what we have in mind we start by covering a sheet of drawing paper, rather larger than the format of the batik, with opaque color corresponding to the dominant color of the design. It would, of course, be more convenient to use ready-colored paper, but it can be bought only in a few primitive colors which hardly ever coincide with textile dyes, and furthermore the always rather irregular application of color by hand gives the work more character and personality. This sheet of paper is fixed to the drawing board to dry flat, and the same thing is done with other pieces of paper which we color according to the dyes to be used.

The background paper is cut to exactly the size of the batik and stuck onto a firm underlay. The design is sketched on it in white chalk, which can be easily wiped off, and the larger areas of the design are rapidly sketched onto the appropriately colored paper and cut out and laid on the background. The pieces can be cut out very roughly to begin with, as it is quite unnecessary to go into detail at this stage, and it will be easy to trim the pieces or replace them later.

The more freely the work is done at this stage the more spontaneous will be the final effect of the design when it is carried out. It may make the arrangement of the pieces easier if they are colored on both sides; they will not curl up, and the scraps can be more easily used. Once the general arrangement of the primary shapes and colors is roughly what is wanted, they can be lightly pasted on the background so that they can be quite easily taken off but do not move at every touch.

If the student finds it disturbing that the edges of his cutouts do not lie flat he can cover the whole composition with a sheet of glass. This gives the design finality and makes it possible to consider it from a critical distance. Then the composition can be improved by trimming the shapes and moving them about, and we can try cutting out thin lines, not necessarily all in one piece. This is better than painting the lines in. The cutout edges are needed to give their stark quality to the whole design, and should not be diluted with drawn-in elements, whose softening effect might be unconsciously transferred to the final execution.

Once the design is to our liking, we stick the different pieces down firmly and decide on the best sequence for the dyeing; light and pale colors are done first. For each dip we make a separate drawing on tracing paper. This is much simpler than trying to trace the outlines from a single drawing onto the cloth before each dip. The tracing is done with the blue used for embroidery transfers, which washes out very easily. If we have to trace onto dark patches, we can

Design prepared with colored adhesive paper. Intended for four tones, or for only three if the shadows on the red background are obtained by superimposing blue. Some imprecision arises from the wax stopping-out process

spread chalk powder over the back of the tracing paper.

A design coming right to the edge of the cloth produces an unfinished look, as if the piece had been cut out of a larger work. A frame around the edges looks better, made either by leaving a strip uncovered all around at each dip so that it is colored with every dye, or else letting the design run away unmistakably at the edge into the background color. A batik of any pretensions can hardly have any other purpose than a wall hanging, and the theme and style should be appropriate.

For the application of the wax, the cloth should be held stretched on a frame so that the wax does not stick to anything underneath. When the cloth is ironed, care must be taken not to pull it out of shape, or the subsequent tracings will not fit over the design already printed.

The tjanting filled with wax is best warmed in a water bath. (It is better to have several tjantings with spouts of

different breadths, or work is very slow when there are broad lines to be waxed.) As in sgraffito we begin with the outlines and fill in the larger areas afterwards. Techniques of working vary, depending on whether the artist needs to support his arm to steady it or not. For filling in the larger areas a flat bristle brush is used to spread the hot wax.

When all the lines and surfaces are sufficiently waxed we prepare the dye carefully in a vat, according to the maker's directions. It is important that a vat be chosen large enough to give ample room to spread the cloth. If it is too small the cloth will have to be crumpled too much, which will produce more cracks in the wax than is desirable. If the vat is large the artist can determine the amount of wax he wants to crackle. After dyeing and drying, the cloth is ironed between thick layers of absorbent paper. The iron should not be hotter than is necessary to melt the wax, and the paper should be changed frequently. Ironing should be continued until there is not a trace of wax left to be absorbed by the paper. This should be watched carefully, as specks of wax left in the cloth can spoil the whole effect of the subsequent dyeings, leaving ugly and quite permanent marks.

The work is made much easier if the design is so arranged that wax has only to be added and none removed between the dips. Then the wax will have to be ironed out only once, at the end.

It may happen, if the cloth is very thick or if the wax is too thinly applied or not warm enough, that the wax does not penetrate clear through the cloth fibers so that the back of the cloth takes the dye. To avoid this, a wax resist can be put on the back as well as the front, or, as is done by the sculptor doing fine modeling in plaster, spatulas can be heated in boiling water, dried and rubbed over the back of the cloth. This will melt the wax once more so that the cloth can absorb it.

The finished wall hanging looks best if enough cloth has been left to make loops at the top and a fringe at the bottom. It deserves a proper finish after so much work has been put into it. The most decorative effect is to hang the loops over a bamboo pole or rod of wrought iron, which, of course, should be hand-wrought.

Right: Munch, The Kiss, two-tone woodcut. This print was pulled from a plain soft wood-block (fir or larch)

Since the discovery of paper, artists have rarely been content to produce their drawings in single copies. They make prints by transferring the drawing onto a material which allows a more or less limited quantity of copies to be made. The principle of printing was used very early for textiles, before the beginning of our era, and it was known to primitive peoples before they came into contact with the more advanced techniques of modern civilization. Seals, or blocks, generally ornamental or with animal designs, were carved from wood, colored, and printed onto the cloth.

Practically the only material used for writing and drawing before the fourteenth century was parchment, which is unsuitable for printing. Not until paper was available were the possibilities of printing drawings investigated. Very

soon after the invention of the printing press, methods of "art" printing were evolved, making it possible even to surpass freehand drawing in delicacy and detail.

There are three different kinds of printing of the type in which the artist himself makes the block: relief, intaglio, and flat. In relief printing the design stands out, as on seals. This is the oldest technique, going back to textile block printing. In intaglio, such as engraving, the lines are cut into metal and filled with ink. The remaining top surface stays blank, that is to say, it is wiped clean after inking the plate. Moistened paper is pressed onto the metal plate and absorbs the ink from the grooves.

Flat printing exploits the mutual repulsion of water and grease. It is called lithography because a flat piece of stone

Kollwitz, Self-portrait, drawn on Ingres paper and lithographed

is used which can absorb both water and grease. The design is drawn onto the dry stone (often slate) with a greasy chalk and the surface is then moistened with water. Lithographic ink (a mixture of soot and linseed oil) is rolled onto it, and, being greasy, it adheres only where the grease pencil has drawn and transfers the design onto paper pressed onto the plate.

Lithography is the most recent of these printing techniques. It was invented by Aloys Senefelder of Munich in 1798. Lithography enables the artist to duplicate his work without any training in printing. He simply draws on the stone —in reverse image, of course—and leaves the rest of the work, which is quite mechanical, to the printer. If the artist uses transfer paper it is even simpler; he need not reverse his design but has only to draw onto it with a

grease pencil. The lithographer prints off the original from the paper onto the stone, thus producing a reverse image of the drawing. The prints can reproduce the artist's drawing exactly. We say "can," because, as in all art, the artist should understand his medium and draw appropriately for it. However, anyone who can draw proficiently in soft lead or chalk should be able to do a lithograph transfer at first attempt. Care should be taken, as it should in any pencil or chalk drawing, not to draw too lightly or too heavily, to avoid blanks or black smudges. The student will best bring off a perfect lithograph by first making a visit to the workshop and watching the whole process through. He will no doubt pick up some good tips from a friendly craftsman.

The simplest method of relief printing is the linoleum cut. This requires a special linoleum, which can be bought in any art shop, where tools for cutting it can also be found. The simplest tools cost very little.

The linoleum chosen should be as light as possible in color. It is covered with a coat of opaque black paint before starting work. The design is first drawn onto a good tracing paper in black ink with pen or brush. The top side of the drawing is rubbed over with white chalk and the outlines traced onto the linoleum from the back, rendering the design in reverse. Everything which is to be white in the print is now first chalked over with white hatching on the black linoleum block and then cut out, so that the light color of the linoleum stands in contrast to the black surface, as it will in the print. A rubber brayer with a handle is rolled in the printing ink so that it is covered lightly but evenly all over, and then rolled over the block, causing everything standing out in relief to be covered with a thin layer of ink. The paper, which should be thin and preferably Japanese, is laid over the block and rubbed with the hand or with a burnisher, very gently at first and then more firmly. The back of a teaspoon makes a good burnisher. When the paper is removed the print can be compared with the drawing and further work can be done on the block, if necessary. Of course, this can consist only of cutting away more; there is no chance of putting anything back.

Some dexterity is needed, and, most of all, cleanliness; otherwise it will be painfully clear why printing is sometimes called the black art. The only way to spread ink properly on the brayer is first to spread it thinly with a brush onto a glass or plastic plate and then to roll it out until it is thin and even. A stack of newspapers and a pile of old rags should be at hand, and turpentine or spirits for cleaning the roller, block, and glass plate before the ink dries.

The woodcut is worked on in exactly the same way as a linoleum cut, but it requires more skill and much more practice; special wood and better tools—if possible sculptors' chisels—will also be needed. Lime wood is best for the block, which must be planed quite smooth. Watery paint cannot be used on it or the wood fibers stand up and make the surface rough. The chisel and gouge must always be used in the direction of the grain or the wood will splinter and tear.

Lucie ter Braake, Haydn. Simple linocut for a concert program (reproduced in actual size)

This danger is obviated by using cross-cut timber of hardwood like pear, maple, or even box. Generally, because of the size of the tree, this can be obtained only in very small single pieces; larger sizes are built up of several smaller pieces glued together. Woods cut down the grain generally show the graining and should be in one piece, but cross-cuts do not show graining and, of course, must be glued tight without leaving any gap.

Cross-cut blocks after being glued together are sawed into slices about an inch thick and polished mirror smooth with sandpaper, using several pieces, each one finer than the last. The slightest scratch on the surface makes a line across the design. The edges of the block should be cut into, to prevent the danger of splitting. Every art shop sells ready-prepared cross-cut blocks.

On an end grain or cross-cut block special engraving tools have to be used; the result is a wood engraving as distinct from a woodcut. A wood engraving is suited to finer drawing than a linoleum cut or a woodcut. A practiced wood engraver does not trace, but draws directly onto the wood. The drawing has to be done in reverse, of course, and perhaps the way to start is with a self-portrait, which can be drawn directly onto the block from the mirror, and which will come out the right way around on the print.

In all these techniques it is advisable to pull a print from time to time to see how the effect is working out. Relief printing differs from the usual graphic techniques in leaving untouched what will be seen in the drawing, whereas in ordinary drawing the artist makes the strokes that are to be visible. If the cutting tools were used like a pencil, it would produce an effect like drawing with white on black.

For intaglio printing, however, the normal drawing procedure is followed; in other words, the engraved lines come out positive in the print. The classic material for intaglio printing is a perfectly smooth and polished copper plate, which can be worked either with a graving tool or an etching needle. This is hardly a technique which can be self-taught, it needs to be learned systematically and with much practice. The following is intended as a description of the process, not as a course of instruction.

Etching comes closer to ordinary draw-

ing than any other of the cutting or engraving processes. It is not so technically elaborate as copper or steel plate engraving. Even an etching, however, does not reproduce a drawing as directly as a lithograph.

The etcher covers the blank plate of copper with the thinnest skin of wax or a ready-prepared etching ground, generally a mixture of wax and asphalt. He then draws on this without special pressure with the etching needle, baring the copper with fine strokes. The drawing stands out against the ground in light copper color. Then the plate is placed in a dish and diluted nitric acid is poured over it. If the plate is very large, a border of wax can be built up round the edge, forming a tray on the plate itself to hold the acid. The acid bites into the copper where it has been uncovered by the needle for as long as it is kept in contact with the plate, working both downwards and sideways into the metal. Thus, all the lines made by the needle become thicker as time goes on. When the right time has elapsed, the acid is poured off and the plate washed. Then the ground is removed with paraffin or spirits. Next the etched plate is warmed, and printing ink is rubbed hard into it with a leather or cloth pad. The surface untouched by the acid is wiped clean of ink, first with a wad of fine muslin and finally with the hand, so that the ink remains only in the grooves. The plate is then put into an etching press, which is rather similar to a wringer, but has strong iron instead of rubber rollers, between which the plate is squeezed, together with the moistened etching paper and a piece of felt, which are laid over it. The

paper sucks the ink out of the grooves and emerges with a mirror image of the etched drawing—and a slight skin of the ink, which can never be completely removed from the top surface of the plate.

This first pull shows the etcher whether the drawing is to remain with all its lines of the same thickness or whether some parts need etching more deeply. If so, all the rest must again be covered with ground. New lines can also be added, and the whole etching process is repeated.

It is characteristic of an etching that the line is never as sharp as a pen stroke on hard paper. The acid cuts into the metal with branches and veins like ink into blotting paper, although this can be seen only under a magnifying glass. The etched line thus has a certain soft-

Woodcut, Gentian. One of a series of illustrations of protected plants (⅓ actual size)

ness. Another characteristic feature is the thin skin of ink over the whole plate, and the quite sensible and visible impression left by the plate on the paper when it was damp and soft. If a large plate has been given a border of wax, as described above, the picture will fade out towards the edges where the wax covered it over and prevented the acid from getting in.

A copper plate, like every printing block, can give only a limited number of prints, perhaps several hundred, even a thousand. The surface of the plate gradually wears away and the drawing gets fainter and fainter. For this reason the first prints are always considered the best. Experienced etchers used to make them recognizable by using a plate large enough to leave a band at the bottom. Sometimes inscriptions or signatures were engraved in these bands, but at the same time they scratched a soft drawing into the already etched plate with the needle (a leaf pattern, an animal, or some sort of emblem). This "drypoint" came out only in the first dozen copies or so, after which it vanished.

In the same way, whole plates can be worked in drypoint. No acid is used, and generally the prints are very faint, but if the scratching is done very forcefully the edges of the scorings stand up in a sort of fringed ridge. This makes the ink spread into a rather smudged line, as though the line had been drawn with a sharp pen on damp paper, making it blurred. Much experience is needed to know beforehand what the effect will be.

While etching and drypoint allow a fluid, free hand in drawing, as when using pen or pencil, the graving tool re-quired for copper engraving has to be pushed with a strong pressure. The graver is sharpened into a point, with angular facets. The lines are not bitten into the metal with acid but cut directly into the surface with the graver. The line is made broader by pressing the tool deeper into the metal, and clear modulations in the thickness of the line are possible. It needs great skill to handle the tool correctly, and classical copper engraving has developed as an austere technique, demanding that the lines be drawn strictly parallel, whether they run straight or, corresponding to the perspective of the curves, are bent. Swelling of the stroke thus emphasizes shading. A dark area is best rendered by cross hatching.

The graving tool always leaves ridges, which have to be removed with a scraper to make a clear print. An incompetent engraving looks atrocious; the craft must be systematically studied, or left alone. This, however, is not the reason that there are so few engravers who can rank as artists. The stylization necessary to contain a free drawing in such precise lines has long since ceased to appeal to the taste of the times; yet it could be made to reveal some new and attractive sides.

Steel engraving is done in the same way as copper, except that a steel plate is used, which is engraved before it is tempered by heating and dipping in water. It gives many more prints than a copper plate, but steel cannot be kept for very long because it is almost impossible to prevent its developing patches of rust, which sooner or later ruin the whole plate.

Rembrandt, studies of Saskia for an etching (actual size)

Printing

Two more techniques come under the heading of intaglio printing: mezzotint and aquatint. Both work on the same principle: the copper plate is roughened, so that if it were printed from in this state it would give a uniform, satiny black surface. Scraper and burnisher are used to make smooth surfaces which print white, for the ink sticks only in the rough places. This makes possible the softest effects of transition and fading, like smearing chalk or charcoal in a drawing, or such photographic effects as bromoil.

The only difference between the two processes is in the method of roughening the copper: for mezzotint it is closely lined in both directions with a mezzotint tool (a sort of knife), and for acquaint resin powder is scattered evenly over the surface and fused onto it; the minute gaps between the grains of dust are bitten out by acid and so hold the ink and print dark.

Whereas linoleum and wood blocks need no special workshop, and lithographs can be handed over to the printer once the drawing is done, copper intaglio is an expert business, requiring a workshop and some training in the craft. The whole process with plates, ground and acids, inking and testing, and finally printing after the trial pulls needs a special room where the press figures as the first essential. Once the equipment is set up it is possible to try more complicated

Below: Goya, detail from aquatint. Right: Piazetta, detail, copper engraving (both actual size)

processes, such as colored etching. This is done by taking prints from the black etching onto further plates, which are prepared as for aquatint. Each plate is then etched for the separate color areas. The black print, which is pulled last, makes sense of the colored areas by printing the drawing over them.

It can be seen how carefully planned and precise the design must be for this process. There is no room for free drawing during the manual execution, and this is the reason why, although there are very tasteful and competent colored etchings, there have never been any of the artistic standard reached by the great etchers and engravers who worked only in black, like Dürer or Rembrandt.

Even in the less complicated processes of colored woodcuts and lithographs the color is never as important as the drawing. Toulouse-Lautrec was a real master of the lithograph and knew its every possibility, but even in his work the color is never more than an enhancing addition to his brilliant drawing.

Prints are generally priced lower than unique drawings, and this is justifiable economically from the artist's point of view, since he can certainly sell 100 etchings for more than he may be lucky enough to get for a single drawing. The technical consideration, however, is irrelevant to the artistic value of prints. They are unquestionably on a level artistically with drawings, and they are essentially unique in the same way, if the artist pulls the print himself and produces each one individually. We have only to think of Japanese color prints: no one else could print them in the same way as the artist himself intended, for as he cuts

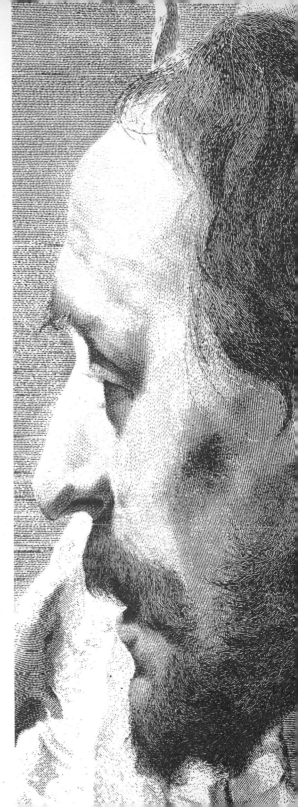

the block he is thinking how he will fade and merge the colors, so that the print has often almost the effect of a watercolor. Apart from such manipulations, the technique of printing allows many effects which cannot be obtained at all with pencil, pen, or brush. It is worth seeing what happens if one tries to imitate an etching with a pen. What has already been said many times must once again be repeated for printing: every artistic medium has its own particular justification because each one has its own power of expressing something which cannot be said in a different one.

The monotype has only a superficial technical connection with printing, for it is a print which can be pulled only once, and on the face of it may sound like a highly unnecessary gimmick. But it is not! A monotype is a relatively simple process: the picture is painted in reverse onto a glass, plastic sheet, or polished stone slab and pressed off onto a sheet of paper while the color is still wet. Printing ink, oil, or watercolor can be used. For a second copy the painting would need to be done again entirely, and it would, of course, never come out exactly the same. The monotype is not the method to be used if something is required in several copies; it is in essence "unrepeatable."

The color on the plate can be scraped off and renewed as often as required; thus, the method of building up the composition is very fluid — quite the reverse of an ink drawing, in which every stroke is indelibly marked on the paper. Corrections and alterations can be made up to the last minute without their showing on the print. Many styles of work can be done in monotype, from a line drawing or a flat color mosaic to a composition in tonal variation or one using many colors. It is so variable that it belongs to graphic art hardly more than to painting, and the more elaborate uses of it require some skill and proficiency in painting. A black and white pen or brush drawing, however, is within the scope of anyone who can make a worthwhile sketch on a piece of glass, and if the color is laid on thinly and uniformly enough the result will always have a dangerously seductive individuality. In the hands of a practiced specialist it can become an incomparable vehicle of artistic expression. Unfortunately, most of the monotypes seen in exhibitions are only too obviously not by experts, but by someone quite unpracticed in trying his hand at a new medium. Then, indeed, the monotype appears to be no more than a highly unnecessary gimmick.

PART II: PAINTING

1. HISTORY OF THE TECHNIQUE OF PAINTING

A painting has three constituent materials: the pigments, the support, and the binder, which holds the pigments to the support. The painter's craft or technique consists in the correct combination and manipulation of these three elements. "Technique" in reference to painting is often confused with style, which is the personal use of the technique, or the painter's manner. This is a psychological, artistic phenomenon, as little to be taught as a style in drawing, writing poetry, or composing music. The craft alone can be taught, and this craft is called, for the painter, painting technique.

The problems which still today beset painting technique arise from uncertainties which can be explained partly by the imperfection of the materials, and partly by the historical development of the technique. From the beginning, painters have used materials which cannot be completely understood without a thorough grounding in chemistry and related sciences. In the old days this scientific knowledge did not exist, and even now it exists only among specialists who rarely have anything to do with the practice of the art of painting. Painters of earlier centuries used to be forever writing essays to expound their theories and problems concerning their material, unless they guarded their empirically found knowledge as a secret. An air of secrecy still surrounds painting technique, although it has been investigated scientifically since the end of the last century.

These investigations were for a long time centered around the world-famous Doerner Institute in Munich. It was named after a painter, Max Doerner, whose experimental work first made the problems of the painter known to scientists. After hundreds and thousands of years of uncertainty these unresolved questions could be answered with exactitude for the first time.

All this happened at a time when painting technique had reached its lowest depths. This had come about in the following way: in earlier centuries the apprentices in a master's studio were concerned solely with learning the craft, the only subject that can be taught. They learned to produce the colors from the natural or, sometimes even then, synthetic raw materials, to prepare the appropriate grounds, and to employ the methods needed to achieve durable and vivid results. Thus, they learned intimately the good and bad qualities of their materials. They learned also how to use these materials to carry out the ideas of their masters and of the period, and the most gifted developed new artistic resources from their thorough grounding in the material side of the art.

Towards the end of the eighteenth century, schools, or art academies, began to replace private studios, and at the same time the industrial production of

ready-prepared painting materials increased rapidly. The production was not based on any systematic study, but on more or less uncritically adopted recipes, adapted to meet the widest requirements possible. Large sales were now the prime consideration; the quality deteriorated in consequence, and with it technique as well.

This situation is now quite changed. The research we referred to has resulted in the supply of excellent ready-prepared painting materials. It is nevertheless essential to be able to choose from among all the materials available, for there are still some very dubious products on the market. The demand from technically uneducated painters compels the industry to produce goods of inferior quality. The aim of the following pages is to explain enough about the character of the individual materials to enable the reader to choose them wisely and make appropriate use of them.

There is as yet no universal terminology for painting materials, due to an unfortunate gulf between scientists, who like to be systematic, and painters, who resist the new unmellifluous words, in spite of their exactitude.

Color, both generally and professionally, means two things: the phenomenon of color, and the coloring material ready prepared with its binder. Pigment means any colored material before it is in a condition to be used for painting. Painters do not react favorably to any attempts to discipline their vocabulary. However, the correct chemical names for different colors are coming into general use, instead of incomplete technical terms or names derived from outdated origins of the colors. For this reason the chemical and technically correct terms are always given first place in this book. The technically correct name is often helpful in indicating the correct use of the material.

Although we shall go more thoroughly into the properties of the different materials used when we discuss the various techniques of painting, it should be noted at once that the type of binder used always prefixes the reference to prepared paints: "oil color" means coloring material mixed with an oil binder, "watercolor" means that the thick glue binder is to be thinned with water. Thus, even here these terms are not quite consistent, although sufficiently clear for use by those concerned with the techniques.

Color is the painter's means of expression—but color as **surface.** Thus he differs from the draftsman, who works with lines, the color of which is immaterial. The classical drawing is in black on a white ground, with possibly some intermediate grays. If sepia, red, or other colored chalks are used, the whole drawing is done in only one color and remains an abstraction of the natural model from the point of view of color, in the same way as the outline is an abstraction of the surface and of the volume. Black, gray, and white are abstractions of the color as is also the translation of the multi-colored natural impressions into a single color tone.

Black and white hardly ever occur at their purest in nature. Neither phenomenon can be designated as "color." Then what is color? For the painter it is first a powder which he spreads on his painting surface with something to make it stick. This says nothing about the physical or chemical properties of the coloring substance. If we look at color powders in the dark it is impossible to tell which is blue and which yellow. Colors can be recognized only in the light. Illumination alone creates them.

You were no doubt taught in school that white, colorless light can be divided up into a colored spectrum through a prism. Light is the radiation of a source of energy. The visible wave lengths of this radiation lie between 397 and 687 millionths of a millimeter. Each one of these wave lengths has a distinct color. These phenomena begin with violet and spread continuously over blue, green, yellow, and orange to red. Shorter light waves (ultra violet) and longer ones (infra red) cannot be directly perceived by the human eye.

If we say of a material that it is blue, it means that this material reflects only blue light waves; all the rest it absorbs and transforms into heat. This can be easily proven: if we touch a white object in the sunshine, it is scarcely different in warmth from the surrounding air. White reflects all light waves. A black object, on the other hand, can become so hot in the sun that it is too hot to touch, for all the light waves that reach it are absorbed, turned into heat, and then slowly given off again. If we cover an object of another color with a layer of blue, this layer gives the impression that the

Colored patches arranged according to the spectrum

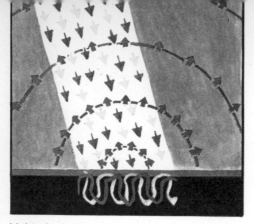

Light absorption when blue surface is illuminated

whole object is blue. This property characterizes the substances which are called simply "color."

The color circle gives an optical elucidation of the properties of color. It is a scheme which includes first the three primary colors: blue, yellow, and red. These are called primary because they cannot be made by mixing other colors, and both by optical and material mixing they can give all other colors. If equal quantities of any two primary colors are mixed together they produce a new color; so there are three new colors: green, orange, and violet. The circle is

now divided into six colors. It becomes twelve-part if each pair of neighboring colors is again mixed. Further intermediate grades can be made by mixing yet again each neighboring pair, until by the time the circle is divided into 48 we have an almost continuous transition of color—a phenomenon which can be seen in perfect form in the spectrum or rainbow.

All these colors are called "pure," as each sector consists of only one or two primary colors, however fine the division of the circle, as against the impure, dull colors in which there is some of each of the three primary colors.

Just as light can be split up into its wave lengths and colors, it can be combined again. If three panes of glass in each of the three primary colors are superimposed, the light coming through them is colorless. Even the mixed color of two of these panes is lighter than the color of either of the two panes by itself, since two thirds of the visible scope of the waves is combined light. This combination of colors is called an "additive" mixture, in contrast to the subtractive, in which light is taken away.

Three primary colors

6-part color circle

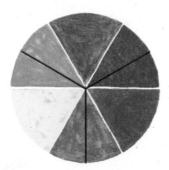

12-part color circle

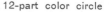
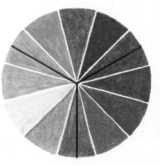

Subtractive mixture occurs whenever substances which reflect light are combined, as in all painter's colors. It can be understood in this way: imagine that colorless light is a whole made up of three thirds. Every patch colored with nontransparent, primary color reflects one third and absorbs two thirds. If we mix these patches of red, blue, and yellow together, then three times one third is reflected, and three times two thirds absorbed. Only one third of the whole light energy encountering the surface is reflected, and two thirds is absorbed; the combination of reflected light is no longer white but darker, which means gray.

In the color circle this subtractive mixture of equal parts of primary colors can be represented as a concentric section of the circle which is dark gray. If you take this section eccentrically from the original circle we produce not a neutral, but a colored gray. The color corresponds to the one or two dominant colors. In the illustration it is a brown, since red + yellow = orange predominate. Otherwise expressed you have $\frac{2}{9}$ red + $\frac{2}{9}$ yellow + $\frac{1}{9}$ blue = $\frac{5}{9}$ brown.

Optical color mixing by rotation

Subtractive mixtures can be made visible by the following experiment: paint a color circle (in three or more segments, it makes no difference) onto a disc of cardboard and rotate it quickly. The eye cannot separate the different color stimuli and they are mixed optically to gray. If instead of the complete color circle you paint an eccentric section on the disc, the result, when it is rotated, is a colored gray: blue-gray, green-gray, yellow-gray (beige or brown), and so on. All dull colors are made in this way, depending entirely on what section of the color circle, or what original colors are used. Gray would also result if only two colors were rotated, if they consisted of one primary color and a mixture of equal proportions of the two others, such as red and green (blue + yellow).

Additive mixing of the three primary colors

Subtractive mixing to give gray (concentric detail)

Subtractive mixing to give brown (excentric detail)

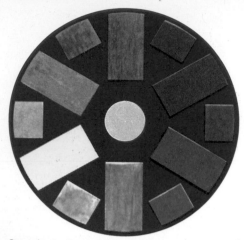

Complementary color chart

seems brighter against its neighbor than it would if it stood alone in a neutral weak-colored surrounding. If you look at a snow scene in the twilight everything looks gray on gray. If you light a lamp the landscape immediately looks uniformly blue. The blue increases in strength the closer the lamp light is to orange, the complementary color to blue.

The same thing happens on a cloudy winter's day if direct sunlight suddenly falls on the gray-white landscape. The shadows turn to pure cobalt blue, even though the glistening snow shows no orange, but a pure white, because many more of the long light waves, red and yellow, penetrate the thick blanket of air between the landscape and the low lying winter sun. Where its direct rays do not fall, you feel all the more clearly the contrast, the weak blue reflection.

It can be seen that green lies directly opposite red on the circle. Every pair of colors lying diametrically opposite each other adds up to gray. These opposed colors are called complementary colors. They and their effects are decisively important in all color sensations, and therefore in painting. This is due to the fact that the nearer two colors approach complementary relations, the more the eye is stimulated. It tries to combine them as gray, but since it cannot do so each color

This does not occur only in winter light, of course, but everywhere and all the time; but it takes more observation and practice to notice it. This is what is meant in the art schools by the insistent exhortation to "see color in everything"; though often no further explanation is forthcoming for the innocent student.

An optical illusion causes the gray to appear to approximate to the complementary colors of the frame surrounding it

The Chinese express their advice more poetically: "In every colored picture one color should be queen. All other colors should be subservient to her so that she appears in all her splendor." By this is meant that all colors other than the "queen," the dominant color, should show a certain tendency towards the complementary, but should still appear dull and impure against the pure, dominant color. In this way the picture is given a unified effect, and is concentrated on the essential, marked in the dominant color.

If the surrounding color is only neutral gray it inclines in effect towards the color complementary to the dominant one. The well-known example is illustrated here: the red, green, and orange frames make the gray windows green-gray, reddish-gray, and violet-gray respectively. All this shows that the human eye cannot see colors "objectively"; it always sees one color in relation to at least one other color; in this it is unlike the ear, which in some musically developed people retains absolute pitch. Such people can define a bird call in the exactly right notes, whether they hear it quite isolated or through the bird chorus of a wood in springtime. It is impossible to register color independently in the same way.

Even the perception of cold and warm colors is subjective. It is like dipping a hand into water, first at 60 degrees, then at 50 degrees, when the latter feels cold; but if the hand is first dipped at 40 degrees, the water at 50 degrees seems warm.

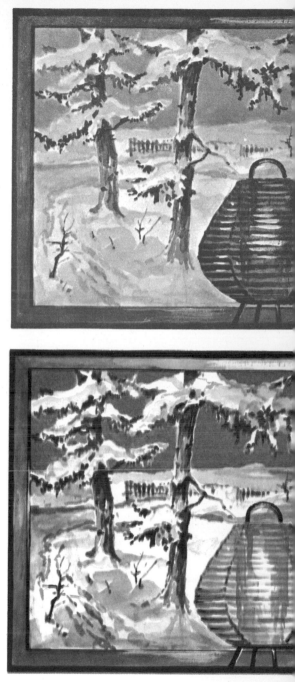

Above: Winter Landscape at Twilight
Below: the same landscape after an orange-colored lamp is lit

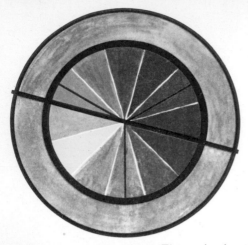

Cool and warm color chart. The cool colors range from blue-green to alizarin red; warm from yellow-green to cadmium red

The diagram shows the general division of the circle into warm and cold colors, but in practice they can work out quite differently. It is quite possible to talk of a cold yellow or red, although these are the colors of warmth and fire as against the blue of shadows and ice. Blue can look warm if it is mixed, and stands in contrast to a red bordering on violet or a light, greenish yellow or "cold" violet-gray.

The psychological effects of color work in the same way. Warm colors seem to approach the beholder, cold to recede and make the space larger. Red reduces space and has an oppressive effect, orange is aggressive and exciting, yellow is quieter and more cheerful. Green is the most neutral from this point of view.

None of these effects is noticeable except in large areas. A picture which is in one color tone can give its mood to the subject. A "lady in blue" has by its color alone quite a different effect from a picture of a woman done in tones of red. But all radiations of color change in relation to others and can turn into their opposites—or remain without any positive effect.

It may be questionable policy to construct a picture entirely on the psychological effects of color, but it is even more dangerous to do it according to preconceived theories, as is the practice of some artists. The adherents of some sects try to arouse spirituality by the use of pure colors, excluding any tendency towards gray. The effect does not work on people not spiritually prepared, and this is why such unworldly art is questionable. We expect a direct impact from all art; it should not require a special mental or spiritual education. This is not the same thing as using certain scientific facts about optics, as the Pointillists did. They built up their color surfaces according to fundamental optical laws out of small dots of pure color. The pictures of the greatest exponents of **pointillism**, like Segantini or Signac, have a direct appeal. Their scientific scaffold is not what the beholder notices, he sees merely the artistic effect.

Every material has color. One might say that the whole world consists of coloring materials. The problem is to what extent they can be used for coloring or painting. First we must draw the distinction between coloring and painting, each a different activity using different coloring materials.

Whether you are going to paint a garden fence or a picture, you use color powders, which feel like flour to the touch. These are mixed with suitable binding material to make paints. Alternatively you buy the coloring material ready prepared in tins, boxes, or tubes, or in blocks which will dissolve in water, and which contain water-soluble glue. In every case the color can be seen as it will look after it has been applied.

If you intend to dye cloth or stain wood you are again given a powder or pieces of crystal, but it generally looks almost black. It dissolves completely in water, possibly with the addition of other chemicals, but even in solution it does not show its ultimate color. This it will not do until it has combined chemically, and without needing a binder, with the cloth or wood fibers.

Unlike paints, these dyes remain in true solution; they cannot be removed. Filtered infusions of tea or coffee are "inks" of this kind. But if a can of oil paint is left standing for some time the color powder sinks to the bottom in a thick ooze which has to be stirred vigorously to make it combine again with the

oil above it into a homogeneous paint.

The same is true of a glue solution, and it is even more apparent in powder which is mixed only with water for painting purposes. These are all pigment or solid colors, which form a more or less opaque layer or skin over the object treated. Pigment colors differ from inks, dyes, or stains both in being indissoluble solids and in their chemical composition: inks, dyes, and stains are organic chemical substances, while pigment colors on the whole are inorganic in nature. There is one exception among the materials used in worthwhile painting: alizarin red has an organic basis. No inorganic substance gives this color; the paint is prepared by giving an organic dye to white clay.

The inorganic pigment colors are for the most part metal oxides and hydroxides, either by themselves or combined

Left: dye-bath. Right: bath with deposit

with clay. They exist in nature as colored earths and are thus usually rather dull, "impure" colors. Artificially produced pigments are on the whole purer; some approximate to the absolute purity of spectrum colors, but never attain it completely. The effect of complementary colors can make them seem so in a picture.

The nature of pigment can be understood from the following example: bricks are made of loam, a very yellow clay, and baked; yet when they come out of the oven they are red. While the heat of the oven fuses the clay into one piece, it causes the yellow in the clay, which is iron hydroxide (rust), to give off its water content, thereby becoming a red iron oxide.

If the unbaked loam is dried and

Loam (ochre). Very light, moderate, and well burnt

crumbled fine, or if baked bricks are ground to a fine dust, they can be used in that condition for painting. Böcklin did this, though it is much easier to purchase yellow and red clay, technically pure and uniformly ground, as ochre. If yellow ochre is scattered on a hot plate it will soon become red ochre. The extraction of the water content makes the powder specifically heavier and denser; it loses some transparency, the characteristic of the so-called glaze colors, which allows the ground to shine through. Opaque colors, which are often burnt

pigments, cover the surface completely with a relatively thin application, so that the color effect is constant whether the ground is light or dark.

Most metal hydroxides can be turned into darker and more opaque colors. Of synthetic paints the most striking example is the hydrous oxide of chromium, hydrous green chromic oxide, or viridian, as it is usually called, an extremely pure, transparent color. By burning or strong heating it becomes anhydrous green chromic oxide, chrome green, a dull color and very opaque. The specific weight alters from 2.74 to 5.21, and the granulation is finer. Not all pigments can be altered by burning, and some are destroyed by strong heat.

There are also pigments which make a chemical reaction when mixed together or with a calcareous binder. All pigments affect the drying time of oil binders. Oil with white lead dries to the touch in about 30 hours, whereas with umber it is still sticky after 100. To avoid these difficulties attempts have been made to use absolutely neutral pigments like ground glass pastes, but these are not satisfactory because they break up the light in undesirable ways. Modern painting technique has therefore to resign itself to using pigments which, like natural ochre and carbon, were used 30,000 years ago for the cave paintings, and which have thus proved their durability.

Both old and new pigments are chosen primarily for their tolerance to light. They are classified according to their ability to combine with binders, principally with lime.

A number of pigments are similar in

color but have quite different properties and prices; for example, the brightest and most light-resistant yellow is cadmium, but it is destroyed by lime. When painting on lime it can be replaced by uranium yellow, uranium oxide, which gives almost the same color; if it need not be quite so pure and bright, Mars yellow, yellow iron oxide, is usually preferred by painters, since uranium yellow is the most expensive of all colors.

The reader may ask, since all colors can be mixed from the three primary colors, why others are used at all. Some artists have indeed taken a pride in using only these three, but quite apart from the fact that it is impossible to maintain pigments of the three primary colors in a condition of absolute purity it is very tedious to be forever mixing colors, and other technical difficulties arise as well.

First let us see how another color is derived from two pigments—for instance, green from blue and yellow. The method is the same with dry pigments and those already mixed with a binder. The grains of color, each perhaps a hundredth or a thousandth of a millimeter in size, cannot be distinguished individually by eye; they combine on the retina in a unified color effect, or, more

Above: alizarin red—light, medium, deep
Below: medium alizarin red—with white, alone, with black

precisely, not they but the minute blue and yellow particles of reflected light rays. A pervasive green pigment, chrome green, for instance, is different. It does not reflect two different light waves, but one single green one.

In practice it is almost impossible to copy a definite color tone by mixing, so there should always be a series of colors ready in the box, even as there is in the mind, which are permanently there as original colors in the identical tone. These paints enable the painter to see the colors in his imagination as he works, just as the notes of the well-tempered piano live in the imagination of the musician, and from them he can imagine all the delicate nuances and intermediate colors and mix them in practice. Added

Left: chrome green (green grains)

Right: ultramarine blue mixed with ochre (blue and yellow grains)

to this, a larger choice of paints makes him able to deal more easily with all kinds of technical difficulties.

It is almost impossible to vary the tone value of individual paints to lighter or darker than the original simply by mixing with white or black pigments. White makes the brilliance of pure pigments chalky, and black often has a dirty effect. With yellow it gives a smudgy green, with red an unattractive brown, and with orange also a brown. None of these colors has any brilliance.

Glazes: Left: ultramarine violet over light ochre. Right: medium alizarin red over viridian

There is no need to give an elaborate explanation of the properties of light absorption of the white and black pigments. A practical test is more to the point. Take three tones of alizarin red — light, medium, and dark—and paint a patch of each. Then beneath the dark tone paint a patch of medium tone mixed with black to correspond to the original tone, and beneath the light tone a patch of medium mixed with white. You will quickly see by the contrasting results how desirable it is to have every possible tone of the important pigments in your paint box. Most synthetic paints are produced in two or three tones. They are not mixed, but the pigment is treated physically or chemically during manufacture. Even so the tones are inadequate to reproduce all the variations of tone in nature.

To remedy this the transparent properties of pure, bright pigments can be utilized. A transparent layer in the complementary color over a dull colored under-painting will provide the rich glowing darks which gave the mysterious depth and glow to the paintings of the old masters.

Whether or not to work with glazes is today an artistic question. Since the Impressionist period it has been rather out of fashion for technical reasons: pictures begun directly from nature, and if possible completed at one sitting, could not be built up on an underpainting, which has to dry all day, while its glazing requires repeated rest periods. Painters and art lovers, too, were enamored of the new effect of flat, opaque colors. However, that is no reason why glazing and its color effects should not be used today, when most pictures are again painted in the studio, and only the sketch is painted direct from the natural model.

At any rate, it would be a pity to be as narrow minded as Lenback, who is said to have turned from the work of a rival with the words, "I believe the swine still uses glazes!"

The exigencies of printing allow us in our reproduction of the pigment colors to give only approximate values. This is no disadvantage to the reader, who must test the colors and mixtures for himself if he is to profit at all from these studies. The comparison of the real paints with the illustrations in this book will be an excellent test of the value of his purchases.

The following list shows which colors are needed for the first practical essays, while those entered in italics are desirable but not essential. The smallest pans of watercolor, but of first-class quality, are sufficient. Very little will be used, so that they will form the basis of a watercolor box for later work.

You will also need a sheet of best, smooth watercolor paper and at least one fairly large sable brush about size 16, with a worn point, since only broad strokes will be made.

Once again let us insist: there is no sense in beginning with second-rate paints and paper.

BLUE: Ultramarine fine ground/Prussian or Paris blue (iron cyanogen)/Cobalt blue deep, light/Cerulean blue.

YELLOW: Ochre Golden ochre/Mars yellow/Cadmium yellow light, medium and dark/Naples yellow (lead antimoniate), light and dark.

RED: Mars red/Cadmium red dark, light/Alizarin red/Venetian red (iron oxide/Pozzuoli red.

GREEN: Viridian (hydrous green chromic oxide/Chrome green, (Anhydrous green chromic oxide)/Terre verte (ferrous oxide and silicic acid)/Emerald green.

ORANGE-VIOLET-BROWN: Cadmium orange/Ultramarine violet/Cobalt violet/Burnt sienna/Cyprian umber/Burnt umber/Caput mortuum.

BLACK AND WHITE: Ivory black/Lamp black/White lead/Zinc white.

There are less varied tones of the different pigments in watercolors than in oil or dry powder colors.

BLUE is found in nature in only two forms: mountain blue, a compound of copper which is impermanent, and lapis lazuli, a blue semiprecious stone. Neither raw material is used today for making colors, although lapis lazuli is unaffected by light. It was used in old paintings as a costly glaze over modeled underpainting, and the stone was thus sometimes called glaze stone. The name ultramarine has also remained current, since it was brought from overseas, beyond the Caspian.

ULTRAMARINE BLUE is now made artificially from a combination of soda, alumina, sulphur, and silicic acid, and is an essential blue pigment for both art and commercial paints, being inexpensive to produce. (There are also ultramarine

red and violet, but they are unimportant.) Ultramarine blue is the nearest of all pigments used to primary blue in the color circle. It has high tinting strength and is very pure. It can be mixed with green or red and gives the purest of mixed violets when combined with alizarin red. It gives only dull greens when mixed with yellow pigments, but it gives a pure blue-green with viridian. Since it has been made to resist lime, it has become the most important blue for murals and house painting. Even in the humblest school child's paint box it is found in a fairly pure form. The best kinds have no tendency towards either red or green. It is unaffected chemically by other pigments.

PRUSSIAN BLUE (iron cyanogen) is the second important blue and is essential to even the most limited palette. It is also known by its older names of Paris or Berlin blue. It is the strongest in tinting power of all pigments, the smallest traces make all yellow and even brown pigments a bright green. With red, however, it gives less clear mixtures, and with cadmium red a rich, deep black, so that the painter can dispense with any black pigment on his palette.

Unlike ultramarine blue (finest), which has strong covering power though it can also be used as a glaze, Prussian blue is a pure glaze color. In thick layers it assumes an unpleasant coppery tone and creates the effect of a hole in the picture plane. Mixed with ultramarine blue, however, both pigments lose their unpleasant qualities of color and become a very deep, pure color, which is most brilliant if the colors are glazed one over the other alternately. Prussian blue being cheap is in every ordinary

paint box. It is useless for murals, as it is destroyed immediately by lime.

COBALT BLUE is an expensive color. It is imitated in ordinary paint boxes by a mixture of ultramarine and zinc white, which never achieves the exceptional clarity of real cobalt. It is clear even when applied thickly. It is a pigment to be used by itself, as it is easily swamped by other colors when mixed; the best mixture is with viridian. It is not very strong in tinting power, and stands midway between a glaze and an opaque color. It looks very rich and has a fascinating effect, particularly in fresco but also in watercolor and mat tempera. Some of its charm is lost when it is mixed with a fat, shiny oil binder. Small additions of cobalt blue make oil colors dry more quickly. It can be obtained in two tones, and there are two exceptionally attractive variants as well: cerulean blue, the color of a cloudless sky and very valuable for atmospheric tones, and blue-green oxide (cobalt tin color), often used to reproduce the color of the winter sky close to the horizon. There is no sense in making any mixtures with these two. They must stand alone, like jewels.

Both these variants of cobalt are equally unaffected by lime and resemble cobalt in all other technical and coloring qualities, including resistance to heat. They are used for porcelain painting and pot glazes.

YELLOW is the most frequent color among natural pigments. The yellow coloring of earths is always iron hydroxide, or rust, precipitated on clays of varying degress of purity. These yellow or red-colored clays are called ochres. The color is purer the less the iron hydroxide

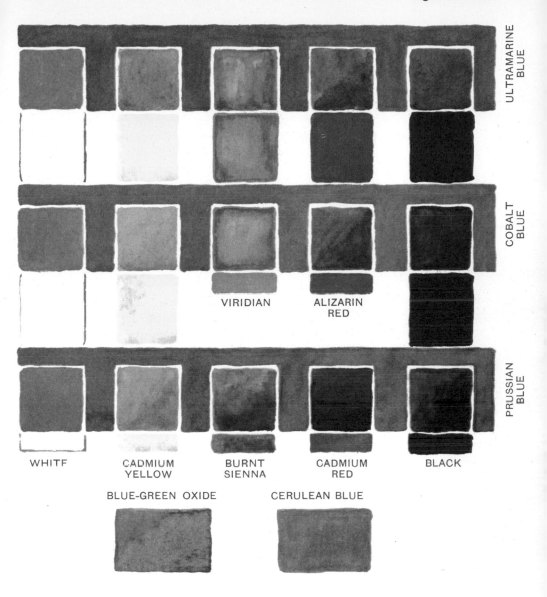

ULTRAMARINE BLUE

COBALT BLUE

VIRIDIAN ALIZARIN RED

PRUSSIAN BLUE

WHITE CADMIUM YELLOW BURNT SIENNA CADMIUM RED BLACK

BLUE-GREEN OXIDE CERULEAN BLUE

is dulled by other additions. Manganese combinations often occur in nature and to a varying extent change the yellow into brown.

Natural ochres are the cheapest of all good pigments. Synthetic ones are dearer; they are yellow iron oxides and are sold as "Mars colors." They are purer in color than the natural earth pigments, but they are still classed with the dull pigments. Ochres are the most widely used colors in painting, as they are often

employed as an underpaint for other dull color tones. They mix with all binders and pigments, and as colors constitute to some extent a reconciling element, quiet and soft, amid the strong, bright colors, like a calm person among a group of excitable temperaments. The same applies to any mixtures made with ochre or Mars yellow. They bring a harmony because of their dulling quality, a pervasive ground tone to the picture, especially when the ochres are used for monochrome underpainting. They are of medium strength, and can be used equally well for glazing and covering. They are chemically neutral and are found in every paint box.

CADMIUM YELLOW is the purest of all light-fast pigments. It corresponds, in its medium tone, to the primary yellow of the color circle. It can be produced in an endless number of tones, from the lightest lemon yellow to orange and even a deep red. Combination of cadmium with sulphur does not alter its chemical structure, but only its physical character, from crystalline to amorphous. The best of all yellows to be bought are light, medium, and dark cadmium.

All cadmium colors are considerably more expensive than ochres and all are affected by lime. They must not be brought together with lead colors, such as white lead, either, as this darkens them. The only whites suitable for mixing with them are the completely neutral zinc white or titanium white. For painting on lime, uranium yellow is substituted for cadmium as far as its high price allows, uranium being the most expensive of all pigments. Cadmium loses its original lightness and transparency as it loses its crystalline form. Deep cadmium and chrome green are the most opaque of all pigments on the painter's palette. Cadmium yellows are pure and can be used in many bright color mixtures. They give the most radiant warm greens when mixed with Prussian blue and viridian. They also mix well with all red pigments. Cobalt yellow, which often has a slight green tinge, can be used as a substitute for cadmium lemon on lime.

NAPLES YELLOW, or antimony (lead antimoniate), should have its place in every well-ordered palette, although it and its reddish variant are not classed among the pure colors. It has another limitation: having strong covering power, it can ruin the transparent character of a rapid watercolor painting, and should therefore only be used very sparingly or not at all in this medium. On the other hand, both in color and consistency it is very attractive in tempera and oil, giving the whole coloration of the picture a misty solidity, something of the tangibility of air, as though a bright yellow were shimmering through fog and cloud. Its stability in lime makes it a valuable addition to the palette of the mural painter. Naples yellow has a very different consistency from other pigments, showing how individual a character a pigment can have. The use of the tactile quality of pigments, apart from their color, is one of the aspects of painting technique which should form part of the equipment of every able, experienced artist.

RED comes mainly in natural earth colors. Most of the nuances of red ochre are named after their original sources: Venetian, Pompeiian, and many more.

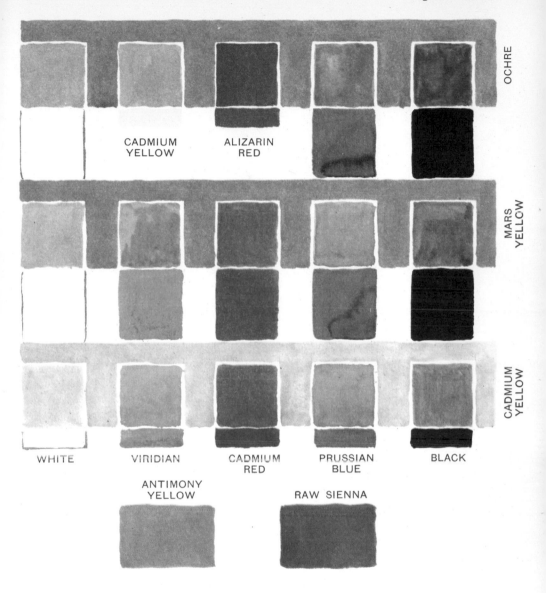

OCHRE

MARS YELLOW

CADMIUM YELLOW

CADMIUM YELLOW ALIZARIN RED

WHITE VIRIDIAN CADMIUM RED PRUSSIAN BLUE BLACK

ANTIMONY YELLOW RAW SIENNA

Iron oxide is the coloring matter in the clay. Red oxides are little more expensive than yellow oxides, and on the whole the observations on naturally colored yellow clays apply equally to the reds. In mixtures they are not very friendly, the red base remains dominant. As burnt colors—there are burnt colors derived either naturally or artifically from yellow ochre—the red ochres and Mars red are more opaque than the yellows. Laid on thickly they can be too in-

265

sistent unless care is taken with the surrounding color.

One of the best known red ochres is that used in red pastels and pencils. An ochre called "red bole" was favored by the earlier Italian masters as a ground color. They always used it as an underlay for a gold ground.

Two classic red pigments have been eliminated from the modern, trouble-free palette: mountain cinnabar and carmine. Neither is fast to light. They will be dealt with in more detail in a chapter on obsolete colors. Their colors, however, were so unique that permanent substitutes had to be found for them.

CADMIUM RED and ALIZARIN RED were the answer. All that has been said about cadmium yellow applies to cadmium red, and it should be remembered that, like cadmium yellow, the red cadmium colors must remain unmixed if they are to retain their brilliance. Unfortunately, they are totally unsuitable as glazes; although the granulation is generally finer than in the yellow sorts, the pigment will not spread in a thin layer. The artist must find the right compromise between a transparent and an opaque application. Neither cadmium nor alizarin red gives a true primary red, but a mixture of the two comes close. This works well because alizarin red is as excellent a transparent glaze as Prussian blue, and almost equally strong in tinting power. It is a dye made from coal tar and the only organically colored pigment on the trouble-free palette. It was found while trying to produce a permanent madder red. Red madder, which is very similar to carmine, was for centuries an important textile dye, extracted from the root of the madder plant which was grown in large fields. Its most important coloring constituent is alizarin, whose resistance to light is destroyed by other organic substances. It can be extracted pure from coal tar, and after the experience of 50 or 60 years may now be considered fast to light. The organic dye can be precipitated indissolubly onto white clay and thus create a workable pigment. This color is quite indispensable, for there is no other inorganic color even approximating it; whereas cadmium red and cinnabar can be replaced to some extent by Mars red (iron oxide).

ALIZARIN RED, like the cadmium colors, can be produced in an endless variety of tones. They range from orange to violet. The darker tones are the most resistant to light. It achieves its brightest effect as a glaze over opaque red and opaque green underpaintings (red and red-brown earths, green earth, and chrome green). In a direct mixture it gives only one really distinguished color: the purest violet of the palette, a mixture of alizarin red and ultramarine blue.

Neither cadmium nor alizarin red is unaffected by lime. Venetian red (iron oxide), Mars red, and cobalt red have to be substituted for them. All of these, however, need to be surrounded by complementary colors to enhance their brilliance. Alizarin red is an example of how the technical peculiarities of a pigment are not to be ignored: in a thick layer the decidedly transparent color loses its deep glow completely.

GREEN can be mixed from the blues and yellows already listed to every shade likely to be required, but a few

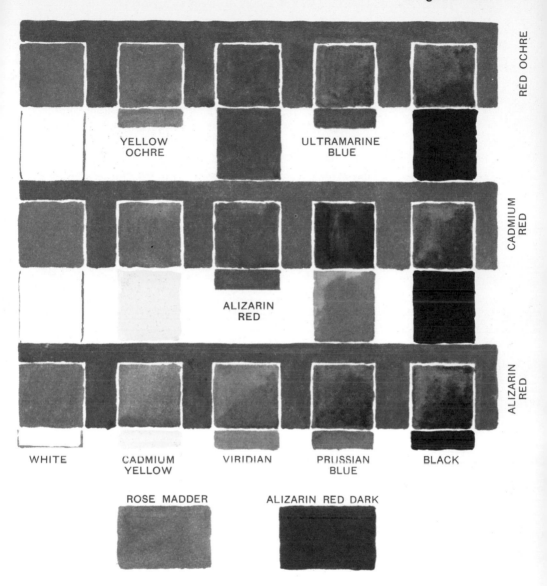

RED OCHRE

YELLOW OCHRE ULTRAMARINE BLUE

CADMIUM RED

ALIZARIN RED

ALIZARIN RED

WHITE CADMIUM YELLOW VIRIDIAN PRUSSIAN BLUE BLACK

ROSE MADDER ALIZARIN RED DARK

pure and cold tones are difficult to achieve; it is practical, therefore, to use independent green pigments. Moreover, there are among them two materials which both technically and as colors are unsurpassed by any other pigments: the two green chromic oxides, brilliant and opaque.

If I had to make up a serviceable palette from a minimum of colors it would include ultramarine and Prussian blue, cadmium and alizarin red, ochre and cad-

mium yellow, umber and burnt sienna, and the two chromic greens just mentioned.

OXIDE OF CHROMIUM (hydrous green chromic oxide brilliant), or VIRIDIAN, is the most important unmixed green pigment, with a cool, very pure tone very close to a spectrum color. We have described how removal of the water of crystallization by heating results in anhydrous chromic oxide, opaque. Both pigments are unaffected by light. The hydrous oxide, viridian, is a decidedly transparent color, which keeps much of its great brilliance even when mixed with white. Combined with cobalt blue it makes nearly the same tone as the costly blue chromic oxide, and also provides useful mixtures with ultramarine and Prussian blues. The richest scale of greens, including nearly all the warm brilliant greens, comes from combination with cadmium and Mars yellow.

CHROME GREEN (anhydrous green chromic oxide) is a pronouncedly soft and warm green and an opaque color. It is less suited to strongly altered mixtures than to slight tinting, and looks well when used pure. Being one of the colors with the greatest covering power, it is very uncertain for glazing. Terre verte, to which chrome green is otherwise similar as a color and technically superior, is better for this purpose. Both chromic greens are found in a fairly pure form even in cheap paint boxes. They can hardly be varied in tone. They are very cheap and are unaffected by lime, and thus are much used for house and industrial paints and for printing and ceramic painting and glazes.

TERRE VERTE (green earth) is produced in cool and warm tones named after the two most important early find-places, Verona and Bohemia. (Veronese green earth is not to be confused with vert Paul Véronèse, another name for emerald green.) All the variants are essentially combinations of magnesium, aluminium, and silicic acid (augite). Terre verte used to be the most important pigment for underpainting. Being a dull transparent color, it held the lightness of the white ground for the subsequent overpainting. It was also the ideal cool and discreet basis for complementary effects with all red pigments. Terre verte is insignificant for direct mixtures, and equally so for thick application. Deep tones in unmixed terre verte are best when it is laid in several glazes one over the other—an affect which cannot be achieved with chrome green.

This example shows once again how different the characteristics of pigments can be even when their colors are nearly identical. Much subtlety can be gained by playing these different characteristics off against each other, but only if each one is known and felt on its own, just as a cook must know the separate taste of each of his ingredients, a composer the quality of each instrument, or a sculptor the tactile quality of stones and woods in themselves before he begins to carve them.

Lastly, a green should be mentioned which is found in almost every color assortment: permanent green. It is generally a mixture of viridian with zinc yellow or cadmium, and is not a separate pigment. It may be useful and give no

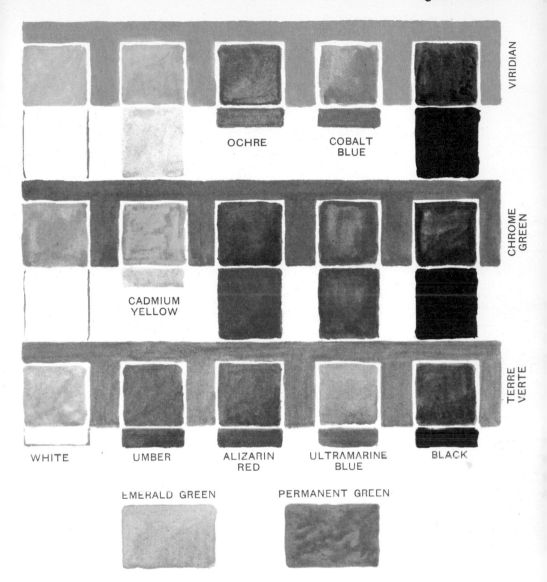

VIRIDIAN

OCHRE COBALT BLUE

CHROME GREEN

CADMIUM YELLOW

TERRE VERTE

WHITE UMBER ALIZARIN RED ULTRAMARINE BLUE BLACK

EMERALD GREEN PERMANENT GREEN

trouble, but I would never advise you to buy ready-mixed colors. They tend to standardize your sense of color and make you more dependent than is desirable. There is, on the other hand, an arsenic green sold as EMERALD, Schweinfurt, Smaragd, or Véronèse green, which is a good, stable pigment. It cannot be imitated by mixing and is essential for cold, light green tones. It replaces the verdigris and other copper colors which were formerly used.

ORANGE, VIOLET, and BROWN are the remaining color groups combined from the primaries. These, unlike original green pigments, are easily mixed and thus are not needed in the palette as independent colors. This is particularly true of orange and violet. There is, however, an orange in the cadmium range. Pure violet, as made by mixing alizarin red and ultramarine blue, does not exist as a pigment. Ultramarine and cobalt violets should be mentioned for work on lime grounds; the latter, cobaltous oxide arsenate, is one of the few really poisonous substances in the palette. Their intensity or tinting strength is not very high.

There are, on the other hand, several valuable original browns derived from natural earth colors which can be made darker and redder and at the same time more dense by burning.

BURNT SIENNA is the most important brown pigment. The purest form of iron oxide is the coloring agent; its reddish color is very difficult to copy in a mixture. Raw Sienna, the hydrous iron oxide of Sienna earth in its natural state, is much less important as a color. Although it has covering power, it remains a transparent color which is unpleasantly obtrusive when laid thick and is hardly ever to be used unmixed. Over underpainting in other colors, however, it is a brilliant and light glaze. Direct mixtures are possible with most pigments for subtle, dull nuances.

UMBER is the darkest original brown pigment. The best natural kind, Cyprian umber, acquires a very dark, reddish tone when burnt. The active agent in this is the iron particles in the earth, which owes its characteristic color mainly to compounds of manganese.

Umber, both burnt and raw, is the classical shadow color. Burnt umber certainly has a shady character in some respects! It is heavy in tone and opaque, and in spite of its high tinting strength it tends to make "holes" in the picture and, like almost all dark pigments, it delays the drying time of oil binders. Nevertheless burnt umber is valuable for darkening all colors, much better in effect than black, and it makes a good rich black when mixed with Prussian blue. Without umber Rembrandt would hardly have succeeded in painting his mysterious shadows.

CAPUT MORTUUM derives its strange name from the color of the skulls in the Roman catacombs, though in fact it has little in common with them coloristically, and nothing at all as material. It is a synthetic compound of manganese which can be produced in a great variety of nuances, based on two varieties, one a deep red-brown and one violet-brown. Being already very unclear colors and lacking in intensity, they are not good mixers. The violet variety gives the shadow tone of newly ploughed earth or, when used as a half-glaze, the color of young swelling buds in springtime, that mauve haze that seems to hover in birch trees or shrubs before the buds have burst. It is a useful addition to a modest palette.

All brown pigments are easy to handle technically. Even the slow drying effect of burnt umber can be helped by a small addition of cobalt or lead pigments.

Brown pigments show most clearly the convenience of having a series of con-

CADMIUM ORANGE

COBALT VIOLET

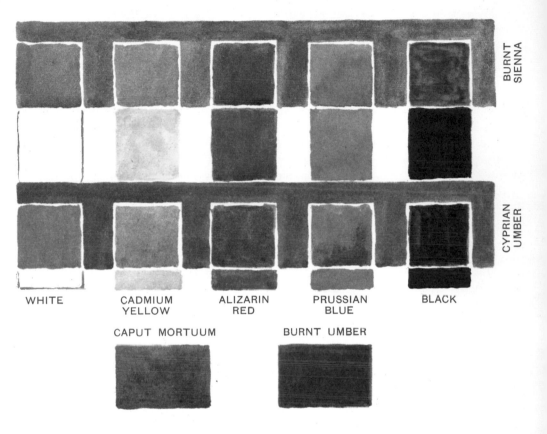

WHITE CADMIUM YELLOW ALIZARIN RED PRUSSIAN BLUE BLACK

CAPUT MORTUUM BURNT UMBER

sistent, mixed tones on the palette. Although it is easy to mix these unclear colors from strong brilliant ones, it saves a great deal of time to have the original pigments for them, and it helps the visualization of color effects to have the mixed tones ready at hand. Thus, it is rational neither from the point of view of time, nor of technique—nor financially—to have too few basic colors. It is best to make use of all the available pigments which are valuable for color and are technically uncomplicated; they are not so very numerous.

You should be warned against fancy trade names, however, and, once again, be advised against the ready-mixed paints offered for sale.

Pigment Colors

Although BLACK and WHITE pigments have nothing to do with color, they both, particularly white, play an important role in painting. The mixing tests we have illustrated show that all pigments mix with white in their own way. It lightens them but dulls them at the same time. This is an effect contrary to a glaze, in which the white of the underpainting lightens the color without altering its character.

White is quantitatively the dominant pigment in all painting, unless the work is done primarily in transparent color, or glazes. Only watercolor and fresco use hardly any white. Watercolor in particular loses all character if much white is used.

The natural white pigments are chalk, gypsum, heavy spar (sulphate of baryta), and clay (white bole). They can be used only as a priming or as a filling material for "cutting" other colors, not for painting proper. They go gray with all oil, resin, and wax binders, and keep their lightness only in glue. For house paint and pastel chalks the color pigments can be "cut" with natural white pigments in large quantities without reducing the depth of color of the "cut" substances—but only if glue is used exclusively as the binder or fixative. This is why some house paints are recommended for use only with glue; a limitation which does not exist for pure, uncut colors.

The most usual white pigments for pictures are white lead and zinc white, although they may soon be replaced entirely by titanium white.

WHITE LEAD (basic lead carbonate), generally called Cremnitz white in its finest varieties, has strong covering power and is thus the main constituent of all opaque whites. It has a warm tone, hardens quickly in oil, and would be the only white used in painting, except that it tends to blacken in combination with many sulphur colors (cadmium pigments, for example). For these pigments the wholly neutral ZINC WHITE is the only possible choice. It has weak covering power, little coloring strength, is cold in tone, and delays drying.

To counter the properties of both whites there are ready-prepared mixtures of the two, but as with all mixtures it is not advisable to buy them, as mistakes can be made in their use. If they are needed they must be mixed by the artist himself.

TITANIUM WHITE (titanium dioxide) occurs naturally, but for the quantities required is generally made artificially. It has a very strong covering power, is neutral in tone and as unaffected by light as the two other pigments. Little is known as yet about how it behaves in pictures, but there seems no reason to fear that its excellent qualities will have to be paid for in the course of time. It may well make lead and zinc white superfluous.

BLACK is totally unnecessary in the painter's palette. The two most important black pigments, ivory black and lamp black, mix disagreeably with colored pigments. If they are used solid they make "holes" in the picture, and as tinting they have a deadening and muddy effect; used as a glaze, they produce an equally dead, gray effect. Much more subtle grays are obtained from mixtures of complementary colors, and the colored darks that the layman will always see as black. Gray does not exist

as a pigment. Black pigments are needed only for graphic work and to some extent in watercolor. They are often considered as organic substances, but in reality they are pure carbon, which is obtained by burning organic substances. An element is never really an organic substance, from whatever natural compound it is extracted. Ivory black is prepared by charring defatted bones; the finest sorts are from ivory chippings.

LAMPBLACK is soot from carbonized oils. Genuine Chinese ink is made from camphor oil. It is deeper and more velvety in tone, almost "colored," in contrast to ivory black, which is colder and grayer. Black made from charred twigs (vine or plant black) is a very light pigment tending to brown tones. All black pigments are difficult in oil, as, being of very low specific weight, they need 200 per cent oil to bind them. This makes drying very slow. Thus, there are sufficient reasons for eliminating black from the palette.

Obsolete Coloring Materials

We have already mentioned several pigments which, though famous for centuries for their coloristic qualities, are highly dubious from the technical point of view. A good craftsman should know, however, why these and some more recently discovered pigments are better not used. Of them all, only carmine has not yet found a fully satisfactory substitute in color. All the others are easily mixed from the pigments already recommended. Do not be persuaded to use them on the grounds that they have retained their color in pictures many centuries old. This is a matter of chance, on which it is safer not to depend, or of very artful and elaborate treatment. Nowadays, as we have said, it is unnecessary to tackle these complicated processes, since there are better pigments which are easier to use.

The old, strong-colored pigments were almost all without exception organic inks of vegetable or animal origin, precipitated more or less loosely onto clay. They are classified under the heading of substratum colors, or lakes, since they became pigments only when combined with a base or substratum. Such, for example, are alizarin red, called madder lake, and some inorganic colors like the iron reds and yellows. Most of these organic precipitations are soluble, particularly in alcohol. They "bleed" if fugitive solvents and thinners are contained in the oil, which soften the oil after it has hardened. The colors, which have also dissolved, run into the softened oil layers and "strike through." This does not happen with alizarin red, as the precipitation is indissoluble. In the old days the organic pigments were used simply because there were no corresponding inorganic ones. They fell into disuse more and more as the chemistry of color progressed and found new colors for the painter, though many of these, too, were unstable.

No more revolutionary discoveries are to be expected in the field of inorganic pigments. This has been proved by the systematic research of Ostwald into the coloring properties of all elements. An increase of painter's pigments can now be made only on the basis of organic compounds, once they are made abso-

lutely light-fast. All the "brilliant" colors have this aim. Among them are colors of a radiance which is rarely found in inorganic pigments; yet they are still very uncertain, and it is foolish.to use them, even for purposes of study, because the color imagination of the student would be diverted from the basic colors of the palette and undermine his foundation in the permanent, light-fast pigments. We shall now briefly consider the characteristics of the most famous historic colors.

INDIGO is a blue ink. It is obtained from the indigo root, or woad, and was used for centuries primarily as a textile dye. It was practically the only blue. A synthetic product was ultimately discovered which was an improvement but not completely light-fast. The color, something between ultramarine and Prussian blue, soon becomes a dull, dark blue when it is a pigment, and is sold even today in this tone as an imitation or as "genuine" indigo. The color tone is thus the result of fading.

INDIAN YELLOW is the main yellow pigment of ancient times. It is an ink extracted from the urine of Indian cows that have been fed on mango leaves. The color is exceptionally beautiful and radiant, but is easily imitated by a mixture of middle cadmium yellow with traces of burnt sienna.

GAMBOGE was always in the palette of the eighteenth and nineteenth century painters. It is a yellow gum resin which fades quickly and even when fresh has no particular tonality.

It was, of course, recognized that neither Indian yellow nor gamboge is fast to light; so the painters of the nineteenth century turned with great enthusiasm to the newly discovered CHROME YELLOW, which seemed to be the answer to all their requirements. Unfortunately, time has told against it, for it has been found to turn greenish and finally almost green-black. Nothing has yet been found to prevent this, and even Van Gogh's famous Sunflowers is deteriorating irretrievably. The strange, macabre yellow tone in the picture is the first stage of decomposition of the chrome yellow he used. Cadmium yellow was still unknown in Van Gogh's time. In spite of this, chrome yellow is still found in several tones in every assortment of paints, and is still bought out of ignorance in

large quantities, especially as it is much less difficult to use than cadmium yellow, which dulls easily in mixtures.

Among the red pigments of doubtful stability is RED CHROME, a similar variant of the yellow pigment as is the red of yellow cadmium.

CINNABAR, or vermilion, is produced in a synthetic variety which is claimed to be fast to light, though this cannot be relied on. Cinnabar has on occasion remained unaltered for over 500 years, but in other cases it has blackened in a few weeks.

CARMINE is again an organic ink, precipitated for painting purposes onto clay. The ink is an extract from the female cochineal insect found on certain kinds of American thistle.

MADDER LAKE is a dye from the madder root, similar in color to carmine. Alizarin red serves as a substitute; it can at best replace only madder lake and,

unfortunately, cannot achieve the brilliant red of carmine.

The term "lake," quite wrongfully attributed to the pigments synthesized today, alludes to the strong transparency of a pigment. Lake refers either to a substance which colors a substratum or to a binder which is transparent and has a sheen or lacquer.

DRAGON'S BLOOD is a genuine lake, a red resin which is both unimportant as a color and very sensitive to light. It is bought occasionally by the ignorant on account of its romantic name.

One sometimes reads grisly stories of demoniac painters who painted with their own blood. It is even told of Domenico Theotokopuli, "El Greco," that in his ecstatic and mysterious painting he deliberately drew blood from his fingers, since he was said always to have his hands bandaged. If this is true—and very little is known of the life of this painter—it is more likely that he suffered from the effects of turpentine on his skin, a trouble which has forced some people to give up painting altogether. Blood blackens after a few days, and is useless for painting.

Famous ancient green pigments are all copper compounds and all sensitive to

light; moreover, one of them, VERDIGRIS, has the fatal characteristic of dissolving in the acid of linseed oil and "bleeding." The old masters laid verdigris as an unmixed glaze in egg white between isolating layers of varnish in order to be able to use the lovely green tone which became obsolete only with the discovery of viridian. Used as described, the organic substance (copper acetate) is also unaffected by light.

The famous, infamous EMERALD, or Schweinfurt, green was as necessary an evil as verdigris as long as there was no nonpoisonous, stable, strong green pigment. Emerald green (copper arsenate) is one of the few really dangerous poisons used as a pigment, and still used today as an insecticide. It can be deadly to men as well, whereas most of the poisonous qualities of pigments are rather the exaggerations of romantic horror, being dangerous only to small children who are at the stage of consuming everything they see.

The well-known VANDYE or CASSEL BROWN has a good brown tone but was never necessary, as umber was known earlier. It is simply brown coal, a mixture of organic substances, and thus sensitive to light. It is still much used, out of ignorance.

ASPHALTUM, or bitumen, on the contrary, has fallen out of fashion. It is a natural organic substance and was used in the last century mainly for underpainting, as its gray-brown tone ideally suited the taste of the period as an underlay for glowing glazes. In the course of time, however, it was found that this underpainting either began to "bleed" or the thick layers of paint above it literally peeled off as they lost all hold on the underpainting. Some of the "black Madonnas"—that from Czenstochau, for instance—turned black not from heavenly intervention but because the asphaltum underpainting was striking out.

SEPIA is extracted from the ink bag of certain species of Mediterranean cuttle fish. It was favored as a substratum color and as ink in the Romantic period and gave an antiquated coloration to pictures. It soon turns gray, however.

In the color assortments of many stores you still find a great number of names which, in the great majority of cases, disguise only half-usable pigments or mixtures.

Surfaces on which you can paint directly are called grounds. First, however, a firm base is required, such as paper, cardboard, pasteboard, artificial boards of various kinds, wood, or cloth. Masonry and stone, even glass and metal, can also be used. These bases are called "supports." With the exception of paper, they are unsuitable as direct painting surfaces. Some would affect the paint chemically and alter it, others are impermanent in color or darken in contact with binders, or do not give sufficient hold for the paint. These supports must be given a ground.

Grounds function mainly as isolators between the support and the paint; they can also act as a sort of underpainting, when they are tinted, for instance, and give the picture a foundation color. In all cases the ground must be appropriate to the type of painting technique used.

PAPER is the simplest painting ground. It takes all glue and pastel colors without any priming, but it must be protected with size against the penetration of binders containing oil or wax. Good quality paper, free of cellulose and as white as possible, is one of the most durable painting grounds if it is properly cared for. Its quality depends on the materials and methods of its manufacture.

Paper as we know it now was preceded historically in China by sheets made from bamboo pulp and in Egypt by papyrus. At about the beginning of the second century A.D., the first paper production began in China from cloth rags, which are still today the basis of all the best varieties of paper. Europe did not produce paper until about 1200, in France. Until then the only known writing surface was parchment, which can also be used for painting. Parchment is the undressed, smoothed skin of sheep, goats, donkeys, or calves, with the hair removed.

Most paper manufactured today is no longer made from rags but from wood, which is reduced to the finest dust and mixed to a paste with water, glue, and fillers (kaolin). This mixture is finely sieved and laid on broad felt moving belts in the paper machine. The water is squeezed out and after pressing and smoothing, the thin sheet of paper is wound at the end of the machine into great rolls. Any wood content lessens the quality of paper, as can be seen particularly in newspaper, made entirely from wood pulp, which quickly yellows and goes brittle.

Today there are very few papers made entirely of rag. One example, however, is good quality, handmade watercolor paper. It is made one sheet at a time and is rather thinner and irregular at the edges, which can be observed, together

with the watermark, when the sheet is held against the light. Watermarks in the paper are not necessarily a guarantee of quality, however. They are made by raised patterns or lettering woven into the sieve. In these places the pulp is rendered thinner and more transparent; the same process can be used in machine-made paper.

A famous brand of paper, made especially for watercolor, is the English Whatman paper, made from pure linen rags. It is sold both in sheets and in painting blocks. Similar good papers are made in other countries as well.

Every paper is sized to prevent the ink or color from running; unsized papers react like blotting paper. The type of size used affects the quality of the paper; good papers have animal glue size, and inferior sorts are sized with resin. The material of the size can be tested by dropping ether on the paper; if it is resinous the ether leaves a brown mark around the edge of the drop.

Most good papers can be used on both sides. In doubtful cases the top of the usable side shows the watermark or stamp the right way around. The surface texture has nothing to do with the quality of paper; more important for painting is the thickness, for if it is too thin, paper does not take the paint well.

The strength of paper is measured by its weight per ream. Painting papers weigh between 72 and 140 lbs. per ream. 210 is a thick card. Still heavier weights produce pasteboard, which is hardly ever made today solely from pure, white rag pulp, and therefore must always be given a proper ground.

Smooth paper for painting

Hammered watercolor paper

Handmade Whatman paper (with rough edges)
A thin coat of watercolor is used to show up the texture

Some papers are manufactured already colored right through. We have already spoken of the disadvantages of these tinted papers; the artist should always prepare light-fast tinting for himself.

All papers swell with moisture; they stretch and buckle, which is very inconvenient for painting. Paper should, therefore, always be thoroughly dampened and stretched. To do this, soak the paper in water and lay it flat until it assumes a dull surface, being sure to turn it over frequently. Then smear the edges with flour paste or strong gum arabic and smooth the paper flat onto a drawing board. A wooden frame made for the purpose can also be used. As it dries,

the sheet becomes as smooth as a drum and buckles very little if it is dampened again. After the painting is finished, it is cut away from the pasted edges; so the sheet chosen must be larger than the finished picture to allow for the waste margin.

Although the texture of paper is no indication of its quality, the surface texture greatly affects the finished painting. Paint looks quite different on smooth, cloudy, and rough, cloth-like papers. Smooth papers can be given a texture with fine sandpaper, which if rubbed first up and down and then across gives a linen or canvas-like effect that shows up especially where it is painted.

Pastel requires a certain roughness of surface. A good ground to roughen the paper is made from skim milk mixed with a little starch flour. The addition of a small amount of pigment will produce a colored ground, but only very small amounts should be added or the pastel will smear. Larger additions of pigment require stronger binding glues, such as gum arabic or capenter's glue.

Carpenter's glue is most frequently used for priming on all surfaces: wood, canvas, pasteboard, or paper. The following recipe is suitable for all of them: soften 70 gr. carpenter's glue (hide glue, which is a transparent yellow-brown) in one quart of water until it is completely absorbed; glue in beads is the best. It swells in a few hours and is more easily weighed than slabs, which take twenty-four hours or more to soften. When soft, the glue in its container is put into a water bath and heated to 158 degrees F., at which temperature it dissolves completely. It should never be boiled or it will lose much of its binding power. Therefore a glue pot should be used, which also avoids the problem of its sticking to a pan, which it does readily if heated directly. The fillers, or thickening, and pigments are added after it has dissolved and while it remains in the glue pot. Chalk, baked gypsum (analin), kaolin, or marble dust are used in making a gesso priming. Chalk is for the softest, marble dust for the hardest, roughest surface.

Both the priming and the surface must be warmed when the priming is applied or the paste begins to coagulate and cannot be spread evenly and thinly. A good, even ground must be built up of many thin coats and not one or two thicker ones.

Papers and thin boards, such as cardboard, must be primed on both sides or they curl. This can also happen with hardboard and composition boards which are only primed on one side. The backs require only light priming, or cheap cloth or paper can be stuck on them to prevent the tension being on one surface only.

Glue in bead and sheet form

Method of mounting a frame in a clamp or press

Mounting large sheets of paper is a specialist's job. It is inadvisable to attempt it without training in bookbinding and the appropriate equipment, including the press. Badly mounted paper comes unstuck in places, causing blisters and loose corners, mistakes which cannot afterwards be rectified and which can ruin the whole effect of a picture. Mounting is thus better left to a bookbinder or mounter. The small expense involved is preferable to the losses sustained from spoiled material.

Sized and primed boards of large size must sometimes be stiffened with a frame glued onto the back. To make the wooden frame stick securely, the priming or backing must be removed from around the edges where the frame is to be glued. This is most easily done with a tooth plane.

The construction of the frame and the mounting is a carpenter's job. After mounting, the frame and board must be put in a veneer press for at least half a day; no glue holds permanently without pressure. With a sufficient number of clamps and some experience of carpentry you can do the mounting yourself; it is not as difficult as mounting paper.

Even the best paper containing no wood pulp will yellow if exposed constantly to sunlight and will become as fragile as when it is stored in perpetual dry heat. Continuous damp causes mildew, which results in permanent stains. Damp storage also softens the glue of both ground and paint; it may begin to rot, at which point the picture cannot be saved. If these dangers are avoided, paper is very durable. There are papers which have survived in good condition from the time when paper was first invented. The best quality paper thus provides both an ideal surface for all glue and pastel colors and, with a suitable ground, a good covering for inferior boards.

Hardboard sheets, which are obtainable in many varieties, are very similar in character to good rag pasteboards. They usually have one rough and one smooth side. The rough side generally has a rather disagreeable wire grating texture which must be entirely eliminated by the priming if it is not to spoil the effect of the picture. The smooth side always has a slight residue of the paraf-

fin which is used in the press to prevent the board from sticking to the metal. Since paraffin prevents the priming from adhering, it must be removed with sandpaper. Smooth surfaces are rubbed with a wooden block with mitered edges, covered with sandpaper .

A board thus prepared provides a very good support, especially for backing paper or canvas. Unlike plywood or massive panels of glued planks, it does not warp.

Wood is a living material, and even after centuries it never quite comes to rest. Absorbing moisture at different rates it always warps in quite unforeseen ways. The illustration shows how various are the pulls in each board cut from the same stem. This pull never quite ceases. Wood must season for at least ten years in the air before it can be worked into boards for painting. And apart from this fact, not all woods are suitable, particularly those which are resinous. Only de-

Inlaid boards

ciduous woods are to be considered; walnut and pear are the best.

In earlier centuries painters used wood frequently, simply because they had nothing better. In spite of the fact that boards were prepared according to all the rules of the art, every old painting on wood is now a problem for the restorer. The board must be protected from warping by inlay, which is the only way to counteract the constant working of the wood.

Plywoods have definite advantages over boards made from planks glued together. There are basically two kinds. One consists of laminations glued together so that the grains run in different directions, the other of veneer surfaces with wooden bars between them. The latter, called "block board," is less likely to warp. Avoid plywoods having round-cut veneers as their outer layer. These always develop fine hair cracks which cannot be hidden even by the thickest priming and painting. The round-cut veneer can be recognized by its unnatural graining. Only **plank-cut** veneers can be used for painting.

Diagrammatic representation of the natural pull of wood

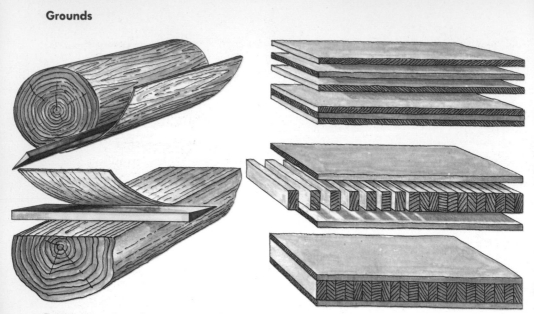

Round-cut and plank-cut veneers; block and plywood

A ground is easily applied to wood without using a lining, and this is about the only convenience that wood has to offer. Boards of synthetic fiber are much more suitable as supports for painting.

Canvas has been the classic painting support for oil and tempera since about the sixteenth century. It, too, needs priming before it is painted, to prevent the oil or other binder from soaking into the fibers of the cloth. The priming also provides a durable white surface, which is needed because even bleached canvas darkens considerably in contact with glue or oil. Other textiles of vegetable fiber, such as cotton or jute, can be used for painting, but none of them are in any way comparable to pure linen canvas.

Linen is woven from the spun fibers of the flax plant. It is sown in springtime and quickly sends up thick, light-green shoots which, in June, produce flowers of a color you would now, as a color specialist, identify as light cobalt blue. The seed cases develop out of the flowers. The fibers come from the woody stalks, which grow more than a yard high. The wood content is dissolved by rotting (steeping) it. It is then broken up and hackled or combed away from the yellow-gray silky fibers. Linseed oil is extracted from the seeds. If painters were to adopt a plant as an emblem of their profession it would have to be the flax.

The spinning of the flax fibers first produces the single-strand yarn. Double or multiple yarn is then twisted from the single strands. The best texture of linen is obtained from untwisted yarn, for it best shows the characteristic thickenings arising from the constantly newly added fibers. They give the finished linen or canvas its typical surface texture. This texture shows to best advantage when

the yarn is woven with a plain cloth weave (rather than the twill weave or its fancy variants) or the satin weave, which is generally used only for fine household linens. For these only the finest yarns are used. Coarser linens are used for painting.

All this, however, is, like the type of weave, a matter of taste; there are no differences in quality.

The quality of the linen depends entirely on the flax used, and the fineness and length of its fibers. Linen with knobs in it, which is often recommended as painting canvas, still contains remnants of wood from the flax stalk; it is this which forms the lumps. Apart from being very noticeable in the surface of the picture, these knobs or lumps show that the linen is second rate. Sail cloth can be used if a very coarse texture is desired. Gauguin was fond of painting on it, and the flat effect of his pictures is strongly emphasized by the coarse texture of his support.

If the canvas is held against the light it is easy to see if the warp (longitudinal threads) and weft (horizontal threads) run equally close together. Good machine weaves are always regular; handwoven linen is not. There is no particular advantage in handwoven linen as such, unless it comes from a good studio where handspun yarn is used, as this shows up most strongly the attractive, irregular thickenings caused by the spinning. Since every bleach injures the fibers somewhat, it is better to use unbleached linen, particularly as it will in any case be covered by the ground.

Every linen receives a dressing in the factory. It makes a better "feel" and makes the cloth shinier when it is pressed. The dressing is usually tragacanth or starch and is harmless. Resulting folds and wrinkles, however, are tiresome, for they show through even the thickest priming. Some linens are as broad as 25 feet (theatrical canvas for scenery) and, of course, must be folded. The folds can be removed only by boiling the cloth and ironing it when it is still damp. The canvas can then be stretched on a frame, or, better still, stuck onto hardboard.

| Plain cloth | Twill weave | Herringbone pattern | Satin weave |

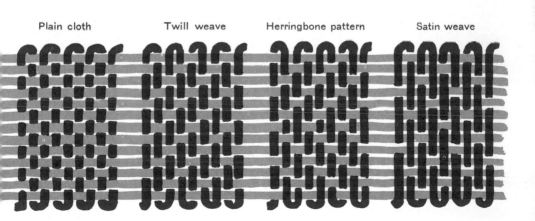

Placing wedges at the corners of a mitered stretcher

The general lay opinion seems to be that a picture has no technical worth unless it is painted on canvas held by the proper stretcher bars. This is, of course, a fallacy, a survival of old fashioned techniques as outdated as painting with fatty oils of unknown constitution. The stretcher is made of four pieces of wood fitted together with double mortices at the mitered corners. For a large stretcher, cross pieces are fitted to keep the frame rigid against the pull of the canvas. The wood is supplied ready-prepared to standard lengths graded to inches and is obtainable in any art shop.

To make the stretcher, the corners of the wood bars are joined as tightly as possible and adjusted with a set square. A piece of thin wood may be lightly nailed across the corner to keep the correct angle until the stretching is completed. The canvas should be at least an inch and a half larger on all sides than the stretcher, and care must be taken to keep the lines of the canvas weave parallel to the sides of the stretcher, for

a slanting weave upsets the painter's sense of the perpendicular when he is working. The canvas is first fixed to the stretcher provisionally with large architects' drawing pins, and thus temporarily stretched, it is given its preliminary two coats: a glue size solution first, which is allowed to dry, and then the first coat of the primer, such as gesso. Once the latter has dried, the canvas can be re-stretched. The pins should be removed in the same order in which they were put in and replaced by special rustless pins.

Stretching large canvases requires at least two helpers and is even easier with four. The work is always begun from the center of each side, pulling the cloth across from the middle of the opposite side. For heavy canvas and large pictures special canvas pliers are used.

Next, the priming of the canvas has to be completed. The first coats were given **before** the stretching because, unlike paper and wood, linen crumples and shrinks as soon as it is damp. The fibers swell when they are wet and shorten and stretch again when they are dry. Thus, if the linen were placed untreated on the frame the excessive stretching of the fibers when it was wet would make it very slack after the first coat of priming had dried. But if the first coat of glue hardens in the fibers before the cloth is stretched, it prevents it from swelling and shrinking much afterwards; although in fact the canvas always gives a little when it is primed again and has to be given a final stretching before the actual painting begins. The stretcher is so made that the edges can be forced apart by wedges. The wedges are placed in pairs into the corners; the laths hold-

Method of protecting a mitered stretcher from knocks, showing how to place and stretch a canvas

ing the angles are removed, and the wedges carefully hammered in as far as necessary, while keeping the frame rectangular, to make the canvas taut.

A stretched canvas is always sensitive to knocks, and the priming makes it difficult to remove dents once they have been made; so it is much better not to stretch canvas but to stick it down. This gives the most solid painting support while keeping the attractive woven texture and hiding the unnatural smooth surface of the board. Even a very thin canvas has a texture that looks like something that has grown naturally, and in this it is superior even to paper.

It is best to hand over the mounting of the canvas to a competent framer or bookbinder, although the process is less difficult than mounting paper. The board should be free of grease and slightly roughened; the paste must be of a good quality which can be used cold, like starch paste or dextrin. Carpenter's glue works equally well, except that the work has to be done very quickly and in a warm room, and the board and canvas both have to be warmed beforehand or the glue will not take.

Driving a wedge into the corner of a stretcher protected from bending by means of a cross-strut

A cold glue allows more time to lay the canvas carefully according to the markings, and if a mistake has been made the canvas can be lifted off and stuck again.

Both board and cloth are covered with paste. Once the cloth is laid correctly on the board it is rubbed over with a straight-edged, rounded block; the movement is always from the center towards the edges, following the lines of the thread. Lastly, the overhanging edges of the canvas are bent under and stuck to the back of the board. The whole back is covered with cheap muslin or brown paper, concealing the turned edges of the canvas.

The painting board prepared in this way is better in quality and appearance than a canvas on a stretcher and is more easily handled, both for painting and framing. It cannot go slack and is virtually invulnerable.

You already know that there are many reasons for priming: it prevents the binder from soaking into the cloth fibers, glue and filler being less absorbent, and with its white or colored pigments it gives a durable background which is unaffected by light or binder.

Only paper is given just a single light priming; boards and canvas must have several coats. Generally, three applications are needed:

1. Size without filler—one coat.
2. Priming with filler—two or three coats, which will darken, however, especially in contact with oil binders thus necessitating:
3. Pigment priming—one or two coats, which can be white or colored, and will not darken with oil.

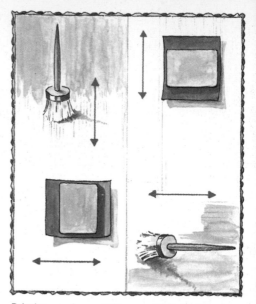

Priming and smoothing a stretched canvas. The left half shows the first part of this process, and the right half shows the second

The second and third categories need more than one coat to make the covering quite uniform. A single thick coat will always spread unevenly, causing the ground to absorb the paint unevenly. Moreover, a thick coat of priming hides the texture of the underlay too completely. A ground painted on in thin and frequent coats is more uniformly absorbent than one thick coat.

After each coat is dry, it is rubbed over to remove the skin of glue that forms, which would prevent the following coat from holding well. Smooth surfaces can be rubbed with a piece of sandpaper mounted on a wooden block; for canvases it is best to use a hard nylon or soft wire brush. Brushing penetrates the hollows in the cloth, whereas sandpaper

would begin to smooth down the canvas itself. To ensure even distribution, the priming is always put on with the brush strokes running at right angles to those used on the previous coat.

The final coloring or whitening coat is left untreated so as to be least absorbent. In all, a maximum of eight priming coats is sufficient. Each one must be applied very quickly in order not to soften the previous coat which has been allowed to dry thoroughly before being covered.

This priming used to be called "chalk ground" as distinct from a ground of equal parts of chalk and oil. The use of the word chalk is quite misleading, for what is meant is actually a pure glue ground, irrespective of whether chalk, bole, analin, or other filler is used. A ground of equal parts chalk and oil would be better called glue and oil ground, the upper coats being given an oily binder, while oil grounds use oil alone except for the first sizing.

The two oil grounds have been mentioned only because they are often the only ones found on the ready-prepared panels and rolled canvas offered for sale. They are very convenient, especially for amateurs and painters with little technical experience, but they have no other advantage. Oil grounds are responsible for the unfortunate habit of rolling primed, and worse, painted, canvases, because the elastic oil film seems to suffer no harm from it. In fact, even a fully oxidized oil film cracks or crumples when it is rolled up, and cracks when it is unrolled. A mixed glue and oil ground suffers even worse. Old pictures which have been left rolled for a long time or are rolled up after many years generally crack right through to the canvas and are a great problem to picture restorers. It sometimes takes weeks to scrape away the canvas from the picture layer and stick on a new canvas—a process called in the trade "relining."

Oil grounds absorb no binder, but this is a dubious advantage. There are excellent technical measures to be taken against excessive absorption by soft glue grounds. Pure glue grounds cannot be bought on the market, for they are very sensitive, and primed canvas must be already stretched, which is impossible on a commercial scale with all the varied sizes in demand. It is better not to try to buy ready-primed supports; no one can, or will, say what has been used on them.

METAL remains alien to any painting with pigments and binder. Although

The paint layer (blue) is shown reacting to the rolling and unrolling of canvas (gray)

paintings on thin sheets of copper survive in good condition from the eighteenth century, it is totally inadvisable as a support. Only enamel colors will hold securely on metal, and they are only really secure when fused on in patches, separated into little cells formed by soldered-on wire, a technique far removed from the character of painting.

NATURAL STONE, on the other hand, forms a good support, both on facades and indoors. Either wax colors can be used, which are made to penetrate the pores of the stone by heating (encaustic), or watery pigments can be made to petrify with the stone by means of waterglass, which is sprayed over the painting. Stone is not primed, although sometimes for mineral painting it is etched.

BRICK WALLS and any other similar artificial stone must be primed for painting. Plaster is generally used for this. At least three coats are applied before it is painted: an undercoat or rough rendering, an upper coat, and a top coat. Each layer contains finer grit and sand than the one below, whether the work is done in pure lime plaster, lime and cement, or pure cement plaster.

Plaster containing cement is suitable only to be painted on when it is quite set and dry. Casein or silica paints can be used on it, and glue colors are suitable indoors. **Fresco-secco** was done with egg yolk as a binder. True fresco, **fresco-buono,** is done only on pure white lime plaster while the plaster is still quite wet. The pigments are mixed exclusively

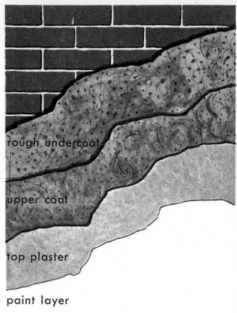

rough undercoat

upper coat

top plaster

paint layer

Fresco plaster

with water and bound into the top plaster by a coating of crystalline calcium carbonate, the "sinter skin," which exudes from it. As soon as the fresco plaster begins to set, the pigment no longer takes on it. Thus, large frescoes are always painted piecemeal; the fresh plaster is added to the brick wall for each section as needed.

We can see that there is no universal support for all painting techniques. At any rate the priming must be suited to the subsequent technique, and the technique is determined primarily by the binding material.

6. BINDERS AND READY-PREPARED PAINTS

"Binder" is the technical word for a substance that enables pigments to be fixed onto the ground. Lenbach's opinion was that "one can paint with anything that sticks." This remark is typical of the indifference of the later nineteenth century to technique. Lenbach was at that moment thinking only of those binders which work as adhesives, and, mixed with pigments, become "colors," that is to say, ready-prepared paints. No one can paint with pigment powder; it must be made suitable for application with either a brush or pen or made into a pencil. The kind of binder chosen depends on the painting technique in view. The terms used for ready-prepared paints, like "oil colors" or "watercolors," give some indication of the binder, but closer examination shows that it is not quite as simple as it seems.

Colors which are petrified onto the painting ground by some chemico-mineralogical process, as in fresco, or are fixed by some material sprayed after their application, such as mineral paints, do not contain a binder. Pastel colors, which are bound by the application of a fixative, also contain no binder.

Adhesive binders are basically of two sorts. There are those which have a more or less constant natural consistency and have to be dissolved and liquified for painting purposes, hardening again after the evaporation of the solvent. All kinds of glue, resin, and wax belong to this group. The others are naturally liquid and do not harden by the evaporation of some constituent but by the absorption of acid from the air. Certain oils have this property—but not all! If even the smallest trace of olive or lubricating oil (neither of which oxidizes to a hard substance) is mixed with a hardening oil it will prevent that oil from oxidizing. The oil layer becomes more voluminous when hardening, but after long periods of time it shrinks again. This is due to the oil giving off carbon dioxide, which is in fact a sort of very slow burning. This can be seen on any very old oil painting. The surface is cracked and split and shows what might be called "late crack formation."

There is also an "early crack formation" which may arise even a few hours after the paint has been applied. This is due to mistakes in technique. Forgers cause them intentionally to imitate late crack formation and make the picture look old. The crackle of ceramic glazes is due to similar "mistakes."

Since late crack formation has been found to be an inevitable evil of pure oil painting, attention has been turned again to tempera, which is a much older binder. True tempera consists of bringing together two substances which generally repel each other: water-soluble glue and oil. This is done in such a way that the two substances form a completely new, inseparable liquid to which, within

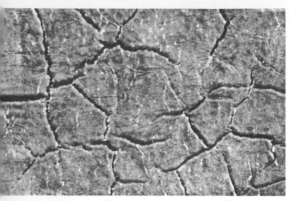

Late crack formation in a picture 150 years old

Late crack formation in a picture 100 years old

Early crack formation in a picture 20 years old
(Macro-photograph by Hans Roth)

limits, either water or oil can be added. The general technical term for this true mixing of substances is "emulsion."

Milk is a well-known example of a natural emulsion, mayonnaise an artificial one. If the reader is versed in the art of making this delicacy he will know that it can succeed only if an egg yolk is stirred constantly while oil and vinegar (the watery element in this case) are added to it alternately in small drops. The egg yolk functions as the emulsifying agent. Egg yolk is itself an emulsion of egg white and egg oil. Pharmacists seem to have the special gift of making emulsions without an agent. If you want to use tempera frequently you should enlist the kind aid of a member of this esoteric profession to see that your emulsion comes off! When it crackles and clicks in the mixing bowl, the magic has worked. The word "tempera" comes from the latin **temperatio,** meaning a proper compound, as against **mixtura,** which means any ordinary mixture. Unfortunately, color merchants are not so precise in their use of the term "tempera colors," as you will soon discover! The technical advantage of genuine emulsions is that neither the glue nor the oil can form a hard film as it dries. A honeycomb of each substance contains minute droplets of the other, although these are too small to be seen with an ordinary microscope. This structural parceling of each constituent enables additions of one or the other to be made without their showing when the emulsion is spread as paint. The surfaces are multiplied; thus, both evaporation and oxidation occur much more quickly.

Diagram showing structure of O-W emulsion (oil in watery element) and W-O emulsion (watery element in oil)

In past centuries the preparation of paint was a long and tedious process. The pigments came to the painter in large lumps or in coarse irregular powders. They had to be ground with pestle and mortar and then further rubbed down on stone or glass with a muller, while at the same time being mixed with the binder.

Nowadays the pigments are bought already ground so fine that no further grinding is possible, for every pigment has a definite fineness suitable to it. The figures, in thousandths of a millimeter, are as follows: ochre .5 to 30, iron reds 1 to 80, Prussian blue .3 to 10, white lead 2 to 5. If pigments are ground too fine their colors tend to go muddy, and in a colloidal condition can change color entirely. Grinding by hand can reach a colloidal state, as you know from Chinese ink. The lamp black "takes" indissolubly only when it becomes a colloid. Pigments are bought today fine enough to mix with the binder when stirred with a stiff bristle brush. As little binder as possible is used, just enough to make a stiff paste. A few hours, or at most a day, give the binder time to penetrate through the powder and show whether the paste is too dry and needs more

binder or is too soft and can take more pigment. Pigments vary in their reactions to binders; some repel water, some oil. Alcohol helps to make a uniform paste in these cases, as it combines equally well with water and oil.

In most ready-made colors the pigments are generally finer than the dry powder. The mechanical rollers between which pigments are mixed with binders grind the pigments still further. This is not always an advantage, as a coarser granulation prevents too smooth a film of oil from forming and reduces the danger of early cracking by making the surface larger. The painting layer is also more solid if the granulation is coarser. For both these reasons the old painting instructions always warned against excessively long and fine grinding of the pigment with the binder.

While most materials are best bought in art shops, it is advisable to go to a druggist for some others, notably cold pressed linseed oil, balsams, double rectified turpentine and gum arabic. The druggist has to follow specifications established by the Federal government, so the products are fully reliable, and their methods of extraction guaranteed. The

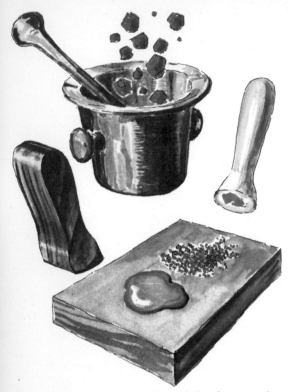

Tools formerly used to grind colors: mortar, stone slab for grinding, agate and glass mullers

painting material industry, on the other hand, carefully guards its processes as a trade secret, which unfortunately does not help the acquisition of a solid painting technique.

Glues are the easiest binders to handle. They are dissolved in water, which evaporates sufficiently after the paint has been put on for the work to feel dry after only a few moments. The surface can be painted over immediately, if the artist is a fast worker, but it should not be gone over too often with the brush.

Some of the water takes a few days to evaporate, during which time the glue remains swollen and can easily dissolve again. The glue can also be dissolved again even after the paint has dried fully, but it takes longer. All glues which act like this are called "reversible," as distinct from the irreversible glues which cannot be dissolved once they have set. The most important of these in painting is casein, a milk product. Glues can also be divided according to their animal or vegetable origin, but this is of no practical importance to the painter. Carpenter's glue, prepared from the boiling of skins, behaves no differently from plant glues like gum tragacanth or gum arabic.

TRAGACANTH is gum extracted from bruising the branches of the tragacanth bush. It provides the most important binder for watercolors and for gouache and other opaque colors generally sold as tempera paints, although in fact they do not contain an emulsion. The more exactly named "egg tempera" and "oil tempera" are emulsions.

You already know how painting techniques and their appropriate colors are named according to the binder employed. Watercolors are an exception to this. They are named after the water, used so copiously and noticeably in the technique, which dissolves them and thins them. It is never worthwhile to prepare watercolors oneself. We shall describe only how the colors we buy are produced. Tragacanth is the binder, but other substances are added:

1. Ox gall, or rather its salts. This facilitates a fine dividing up of the pigment, which thus allows a very thin application.

It has the property of neutralizing the smallest traces of grease. Ox gall can be bought in every art shop for the purpose of neutralizing the surface of paper, which often becomes marked with grease on its way from the factory to the user. It may not be visible, but it will prevent the paint from taking evenly; thus, it is a worthwhile precaution to rub ox gall over otherwise untouched paper.

2. Honey, sugar syrup, or glycerine. Substances which prolong the drying time of watercolors—particularly those in porcelain pans—so that they are more quickly soluble.

3. Boracic or benzoic acid salts. They act as preservatives. Without them all glues in solution putrefy.

The characteristic smell of watercolors is often given by oil of bitter almonds, added solely to disguise the rather unpleasant smell of the glue.

Watercolor pigments are often so finely ground that they act as colloids. This is noticeable if an attempt is made to wash off the color. Some colors, although they become fainter, will stay in the paper. Genuine watercolor painting was made possible only by this fine grinding of the pigments. The method was evolved in the seventeenth century and was developed to its full perfection by the English painters Girtin (1773-1802) and Turner (1775-1851). Until then only "gouache" colors had been obtainable as finely ground pigments. Unlike true watercolors, the latter are not fully transparent and require the addition of white to make them lighter. Gouache colors as now sold are an unnecessary halfway house between water-

colors and opaque colors. The pigment of the latter is hardly finer than that of all the rest, including the finest sorts of powder color. Opaque colors can be prepared at home and should be used within a few days of mixing. They generally use tragacanth as a binder, but can also use gum arabic, cherry gum, or egg white.

CHERRY GUM is extracted from the cherry laurel. It was used in earlier centuries as a glue for cherry gum tempera.

GUM ARABIC is extracted from Arabian and Indian acacias. Both gums are very light and almost colorless in solution.

ALBUMEN is the main constituent of egg yolk, which was, before the development of **fresco-buono**, the most frequently used binder for mural painting. The fat content of the yolk makes it less liable to dissove after it has dried than egg white, and its color soon fades in the light. If egg white is used it should be whipped and then strained, so that it loses its coagulated, sticky consistency and mixes more easily with water.

I would caution you against mixing glue colors for yourself from the usual trade powder colors unless you are going to use large amounts in a short space of time. Too much preservative can have a deleterious effect, and it is difficult to judge the right quantity for small amounts of paint. It is best to avoid preservatives altogether. The advantage of mixing glue colors oneself is that they are then certain to be pure pigments, for bought opaque colors, especially the so-

called poster colors, are often mixed with other materials to give them body and density. Fillers are added to make the paint more uniform and solid, and also to make it cheaper. This reduces the intensity of the color, and is particularly noticeable in mixtures, which rarely have the brilliance you would expect from the brightness of the constituent colors. Complementary juxtapositions, too, are less strong in effect because all fillers have a dulling effect.

If opaque glue colors are used only occasionally it is best to buy what are sold as "artists' tempera colors," as they are most likely to be undiluted pigments, if they are made by a reputable firm. The binder used is only glue, not an emulsion. These incorrectly styled "tempera" colors give an optical effect similar to that of a genuine mat tempera or oil painting.

Since few artists today prepare their paints themselves, it is difficult to buy the right jars to keep them in. We therefore illustrate the type of jar provided for the author by a glass factory at small cost. It can also be used for mixing up the paints, and will save you the trouble of trying to fill tubes once the paint is mixed, a procedure fraught with difficulties and waste. Once the paint is kneaded in the jar, it should be rolled together to form a smooth lump and covered with a close-fitting plastic disc. A piece of ordinary adhesive tape can be made into a handle for lifting it. The jar itself is closed with a close-fitting rubber lid. The plastic disc will keep the paint from contact with the air and is especially necessary when there is not much paint left. It can easily be lifted out with tweezers. A stiff plastic spatula can be used to take out the paint. The jars are easily cleaned: they should first be wiped with a paper towel, and then washed out with water or white spirits, according to the binder used. Jars such as these can be obtained from firms supplying cosmetic factories, or a druggist will get them for you.

There is the danger with all glue colors you make yourself, and especially with casein, that you will put in too much binder. Even if it is thinned with water, it will make a skin over the painting. Carpenter's glue, tragacanth, gum arabic, and cherry gum should all be mixed in the proportion of 100 cc. of water to 7 gr. of dry substance. If the solution is stronger than this, because of careless measuring, the paint may scale or crack. It is therefore advisable to make trial strokes with the brush to see if the paint is just firm enough. Better too little binder than too much! If the color does not hold

Mixing oil paint with a round bristle brush in a glass container

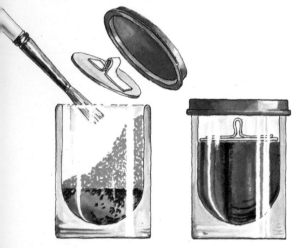

firmly on the painting, it can be sprayed with a very dilute solution of glue. A glue solution can be tested by smell. If it is beginning to go bad it is useless.

CASEIN is the best irreversible glue for painting purposes. It is derived from sour skim milk. It must contain no fat, as this prevents it hardening. It is not heated, but strained through butter muslin for 24 hours until all the whey is removed. The remaining curd is called casein. It swells a great deal in water, but is not soluble. To make it dissolve, an alkali, such as lime in solution, must be added.

A glassful of pure powdery white lime can be obtained from a builder's yard. It is best taken from the top stratum of the pit. It should be added to the curd in pea-sized quantities, one at a time, until a glassy, uniform, and sticky mass is obtained. For 70 gr. of this dissolved casein only a few gr. of lime will be needed; one quart of water is poured on and stirred to make a uniform solution, producing a glue which is probably still too strong, depending on the consistency of the curd. If it is very dry it may need twice the quantity of water. A test can be made with a cheap pigment: the brush stroke should dry hard in two or three hours, but must not scale off the paper, which should be firmly stretched, even when several coats are laid one on the other. Casein takes about a week to become completely insoluble in water. Paintings done in casein colors can thus be considered weather-proof, but only in so far as the support is weather-proof too!

Naturally, only pigments unaffected by lime can be used with casein. This is true also of the casein powders that can be bought ready prepared, as they too need a lye to make them dissolve, generally borax, potash, or soda. Casein, except in dry powder form, is as liable to attack by bacteria as any glue, and must thus be used immediately after it has been dissolved. Formalin converts it into a stable horny mass (galalith), and if a solution of formalin is sprayed on the finished painting it may cause the paint to come away from the ground. Undiluted casein is a strong emulsifier, making other materials emulsify very quickly. It functions at the same time as a glue.

RESINS and **BALSAMS** behave in the same way as glues for painting, except that they are soluble not in water but in volatile oils; spirits of turpentine (generally called simply "turpentine") is the most usual one used in painting. This is mainly a distillation from balsam, a natural secretion of conifers. Balsams can be considered as resins which occur in nature in a heavy solution with turpentine. French turpentine, which is twice distilled, is considered the best. Doubly rectified French turpentine can be bought both in art shops and drugstores. Ordinary turpentine contains unevaporated resinous elements. If it is dropped onto a glass plate it should leave no trace that can be seen or felt as sticky after it has evaporated. Resins and balsams dissolved or thinned with turpentine take much longer to dry than water-soluble glues. When dry they form a hard, glassy skin which is very brittle.

Resins, like reversible glues, remain soluble. If overpainting is done with resin essences there is a danger of taking

off the underpainting, at least super-ficially, and smearing. An addition of beeswax can afford some protection, and this also modifies the brittleness of the resins. Resin, like oil, "burns" slowly over a long period. This makes it crumbly and dark, especially if it has been used without pigment as a finishing varnish. Finishing varnishes play an important part in oil painting, because resins do not yellow and can at any time be softened and removed with turpentine, as long as they do not contain too much wax.

Perished resin varnishes can be re-generated by the famous method de-veloped by Max von Pettenkofer: the picture is exposed to alcohol or petrol vapor in a closed container, thereby giv-ing the varnish back its firmness and transparency.

SHELLAC shows that a small amount of wax can prevent the deterioration of resin. As you already know, the basis of shellac is the resin of tropical trees which is secreted when the trees are punctured by insects. This resin contains animal wax derived from these insects, and this makes it an ideal painting me-dium, though it is, for some unknown reason, very little used. It is sold in thin sheets and is used mostly as a polish for wood and as an insulator in the electrical industry.

For painting, light colored sheets that have not been artificially bleached are the best because shellac loses some of its solubility from the effects of light. It is dissolved in 95 per cent alcohol under mild heat to melt the wax in it. In a 2 per cent solution it is the most usual fixative for spraying on chalk drawings and pastel paintings. In thin coats it is also very useful as an insulator against absorption on glue grounds. Paints take badly on thick layers of shel-lac, and glue colors even scale off.

MASTIC is the most important resin used in painting. It is obtained in the tropics and sub-tropics from the mastic bush in the form of pale yellow balls or droplets which still have the earth and bark ad-hering to them. It is easily soluble in turpentine. A standard essence of one part (weight) resin in two parts of tur-pentine is the most practical. It is made in the following way:

A glass vessel which can be hermeti-cally sealed is half filled with spirits of turpentine, and the drops of mastic are hung in a piece of gauze over the liquid without touching it. The vapor from the turpentine, which quickly develops in sun-shine or warmth, gradually dissolves the resin, which then drips through the gauze into the turpentine. The bottle is shaken now and again to wet the gauze and ac-celerate the solution. All impurities will be held by the gauze, and the liquid will be clear and light yellow. Mastic can be added to the bag until the required con-centration is reached. This can be gauged by weighing; the contents of the jar should increase by 40 or 50 per cent, assuming that the turpentine has not evaporated to any marked degree. Mas-tic dissolves much more quickly if heated with turpentine, but it turns brown and is thus rendered unsuitable for painting. Reaby-made mastic varnishes may con-tain admixtures of other substances such as poppy oil, which looks just like mastic

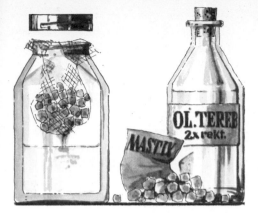

Dissolving mastic in two parts rectified spirits of turpentine

Canadian turpentine or balsam (Canadian fir) and the olio d'Abezzo from stone pines. Many of these cannot now be bought except at drugstores, but it is not really very important which tree the turpentine comes from. It should simply be as clear and transparent as possible and viscous, not crumbly and dry. Dropped into spirits of turpentine it should become thin. Good turpentines are as good as resins for binders; they do not yellow, but they are slower to exude the spirits of turpentine in which they are dissolved and thus stay sticky longer. Balsams, particularly Venice and Strasbourg turpentine, are some of the best substances for quick drying emulsions.

There is a whole series of resins, such as copal and amber, which used to be in favor with artists. They are, however, dubious in effect in the picture, since they give such a brilliant shine that, in general, it is better today to avoid them.

but delays hardening considerably; a thin application of mastic essence on a glass plate will dry completely to the touch in 24 hours, while poppy oil takes several days.

DAMAR is generally mentioned in the same breath as mastic, and in fact the two resins act in much the same way as far as painting is concerned. Damar solutions are as clear as water, which is an advantage, but damar is considerably more brittle than mastic, and also less fast to air and damp. Thus, varnishes made of damar sometimes cause a milky-blue "bloom" on a picture, which will disappear once the damp has been expelled. Mastic is therefore a better binder, its slight yellow tinge being hardly noticeable in combination with pigments.

TURPENTINE is a balsam secreted by conifers. The following kinds are differentiated for painting: Venice turpentine (larch), Strasbourg (silver fir),

WAX has so far been mentioned only as an additive to oils and resins. It is also a binder on its own and was much used in antiquity when it was the most weather resistant of all binders. Surprisingly enough, modern science has not yet been able to discover how wax was made sufficiently fluid in those days to be used at ordinary room temperatures for painting. It is known that in preparation the wax was melted on the fire and the pigments added to it, but the hot wax color does not remain liquid on the brush, and thus could not be applied to the picture. Even at a temperature of 104 degrees F., when the sweat is pouring from you, you

will find that the wax stiffens on the brush between the pan on the fire and the picture, making it quite impossible to spread on the canvas. Brush marks on old wax paintings make it quite certain that wax colors were put on with a brush. Moreover, so-called "Punic" wax was used, which does not melt below about 212 degrees F., whereas unprepared beeswax needs only a temperature of about 147 degrees F.

Probably the solution to the problem lies in using a slowly evaporating medium which is liquid when cold, something like turpentine oil or petroleum. But if you try to keep wax liquid in this way at a bearable temperature it needs about 15 or 20 times the amount of medium as of wax; since the wax alone is the binder, it could in this solution only make very weak colors, and they would not hold very firmly to the ground. This could be helped by warming afterwards, which would at the same time accelerate the evaporation of the liquifying agent. This was certainly done in antiquity, for there are traces of marks from iron spatulae to be seen on antique "encaustics" (wax paintings are called after the Greek word meaning "to burn in"). The brush marks show, however, that strong colored paints were applied at one time, rather than a long series of weak coats built up by overpainting.

I have tried this method, using wax thinned with turpentine, and found that sufficiently strong color effects could be achieved, which the transparency of the wax made very attractive. I would rather you did not ask, however, how long it took to put on the innumerable coats!

Certainly the antique encaustics were not painted in this way! Perhaps you can solve the riddle.

There would be no need to make such a fuss about this accursed wax were it not of such a perfect consistency, almost unalterable and of unlimited durability. Wax has been found unaltered after 5,000 years. It does not yellow nor crack and is not sensitive to acids in the air nor to weathering nor water. It shrinks a great deal in high frosts, however, and would crack in high latitudes on an outside facade in winter weather. It can be seen how durable wax is from the paintings done on marble, where the areas surrounding the pictures have weathered, leaving the wax paintings themselves unaltered and standing out like a flat relief on the surface of the stone. If anyone succeeded in making wax usable for painting under normal conditions it would make all resins, oils, emulsions, and water-resistant gums superfluous; we should have a single, uniform, and completely unproblematical binder.

All this refers only to pure beeswax. The best kind is the so-called "virgin wax" from cells not yet used for hatching grubs, which is ivory white in color. This can rarely be obtained, except by lucky chance from a beekeeper. But even ordinary pure beeswax is good. It can be bought at good hardware stores. If it comes from a beekeeper it has to be purified in boiling water. All dirt sinks to the bottom of the cake of wax that forms over the water as it cools, and which can be scraped off.

Punic wax was obtained by boiling up the wax with sea water. When hart-

shorn salt was added, the calcium and magnesium salts combined with the wax and caused its higher melting point. If you wish to make Punic wax yourself there is no need to go to the expense of a trip to the Mediterranean, it can be done easily as follows:

Boil 50 gr. purified beeswax in 500 cc. distilled water and add 5 gr. soda which has been dissolved in a little water. This forms a kind of soap with the wax, into which is stirred enough of a 10 per cent solution of magnesium chloride to make the Punic wax fall out in more or less firm crumbs.

In antiquity this wax, under the slogan "punica est optima," was used as widely as linseed oil varnish is today for painting of all kinds. The underwater surfaces of ships were protected by coats of it. The few encaustics of an artistic kind which have come down to us are as fresh in color as though they had just been painted.

LINSEED OIL over the years has proved itself relatively the surest of all oils used. Therefore it alone will be treated here. The much prized nut and poppy oils have the fatal drawback of occasionally softening without apparent reason, or even of never hardening.

Linseed oil is extracted from the seed of flax. For painting and medical purposes it is pressed out cold, for although more oil can be obtained by pressing it under heat this darkens the color and alters it in other ways. Care must be taken that the seeds are not mixed with those of any other plant or wood, as the oil will then not harden. The raw oil contains a watery slime which has to be removed. In old painters' manuals many recipes, some very strange ones, are given for the extraction and purification of linseed oil. Painters had then themselves to press and purify the oil. With today's science and technology it is, of course, hardly a part of the painter's art to extract oil from flax.

Opinions still vary on whether the oil is best if used when quite fresh or after it has matured. It is certain that newly pressed oil oxidizes more slowly than an oil which is six or nine months old. Rancid oil cannot be used; it is easily recognized by its smell and taste.

The oxidation of oils can be very much influenced. It can be accelerated by pre-oxidation, for instance, by blowing oxygen into it. This produces linseed varnish, which is used, instead of untreated linseed oil, exclusively for commercial paints.

For the artist's use "stand oil" is made in the following way: Linseed oil is exposed in an open container to the action of air and sun in contact with lead oxide which always forms on the surface of lead plates or rods. This thickens the oil, because the hardening process has already begun, and it gives a very shiny, fat effect when applied. It hardens quicker than untreated oil.

A number of pigments have the same effect, especially the cobalt and lead compounds. They act as catalysts, accelerating the rate of the reaction, in this case the absorption of oxygen by the linseed oil. If a pigment is said to be a "good drier" this always refers to its effect on oils, which harden by the absorption of oxygen.

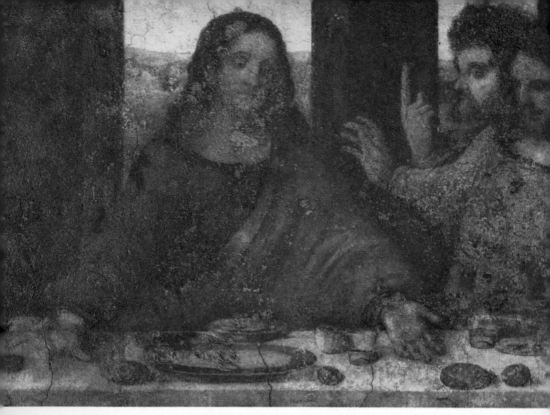

Leonardo da Vinci, The Last Supper. The picture was given a final coat of oil paint on a fresco ground and is shown here after restoration. The plaster had become mouldy in places, and was spotted out with gray-brown local color

Some pigments delay oxidation; lamp black is one of the worst of these. It may contain remains of nonhardening oils, and, in any case, like all dark pigments it requires much more binder to make it adhere than do light pigments. All these matters are related to the formation of cracks while the paint is drying, what we have called "early crack formation"; if quick drying oil colors are painted over those which harden slowly, particularly if these have not completed this process, the upper surface will soon break. Thus, in oil painting the rule is always to use slow hardening colors over quickly oxidizing ones. If the composition demands otherwise, then traces of "quick dryers" are added to the slow-drying colors and painted over only when the under layer has become quite hard. The old masters managed in this way to lay thick layers of white lead over dark and slow hardening colors without causing any cracking, except the inevitable late crack formation.

If you examine old pictures carefully you will often see that the surface is not uniformly covered with splits and cracks, but that there are large cracks in some places and none at all in others. The reason for this is the variation in thickness of the paint and the different behavior of the pigments.

Linseed oil, like all painting oils,

300

bleaches in the light and yellows in the dark. For this reason it is pointless to use bleached oil; it yellows and discolors all the more on the canvas. A thick layer of oil which reduces the penetration of light through to the bottom, yellows more, and more permanently, than a thin one.

It is also a great mistake to think that oil colors cannot absorb moisture. This can be demonstrated by spreading linseed oil on a glass plate and leaving it to harden for as long as a month or two. If the plate is then laid in water the oil film can be seen to swell and ultimately to come away from the plate entirely. A similar experiment with casein would have a contrary result: the casein would not be affected by the water. Transitory moisture does not damage oil paintings, and this may be why the layman imagines that an oil painting on strong canvas is the most durable and solid of techniques. He needs to revise this conception. The fact that the great masters succeeded in painting pictures which have withstood the test of several centuries is a tribute to their care and attention, but it does not make the technique in general any more certain.

Oil painting is quite useless on a wall. The film of oil seals the pores of the plaster, which then starts to rot, bubble up, and finally crumble away. It is amazing that there are still house painters who recommend washable oil plinths in buildings. A tragic example of the dangers of oil painting on plaster is the famous **Last Supper** of da Vinci. Always experimenting with new methods, Leonardo painted over his picture in oil colors. Its deterioration continues relent-lessly, defying the most highly developed techniques of conservation and restoration.

Although pure oil colors are still produced in great quantities, many good paint factories now have reduced the content of fatty oils in paints and produce the so-called "resin" oil colors. They contain a large, unfortunately unspecified, percentage of resin and some wax, which is also added to pure oil colors. Wax both protects resin varnishes from perishing and prevents pigments from separating from the oil in the tubes or forming a sort of jelly which is impossible to paint with. Resin oil paints harden more quickly than pure oil colors. Both evaporated solvents for resins and wax reduce the amount of binder and accelerate the absorption of oxygen by the oil.

In addition to bought oil colors, which are nowadays always resin oil paints, a suitable resin oil color can be obtained by carefully warming together 100 cc. of linseed oil with 5 gr. wax melted at about 158 degrees F., and adding, when it has cooled and been placed in a jar, 100 cc. mastic essence (of a proportion 1:2). Shut the jar immediately and shake it so that both substances are well mixed together. The pigments are kneaded with this binder into mounds of paste and left to rest at intervals to test the amount of binder required by the different pigments. These mixed pigments can be thinned with turpentine, just as watercolors can be thinned with water, without affecting their adhering to the ground. After the turpentine spirit has evaporated, 100 parts of linseed oil,

about 30 of mastic, and 5 of wax will be found in the hardened paint.

Our list of organic binders is now at an end, for all other oils, lacquers, varnishes, and such like, though they may be usable, are no better than those already listed and tend to muddle the painter and involve him in technical difficulties.

To avoid the difficulties of oily binders it is better to use emulsions instead. They provide the advantages both of oily and watery substances, while the disadvantages are rendered harmless by the emulsion texture. A simple emulsion is obtained by combining an egg yolk with glue (tragacanth or gum arabic) and linseed oil, to which an essence of resin is added later. The method is the same as for making mayonnaise.

The emulsifying properties of an egg yolk are, of course, limited; it will function for about 75 cc. of gum solution and 150 cc. of oil, depending on the size of the yolk. It is best not to try to use it to the saturation point.

Before making any emulsion it is wise to measure out the various constituents carefully, as the bit-by-bit method makes it difficult to remember exactly how much has been used. An emulsion is most easily made by mixing it in a water bath at about 75 to 85 degrees F., and then stirring it until it has cooled to room temperature to prevent its separating.

An emulsion can be made even without an emulsifier—for instance, with gum arabic and essence of resin (and with linseed oil). It is a sleight of hand possessed by chemists as part of their professional equipment. A successful result is announced by a sort of clicking sound in the mixture as it is stirred. The substance making the "honeycomb" formation should always be double in quantity to that which is being mixed in and, when necessary, thinned only with the substance which combines with it. Otherwise too much of the enclosed material would break the cell-like structure of the "honeycomb," and the mixture would curdle.

If you make your tempera colors yourself it is sufficient to make a paste only of a selection of the pigments which you intend to use. If a pigment is to be used only for a nuance in a mixture it can be taken from the watercolor box or the collection of oil colors, according to whether the tempera reacts better to an addition of water or of oil and turpentine. But, as we have said, this addition of other types of paint can be used only for mixtures, not for putting on by itself! This method saves much trouble and rightly used does not affect the technical quality of the tempera painting.

Once a layer of tempera color has hardened completely it is less sensitive to the solvent of the following layers than glue or oil colors necessarily are, but it does remain sensitive to some extent. The only paint which for practical purposes is completely insoluble to the following coats is a resin oil emulsified with casein—a relatively easy emulsion to make without an emulsifier.

LIME and **WATERGLASS** are inorganic binders. They are never used directly together with pigments; at most they are added, in a very dilute form, to the water in which the colors are ground. This is, however, not sufficient for fixing the pigments onto the ground.

Lime in the form of thick lime water can be used in a limited manner as a binder mixed with the pigment, but only for light colors much dimmed by white, and even they can be used only in a single layer, which is rarely sufficient in painting. If more than one coat is put on, the paint flakes off either as a whole or in separate layers.

True fresco, **fresco buono**, is very different. The pigment is ground up with water or lime water, or is bought ready mixed in bottles. It is painted onto the fresh plaster and the hardening lime covers it with a thin transparent skin.

We have already dealt thoroughly with lime plaster in the section on sgraffito. The use of pure lime (without cement) which alone gives fresco plaster its binding power is the reason why today paintings on facades in **fresco buono** technique can no longer be durable; for lime in every form reacts strongly to all acids, however weak they be. The author experienced this first as a young boy: he left a half lemon on the marble rim of his washstand and found a few hours later that the pretty star pattern of the fruit section had eaten into the "eternal" stone. His mother was less impressed with the charm of the design, since it was quite indelible. Lime plaster is equally sensitive even to the sulphurous acids in the air from the smoke of coal fires. In a few years they can destroy the crystalline lime layer over the fresco and bring about the deterioration of the paint as well. This is the situation in northern latitudes—at any rate since the introduction of coal firing. The greater moisture in the air is an added enemy,

making even the carbonic acids in the air destructive. The only hope of preserving fresco in northern climes is to use it indoors.

The only really weatherproof binder is waterglass, which has only recently been used by artists. It was first tried as a binder for painting in 1842 in Germany. It was at that time used mainly as a protective coating against fire for stage scenery, the stage then being illuminated by open lights. In 1880 A. W. Keim began to study and improve the technique of painting with waterglass. He called the technique "mineral painting"; it is nowadays sometimes called silica painting.

There are three kinds of waterglass: potassium, sodium, and double waterglass, which is made of a combination of the other two. The formulae are simple: K_2SiO_3, and Na_2SiO_3. Potassium waterglass is the only one suitable for painting purposes. The pigments must contain a certain percentage of zinc oxide (zinc white) and magnesia in order to petrify with dry plaster or natural stone through the agency of the waterglass. They are painted on the ground, as in fresco painting, with only water or with very dilute waterglass. The waterglass is sprayed on afterwards like a fixative. It then combines with the carbonic acid in the air to make potassium carbonate and silicic oxide. The potassium carbonate is water soluble and is removed by washing or simply by the rain. If sodium waterglass were used, sodium carbonate (soda) would be produced, which does not wash off easily and would veil the painting.

7. TECHNIQUE OF PAINTING

The technique of painting, as I have already said, is not to be confused with the style of painting or personal touch of the artist. Technique is the artist's trade, which he must master in order to be able to express himself. Technique, however, is closely connected with the artistic idea: a painter who is master of many techniques will not only interpret an experience or visual impression into a formal composition, but will also immediately translate his vision into a definite technique. Some people go about it the other way: they have devoted themselves to a single technique and only let themselves receive visual experiences which correspond to it.

Rembrandt, for example, was never, from all we know of him, inspired to a picture by a tender balmy spring landscape which would require the soft transparent coloring of watercolors. Rembrandt had to use oils in order to achieve his mysterious deep darkness from which he could then draw out the light only with thick layers of paint. Perhaps one could say more correctly that his motif dictated this particular technique, which could only be oil painting; and from this technique, the famous chiaroscuro, he never deviated.

Titian also often painted on a similar principle, i.e., bringing the light out of the darkness, but he used a less heavy painting for the light and gave an essential role to a light underpainting, letting it shine through the thinnest glazes, sometimes using 30 or 40, one over the other, and at the end putting in a few opaque lights. Titian's pictures often stayed in the studio for months, as each layer had to dry out before he went on to the next; so he had several pictures under way at the same time. Monet or Cézanne would not have got very far with such a procedure. They painted mostly outside from nature at an intense tempo. The picture was begun in a few hours and often finished without a break. The Impressionists used the so-called **alla prima** oil technique which can be executed only with the most consistently behaved tube oil colors.

Value judgments are irrelevant to a painting method insofar as it is a means of expression, but a picture can be judged from the technical point of view with absolute standards. The best technique is that which maintains the picture permanently in the condition in which it was left by the artist. Permanent is a strong word, for ultimately all material is perishable. Experience shows, however, that paintings which have not altered after a few years or decades can last for centuries without traces of decay.

You already know what the different factors are which contribute to this problem: the three components, pigment, ground, and binder. The most problematical is the binder, the least complicated, the color. The ground or surface stands

in reliability between the two. But even the best technique is uninteresting if its materials are wrongly or imperfectly used. And the picture is uninteresting if it speaks to no one and provides no experience. However, whoever has taken the trouble to learn painting properly will surely have something to say with it.

The whole wide range of techniques stands between the two poles of watercolor and oil painting. All the rest are intermediate modes of expression, to be recognized externally from the depth of color obtainable. It can be theoretically imagined thus: watercolor works from a white ground into the color and dark and soon reaches its limit there; oil painting grows from the depth of darkness into the light, which can extend through colors to pure white—white put on and not achieved by leaving out, as in watercolor.

This, at any rate, is the broad principle of technique, which can, of course, be varied, particularly in oil, where it is possible to work with the thinnest transparent paints of which watercolor consists entirely. With these transparent paints it is possible to achieve a glow of color comparable to the stained glass of a cathedral when the light is shining through it.

The many techniques are best understood by experimenting with the tendencies and styles of the two opposed methods, both in seeing and execution.

The similarities and differences in painting can perhaps be best explained by a comparison with music, for both arts have many ideas in common, even many common terms—for instance,

"tone," "color harmony," "tone color." A painting can be compared to the many-colored sound of a full orchestra, a solo song to a drawing. As in musical technique there are in painting many Italian terms which cannot reasonably be translated: **al fresco, fresco-secco, alla prima, sfumato** are words familiar to every painter and art historian. A comparison with instrumental music will make the qualities of watercolor and oil technique quite clear: the watercolor begins with a soft and gentle note and ends with a full deep concord. Everywhere at the same time the greatest depth of which it is capable should be enveloped in the fluidity of the lighter colors.

The oil picture begins with a mild deep sound of solo wind, grows in the many colors of the full orchestra, over which stand out the trumpets and horns with the brightest tones; violins and flutes draw light contours, and the high lights resemble the echoing cymbal.

Even if an oil painting is performed in the hurried pizzicato of Kokoschka the mark would be legato and the time andante. Watercolor can only be prestissimo; the technique allows of no exception.

Technically speaking, watercolor is the simplest way of painting. (This you know already from what has been said about water paints and paper.) When it comes to ability, however, and sureness, it is one of the most demanding of all techniques on the painter's ability.

Oil painting requires a thorough knowledge of the materials, and the way the picture is built up technically needs

to be well thought out if it is to last. The old masters knew their job so thoroughly because they produced, or at least prepared, everything themselves: the grounds, pigments, and, most important of all, the binders. The Impressionists (and not they alone!) relied on the products of industry which were just coming on to the market and were by no means perfected. They worried very little about the technique of mixing and putting on paints, and the result is what one would expect: very many pictures of the second half of the last century are deteriorating irretrievably. A consistent oil color has never been found which will stay unchanged in both upper and under layers. Added to this the different pigments influence the setting time of oil binders. For this reason oil colors cannot be worked with so unconcernedly as watercolors. On the other hand, with oil colors you can, if you go the right way about it, work at the same picture either at one sitting or after weeks or months, glazing and repainting solidly.

If you are equally conversant with the principle of watercolor painting and with the various ways of painting in oils you can proceed with all the other techniques. A painting with reversible glue as binder can be done as quickly as a watercolor, but it also allows as leisurely work as oil colors. This depends entirely on what you wish the final effect to be. Fresco on damp plaster requires the same speed, and as far as possible single-coat painting, like watercolor, while with fresco-secco you have plenty of time and can overpaint as you wish. Painting with genuine tempera and the mixed techniques of mineral painting allows both the thin transparent texture of watercolor and the opaque, even-modeled effects of oil color. Pastel is the only exception; it is made up of fine or broad lines, but this you already know from the section on drawing.

First you need either a single sheet of paper or a watercolor block. Directly before starting work, the paper is well dampened and stuck or, if necessary, pinned down. If you have a painting block you must thoroughly dampen the top sheet with a sponge cloth several times, though not so much that it forms uneven patches of wet, which would make it ripple. A single wetting is not enough. It takes quite a while for dry paper to soak up enough water; once it is soaked through it will hold the moisture for some time.

During this process, while the paper is relatively dry before another wetting, you can lay in a few pencil outlines of your intended picture. Wet paper will hardly take pencil at all. The lead should not be too soft—H is about right. The drawing should be done so lightly that the lines can be left without spoiling the effect of the finished painting. After the drawing, dampen the paper again and leave it to dry while you get the paints ready. If you work with semi-permanent pan colors, drop a little water onto each with a pipette so that the paint will come off more quickly later. Always keep two jars of water at hand: one for washing out the brushes and the other, rather smaller, filled with clear water for the pipette or for clean brushes. Ordinary tap water is often very hard and full of lime, which makes watercolors flake; for painting you should use boiled water, at least.

Right from the start get used to working only with thick brushes of the best quality. An average size is No. 6, with which you can make the finest lines, if it can be drawn to a fine point when damp. This point, of course, wears away after a dozen pictures or so—according to size—but even then the brush is excellent for less fine work. Even when it has grown

The best artists' watercolors in tubes and chinaware in the sizes usually obtainable; and students' and scholastic watercolors

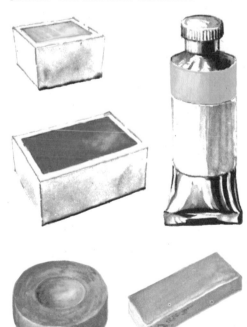

quite blunt it will still take up a good quantity of paint, and this is important: in watercolor painting the brush must always be full, whether you are doing fine detail or large surfaces.

To paint freely with watercolor you must expect a certain waste of paint; wash the color quickly and broadly onto the paper with a full brush. This will give enough color, probably too much. Rinse the brush thoroughly, press it out in an absorbent cloth, and use it to remove the excess from the wet painting. Do not color frugally and tediously; do not add a little again and again until the color is dark enough; it makes a wretched daub.

The paints are best kept in a large tin box, which can be bought for both pans and tubes. It is, of course, beneath you to buy a box ready filled with paints. Select them to your taste according to what you now know about pigments. Tubes or pans—it is all one, but take note:

Pans are more economical, for you use only what you need, but it takes longer for pan colors to soften. To take out paint from the pan, use cheaper brushes or old blunted ones that are no longer fit for painting. Never use a dirty brush on a pan! You will never again get a really pure color, and that is one of the essentials of watercolor. More than in any other technique muddy colors are to be avoided.

Tubes are simpler. You simply squeeze the quantity of paint required onto the tin palette and take from it for mixing or painting direct. Do not imagine that

Watercolor artist at work. His equipment consists of a container with water to wash brushes and solvent, a pipette, jars of used and unused brushes, pencil, eraser, damp sponge, a rag. He is using a watercolor box fitted with pans and a folding lid forming a palette

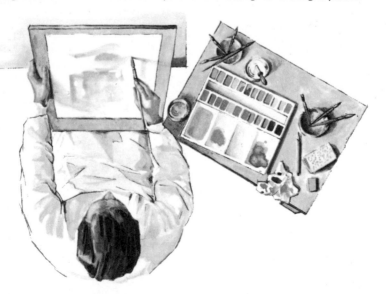

a collection of colors mixed in a disorderly smear will be an inspiration! If you want to experiment with mixtures it will perhaps help to have several palettes ready. Watercolor palettes are made of white enameled tin and have shallow hollows to hold the fluid paint. Generally, the lids of paint boxes are made to serve as palettes, but they can also be bought separately. It is not very practical to have several porcelain dishes, especially if working in the open.

If you use pans the palette needs only the largish hollows into which plenty of the liquid paint is placed and mixed. For tube colors there is a palette with a row of smaller hollows into which the contents of the tubes are squeezed in small quantities, and from there moved onto the larger hollows as the paint is required.

Since watercolor must be painted broadly and fast and since every new shade must be mixed clearly on the palette, we shall soon fill up all the space on it. It would take far too much time to clean a section for each new mixture, so it is best to use a second palette and even a third if necessary. Unused left-over paints are then still available, and this can be very convenient if a first application has been too thin and needs going over again. This often happens as the work progresses. Watercolor can be done quite well with one brush, but three are better: one for yellow, orange, and cadmium red, one for alizarin red to violet, and one for

Detail (1:1) from a watercolor study using rough Whatman paper, once slightly wetted

better to have two brush jars, one for blunt brushes for taking out paint and mixing it and one for painting brushes. If the brushes stand spread out like a sparse bunch of flowers it is easy to see which one you want.

Often even several palettes get filled up, and sponge-rubber cloths or rags are needed to wipe them clean. A whole stock of these should lie ready to wipe away paint that is finished with. Dirty cloths can be thrown into a box, and after the artistic side of the work is done they must be carefully washed out under the tap. These cloths are also excellent for removing unwanted paint from the picture.

Later, when the paper has dried out too much from the first painting, it cannot, of course, be dampened with the cloth again. A fixative spray filled with clear water is then used—but be careful! Not more than a breath of water should be sprayed on—perhaps to be repeated again later—or the colors will run into each other and all over the place.

For painting with watercolors you should sit at a table supporting the block or board at the edge with the left hand. Then you can hold the surface flat and at the correct angle. The more fluid your painting is the more the color will tend to run down and be darker at the bottom. This has to be prevented. The palette, too, should lie on the table. If it is held in the hand the fluid colors will spill into each other in the heat of the

green to blue. If you want to work in the really grand manner, use one more for gray and one for brown. If you work with only one brush it must be very carefully cleaned before each use. This takes time and is never quite certain. If, for instance, you use yellow after blue it is more than likely that a trace of blue will stay in the brush and give the yellow a greenish tinge.

It looks very fine to hold all the brushes in the left hand, and the palette too, but it is not really very practical. It is much

Stage reached when work stopped about an hour later. The end was precipitated by approaching mist, and as a result the shadows were overworked and too dense

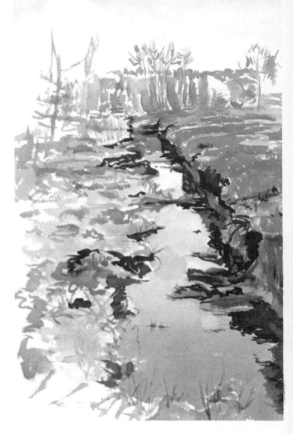

moment. Easels and palettes held in the hand are used only with thick, not liquid, paints.

However much you try to get the final tones at once, you will very rarely succeed. As you work, the effect of the picture evolves only gradually, and you see how to heighten it with darker depths and alterations in the colors; also you will need to put on two or three layers of color. Provide yourself, too, with a few strips of paper for testing colors, particularly mixtures; watercolors always look different on paper and on the palette.

In watercolor you are working only with transparent paints. The white or tinted ground shows through all the painting. If you want to hide it with an opaque color, then give up watercolor altogether. If your painting has the effect of one done in opaque paint, however cool and clear the color may be, the spontaneous, fleeting and watery character, the tenderness of its nature would be lost. Opaque paint or paint too much overlaid produces "holes" in the picture, particularly if in other places there is no more than a single layer of paint.

You know by now, of course, that white should never be found among watercolor pigments. White should be created only by untouched paper, at most gone over with a clean brushful of water. If a patch of color is too dark it can be moistened with a clean brush and some of the paint removed. Natu-

rally, the paper will never be quite white again where paint has once been on it.

The nature of the paint allows the following method to be tried: let a first draft in not-too-heavy paint dry completely and then lay the whole sheet of paper in water. As soon as the colors are dissolved, rinse it. This must be done quickly and thoroughly to prevent the runny paint from sticking in new places where it is not wanted. The paper is then dabbed dry with a series of clean cloths;

311

this removes still more paint. A very faint image will remain, its strength depending on the kind of paper and the paints. If the pigment is colloidal in fineness, more will stay in the paper than if the coarser pigment powder was used. Differences in the granulation will thus affect the depth of color left by the different paints. You can then paint further on the paper while it is still damp or has been dampened again.

This method gives you a sure foundation for a carefully thought out, detailed composition; but, of course, it loses the rapid, unfinished charm of a spontaneous painting and, as has been explained, the pure white of the paper.

Another method gives a similar effect: you work over the whole picture with very weak colors and put in deep, full colors only when you are certain of everything else. The final effect is more brilliant and harder than with the washing-out method, because some places on the paper can be left untouched.

At first every watercolorist tends to make a number of technical mistakes due to a lack of sureness in putting down form and color. One of these mistakes, or faults, is working too slowly. If the paper dries too much, the paints, particularly the very fluid ones, dry with a dark rim round them which is very hard to take out, even by washing over with water. It would be wrong to give up using liquid paint because of this, as the animation of the work would be lost and the temperamental effect of the picture with it.

If you want to begin more gently, more tentatively, then start with cool, light colors. This is done for a tentative beginning in any technique. The natural model provides a parallel: the distance is always cooler in color than the foreground and tends to blue. Warm, close colors come last. If you paint with the reverse procedure, the picture becomes heavy and without contrasts, which is especially unfortunate in a watercolor. Every picture should be built up from weak to strong colors, not vice versa. In watercolor painting this means omitting the strongly colored areas until the cool, duller colors and weak shadow tones can be seen.

When discussing pigments we mentioned that black has its place in watercolor, if it is transparent. Otherwise it would be an alien element among the colors. Black should always either stand alone or under a color. If transparent black is laid over other colors it kills them completely and makes them colorless and dirty, but as an underlay it can, particularly in a very thin gray application, give the illusion of substance and solidity. The limits of depth are reached in watercolor when the application of a dark color begins to be opaque. It may be that you sometimes put on a light yellow or green or blue so that it is almost opaque,

This picture of a stream quite familiar to the artist was painted one misty spring morning. Light conditions remained constant for some hours, allowing time for greater deliberation, and enabling him to achieve the gentle tones without overpainting. Whatman paper was used, and as it was continually drying, had to be partly wetted again (detail, ½ actual size; the surrounding landscape was shaded off)

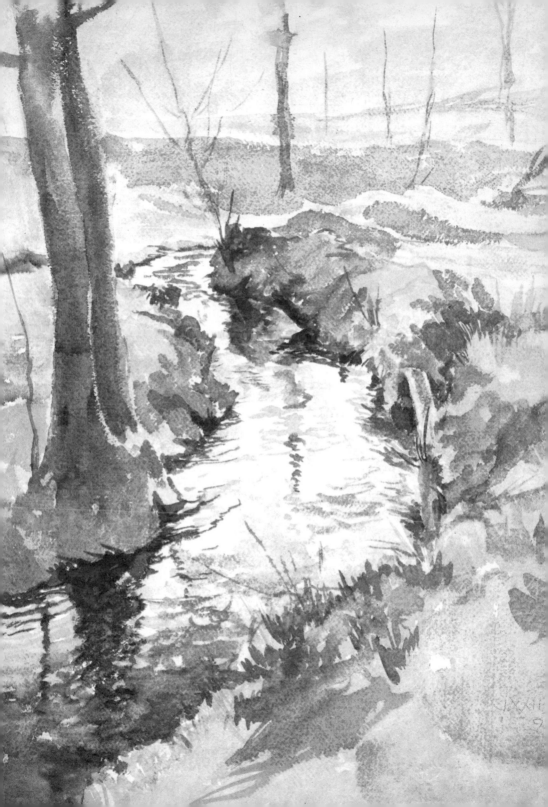

but if the color becomes darker it is permissible only if it lets through a shimmer of the color of the paper. An impression of great depth can be achieved in watercolor even with very light colors. Like a drawn sketch, the watercolor which most stimulates the beholder to co-operation arouses his imagination and thus can affect him more than an oil painting. The oil painting has to formulate more unambiguously with its depth of color and the technical manner of reproducing exact detail, or else be consciously indistinct. The fortuitous does not suit it.

Illusion or suggestion, inviting the collaboration of the beholder, is the essence of the watercolor as an art form. For instance, the illusion of twilight and darkness can be obtained not only from depth of color but from tone: you can paint a twilight scene in the lightest colors if the characteristic color harmony, the dominant tone of the hour, is rightly caught. This matters more than depth.

I said, earlier, that watercolor is composed of "pure" applications of color. This does not mean that you must, for instance, make green by putting pure yellow and pure blue onto the paper. By "pure" is meant clear and definite mixtures made on the palette. (In no painting is it permissible to mix paints on the picture itself.) Correction of a color can be done only by overpainting with a transparent wash or, if that cannot help, by washing out the wrong color with water. Overpainting requires great

speed so that the color underneath does not smudge. It cannot be done while the paint is too wet. A feeling for the correct moisture of the paper is a matter of experience and ultimately, too, of personal taste. Some artists produce their best effects with absolutely liquid colors which even run into each other; others can work only if the paints dry clear, without a rim, next to each other.

Every painter has his preferred technique, but there are some effects which can be expressed only in watercolors: cool light, misty springtime, soft autumn, and, ever and again, water—rain, streams, lakes, melting snow. It seems that anything that is wet calls for a technique that uses water profusely as its elixir.

You can see how difficult watercolor painting is. Even if you prefer painting in oils and find yourself more at home as a beginner seeking out the right coloration by trial and error with oil paints, watercolors are still the best teacher and ultimately the best criterion of ability, for you have to define your form and color at the first stroke, practice speed and concentration and work broadly and simply. Thus it is quite right that watercolors are used almost exclusively in the schools, although a good painting is so difficult. It is, besides being the simplest technique, of the highest educational value.

Watercolor is the beginning and the crown of all painting technique.

If all the principles of watercolor painting are turned upside down we get those of oil painting. This is most plainly seen in a technique developed since the beginning of so-called "plein-air" painting: work in the open air and not in a studio. It is called alla prima and implies an application of paint without underpainting or glazes, enabling the artist to finish his picture in one sitting, directly from the object.

Factory-made oil paints in tubes are essential for this; they do away with the need for preparing the paints and allow the painter to complete his work directly in the open air instead of working in oils in the studio from a watercolor or gouache sketch. One can safely say that without factory production of paints in tubes the development of plein-air and impressionist painting would have been impossible. The method of working is so simple that any tyro can cope with the technique once he knows something of the fundamental principles involved in the use of the materials. If he is lucky enough to come by first class paints and a semi-serviceable painting surface (there are no first-class surfaces to be bought!) then his oil painting may last for a long time in a satisfactory state of preservation.

There is no need to spend time in lengthy instructions; you can have a try straight away:

Buy painting board (card) prepared with a half chalk ground, some flat bristle brushes, one each of sizes 2,3,4,7,9, and some oil paints (these will, in fact, be resin oil colors, but today they are simply termed oil colors in the trade). The choice of colors can be the same as those recommended on p. 261 for the first attempts in watercolors. Added to these you now need white pigment—either titanium white or lead and zinc white. A ready-made assortment of paints always contains a few undesirable colors. You will also need some turpentine (genuine spirits of turpentine) and white spirit (turps substitute) for cleaning the brushes. If you have only one palette you will need a palette knife to scrape off unwanted remains of paint and make space for new ones—an old table or kitchen knife will do the job. Finally, plenty of old rags for squeezing out the brushes and cleaning the palette knife must lie ready at hand.

Showing still more clearly how oil is the opposite of water painting, the painting surface must not be white. You can choose any dull color which fits in with the color scheme you have in mind. The most suitable is either a pervasive shadow tone or, if you are going to work with glazes, its complementary color.

The coloring of the ground can be done in several ways—for instance, by painting in ordinary water or glue paint (sold as "artists' tempera color"). If you find this rather fluid paint too risky, because it may soften and smear the

priming, you can adopt one of three courses:

1. Mix dry powder color to a liquid with mastic varnish in the proportion of 1:2 and thin again with spirit of turpentine.

2. Dilute oil paint with turpentine until it is runny.

3. Rub over the white surface with pastel, wipe in circular motion with a thick wad of rags, pressing quite hard, and then fix with solution of shellac until it will not smear—no harder—as though it were a chalk drawing. This method of coloring the painting surface is the best under the given conditions; it contains no dangerous binder, the coat of shellac prevents it from being too absorbent, and the subsequent painting cannot dissolve the priming. It also has the advantage of being dry in a few moments after application. With a priming of oil color you will have to wait at least a day before beginning to paint. Priming with glue paint takes an hour or two to dry,

Flat brushes Nos. 4 and 16, with short, medium, and long bristles

or longer unless it is exposed to heat or the sun. Furthermore, a coating of glue paint leaves the surface more absorbent than shellac fixative or resin oil, and the painting method to be described requires a surface as little absorbent as possible.

The painting should be done standing, and the surface should be almost upright. This gives the painter the greatest freedom of movement and accustoms him from the start to step back to check the effect of the picture from the distance of a few paces. An easel is therefore required. Advice on choosing an easel is given in the section on The Studio and Its Equipment.

After these initial preparations, you can begin. First comes the drawing in on the panel. Unfortunately, it is still considered "professional" to draw in with charcoal, although the black from the charcoal immediately takes away the purity of the colors put on over it. Pencil is equally unsuitable. It is best to draw with a fine brush and very thin color. If you are still uncertain, use a pastel or red chalk, according to which color best suits what will follow. On a foundation of terre verte green, for example, it is best to draw in with terre verte pastel; of course, a harder pastel would be more convenient and more delicate, but unfortunately it exists only in red, black, and white.

The rule is to draw lightly for the blocking in and to rub out with a rag as many of the wrong lines as possible, blowing away any chalk which lies too thickly.

Do not on any account attempt detailed drawing at this stage! The drawing in is only intended to divide up the painting surface and settle the composi-

tion, and this in not too-definite a manner; after all, you are painting now, and in painting the color is as much a determining factor as the form. In any case, all details will be covered over with paint again. If you were embarking on a largish painting, a sketch of the composition in color would be part of the preparation.

Now take the paints. The first selection which you squeeze, but not too lavishly, onto the palette should not be all the brightest colors. The darker colors should predominate at first; they will give a rather neutral colored mat, and broad indication of the picture. Even if you have to paint large areas, say, in cad-

mium yellow, you should underlay them first with a "rub-in" in medium ochre. Parts of this underpainting will, perhaps, be able to remain at the end as half-shadow, particularly if it has been applied as it should, not aggressively and thickly but lightly, with thinned, almost transparent paint. "Blunting," "granulating," or "dimming" are the rather outmoded painter's expressions. Instead of thin, transparent painting the laying-in can be done in separate touches, or scrubbed onto the panel with a rather dry brush and unthinned paint. This is a matter both of personal taste, of your now developing personal touch or way of painting, and of practice. In this first

Painting in oils. In addition to the colors, the equipment includes cleaning materials, diluent, spatula, and palette knife

stage of painting you begin to model the forms, for you are, as Rembrandt kept saying to enlighten others and remind himself, "a painter, not a colorist." "Coloring" you do only once: when you tint the ground. In the first mat stage of painting you put in the shadows and other dark areas and lighten with colors mixed with white where form or color require it.

The first selection of paints on the palette has included white pigments, among them white lead, which causes the colors mixed with it to harden quickly. Pigments sensitive to lead, such as cadmium sulphide, are hardly likely to be needed at the beginning, but when they are used they must, of course, be lightened with zinc or titanium white. For this is the characteristic of the **alla prima** technique, and indeed of all body paint techniques, at any rate in the top layers; white is added to all colors to lighten them. Even were the ground white it would not be used as it is in watercolor. This use of paint gives quite the opposite effect both from watercolor and from a glazing technique in oils.

You started modeling the forms slightly at the first painting. In the method presently under discussion darks and lights which give the sense of relief should now be indicated in the many colors suggested by the natural model, not merely modeled in dark and light of the local color. This method of work would require a modeled monochrome underpainting in the complementary color finished with glazes of the local color.

Although the color is built up gradually, the picture is completed in one sitting. This is technically necessary, for the paints must be laid on one after the other, "wet in wet," before the binder begins to harden. It is dangerous to continue working on a half-dried painting because fast-drying paints on the top would break and form early cracks. In **alla prima**, the oxidation of the oils and resins proceeds as though all the paints were put on in one application.

The convenience of oil painting is that the colors, even when thinned, cannot run into each other unless they are so fluid they run from the palette too. Thus, although the paints are put on as a more or less soft paste, they make no hard rims as does watercolor when the paper is too dry. And though here, as everywhere, it is much frowned upon to mix colors on the picture itself, the consistency and long hardening time of oily binders do allow a little working together of paints lying side by side.

When the work has taken shape from

Ph. O. Runge, sketch for a portrait of the artist's mother. Oil colors on canvas. This sketch gives an exceptional insight into the proper organization of the alla prima method. First came a thin underpainting in unobtrusive colors, so that in the shadows the green ground partly showed through. The high lights were then painted in opaque directly onto this layer, as were patches of reflected light in the shadows. Runge used the green ground which shimmered through as a complementary color for the reddish glaze which covered the whole, thereby rendering the skin tone in all its lifelike freshness and engendering the most varied shades of optical gray.
With unique application, Runge extracted the utmost from color mixing as well as from transparent overpainting (glazing) and also direct opaque shades. By combining these two effects he gradually attained an outstanding plastic and almost glassy look. He might well have revolutionized the handling of color, but he died at the age of 33.
The sketch reproduced here was obviously kept for a long time rolled up. The cracks running through paint layer and primer all the way across show clearly the damage caused when the picture was unrolled

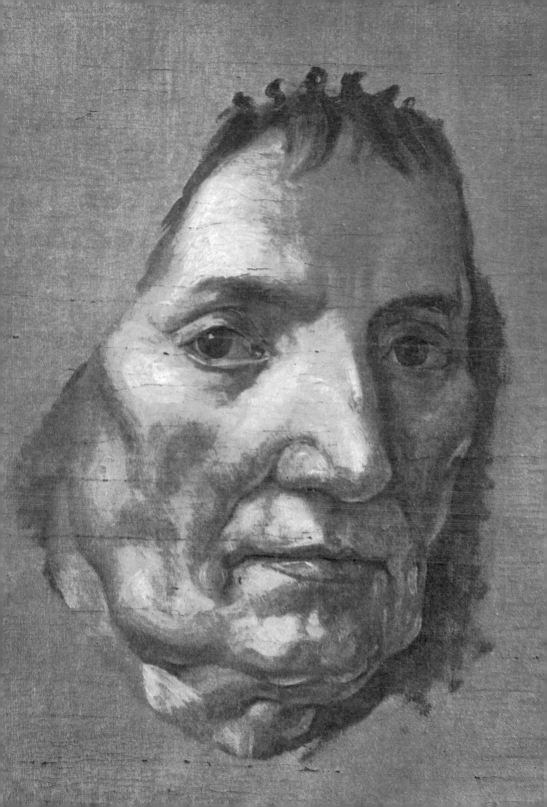

H. Gilman, Mrs. Mounter at the Breakfast Table. The underpainting for this picture seems to have been applied boldly with very little detail. Completely opaque color areas are juxtaposed without overlapping, like a mosaic built up of patches of oil paint

the form and color point of view it is worked up with stronger colors and lights until the last high light adds the finishing touch.

If you have done it well then the painting can be considered truly finished. In some places the tinted ground stands almost untouched, and the more neutral-colored ground work shines through the upper painting, though in places this may be so thick that not even a black ground would show through. Thick painting gives the surface a pleasing, tactile, plastic texture. Carried to extremes this manner of painting has led to painting with the knife.

The method described above is that used by the majority of painters since the beginning of Impressionism to the present day. Technically it is preferable to make one's own glue ground, rather than to use bought ones; the best are on hardboard with glued-on canvas. The texture of the woven cloth corresponds to impasto **alla prima** technique much better than a smooth board. The surface should be protected with shellac sufficiently to prevent its absorbing the binder from the

bought tube colors; for this produces both yellowing and the so-called "sinking in" of the colors. When this occurs the absorption of the binder allows the colors to harden without any sheen, and as this never occurs uniformly it gives a blotchy effect to the whole picture. The paint sinks again, however often these mat areas are repainted, unless the area is first allowed to dry thoroughly and then given a coat of varnish. This process, however, would bring an entirely unwanted binder into the painting. A finishing varnish gives the surface a uniform sheen and protects the penetration of dust into the unevenness of the paint. It must not be put on too soon. A good varnish is 1:2 or 1:3 mastic essence with at least 2 per cent addition of wax.

You can also dissolve wax alone in turpentine with a small addition of mastic to give a paste which is just spreadable. This varnish is the surest protection against damp; it should be applied very thinly with a soft bristle brush. The drawback is that it remains soft for a long time, unless you expose the picture surface, after careful brushing, to warmth until the turpentine has evaporated. The surface begins to sweat, and some water evaporates along with the spirit of turpentine. Strong heat should never be used with oil because this browns it rapidly. Gentle warmth, from 140 to 160 degrees F., is unharmful.

Another reason why coating varnishes should be put on very thin is so that they will not arrest the oxidation of the oils. It probably takes 60 to 100 years for a thick oil paint to be fully oxidized. This is when late crack formation sets in.

We can make one final comparison between watercolor and thick **alla prima**

oil painting: both methods are technically easy to manage. Both require ideally that the work be completed at one attempt in front of the subject.

But whereas watercolor painting entails no technical risk to speak of, oil and resin oil painting are the most dubious of all methods. However, corrections are always possible with oil paints. They allow the artist to work as long as he wishes at a painting to gain the greatest effect of form and color. Any error can be rectified without aesthetic damage to the painting, or covered over, scraped out, and repainted, and even made pure white right at the end. On the other hand, a watercolor is ruined if it is corrected or lightened with white.

Both techniques have one good thing in common: they show hardly any difference between wet and dry colors, whereas all glue techniques and fresco paintings suffer from a very great alteration. Opaque oil paints and watercolors are thus the best techniques for the beginner and should both be practiced.

Lastly, we must consider a branch of **alla prima** technique much used at the present time in abstract painting: palette knife painting. The paint is not put on the canvas with a brush but with spatulae of the most varied sizes, even some small trowels like those used by builders for laying bricks. The paint is used unthinned, straight from the tube, as though it were putty or mortar. A palette knife cannot at once give such precise form as a brush, and modeling is done after the paint is put on with the edge and point of the knife. The character of the picture surface thus painted is rather like a low relief. The shadows of the solid paint are part of the effect and often constitute

the picture's only charm. Spiritual content is often in short supply when so much seeking for effect is involved. For if anyone thinks he needs the texture created by the shadows for realizing his artistic concept, he can paint it in with thin paint, and probably give thereby a better idea of whether he has something significant to say or is simply covering the surface with a colored texture which is more or less all there is to be expressed. Many, however, go a step further: they model a low relief in gesso and cover it with thin paint, or they squeeze the paint straight from the tube onto the surface and develop great virtuosity in spinning out the ooze in the finest threads.

I will offer no opinion as to whether with methods of painting such as these there are other, hitherto unrealized ideas to be expressed. But it is certain that such a use of paint by the pound in this way implies a great lack of respect for it. Its charm as a substance can be thoroughly enjoyed only by using the whole range between softest glaze and a thin body color. Again, there is the question of the technical dangers of putting on paint inches thick at a time. Only in lucky cases will the compact layers remain without huge splits until late crack formation occurs. Thereupon, when the thoroughly oxidized oil begins to "burn," enormous cracks will be accompanied by the shrinking up of lumps of paint, and much of it will fall off. Even were this not to happen, the inevitable coarse splits will ruin the intended effect of the picture—quite apart from the fact that the thicker the paint is, the more the oils yellow and brown.

Knife technique. Detail, actual size

A medium which is handled in much the same way as impasto **alla prima** oils is opaque glue paint. Glue colors produce a dead mat effect, however, and can never rival the depth or luminosity of oils.

The difficulty here is that glue colors look distinctly darker wet than dry. This aspect is most pronounced in the medium hues, and means that the artist while still at work on a picture cannot know with certainty what the final effect will be. It requires some experience to use glue colors without spoiling a picture by constant retouching. There are, moreover, technical limits, even where use can be made of impasto overpainting; glue paint applied too thickly is liable to break away from the ground, develop cracks, and crumble. Properly bound glue paint should be indelible when dry (but on no account contain too much glue). Assuming that such paint is used, it will adhere well, and hide the ground without caking.

Glue colors have greater hiding power than oils applied equally thinly. The reason for this is that oil holds the color particles permanently congealed, as it were, while glue solutions shrink noticeably in volume in the drying; when this happens on a big scale, the particles cling to the under layer like fine pebbles. Only when they are wet, therefore, can glue colors equal oils in depth. Once the water contained in them has evaporated, leaving only the glue, the pebbled surface is left considerably enlarged and capable of reflecting more light. The color is almost as vivid as pigment in powder form, and its hiding power is correspondingly enhanced. A study of seventeenth and eighteenth century gouache still lifes with flowers, painted on a dark ground, demonstrates the truth of this. For oil colors to have the same hiding power, they must be applied much thicker. If you apply a little glue color to a glossy paper and then draw a hard pencil line across both the paper and the patch of color, you will find that whereas the pencil only leaves a faint mark on the shiny paper, it shows up clearly on the color patch, because the

Half varnished patches show the difference in color between wet and dry glue paint

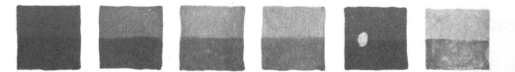

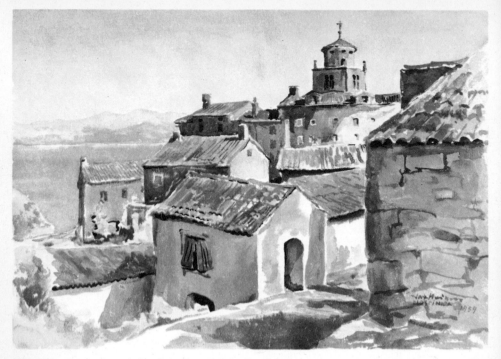

The theme was a travel sketch in watercolor. For the glue color version, white watercolor paper was primed with cobalt blue and cadmium red watercolors. To give an accurate rendering of this scene, high up over the Adriatic where pirates once nested, as it was imprinted on my mind, I compressed the composition somewhat, reducing the big shadows on the right and leaving out the bushes on the left

rougher surface of the pigment acts like sandpaper. Conversely, a patch of oil paint would become even glossier than the paper, and the pencil would give off hardly any particles of graphite at all.

To learn to judge how much glue colors will lighten in drying, you should try making a number of brush strokes in glue color, then half cover them with a thick coating of a varnish composed of pyroxylin and amyl acetate.

This experiment should not lead you to suppose that you can impart a darker hue to a finished glue painting by varnishing it over. What occurs in this case cannot be gauged in advance, nor can it

by any means be regarded as a comprehensive painting technique. The picture is robbed entirely of its essential charm, and with it a large part of the artist's inspiration. The same thing happens to watercolors when they are varnished. Conversely, the chalky tone of an opaque glue painting can render effects which are virtually unobtainable in any other medium, although not altogether unlike a certain type of pastel.

Glue painting, then, has its own characteristics; but quite apart from this, it is well suited to sketching and to preliminary sketches for oil and true tempera painting—far more so than watercolor,

Stage 1: The background and light areas were covered with titanium white, lightly tinted. This resulted in greater brilliance for the luminous colors to follow. The priming color was mixed from the start in the main shadow tone, and this was largely left. It could be further varied, as necessary, by the use of pale glazes

for example. It should be noted that while watercolors must be applied on a wet ground, glue color, which is equally direct in its application, has the advantage of always being painted on a dry ground, so that, despite rapid execution, the paint underneath never runs or smudges.

The most suitable support for this medium is cardboard. Paper that is less than 14 ply buckles when painted and remains buckled even after the paint—which varies in thickness—has dried out. This may occur with cardboard, too, and depends on the quality of the board and the way the paint is used. For this reason,

pasteboard, or a synthetic fiber board with good quality paper of the required thickness glued to it, provides a better support. In addition, any support which is good for oil painting will serve the purpose, as long as it is properly prepared to receive glue color. The final choice of a support is determined by the format and by the artist's aims.

Similar considerations determine whether to leave the ground white or to tint it. The best and easiest way to tint paper is to apply a very runny watercolor with a flat brush from two to four inches wide, known as the blending brush, moving it back and forth over the paper. To

Stage 2: The colors are everywhere uniformly intensified, and it would have been possible to complete the work boldly at this stage
Stage 3: Too much elaborate detail at this stage marred the artistic effect. This shows that one can never stop too soon; and also that watercolor work does not transpose

do this, the support must lie flat to avoid collecting paint at the bottom edge, thus ensuring that the surface is kept fairly even.

It is also possible to tint the glue ground with pastel chalk. When this is done, however, shellac should not be used for fixing, as glue colors do not adhere well to this fixative and flake off with repeated overpainting. A weak glue solution, such as gum arabic, tragacanth, or skim milk, makes the most satisfactory fixing agent; carpenter's glue is not good, as it cools down too much in the spraying and sets prematurely. The glue must be thin enough to travel up the blowpipe.

The spraying calls for particular care, since water stays on the paint surface longer than the alcohol in shellac, which evaporates more speedily. As soon as the medium has been rendered indelible, work can proceed as with **alla prima** oil painting. The same palette and brushes will do, and water may be used for thinning and washing.

As mentioned earlier in connection with ready-made colors, "artists' tempera," as it is called, will prove fairly safe; but it is better to obtain pigment in powder form and make it up for yourself, using an appropriate glue solution. In this way, you will be sure of painting

into other media. Despite the exaggerated shadows, the white from the previous sketches shows through and loosens the whole composition. The correct way to obtain this effect in glue colors would have been to paint directly on to unprimed white cardboard. Ordinary bought tempera colors were used for this picture

with pure and unadulterated colors.

Deciding whether to use a white or a tinted ground will be determined by your particular aim; and whether white or tinted, it should play a part in the picture as a whole. A delightful effect is achieved when a tinted ground is left to show in places. Using glue colors, and carrying out the underpainting in watercolors, the color can be made to darken very gradually so that the tinted ground is distinctly preserved. On a white ground, the underpainting has a naturalness and delicacy which looks wonderfully fresh against the overpainting. The final coat may also be applied more thickly, if this

is in keeping with your aims and methods. From a technical viewpoint, this is quite safe, provided that the layer of paint is less thick and cakey than it is with **alla prima** oils. The technical possibilities of glue painting are increased if casein is used in place of nonreversible glue. This can hardly be done, however, without restricting color choice, since it means that no coloring matter sensitive to either chalk or lye may be used. Even when casein has been left to set for a full week and is completely insoluble in water— and the water used for thinning has evaporated—it will be all but impervious to simple overpainting. Prolonged wash-

ing is the only method. Hence, the best use for glue colors is for really extensive and time-consuming work. For instance, pictures requiring glazing are difficult to do well because the layer beneath the nonreversible glue dissolves so rapidly. With casein, too, the colors lose rather more of their brightness than with the glues previously mentioned. When a mat painting is completely dry, it can be given a sheen by brushing or by rubbing with a woolen cloth. This makes the colors appear somewhat deeper and is a procedure which thoroughly suits the medium. If the paint is laid thinly onto a white ground it will look like a genuine fresco. Naturally, it is a prerequisite that either the untreated sheet of paper or the glue ground should be prepared with casein-bound pigment before painting begins so that, even when the ground is untreated, it is given a layer of casein.

If you try applying this undercoat on cardboard not treated with glue, you will find at once that the cardboard will roll up with great force. Fresh casein is a powerful binding agent, and it is often insufficiently thinned. When this happens, it rolls off in broad flat cakes, taking even the primer with it. For this reason, the paint layers should barely go beyond the point of indelibility. If this point is not reached, a very strong dilution of casein can be used afterwards as a fixer. The most risky procedure is the impasto use of a casein color containing too much glue. It detaches itself stubbornly from the ground. Abstain altogether from impasto work with casein colors. However, if this is the very effect you want, but at the same time you wish to avoid the yellowing and browning which often accompany oil painting, then you are better advised to use true tempera.

The same bristle brushes should be used for casein colors as for oils. For large-scale work, such as mural painting, it is better to use correspondingly larger round brushes and to reserve the usual flat brushes for fine detail. Round brushes always take up more color, and naturally induce a different brush technique from flat ones, which are best suited to the juxtaposition of rectangular patches of color. When using both types of brushes in the same picture, you will find the best way is to start with the larger round brushes and then paint in the details with flat brushes, so that ultimately the entire work is painted over. This is the only way to achieve any unity. Otherwise, if you leave one part of the picture as painted with round brushes, while another exhibits the cubist style which comes of using a flat brush, this unity will be lost.

You can also follow this method with glue colors, for which both round and flat hair brushes are indicated. As a rule, flat bristle brushes are too stiff for malleable glue colors, even in relatively thick applications. They are also apt to scrape off the water-soluble underpainting.

In summary, the four methods of approach enumerated below should make it easier for the reader to grasp the countless ways in which thick glue paint can be used:

1. Simply cover a white ground on prepared or unprepared paper, using flat hair brushes and opaque color.

The paint is laid on in the same way as with **alla prima** oil colors, contriving an immediate and complete opaqueness. An underpainting may be executed using opaque color thinned in water.

2. Begin with a light coat of watercolor on unprepared white paper using a round hair brush, and then finish it off by painting the picture over a second time with opaque color alone, using a flat hair brush. Your first attempt will show, however, that you must be more familiar with this working method before you can extract from it all the lovely effects of which it is capable: the thin layer of watercolor shines a good deal brighter than the opaque color which follows it. Since underpainting is justified only when its effect is still discernible in the finished picture, leave the lightest and brightest parts untouched, and apply the opaque colors only to those of medium, dull, and dark hues. The same is true of the two types of paints as of the two types of brushes: you will obtain a satisfactory effect only when, even leaving a few spaces, every part and every object in the picture is painted over with opaque color. To take just one concrete example: if one were painting a landscape with a watercolor undercoat, it would be a big mistake to leave the sky untouched, solely because in nature it stands out so brightly against the colors of the

Detail from illustration on page 327, actual size

earth and vegetation. To give just one possibility: the picture would gain greatly in depth and breadth if at its zenith the darker colors of the sky were overpainted in opaque color, the foreground in the same way, while on the horizon the opaque color were most sparingly used for both sky and earth.

3. Proceed as with No. 1, but on a tinted ground. This is undoubtedly the easiest and most direct way of using opaque color.

4. Proceed as with No. 2, but on a tinted ground. In this way, the tinted ground takes on some of the luminosity of the underpaintings, so that the colors look restrained and at the same time related to one another. Using this method, complementary values of gray can be obtained very nicely: for example, by using predominantly red tones over a green ground; or by laying ultramarine blue dark patches over yellow ochre. The most luminous colors and the high lights can, of course, be brought out only by applying completely opaque paint. Reference has been made so far to water-soluble glue colors, but the same remarks apply to casein colors. When a watercolor is intended for glazing, underpaintings will be carried out in well-diluted casein color, and light-colored plaster may be substituted for white paper. Using casein, a possible variation on procedures 2. and 4. is to glaze the opaque layer, a process which seldom succeeds if watercolors are used over a layer of opaque paint,

as the watercolor all too easily causes the opaque layer to run and smudge.

For the beginner, glue and casein colors are the least problematical materials with which to obtain experience of practically the entire range of painting techniques. Their range includes the use of watercolor for glazing, as well as the relatively primitive **alla prima** oil technique, the different types of fresco, as well as the balanced build-up of a multi-layer painting in tempera, using a resinous solution or a mixed or alternative technique. An attempt may even be made to achieve the characteristic shades of pastel work, without doing violence to the materials, for the chalky tone of opaque glue painting comes very close to that of the pastels. And all this can be done without the long waits for the paint to dry out and without having to come to terms with the catalystic peculiarities of the pigments. As soon as the water has evaporated, both with water-soluble glue and with casein, the paint layer is ready to be worked over again. Lastly, glue colors are less trouble for the artist to prepare himself than, say, the preparatory ground, and require less in the way of study and experiment. Carefully executed, glue color painting holds its own, from a technical standpoint, with any other kind of painting; but we must remember what it is intended for. A picture painted in permanently water-soluble glue color should be placed behind glass and framed; and casein colors are the right medium for wall painting in a room or for a large-scale panel with a dead mat surface.

11. PAINTING IN TEMPERA

If the binder used is an emulsion, a somewhat more advanced painting technique is required. All the methods dealt with so far have been such that, provided the ready-made materials were of the finest quality, the resultant picture would be as durable as if one painted with homemade painting materials. Any deterioration observed in following the methods so far described should be attributed to inexpert handling rather than to the materials themselves.

If the ground and paint layers contain a good deal of oil, the picture will yellow and blacken and develop cracks. Colors which contain too much glue are apt to fall off. Both phenomena accompany the use of a fatty medium or a solvent containing too much glue to thin the colors, in place of turpentine or water.

Admittedly, genuine tempera colors are also to be found on the market, but only an experienced chemist can say how the emulsion used was compounded. The names "egg tempera" or "oil tempera" merely tell you that you have an "O-W" (oil-water) emulsion in egg tempera, which you can dilute only with water, and which, when painted, will remain soluble in water; an oil tempera color, on the other hand, will be a "W-O" (water-oil) emulsion, and can be diluted only with turpentine. You now know enough to guard against the mistake of adding oil to a fatty oil tempera

to make it more runny, a process recommended in many old art textbooks. With the exception of casein colors, which are deliberately kept short of binder, all homemade colors should contain just enough binder to make the pigments adhere.

Experience shows that all bought colors contain too much binder. The reason for this is that the purchaser would find fault with a margin too narrow to guarantee indelibility. He would not know what to do, and on the next occasion would buy a different make.

Thus, it is a mistake to add extra binding agent to bought paints. Solvents which evaporate are the only ones to use. If, despite this, the makers continue to market every conceivable "art material," with no more precise indication of the drying time than "slow drying" or "quick drying," it is because over-fatty colors can be smeared on with such gay abandon. Due to their fatty oil content they take on a sheen when they harden; and, when a glaze is used, they do not attack and dissolve the underpainting. In principle, therefore, bought colors have no place in the supplies of the artist who wants to develop a really good technique.

This fact should be particularly borne in mind in handling true tempera. Bought materials only deprive a compound with this type of binder of the advantages peculiar to it. The advantages of the

lean "O-W" emulsion and of the fatty "W-O" tempera are, as you know, their ability to dry rapidly and the fact that normally they do not crack or turn yellow. Their drawbacks are the need either to use up the tempera colors made with egg or a casein within a few days, or else to substitute a preservative to forestall deterioration. Materials of this kind, to be found at any art supplier's, are very difficult to measure accurately for oneself; they also diminish the binding power of the medium, and this in turn entails the use of more binder than is strictly called for. However, the inconvenience of frequently making up easily perishable tempera should not deter you, once you are convinced of the abiding artistic value of your work.

The easiest ways to handle lean or fatty tempera are much the same as for oil or glue colors. But even with lean tempera, such as the commercial egg tempera, you will not obtain the best results on paper without a primer. After a while the oily constituents seep through the paper. You may test this for yourself by studying the back of the unmounted sheet of paper, some weeks after a painting is completed. It will be seen, too, that the whole effect of the picture is grayer and yellower, as the luminosity of the originally white paper has been lost. When using lean tempera, therefore, such as those containing vegetable gum or resinous oil, the paper must first be given at least one or two coats with a glue-bound preparation. Conversely, fatty tempera should only be used on the same sort of ground as oil painting. In using tempera, one principle which we have so far only referred to in passing

Jan van Eyck, The Lucca Madonna. On the left, the whole picture; on the right, a detail from it. The brothers Hubert and Jan van Eyck were long regarded as the inventors of oil painting. However, recent research has established that most of their pictures were painted in alternating techniques, with layers of oil and resin between layers of tempera. They are in an outstanding state of preservation, which would hardly be possible with pure oil paint. After over 500 years, they are almost entirely free of cracks and not yellowed. The faint late crack marks noticeable on the detail clearly result from too thick an application of lead white

now presents itself: always paint fat on lean. So far, this has been implicit in the instructions themselves. It is irrelevant to the use of glue colors, and with the **alla prima** oil technique described, it is precluded by the use of any strongly diluted underpainting. If a very diluted oil paint is used to give a glaze-like tint to the ground, this should show through. Both fatty and lean tempera colors can receive the same treatment if you start with a light shade of underpaint.

The position is different when it comes to large and protracted works of art. Then the last layers will consist of undiluted fatty tempera colors with, if required, the admixture of a wax mastic to make them flow better. Thus, you begin with a lean tempera diluted with water. Over this place a coat of undiluted tempera. Continue with fatty tempera, first thinned with turpentine, then undiluted. Lastly, use super-fatted undiluted tempera colors. This not only obviates the need for a varnish to seal and protect your surface, but also gives a depth of color as rich as that of pure oil painting. The colors harden without any perceptible lightening in shade.

The technical significance of fat on lean is quite clear: the ground should dry or, it may be, oxidize as quickly as possible, so that if delayed-action oxidation occurs it will cause no increase in volume which might make the upper layer split or give rise to early crack formation. This is not really as elaborate as it may sound once you are used to the fat on lean principle in all painting; you will then find that you conceive of the construction of a picture in the appropriate artistic terms. Note that even though while painting in lean tempera the result looks like glue painting, and in fatty tempera more like oil paint, the tempera color always results in a slightly brighter and chalkier tone. This does not altogether hold true when the upper layer is super-fatted, however. Tempera color laid on a shiny surface, like casein painting, can be brushed and rubbed. Naturally, the less fat it contains, the weaker it will be. When applying a protective top layer which will preserve the colors' luster and depth, then it is pleasanter and more in keeping with the materials to apply the sheerest coat of wax rather than a greasy resinous varnish.

Within reason, there is unlimited scope for the impasto application of exceptionally fatty tempera, and certainly more so than for pure oil painting (with the exception of palette knife painting). Thick applications of tempera color always remain spongy and porous, owing to the inner structure of the binder; and the result is a picture at once transparent and, when exposed to the air, able to dry right out and oxidize through and through, and become exceptionally hard. Tempera hardens to such an extent that it takes considerable force to remove a paint layer from its ground, while a layer of oxidized oil paint remains softer and more sensitive after oxidation.

A tempera painting attains its greatest degree of hardness and permanence, however, when from the ground up its construction follows its own special rules. This is a method known as a mixed or alternating technique, and is only relevant to studio conditions. As against working in **alla prima** oils, this tempera

technique starts from a completely different visual concept, a creation in the true sense of the word, in which the model or impression is received but not copied from nature, and remains a more or less distant memory.

If yet another comparison with music may be made, this technique corresponds somewhat to the final and most polished of interpretations, perhaps of a piano sonata, played by an artist who has long since committed the sequence of notes to ear and finger and can apply himself more to tempo and touch.

This mixed technique is the one used by the true master of his craft; it belongs to work in the studio based on thorough and constructive thought, where the very slightest potentiality of the paint can be used to its maximum. Every single operation can be broken down to the smallest detail. If you wish to sustain your attempt and achieve its object, you must be clear in your aims, in command of your medium, and skillful in execution. You cannot hope to work as you would with the **alla prima** technique, developing color effects of formal designs from a vague idea while you are painting.

Mixed techniques are built up in the following way: on a carefully prepared white glue ground, make a rough sketch in red chalk. Next, go over the firm outlines in watercolor. At this stage, considerable detail may be included, since the drawing will not receive a thick coat at the beginning; subsequently, however, every part of it will be used.

For tinting, use a 1:3 mastic solution, or a light balsam solution with the addition of the pigment powder, possibly terre verte, to give a nice spreadable glaze. If the ground is too absorbent, it needs a preliminary coat of shellac as insulation.

This glaze is also known as the imprimatura. This concept is derived from a method of chalk drawing used by Holbein the Younger (already mentioned in the section on drawing). In tracing from life, a little of the red chalk was pressed from the back of the tracing paper onto the new sheet of paper, leaving a faint red outline. The idea of "imprimatura," then, comes from the "impression" made by the tracing chalk. Here the purpose is very much the same as that of the imprimatura in drawing, but achieved with the brush; it gives a monochrome underlying tone on which to obtain a moulded effect by lightening with white. This means that using white lean tempera directly on the imprimatura while still wet, you now paint in your brighter tints over a line or color drawing, so that the drawing shows through. Thus, the picture begins to take shape as a tone monochrome chalk drawing. This lightening with white should allow the color of the imprimatura to show through even where it is brightest, and should go lightly over the darker parts of the picture, so that in the end the entire imprimatura receives a coat of lean tempera.

A notable characteristic of this method is that the resinous solution takes up the watery tempera so well—tackily, it must be admitted, but with great power of absorption. The two layers dry out rapidly, at least superficially, and are quite hard and free from tackiness within a few hours.

A second characteristic, and one which becomes clear only when the whole

process is repeated, is that when using lean tempera direct on the wet imprimatura you can draw lines finer than any you could achieve with oil paint, for example. The old masters portrayed the delicate lines of beards and furs and chased work in jewelry in this way, using marten-hair brushes.

When all the paint has dried and no sticky patches are left, a second imprimatura should be laid on. This time, concentrated essence can be used for mixing; furthermore, the different parts of the picture can now be colored in in their appropriate local color. Here you will see why the first imprimatura had to be entirely covered with tempera; the tempera protects the second imprimatura from possible running and smudging.

In the areas of wet local color you should next lay either lean tempera (white) alone, or paint with all the colors in your palette (this is far from the final layer in your picture)—in a very unobtrusive hue, at first an intimation of what is to come. At this stage your picture will correspond somewhat to the rapid sketch, well-diluted in turpentine, which serves as the underpainting in **alla prima** oils. If in the course of the second application of tempera the

imprimatura dries off somewhat, you may continue to paint over it. If the watery tempera colors run, however, you must again apply resinous varnish. The expert way would be to paint the whole picture in this manner; in other words, continue painting further coats onto resinous glazes. On the principle of fat on lean, you will use fatty tempera in the upper layers, particularly when you wish to paint direct onto a layer of tempera without a resinous glaze when you complete the picture. It is not so usual to lay a final coat of over-fatty tempera as it is to varnish the whole picture over when it is completely dry, using a waxy mastic essence or wax alone. This imparts a smooth, hard enamel-like surface to the picture. There is no sense in using impasto painting in mixed technique, which in any case is unsuited to the artistic concept involved. This is a technique which extracts the utmost from binding agents and pigments, or, to put it differently, which entails no waste of material.

The artist who uses the mixed technique must feel drawn toward it and be willing to forego the somewhat facile charm of impasto paint with a plastic texture. He must also use a smooth ground. As only the best ground will do

Pure red sable brush

This study, designed to illustrate alternating technique, shows, from bottom to top:
1. A glue ground, with drawing in watercolor — 2. Imprint (the imprimitur — see text) in a 1:4 mastic and chrome oxide solution — 3. Lightening with white, using titanium white egg tempera — 4. Diluted resinous oil used to render local colors — 5. Final coat of egg tempera varnished over with wax

for such meticulous work, you will undoubtedly take canvas-covered board. The canvas must be finely and smoothly woven, however, and the primer must be polished with sandpaper, producing a ground as smooth as paper, whose linen texture will in time be completely obscured.

Hence, the mixed technique is absolute painting, the method which rejects any external material appeal. It is the method which gives precedence to content, what the picture is about, over means, how it is done. The tendency to value these nonessentials at the expense of the subject is one found in all fairly recent paintings.

The subject matter of a picture painted in mixed technique is brought out by rich color effects, not by striking mannerisms. The color effect is based on a gray brought about partly by optical color mixture, which in turn consists partly of an additive light mixture. The glaze is like colored glass through which reflected light shines strongly at different angles of refraction; this brings out interfering colors such as exist in genuine pearls. Thus it is impossible to copy a picture painted like this in oils, using **alla prima** technique. Anyone who has attempted to do this will have discovered how primitive any kind of **alla prima** technique is when compared with mixed technique.

So far as scientific research into painting methods has been able to ascertain, mixed technique was discovered by the brothers Hubert and Jan van Eyck, and they are among the select few, the greatest painters of all time. They do not owe this to their technical ability alone, to which the amazing state of preservation

of their works bears such eloquent testimony.

If the mixed technique is out of favor at the present time, one does not need to be a prophet to predict that in the changing cycle of fashion it will again play a great part. That is, of course, unless technical progress provides us with a further simplified medium with all-embracing artistic potentialities. The first step would be the discovery of a completely foolproof binding agent, capable of making the paint layers into a homogeneous whole and liable to no further change. Synthetic materials are constantly being improved and might in time make such a discovery possible. From a technical viewpoint, the mixed technique rests essentially on the contrast between the use of resinous glazes and lean tempera colors thinned with water, i.e., an "O-W" emulsion: it lies embedded like trellis work between the films of resin.

When once you have grasped this notion, you will see how worthless would be the use of a fatty "W-O" emulsion in mixed technique. An unnecessary layer of fatty paint would result. The same is true of casein tempera. The strong binding power of its glue constituent renders it unsuitable for painting in several layers. Casein tempera is a good binder for a weather-proof "O-W" tempera applied in a single layer.

An artist can tackle these problems only against a background of wide practical experience, and he must know what his aim is. He will then find his way by means of systematic experiments. All that can be given here are basic ideas, but these can be subtly adapted to any and every form of painting.

12. THE USE OF COLOR WITHOUT BINDING AGENT

Another lasting medium of artistic expression is color used without a binder, such as pastels, true fresco, painting with waterglass, and silica painting.

PASTELS are technically the simplest medium to use. The only requirements are suitable paper, pastel crayons, and a fixative with a diffuser. No palette, brushes or vehicle are required. Drying offers no problems, and once you have chosen your materials correctly, you are unlikely to make any technical mistakes. Instead, we encounter difficulties of quite a different kind.

What is most awkward is that colors cannot be mixed in advance, an unbreakable rule in all other media. With pastels you have no choice but to use each crayon as it stands, and then to blend them in. This fact led to boxes of pastels containing many colors. If you try to get along with a modest assortment of possibly 20 or 30 crayons, you will soon discover the technical limitations of the medium: you will need so many superimposed colors that it will become impossible to fix the powder firmly to the paper. The only way to manage with a very few pastel colors is to adopt the pointillist method; but this scientific manner of picture building is not for everyone. When you have at your disposal not less than a hundred or so crayons, however, a fresh difficulty arises: you forfeit the contact with the pigment which you are used to with any other medium. The chalks remain purely objective and external to you. It is true that with pastels the properties of the individual pigments are virtually inexhaustible. Their glazing and hiding power and their richness and ability to blend well are largely offset by the manner in which the powder is applied. As a rule gradations of brightness are produced by white pigments. Those sold commercially are usually chalks, earth pigments and gypsum, which can also be used as fillers. It is true that these pigments cloud the colors, but by this very clouding they emphasize the special characteristics of the medium: the hazy, nebulous colorings and a soft, tender expressivity. "Pastel color" is a widely used term.

It is a term which recognizes the pastel's peculiar power of expression, which, like every medium, has its own range. The logic of this will possibly become more apparent if you imagine a violin concerto played on the trumpet, or military music played on the harp. The art of pastel painting marked the style of a particular epoch, the rococo, and this could hardly have been otherwise. For although pastels were already known at the close of the Renaissance, it was not until the eighteenth century that the medium reached perfection, above all in portraiture. It was immediately abused, for ultimate refinements such as high lights could not be added firmly or precisely enough with the crayon, especially in miniature work; therefore the artists resorted to the use of fine brushes and opaque colors.

The Use of Color Without Binding Agent

Crosshatching, rubbed and not rubbed

Apart from this, the use of some type of crayon is older than the hills, and by far the oldest method of painting. The cave paintings were carried out with crayons, although admittedly not in the manner of a pastel. If prehistoric men had thought of applying their earth colors, chalks and coals, with brush and binder, they would probably not have gone on using crayons. Crayons were very keen for rendering shapes with precision, and the results are models of figurative representation. It is fortunate for us that prehistoric man remained loyal to his crayons, as it is unlikely that any cave art would otherwise have survived. The only conceivable binding agents of the time were adhesive plant sap, blood serum, and animal size, all of which, after so long a period closed up in the caves, would have perished.

So you see that, aesthetically, the binding agent is the root of all evil, at least where contemporary pastels are concerned. For the pastel can maintain its singular, misty effect only until it is fixed, and the effect is often damaged by fixing. Without fixing, the powdered pigments are held together in loose strata like the scales on butterflies' wings. Fixatives cause the color particles to

stick fast and the light is then reflected off a level surface, as when color is applied with a brush. The picture will take on an appearance reminiscent of normal glue paint technique. The only way to avoid this effect is to leave your pastels completely unfixed. The rococo pastel artists did exactly this. In any event, since pastels are so sensitive that they must be framed behind glass, they can in fact last quite as well unfixed, especially on a velvety surface which improves the adherent qualities of the particles. The rococo painters used roughened parchment.

Today, velvety "pastel paper" may be bought ready-made. However, only a master will succeed in using this type of paper without producing tawdry color effects. A further point is that these velvet-type papers are always tinted, but not always with light-fast colors. Thus, they are best recommended for use with completely opaque chalks.

The most sympathetic paper is a rough white, such as a first-class Ingres paper. To give it a tinted ground, rub it lightly downwards and across with a broad pastel chalk. Then, with a soft wad of cloth, merge the chalk strokes in an even, circular motion over the surface. However carefully you do this, some irregularities will still remain, almost a texture which has a lively charm similar to that of an imprimatura. As with the latter, you can begin with a drawing underneath, which must, of course, be fixed before the paper is tinted.

Fixatives tinge the colors with gray, particularly if fillers rather than pure white pigments are used in the composition of the crayons, as they are apt to

darken in the binder. This is almost the rule with ready-made pastel colors. As a matter of fact, manufacturers often use coal tar for pastel colors, which are seldom if ever light-fast. After a time, the picture becomes progressively paler; only inorganic permanent pigments retain their effect. You can imagine how extraordinary a picture will look then. Happily, the coal tar colors in use are partly soluble in alcohol. I say happily, because this enables you to make a test. On a sheet of thin paper, such as French Ingres, draw a line with each of your pastel colors, one beside the other, and then spray them with alcohol. The soluble colors will at once penetrate the paper and make runny blots on the reverse side. Unfortunately, this does not mean that all the colors which do not go through will prove satisfactory. Certain coal tar colors are not soluble in alcohol, among them alizarin red (which is intrinsically satisfactory) and such dubious, impure pigments as chrome yellow, Cassell brown and cinnabar. The graying of pastel paintings due to fixing can be obviated by the exclusive use of zinc white, flake white, and titanium white instead of chalk and analogous white pigments. But to be quite sure, you should make your own pastel colors. Only then will you be certain of working with worthwhile pigments.

Pastel artist: His equipment consists of a box containing 80 colors, a bottle of fixative with spray diffuser, a stump, and a rubber eraser

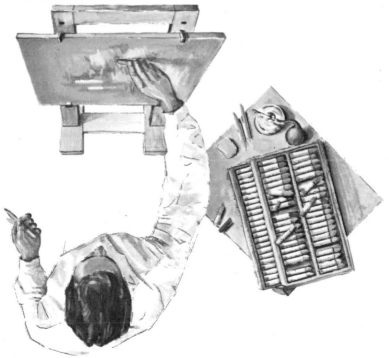

The Use of Color Without Binding Agent

You should set about preparing your pastel chalks more or less as follows: using a small trowel, knead your powdered pigment with water and a trace of tragacanth gum. This dough-like paste should be left for a day or two with a damp cloth over it to allow the pigment to become saturated with water and gum. When it has been left in this way, you will see whether to add more water or more pigment. When your mixture has reached the right consistency, take some pieces out and roll them on a tray to a uniform thickness. The crayons can then be placed on a baking sheet lined with parchment and placed in an oven. They should stay there on a low heat, with the oven door open, for a few hours. To dry them in the air takes too long and gives the glue time to go mouldy. Unfortunately, the exact quantity of glue cannot be laid down; it is simply a matter of finding out for oneself. Just enough glue is needed to hold the crayons together, but several pigments cohere without glue at all, with nothing but water.

To obtain a mixed color or a tint lightened with white, you should proceed as follows: first make long, thick crayons of equal size out of the appropriate pure pigment and white (preferably titanium white), and keep them really moist. Next, cut one tenth of the length off the end of the colored crayon, and substitute a piece of the white crayon for it. Blend the two together, and you have a new crayon. This affords a clear-cut and reliable means of obtaining any mixed or whitened tint.

As each crayon dries, place a strip of thin parchment around it, with appropriate remarks. If you take the trouble to make crayons out of all the important pigments, say 20 of them, preparing each in its pure, mixed and whitened form, you will soon have a set of 100 or more crayons, which should last you quite a long time. This gives you an intimate contact with your colors, and is a new and most rewarding experience which amply repays all your labor. Apart from this, a pastel painting is built up on the same principle as an **alla prima** oil painting. Thus, you proceed from medium tints to darker ones, with the cool colors predominating. Next, paint in the brighter and stronger colors, rendering the deepest and warmest shadows, and last of all the high lights.

This should be gone over lightly, not pressed or rubbed, and for this reason corrections should not be made to the lines, but whenever possible and needful it is better to erase the wrong lines with a soft rubber eraser and go over them again. However, supposing the wrong color adheres as a result of repeated fixing, all you can do is to prepare and fix a fresh white ground to receive clean, bright colors again. The colors will stand out best on a white ground.

The nature of your craftsmanship will determine whether you obtain individual mixed tints and delicate fusions by rubbing with your fingers or with a stump, or whether you prefer to shade the colors lightly into one another by hand. The second of these methods is the best way to steer clear of an effect of meretricious

This nude study was painted on white cardboard to bring out the individual paint layers. The ground was lightly rubbed in with the finger; the lines applied over it were not rubbed

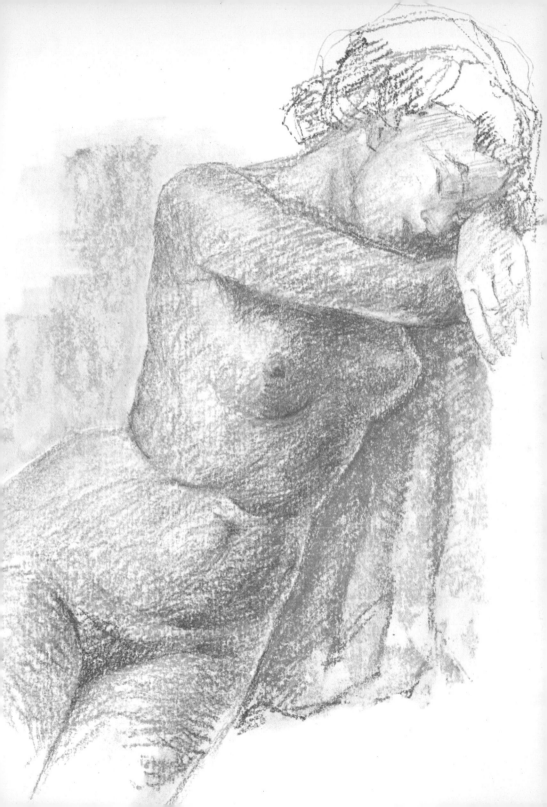

sweetness. As with drawing in chalk or with a lead pencil, so with the pastel: beginners are all too ready to stump and smear their work, delighting in the delicate way the colors run into each other, and not realizing what a sugary mess they are producing. The discipline entailed in shading in, however, would speedily bring about a notable improvement. Only the artist in command of his materials will be sure of enhancing his effects by blurring his lines. With this in view, study the pastel paintings of the rococo.

We have already noted that pastels must be kept framed behind glass if they are to be hung on the wall. Unfixed pastels must also be treated in this way, since in a portfolio, for example, they will leave marks even on the smoothest interleaf. The glass must not be in direct contact with the painting. A simple way to prevent this is to give the pastel a mat cut to a suitable thickness. There is a danger, however, that when the glass is polished on the outside with a woolen or silk rag, the color particles will be drawn to the inside of the glass by electromagnetic action. This is a frequent phenomenon with the modern pastel, but rare in old ones. Possibly this may be due to the use of flake white (white lead) as the white pigment in old works, and the fact that its use is no longer allowed in pastel chalks sold commercially. Surely a somewhat exaggerated precaution? For even if white lead is poisonous, who is likely to breathe it in fatal amounts? It would not be at all easy to kill oneself with it; and anyone who wanted to could find surer methods. At all events we have in titanium white

(RN 56) a wholly innocuous substitute for flake white.

The pastel medium has latterly branched out, chiefly under the stimulus of W. Ostwald, to bring mural painting within its range. A painting of this kind bears no comparison with a small-scale pastel, but with a pastel mural this is not the point. The point is rather that the use of pastels on the wall is straightforward and makes for an effect which is aesthetically most in keeping with modern notions of wall painting. This prompts us to the following reflection: a mural should not resemble a picture stuck on or cut into the wall, as they all used to; instead it should liven up a plain wall without attempting to disguise it. The wall must still be an integral part of the architecture. Figures and similar objects should be apposed directly on the wall and not be separated from it, as formerly, by anything in the nature of a background or a frame. A brief glance in passing cannot take in the background graduations. Yet on closer study, they create an illusion of depth and breadth, an impression that the background suddenly recedes; and this can be all the more delightful if no attempt has been made to indicate perspective. A moment later the design appears to return to the surface. The total effect is strengthened by the roughness of the plaster. Naturally, it does not lend itself to the application of a close, opaque color; the use of porous colors, however, causes the texture and shade of the plaster surface to extend to the whole design and underlines the nature of the wall surface.

We can, of course, make pastel com-

pletely opaque, by stumping or brushing in the color, for example. But this is wrong and, indeed, does violence to the material—just as it does to lay on porous colors with a half-dry brush. Obviously, pastel murals must be extremely thoroughly fixed. Shellac solution is not really suitable. However, the binding agents used for liquid wall painting, foremost among them casein solutions and waterglass, are well worth considering. Nonreversible glue solutions can also be used indoors, though they must be given a dressing of formalin, and protected against the effects of humidity. A further prerequisite for the stability of a pastel on the wall is the right type of plaster. It must be thoroughly dried out, and care must be taken, when tinting the surface all over, to use only a binder which will suit the fixative to be used later.

The artist who wishes to execute a painstaking mural will accordingly prepare his own primer on fresh, dry plaster not treated in any other way. Where casein is used as a fixative, priming is best carried out with the weakest possible casein bound color. This need not dry indelibly instantly, since a further casein solution will be sprayed on later. Hand sprays rather like air sprays are sold for this purpose. Immediately after use they must be thoroughly washed out in water. The safest way to test indelibility and make sure that not too much glue is used is to try out the same plaster on a piece of board. For casein pastels, bought pastel chalks will do.

Details (1:1) from study on page 343

13. FRESCO

Fresco painting is the most famous of all mural techniques. People who should know better misuse the term "fresco," using it to describe every type of wall painting. However, it means only a picture painted on a freshly plastered wall while still quite wet. It is more correct to speak of "fresco buono." The Italian word "buono" (good) is used to distinguish authentic fresco technique on fresh plaster from "fresco secco," in which the plaster, though fresh, is quite dry.

The latter process is actually the more ancient. It was known to the Egyptians, Greeks, and Romans; and its technical peculiarity is the admixture of a binder, in this case, size. Byzantine and Late Roman paintings in fresco secco are celebrated for their use of egg yolk; their work was often given a protective coat of wax varnish, but this was possibly not until a later date.

There are many fresco secco techniques, but all require wall plaster specially prepared for the purpose which led to the discovery of the fresco buono process.

Lime was known as a thin liquid binding agent at a very early time. After a number of intervening developments, the

Michelangelo, detail from the Creation of Adam in the Sistine Chapel. Note the emphatic contours, corrected in places in the course of painting

346

first attempts were made, in Italy about 1300 A.D., to paint "al fresco" on fresh plaster with unbound watercolor. The first to appreciate this seemingly modern technique and to make brilliant use of it was Giotto.

The technical preparations center around the production of suitable plaster, capable of taking up the colors from underneath. The reason for this is that the colors are mixed with water alone, or with lime water, which binds them better. For the mortar, only pure lime mortar will do. Cement or diluted cement mortar is quite unsuitable. Fresco mortar is always made out of burnt lime slaked in the quarry. It must stand in the quarry in at least four inches of water for a minimum two months, and much longer if possible. The mortar is composed of this quarry or bog lime, mixed together with sand and water. Spiky river-grit and sand are suitable, but for the best fresco mortar, marble grit or marble sand is used, as they produce the whitest and hardest plaster. You may like to think of lime plaster as a primer on a brick wall. This primer holds the colored pigment, but it will do so only as long as it is quite fresh, which, in practice, means soft and wet. Thus, one of the chief points is that the brick wall should be thoroughly wetted before the plaster is laid on it; if possible this should be done some days previously. To give a better hold, the joins between the bricks may be scraped out about half an inch.

Maulpertsch, a cartoon for a fresco painting. Note in what detail this design was worked out, to be transposed later with a quick sure touch to the fresh plaster

Fresco

The first layer of plaster consists of about four to five parts grit and coarse sand and one part lime. It should set very hard indeed and if need be can be made thicker still by beating it with a stick. It should be about one inch thick. If beating makes the surface too smooth, it should be roughened to provide a good hold for the next layer; this consists of about three parts finer sand and one part lime. Lastly, a layer known as the fine plaster, consisting of two parts fine and finest sand and one part lime, is applied. Rub this surface down with an emery board to make it really smooth.

This kind of plaster will be dry on top in at least three days. When the colored pigments have been applied with water, a thin transparent film of crystalline carbonate of lime is formed. The pigments become more or less petrified together with the plaster. At least this is the aim, but it succeeds only if the carbonic acid in the atmosphere penetrates the entire layer of plaster by about one and one-half to two inches. The carbonic acid in the atmosphere can reach the lowest layer only if the plaster is sufficiently porous. The consistency to aim for is one which appears to contain too much water. Some of this water will be used up in crystallization and the rest will evaporate, thus inducing a certain porousness.

The success of these hardening and evaporation processes depends on factors which can be neither predicted nor regulated with accuracy. What tips the scales is the composition of the limestone and the atmosphere after the application of the plaster. Heat causes the water to evaporate too fast, so that it is no longer

Lead palette for mural work with liquid paint. Work will be brisker if more than one palette is kept in use

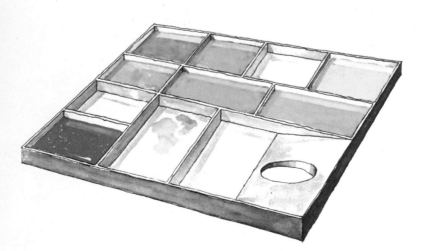

available for crystal formation. The most favorable conditions are an average temperature of about 60 degrees F., as this enables the evaporation and the absorption of acids from the atmosphere to proceed together. It is worthwhile providing artificial means of supplying these acids, as the air contains only a small percentage.

In the Middle Ages, and sometimes even in the baroque period, little hairs, such as those from calf's skin, were incorporated in the plaster to make it more porous. For one thing the capillaries helped the water to rise to the surface; and for another, the hairs were partially destroyed by the corrosion of the lime, thus creating a system of very fine air holes. This enabled the acid more easily to penetrate the furthest layers.

We know of fresco plasters which

Dry pigment in tin, prepared color in glass, round brush for painting, and circular brush to cover large areas in local color

today, after over 600 years, are almost as stable as modern cement plaster. Others again have been found to be so brittle underneath that the limestone carbonate can never have been properly formed. This suggests that the water evaporated too quickly and that the brickwork was not as wet as it should have been.

The outward sign that the plaster is being formed is that at first the plaster looks wet and shiny, but after an hour or two it turns mat. This tells you that it is time to start applying the paint. This stage appears to last for about 48 hours, but in reality as soon as the surface looks mat, the process of carbon intake has begun, though slowly at first. The watery layer of paint delays this process, until a certain stage is reached. After that it cannot be halted, and the plaster surface becomes shiny again. In appearance it is almost as if a very fine film of ice had formed over it, rather like the gleam of a polished egg shell. When this stage is reached, no more pigment can be taken up, and the picture should have been finished several hours previously.

Thus, the fresco painter's allotted working period, from start to finish, is very short indeed. It goes without saying that the great masters of the art of fresco could not complete their gigantic mural and ceiling paintings in this space of time. Accordingly they used to do their work in sections. They would carry on until they reached as clear an outline as possible, such as that of a figure. Up to this outline, the surrounding layer of plaster was marked out, right through to the wall fabric. When the artist com-

pleted his first figure, the plaster could again be applied to another part of the painting.

This difficulty, together with the impossibility of seeing a monumental work **in toto** from the artist's scaffolding, makes it essential to work from a detailed design.

The first step is the small-scale sketch, followed by individual studies such as whole figures, heads, hands, and drapery. Next the sketch proper. This may be on the same reduced scale as the first sketches, or somewhat larger, or very occasionally, even at this stage, full size. As a rule, glue colors will be used on white cardboard paper. At this point the cartoon known as the "tracing" is drawn, a full-size sketch of the most important outlines, which is pressed into the wet plaster. This cartoon obviously must be made on soft paper only. The outlines are marked through with a blunt metal graver or any other suitable tool. It is also possible to perforate the outlines, and then to trace them onto the wall by filtering pigment through a bag of powder. Any falling particles will be held by the plaster, so this method cannot always be used. Moreover, you may wish to use pigments which would be destroyed by the lime, thus disappearing after a time, such as the cadmium and alizarin colors and cyanide blue. A colorless outline lightly pressed into the plaster will not be inconvenient when painting, and it leaves the artist free to work. Fresco painting is carried out on the same principle as watercolors, that is, proceeding from light to dark. Glazing is likewise used without adding white pigment. In monumental works, however,

these principles are followed less strictly. It may be necessary to mix in some white pigment, and if so, white lime is the only sort to use. There is little use for black, but if it is used, carbon should be avoided. Even though the lime does not destroy the carbon, it binds it only temporarily; in the end it decays together with a thin surface layer of plaster. Manganese black is better. As with all monumental painting, simple and large-scale use of color is alone appropriate and impressive. This accounts for a fundamental difference between fresco and other media as regards planning the picture; we must also remember that relatively little correction is possible while work is in progress. The ideal is to do all the painting at a stretch, for too much over-painting interferes with the process of binding the colors to the ground.

The color is best applied with a sort of soft round watercolor bristle brush of gigantic proportions. The brush should not be too stiff, as it would tear away the soft surface layer of mortar. Hair brushes would be too quickly spoiled by the lime. Once the fresco is finished, no further treatment is called for. On the contrary, to overpaint it or varnish it in any way would utterly nullify the special effect of a fresco painting, which is of exceptional beauty. As a painting medium in the truest sense, it does not belong on the face of a building, but in a large room. Only there is there a guarantee that the fresco will suffer as little as possible from attack by acids in the air.

For an external wall face, the only satisfactory method is to paint with waterglass, known also as silica or mineral painting. Once the technical process of binding has been fully dealt with, there remains little to be said about the actual method of painting. As it is hardly possible to make one's own materials, a description of these processes must read rather like an abstract from the printed instructions of the manufacturer. The colors are thinned with water or waterglass and applied with a fresco

H. Weidner, Augsburg Market. Silica painting on facade, covering a broad area (Lohwald Works)

brush to dry plaster previously scraped; or alternatively they may be laid on in crayon form, like pastel chalks. All the pigments must be tempered with zinc and magnesia. The binder, waterglass, is usually sprayed on after the picture is painted, or it can be used as an intermediate fixative where a heavier application of paint is desired. That is all. The build-up of the picture depends on whether you use a dark-tinted plaster, a special facing plaster which is colored in a block, or a light-colored plaster. This determines whether the picture is built up like a watercolor, an oil painting, or a pastel.

Compared with the marked individuality of other media, the total impression is not very striking. To quote from Wilhelm Busch, we might say that it is nicely colored, and therefore good. This criticism is not merely derogatory. The outstanding durability of silica paint assures for it a future of great promise and leads us to suppose that some great artist will use it to achieve effects never before thought of; especially as it is not absolutely essential to have a plaster wall surface underneath. The manufacturers of silica paint also sell primers which can be applied on any support to give a good enough hold, and these make a satisfactory foundation for silica colors. On a ground of this type you will be able to experiment in your studio.

When you come to reflect on everything that has been said about the most important painting techniques, you will see that all techniques are good when they are properly handled and all are bad if you make mistakes. None is perfect. Your choice must depend as much on your personal inclination as on the use you intend to make of your work. Any artistic experience can be transposed into any medium; though it is a fact that some seem to call for one kind of medium and others for another. Thus, it is most revealing, particularly for a beginner, occasionally to carry out the same motif in a variety of media. It is dauntless zeal which will achieve the goal, and not irresolute musing.

In painting, the surface area counts far more than it does in drawing. You know the principle, which is that there are no colored lines, only colored areas. The line, as a means of abstract graphic expression, can only enclose spaces and separate them from one another; it is color which sets off the surface.

In drawing, the line is about the only way to contrive a convincing illusion of space. The line can be used with similar effect in painting too, but it is not a specifically pictorial means of expression. Apart from the fact that a polychrome picture is always more effective than a colorless or monochrome one, color can be used to render the illusion of space much more clearly than lines or tinted surfaces.

Whether you are doing a pure line drawing or a drawing with tinted surfaces, you must adjust the scale of objects to their diminishing size as they approach the horizon or vanishing point, if you are to create an illusion of space. This is not the case with color, but you can conceive light or dark areas to the point where the colors vanish. It is entirely a matter of circumstance whether you fix on light or shade; looking outwards from a woodland glade, the colors vanish into light, while looking inwards from the edge of the wood, they seem to vanish into darkness. Furthermore, strong colors push weaker ones into the background, just as pure colors appear nearer than impure ones. Where shades are of the same strength, red and yellow advance more than blue, and warm colors before cool ones. The following

Illustration of the color vanishing point (looking into the wood and out of it)

instance arises out of the different degrees of pervasiveness of the light rays, and it also determines the effect of color perspective: Imagine you are driving along a street with a clear view towards a traffic signal. You will hardly notice the green light from a distance, while the amber light will seem suddenly to leap unmistakably out at you, and the red light to recede. The red glass acts as a filter for the red rays from the white incandescent light which shines farthest, but as a color comes closer to a blue than to a yellow, so accordingly its effect is less aggressive. On the other hand, drive along the same street in a really thick fog; from a corresponding distance away you will probably see neither green nor amber, but you **will** see the red light, and probably brake too soon. This is because against a dull gray background, the red seems to advance so much more —in the absence of any other strong colors to judge by—that you are likely to underestimate appreciably your distance from the lights.

Color dynamism: the nearest is orange, the furthest is blue. Green and violet are not particularly dynamic

Hence, it follows that you cannot produce an effect of perspective if you use only one color without any modulation, for instance, an even gray tone. You need the contrast with other colors. Similar contrasts will determine whether the foregoing should be reversed: pure in-

Colors lose their dynamism progressively as they grow lighter and grayer

tense blues can on occasion produce an effect of greater proximity than dull yellows and reds.

We may substitute "bright" for "dull." In the present context it is practically the same thing. Think back to the difference between additive and subtractive mixtures: a subtractive gray contains the same color components as an additive white. The differences are merely due to a loss of light through absorption.

The farther away an object is from you, the more the variegated reflections of white light from a distance will cover up the colors reflected from smaller objects and shadows. An additional factor is reflection from the atmosphere itself. For example, if you gaze into the entrance to a tunnel, the darkness at the entrance will lessen in intensity the farther you go from it. The air between you and the tunnel reflects white light, and the greater the humidity, the more light is reflected. To the human eye, the absorption of red and yellow rays seems to be correspondingly greater when blue rays are reflected. Thus it happens that in humid conditions landscapes appear bluer and more spacious than they do in a dry atmosphere and sunshine: clear colors come forward toward the onlooker. This is a phenomenon which a landscape painter must fully appreciate if he is to depict what he perceives just as he perceives it. The Chinese were masters of the art of conveying a sense of space by suggesting a darkening atmosphere, particularly in graphic work painted in thinned China ink, with a near color effect. In classical Chinese art, linear perspective played a very minor role, if any.

Alongside this atmospheric darkening, the plasticity of silk, which reflects the light in tiny particles, also serves to achieve depth of perspective. Coarse canvas can be used in the same way. Pictures executed on canvas whose texture remains visible have more atmosphere to start with than those painted on a smooth support. This also applies to watercolors on rough paper. Where the texture of the support has its own light and shade, the picture not only

Pure green and pure blue advance more than darker and more opaque yellow and red

Gauguin, Horsemen on the Beach. The blue of the sea recedes sharply against the red of the beach

gains a surface, but also produces an impression of several planes graduated in depth. Moreover, the texture helps to some extent to avoid crude and blotchy shadows which look like holes.

The Impressionists were the first artists in the western world to "see" the atmosphere overcast with all shades from gray to white in a bright light. They achieved an effect of depth and flatness simultaneously in their pictures by the appropriate mixture of grays and whites in their colors. The plastic thickness of the paint also helped, resembling as it did a woven fabric. Here the effect is even more forceful and conspicuous, however. The Italian artists of the Renaissance had already discovered and rendered a shadowy atmosphere instinct with mystery (you will recall the comparison with the entrance to a tunnel). This was the celebrated **sfumato**, the smoki-

ness, quite different from atmospheric humidity. They saw it not only in open landscapes, but indoors too, in the rooms where they painted their portraits and figures. This **sfumato** enabled them to banish from their pictures the harsh contours which had previously marred the pictorial effect. Over the main parts of the painting, they set the light flowing forth in a gentle glow against the dusty obscurity. Analogous aims and effects are attained in photography by placing a soft-focus attachment in front of the lens. Leonardo da Vinci and Titian were exceedingly enthusiastic about the phenomenon of **sfumato**, but they used it with the subdued grace of their day. They were, of course, among its most glorious exponents. Then came Rembrandt, who shattered this sobriety, carrying the trend relentlessly to its utmost limits. He rendered darkness and

shadows with an intensity to be found nowhere else in the history of painting: and yet he did not create "holes." The black of the **The Man with the Gold Helmet** is shot through with a riot of color; the air becomes palpable, suggesting that one is feeling one's way through a room utterly devoid of light. One senses vaguely what is concealed in the shadows. Rembrandt produced this effect by using countless glazes. He is understood to have used 30 to 60 of them, and Titian is known to have worked in the same way. In all probability the glazes were carried out in complementary colors, and these produce shadows which no longer appear to be colored. How different from the workaday black which stares up at you from a tin of shoe polish! The discovery of the visible atmosphere and the first attempts to use **sfumato** in painting it mark the beginning of something which can properly be called "painting." Until then, artists had colored rather than painted; a single object was rendered in local color and distorted in the process. Color perspective was used only by accident, not consciously. Linear perspective was almost the only means employed to give an impression of depth.

To penetrate the mysteries of color perspective, while bearing in mind that the ever-changing exceptions and special cases far outweigh strict rules such as those of linear perspective, you can hardly do better that follow the main stages of its development; after Leonardo and Rembrandt, Watteau marks just such a stage before the Impressionists, and among present-day artists, Kokoschka has given it fresh significance.

The alpha and omega of the study of color perspective lies in the perpetual observation of nature. This will reveal that when colors are blurred for purposes of perspective, the result is not neutral gray, but a variation of tints on the original color, accompanied by a blurring of outline.

The tinting and brightening of the original color (or its darkening, for that matter) is liable to alter at any moment. For example, red does not always turn to gray-pink; the nearer the color is to the horizon, the more dependent it becomes on light conditions. You may have occasion to observe a tiled roof in widely differing circumstances: in the sunlight, rain, and under a cloudy sky, in the morning and in the evening; each time it will look completely different; and to paint what you see, on each occasion, you would need every color you have.

15. COLOR COMPOSITION

We have already seen that the effect of perspective can be created by the exclusive use of color or of lines and other graphic methods; or by a combination of the two. The same holds true for pictorial representation.

You will easily discover whether a composition is executed by means of color alone, or graphically, or the two together, if you make a black and white photographic print. If the composition was drawn graphically, the black and white picture will be clearly defined; if color was used, the monochrome reproduction will have no clear lines. With sufficient knowledge and experience, you should be able to visualize this without bothering to test it. The same means can be used to distinguish between perspective achieved by line or color. The fact remains that the principles of color and line are much more closely related in respect to composition than to perspective. A composition is not built up in the same way as linear perspective, and "rules" in the strict sense do not apply. Composition is far more a matter of sensibility than of logic. Let us review the various means by which a picture can be composed:

First, the "selective" picture; by this is meant the best picture a photographer can obtain, given the size of his camera. It is an entirely passive exercise in the art of composition, as the photographer can only select his composition, neither

adding to nor subtracting from it. What he can do is to use special lenses which will bring near objects nearer, or make distant ones appear more distant—in other words, alter the depth of perspective. The photographer is also bound by the size of his plate and his film, and the most he can do afterwards is to crop it and adjust the size of the picture accordingly.

On the other hand, draftsmen and painters alike are able, if they so wish, to decide on the best size for their pictures by using an adjustable finder. But there is a good deal more to their art than this passive function, for by bringing objects closer together, or placing them wider apart, they can give the

 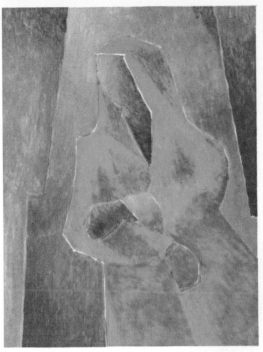

picture content an appearance of greater depth, urgency, or breadth, or otherwise alter it entirely. In any selective composition the edges of the picture itself are fixed immutably. When these confines are pushed back, fresh, possibly disruptive elements are introduced into the picture. If they are later made to contract, something essential may be left out, spoiling the whole effect of the composition. What is left may be not a picture, but merely a detail. A conscious, active composition does not cling fast to the edge of the picture.

Less haphazard than a selective composition, which resembles a view out a window, an "active" composition grows out of a relatively ill-defined expanse,

rather like spotlighting a particular scene on a darkened stage, or a landscape at night. The darkness is less of a factor in the event portrayed and serves more to set the tone; here we have life itself, the world, the cosmos. A composition

Color composition

Left: One color (yellow): light, medium, dark cadmium yellow — burnt sienna — yellow ochre — Naples yellow (reddish) — raw umber — gray (ultramarine blue, ochre, and alizarin red mixed)

Center: Two contrasting colors (blue and red): light, medium, and dark cobalt blue and oxide of chromium blue — burnt sienna, cadmium red, caput mortuum

Right: One main color (green) and several duller subsidiary colors: hydroxide of chromium (green), with traces of pale cadmium yellow — Naples yellow (antimony) reddish, mixed and painted over with ultramarine blue, alizarin red, ochre

like this does not make one want to look farther, as a selective composition may well do.

Picture framing is also to be considered from the outset. A selective composition inevitably calls for a frame to shut it off, and a mount is often used. The type of composition which grows out of the surface does not need one, however. In other words, you cannot alter your selection once you have decided on it without interfering with the effect of the picture itself. On the other hand, you will find that you can enlarge the area of a picture with ill-defined limits, without altering the effect of the picture.

Contracting the surrounding area is rather a different matter. The design will lose its urgency and become more commonplace. This may not affect the composition of the scene itself, but it will affect the picture's spiritual content. To take an example: if you stand on a broad plain, the effect of the expanse, solitude, and so forth is largely due to the immensity of the heavens above. If you view this same landscape through a finder, which takes away a good deal of the expanse of sky, much of its grandeur will also disappear. There was an academic maxim which would seem very much to the point here: it laid down a ratio of 1:2 or 2:1 between earth and heaven. To construct their pictures so that the "empty" space was left in all its glory was one of the masterly achievements of the classical Japanese and Chinese painters and has never been surpassed. If hitherto we have been concerned solely with the surrounding shadow, this should not be taken to mean that it is a sort of inevitable constituent of an "active" composition. The reverse is true! The surround may equally well be bright, but what it must do is to stand in some kind of relationship to the picture content, whether by reason of its texture or its color. The surrounding area may be white, especially in a watercolor; and in a watercolor this will usually be the white of the paper, or support. In other media, a gray or tinted ground can also be very delightful, particularly when the tinting is not tonelessly smooth and dead but shows the irregularities of the brush strokes. It is then that it really contributes to the picture. Modern mural painting exploits the support to similar effect. The texture and color form a lively continuation of the picture itself, and act as a unifying element with the architectural limits and joins, which in their turn are underlined by a representation focused on one spot. This spot then becomes an animated center in a fixed surround. This manner of composing a mural painting undoubtedly marks an advance over the rigid framing of murals practiced in earlier times. It is an advance which enables us to achieve as much or more, with limited means, as in a painting which utilized every available space between joints in the building, and released a shower of shapes and colors. Even the most receptive onlooker will feel no more than this, and even he will probably not take away much of the detail of the picture, however often or searchingly he looks at it. A modern, simple type of mural, with its greater economy, makes a more lasting impression. Just try to reproduce from memory at home something you have seen in, shall we say, a baroque church. You have scant

chance of success. If you try with a sgraffito, a mosaic, or a painting on a modern building, you are certain to draw a fair reproduction.

This indeed is the aim of composition. We aim to produce a picture at once forceful and memorable; a picture which will be at its most commanding when the boundaries of the surface are not too rigidly adhered to, depended on, leaned on; a picture which remains the focal point of an expanse, quite apart from its own centers, tensions, and rhythms. As there is no book of rules for composition such as there is for linear perspective, we shall not attempt here to translate into terms of color precepts which you have already learned about composition in drawing. It is more instructive to seek out, brush in hand, what exactly constitutes the composition of this or that well-known painting. The following may be found relevant:

The a posteriori analysis of any work of art, or of an artistic era for that matter, is open to question, whatever its purpose. Were the old masters to be told all that later generations have read from, or into, their works, they would be beside themselves with astonishment. It has become an absurd parlor game in art history to don the armour of immense learning and clap a completed work of art in the steel frame of rigid logic. Those who do this fail to notice that they have a gyrocompass in their head fixed at "Just you rhyme, or else. . . , !"

Apart from the fact that it is of no importance anyway, no one can state afterwards why and on what basis an artist suddenly felt impelled to alter his conception. A correction is unlikely to spring so much from pondering as from the artist's sensibility. Painters and sculptors, if they are worthy of the name, do not think; they see and feel, just as a poet hears and feels what he writes, and as he goes by sound and not grammar. Turn back if you will to the detail from the Michelangelo fresco. Art critics will be ready with cogent explanations as to why Michelangelo colored over the marked contour, which he had drawn in so vigorously on the cartoon. But I feel certain that if he had altered nothing, the same critics would explain why not with no less cogency.

With this in mind you will know better than to regard the following analyses of two compositions as infallible. We are groping after the truth, not expounding it!

One thing is certain, however, and this is that the usual test, which is to try to convey a surface composition by means of schematic lines, is preposterous. Movement can never be interpreted as line, but only as surface area, and even direction lines describe a path of vision rather than a line of vision. Add color, and the design will be composed mainly of colored areas, which it is quite absurd to express in terms of lines.

Lines used to analyse a color composition can only be regarded as a plan, a framework or pointer to indicate the general trend or feeling of movement.

The two pictures on the pages that follow are placed side by side because both have the horse as their ostensible subject. Their artistic aims are otherwise quite dissimilar. The picture by Marc is a well-balanced, selective composition, which leans heavily on the picture's

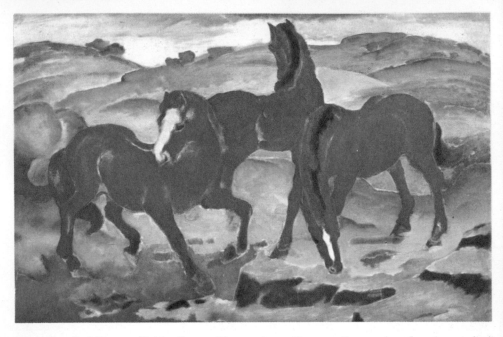

Marc, The Red Horses. Right: Composition analyses (linear pattern and surface impression)

boundaries. These boundaries can neither be contracted nor enlarged without significantly altering the true sense of the picture, which hinges on the three horses. They are intercepted in the course of motion; and taken on its own, the scene is like a high-speed photograph. This motion, as it were, frozen, is stretched across a network of horizontal and vertical lines, facing left, and is emphasized by a triangular link between the focal points of the picture, that is, between the three heads. The marked bias of this network in a leftwards, downwards direc-

tion is taken up by a set of lines leading downwards to the right, but this is revealed only on closer study. The result is a returning sense of repose and delightful harmony. These lines weave the animals and the landscape into a whole. The diagram shows that the true motif of the picture is a series of planes which whirl around, wind about, and finally settle as they were. The three horses are

Reuther, Horses. Below left: Composition Analyses (surface impression and linear pattern)

treated as a whole, and the potentially unwelcome effect of frozen movement is thus offset.

The color likewise brings out the motif. An intense red impels the scene forward, and the violet of the middle horse is seen as a connecting shade of red. This is the keynote which shines brightly and is everywhere repeated, both in the foreground and in the background. The yellows and blues produce the same effect, and as a result a web of colors may be discerned in addition to a web of lines. The green is the only color to appear in the background and nowhere else, but in this way it impels the main motif forwards, but this again is modified by the clear blue with its warmer effect.

Although the picture is exceptionally gaily colored, it is seen at first glance as a colored fabric, a gay material. Closer inspection brings out its amazing vitality.

Whereas Marc applied his colors in thin coats, and exploited to the full their chromatic potentialities, Reuther used the palette knife to produce a porous effect. He does not treat his colors as "absolute" and costly paint to be carefully husbanded, but as a palpable material, reminiscent of a granular whirl of lines on a dark stone. Reuther's picture has two-color planes. The first, the foreground, holds the true picture content, horses and riders, in dull, grayish-pink-violet tones, with many gradations of black; the second, the background, is a bluish-green and conveys an impression of indeterminate distant expanses with a glassy look about them, in spite of the fragmentary porous paint layers. The shadows, which seem to keep breaking through, weld the foreground and background together into one plane, even though the shapes and color surfaces of the motif itself stand out much more unequivocally against the background than they do in Marc's picture. It is doubtful whether the connecting lines which we reconstruct were used at all in visualizing and planning the work. The painting does not depict any motion in progress. Animals and riders alike are impassive and at rest; but the whole is instinct with the possibility of an imminent departure—at a gallop. A springy rhythm built up of arcs points upwards to the right, where it is intercepted and balanced by an arc which rears up toward the left-hand portion of the picture like some massive bridge thrown across slender supports, calling to mind an audacious construction in reinforced concrete. Nevertheless, this picture, which is difficult to explain in detail, has some of the formal elements of the prehistoric cave paintings: massive bodies on thin, fragile legs, which accentuate the fleeting, fugitive nature of animals. This tendency has become almost a stylistic commonplace among present-day artists to whom the subject matter serves as a starting point. The two principal lines of the composition are intercepted by a swirling movement starting in the direction of the horses' heads. The circumference ravels itself into a knot over against the two heads, and as with all live animals it is problematic whether the imminent wild movement which one senses will proceed from flight or from a bitter struggle. The riders' function is accentual; they stress the element of tranquility, but rather than taming the animals' primitive force, they are at its mercy.

16. THE CARE AND PRESERVATION OF PICTURES

There are overzealous housewives who, in a fit of frenzy, will clean the life out of an oil painting with soap and water. "This bit must be done too. Look!" they will say, showing you the dirty finger tip they have just run over the picture.

A given oil painting may appear to survive the cleaning process once or twice unharmed. It will depend on whether the paint is in thick layers or thin, and whether the ground is bound with glue or with oil. In any case, the picture will develop premature flaws and cracks, for the soap and water are bound to penetrate it somewhere, turning the oil to soap or soaking into the ground. What may also happen is that some of the oil paint is "cleaned" right away at once; the mitered frame over which the canvas is stretched will press through; the top layer may go mat. It goes without saying that by then the picture is worthless!

Even if the determined cleaner is warned not to use soap and water, pictures will still be dusted. The trouble is that the dust is rubbed in rather than out. If you find this hard to believe, take a picture down after dusting and remove it from its frame. If the picture is painted on canvas and has a mitered inner frame, you must put something in to fill the empty space at the back. Place a suitable object, a book or folded cloth of the right size, on a firm base which may be a smooth paper base. Next, turn the picture upside down so that the back lies like a close-fitting lid over it all. Work on the front, applying careful pressure, and do not allow the beveled edges of the mitered frame to press through. Then, take some white bread, preferably still warm, and on no account more than a few hours old; scoop out the soft crumb, and form it into little balls which you can roll lightly over the surface of the picture. You will hardly believe how much dirt adheres to the bread crumbs. Throw this away, and take a fresh piece. Apply very little pressure to start with, then more. Try the complete process on only one part of the picture, and you will soon see that the portion you have cleaned is very much brighter and new looking than the rest of the picture.

A soft rubber eraser removes the dirt equally well, but it might leave traces of vaseline behind, so that you would have a nondrying fat on your picture. Thanks to its fat-free adhesive properties, the bread leaves no trace. Naturally, you should not use a milk loaf or one made with fat.

This is the finest method and the one always used by picture restorers before they do anything else to a painting. No one without first-class professional skill and experience should ever attempt to do more. A picture not protected by glass should never be cleaned with a duster or a feather mop. On the other hand, the use of a vacuum cleaner with a metal attachment is permissible. It may be moved over a picture lying flat,

Filling in the empty space behind a wedge-framed picture to clean its surface

but should not actually touch the surface. With care, it is also possible to blow the dust off, provided the stream of air is not so strong that it blows the dust **into** the pores of the picture. Even the most sensitive watercolor, in fact any painting, will tolerate cleaning with bread crumbs. This method is also the only one that can be used to clean a simple glue color painting on the wall. All oil paintings lose something of their brightness in time, it may be only in places, and this makes them look patchy. When this happens, a protective varnish is applied. However, no very recent painting should ever be treated in this way if you do not know exactly what the binder was made of. Surface resinous glazes are easily ripped off, and then the picture is past saving. For a year or two after application, resin undergoes a process of oxidation and then is no longer so easily dissolved. In any case, mastic should be laid on as swiftly as possible, preferably in a single stroke. Repeated applications with a hard brush will take off even an old layer of resin. The least

dangerous process is that of varnishing on top of pure oil paint. After two years' oxidation, neither turpentine nor mastic will do any harm. Daily professional dealing with these matters alone can give you the experience you need to be able to say at a glance what was used for binding. An expert will also know the most appropriate way to test doubtful cases. All painters are occasionally asked to undertake to restore a damaged picture. In principle, they should refuse to do this, even if they have the necessary technical ability; for special experience, over and above sheer knowledge, is required to restore a picture. Unfortunately there are more dabblers than craftsmen in this field. A painting of particular artistic or historical merit should not just be handed over to a picture restorer, even one of some repute. It should be entrusted to a public institution specializing in art restoring, which has the means to assess the extent of the damage, and can say who is the best person to go to under the circumstances. This method usually gives the best value for the money. Small picture restoring firms are prone to recount awful stories, in order to get as much money as they can in return for sketchy, shoddy work. Above all it is only too easy to spoil a picture completely.

The explanations that follow should not in any way be regarded as a guide to picture restoring, but are meant to supplement your knowledge of painting techniques and enable you to view the subject with confidence.

Any picture in need of restoration should first be treated on the wrong side. Any broken or otherwise damaged can-

vas, or holes, cracks, or rents in paper, split or warped boards should so far as possible be put right before the real work of restoring and preserving begins.

Severely damaged canvas is usually glued onto a new canvas, after removing any rough parts or paste which may have been applied for protection. In former times, weeks were spent in detaching the whole canvas from the reverse side of the picture, while the front of the painting was temporarily fixed to a firm base. This was a risky way to care for a piece of art, and has been abandoned. The process of affixing a new canvas behind a painting is the restoring process most frequently undertaken today. Any cracks and flows can be ironed out at the same time. The adhesive used must be one which will not cause the canvas threads to swell. Old canvas, which has been kept taut and over-stretched for a very long time, may shrink by as much as 5 per cent or more, squeezing the layers of paint together so that they fall off.

Sometimes a board of a special aluminum alloy is used instead of canvas. Very large wooden boards must be inlaid from the outset, as already described, to halt any tendency to warping. Rents and cracks are repaired with glue. Rents and cracks in a paper support are dealt with by pasting underneath, ironing out, and pressing. If parts of the picture are damaged, the golden rule is never to paint over the faulty parts in an attempt to imitate what you imagine the original painting to have been. Experience has shown that it is best merely to fill in the faulty parts in a plain color, to tone in with the surrounding area. The bad parts

will then not be too jarring, but will remain recognizable. Any attempt to match up and disguise these parts is taboo; this is little short of forgery.

A knotty question is the renewal of yellowed or tarnished paintings, or those which have darkened through chemical changes. Little can be done for a painting which has gone completely yellow, though you may try placing it in the light, as this sometimes bleaches out the yellowed oils to some extent.

There is no help for a painting in which the pigments have changed because of chemical reaction. This is a process of decomposition almost always present when chrome yellow has been used. In the initial stage a strange unhealthy shade appears, which turns to a kind of green (this is apparent in the present condition of Van Gogh's **Sunflowers**, and this is the "mysterious" quality for which this picture is so admired). In time chrome yellow becomes a greenish black. Coal-tar colors go gray.

If it is merely a question of a surface oil varnish, applied by an experienced painter or restorer, which has gone yellow or brown, the varnish is merely removed. This is done meticulously, bit by bit, by spotting out with turpentine, alcohol, or similar means. A responsible restorer will constantly use his microscope to check whether the varnish removed contains any grains of pigment. If so, whether or not he has already removed a glaze, he must at once suspend his work. As a rule, when a yellowed varnish has been removed, "the golden tone, the glory of the old masters" which spectators may have raved about, is shown up in a harsher and candidly disappoint-

ing light. This, however, corresponds to the artist's intention. If he had wanted the golden tone, he would have used ochre or some other yellow pigment for his final coat of varnish. Resinous varnishes, which we call "dead," that is, varnishes which have begun to crumble and have lost their transparency, are not handled directly. Pettenkofer's now celebrated method is to expose them to a steam bath of turpentine, alcohol, or petroleum in an enclosed tank to restore lost cohesion to the layers of paint.

Mildew will always put in an appearance if there is enough moisture and nourishment for this type of fungus. Dust may contain suitable nourishment and help it to grow on the front of an oil painting where it could not otherwise hope to live. More often it is the back which is attacked, and the glue in the primer is eaten away. This unhappily also shows in the front, which seems to puff up and later decays.

Pictures which have gone mildewy should first be dried until the fungus and its spores can be removed, like dust, with bread crumbs. Then alcohol is applied several times to kill the germs. That is all. Damp stains are very hard to remove. They are due to the matter secreted by the fungi. Bleaching with hydrogen peroxide is not without its dangers because of the risk of attacking the paint layers in the process.

The restoration of pastel paintings whose colors were either not fixed at all or whose fixative has lost its binding power is a subject apart. A good deal can be done by very patient dabbing on the places which have become affected. The picture will lose something, of course, but will still be recognizable. If powder

pigment has stuck to the glass itself, the only thing to do is to remove the picture carefully from its frame and clean the glass, and if necessary put back a new one instead. It is risky to apply a fixative after the painting is finished. Old pictures were painted without the aniline colors, which were not yet known, but they are likely to have used gum substances, which are every bit as sensitive, if not even more so. The least that can be said is that no fixative with an alcohol content should be used. Glue, or skim milk, would certainly not make the colors run, but it might give a delicate painting a hard, brittle appearance.

To sum up, a painting of any value should be entrusted only to a fully qualified restorer. But how is one to tell if the picture in question can properly be considered valuable?

All painters constantly find themselves in the dilemma of having to act as assessors in their friends' homes. They are led before some futile work by its proud owner. One has only to describe this monstrosity for what it is to offend him mortally. But because a picture looks bungled, this does not mean that it is worthless, for a painting of the highest order may lie beneath. "Suspect" paintings of this kind have long been X-rayed. The individual metal ingredients of the pigments show up quite differently when X-rayed, and it is easy to see if there is another painting under the top layer. Many a celebrated painting has been uncovered when a worthless painting was washed off. On the other hand, under some worthless modern overpaintings all that has been found was a forgery. It is extremely difficult to prove the authenticity of an old master. The very greatest

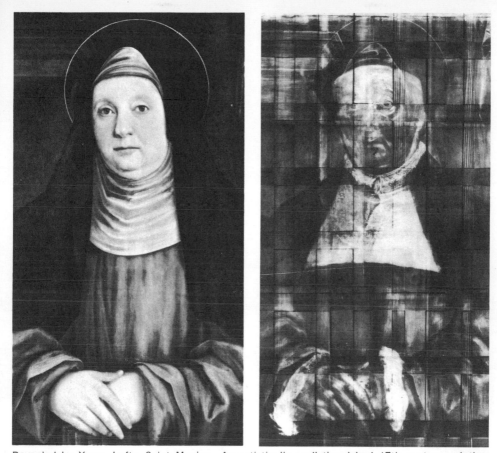

Revealed by X-ray. Left: Saint Monica. An artistically undistinguished 17th century painting. X-ray photography revealed the far more valuable portrait of Magdalena Wittich by Christopher Amberger, who lived in the 16th century (X-ray photograph by Hans Roth)

experts are often taken in. A signature is no guarantee, as it may be forged just like the rest of the picture. When an expert examines a picture scientifically, he first tries to ascertain whether by any chance it was painted with pigments unknown at the time of the painter in question. Examination of the pigments under the microscope provides further information. The grains of old pigment are less uniform than those produced today. The age of the canvas, wood, or other support is a further clue. It is frankly no easy matter to give an accurate assessment of an old support. A professional forger will always find means of obtaining old boards, canvas, or paper. Nevertheless, if enough of the paint layer can be spared for the expert chemists and physicists, they should be able to unmask any modern forgery. Contemporary copies or forgeries, if well executed, are almost impossible to detect; if badly executed, however, the expert will spot the forgery

Framing a picture on a wedged stretcher (back view). Spring clamps, triangular chips or tacks driven in are used to secure the frame. The stretcher itself is not touched. Cork discs keep the picture from touching the wall

by the signature, which, if exposed to infra-red rays, will show the original signature underneath.

This is all intended for your information, rather than for practical use. On the other hand, the framing and preserving of your own pictures are matters which it is essential for you to know something about. The worst enemy of all works of art is humidity. Constant extremes of heat and dryness are likewise undesirable. All pictures with a mitered inner frame or fixed on a board should be placed in a picture frame with a broad enough rebate to keep them from being jolted or from falling out. All types of material shrink or stretch to some extent, depending on the degree of humidity in the air. Mitered inner frames and boards should never be nailed directly to the picture frame. The right way to attach them is either to drive in suitable pegs or small metal plates, or to fasten on small steel spring brackets to hold them firmly but flexibly. The use of brackets on the back of the picture also has much to recommend it. When the painting is so sensitive as to need glass to protect it, the painting and the glass must not touch; this applies to watercolors and glue color paintings as well as to pastels.

It is best to use a mount not less than about one tenth of an inch thick. In many cases, even if no mount is used a frame with a double rebate is the answer. The frame puts the finishing touch to the picture; its shape and appearance must be chosen to match the aesthetic impact and style of the whole.

Above left: cross section of frame with spring clamps
Below left: with tacks or metal chips (triangular); spring clamps are best

Above right: The glass and picture divided by strong passepartout
Below right: Here the glass is separated from the picture by inserting a strip of framing felt

Anselm Feuerbach averred that the use of a good brush was half the battle for a good picture. We know from Goethe that the sight of a pad of clean paper and a handful of well-sharpened quill pens stirred in him an irresistible craving to write. And the most callow novice feels his fingers itching when a fresh white watercolor block lies before him, a splendid paint box open in front of him full of bright colors, and water and first-class brushes all stand ready. If this novice can in addition be left in peace and quiet there is no holding him, however little he knows.

Take this same beginner into the studio of a great painter, where ill-treated tubes of paint, empty vodka bottles and bedaubed palettes lie scattered in wild confusion, not forgetting the dirty window panes, the dust and unfinished paintings everywhere, and he will certainly put his hands in his trouser pockets and never speak of touching a brush again. Without being a Philistine, all he will take away from his visit will be, not to put too fine a point upon it, a feeling of condescension.

Listen to what the son of a Chinese painter, Kuo Hsi, wrote, a good 900 years ago: "On days when my father decided to paint, he would sit down before a bright window, tidy his desk, and burn incense on either side. Then he would take a fine brush and the best China ink, wash his hands, and clean the ink stick, as if making ready to receive an honored guest. He would gather his thoughts together, and then set to work. . . ."

The same spirit animates the studio of C. D. Friedrich, as conveyed in Kersting's picture. Anything simpler or more modest it would be hard to imagine. Nor is it conceivable that Friedrich's painting could have taken shape in either a sumptuous or a slovenly studio. Vermeer van Delft's picture of a studio conveys, again, a serene, cheerful, solid middle-class atmosphere. One hardly expects this pleasant, tasteful room to be an artist's studio.

Compare this sight with that which appears to be **de rigueur** in every film containing a studio scene, and you will ask which comes closer to the truth. It may be a question of taste how and where one works. But it is certain that simplicity, tranquility, and orderliness are more conducive to concentrated work than grandeur, distracting in its smugness, or shambles where one can work only in one mad rush. This makes impossible any sensitive, creative work. A room in which one spends a great deal of one's time has an imperceptible influence, first on oneself, and in time on one's work. When arranging your studio, you should bear this in mind. One last point: the studio does not exist to impress your visitors.

The first thing to decide on for a studio is the lighting. It is beyond doubt most practical to face north, as this keeps out the direct sunlight, which would make work impossible; but it is usually cold,

and many people find that it weighs on them. To face in any other direction means bringing at least some sunlight into the room. If curtains are used to screen it off, the light is no longer uniform and untinted. It is best then to face north; but with an overhead light source which can be screened, or with a window facing south, but far enough away from the work bench, ideal conditions can be contrived, free from any hint of gloom or oppression.

The window by which you work can scarcely be too big. As a screen and for nighttime, it is best to use plain white curtains; the room should indeed be white all over. An artist who expresses himself constantly in color feels restricted if he has always to contemplate the same color sources. Gray walls make for a cheerless light and benumb the imaginative faculties. White walls will most easily enable you to create the light conditions in which the picture will ultimately be seen. These are the light conditions under which it should be painted.

The most favorable light is that coming from the left, preferably from above and behind, so that the right hand in working does not cast a tantalizing shadow over

Kersting, C. D. Friedrich in His Studio. It is interesting to note the presence of a ruler and set-square as indispensable equipment. (See text and illustration on Page 34

the surface of the picture. However, you can easily become accustomed to having your light source on your right, if the lighting and positioning of your model call for it. Supplementary overhead lighting is particularly useful in this case.

It is always risky to paint by artificial light, for there is none which corresponds exactly to daylight. Many of Rembrandt's light effects lead us to believe that he painted by candlelight, but beyond doubt he confined this to under-paintings and in-between stages. The final coat of color he certainly laid on during the day, carrying the nighttime appearance of the scene in his mind. Artificial light if used should not be cold or harsh, nor should it be too warm or gentle, and it is best to avoid light from a single source.

The size of the room will be determined by the size of the picture which you intend to paint. This consideration apart, one artist will choose to work in a small room, and another in a spacious hall. What matters is that the artist should be able to step far enough back from his work to take it all in in one single glance at an angle of 30 degrees. For purposes of ready reckoning, this means that the distance from which the painting is to be seen should be twice the length of the picture's longest side. A picture which measures 5 by 7 feet should be seen from a distance of 14 feet. With the exception of watercolors, all picture surfaces should be placed perpendicularly, or very nearly so. For this you must use an easel. Unfortunately you will find nothing on the market between the antediluvian model, such as that in Vermeer's picture, constructed on a shaky tripod, and portable frames of the most complicated design. Yet it is a simple enough matter to construct a movable easel with a counterbalanced weight. A drawing board can be obtained, however, equipped with a counterbalanced weight or with a hydraulic adjusting device. It is useful for painting if your drawing board has a block which compensates for the table's perpendicular tilt. An easel with a counterbalanced weight will help you to work a great deal more smoothly. With it you will be able to adjust the height of your board to the nearest fraction of an inch, and vary the position of the easel to suit the lighting.

Unfortunately, again, there are no artist's trolleys available. Of course, you may use an everyday service wagon, but it is worth the trouble to make one to measure for professional studio use. Many types of work require the use of a table. The usual height of about 30 inches is far too uncomfortable; a height of about 23 to 27 inches, depending on how tall the artist is, is very much better. This gives you a better view of the table top, whether you are engaged on a sketch or painting a watercolor which must be kept horizontal to catch the excess paint. For drawing you will often find a table with adjustable beveled board comfortable to work at. This has already been illustrated on p. 85, together with its chair. At one time, dining room chairs were made like this, so that it was possible to remain seated at the table for hours on end, upright, yet at ease. Front lighting is best if you are working at a table.

You will find it extremely useful to cover one or two studio walls with fiber

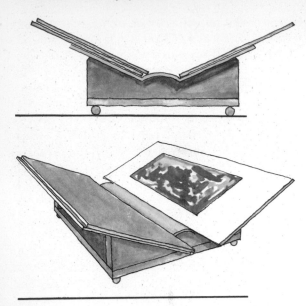

Homemade trough for easy refer-
ence to studies and pictures

boards about one half inch thick, to a height of about 6½ feet, or to the ceiling. The exact material you use is unimportant, so long as it is soft enough for a pin to go in and out easily. Here you can put up sketches as necessary from time to time.

These boards are less expensive, even if they occasionally need replacing, than wall plaster, which you would be constantly repairing, as you would be forever hammering in nails, and fragments of the plaster would keep falling out. The boards should be given a coat of white commercial emulsion paint. The usual size for the boards is about 5 by 8 feet; but it is best to use the biggest you can, so that they can on occasion be used for rough drafts and sketches. Use good drawing pins and you will easily be able to put up and take down large pieces of stiff paper. Naturally, they will not do for heavier paintings, but for this

purpose long enough nails should be used, driven right into the wall. This enables you to drive the nail home properly without an unsightly mark from broken plaster. You may in addition fix a guide rail at the top to take wire cable or screen rod on which to hang heavier pictures, as is usual in museums everywhere. In any case, you would need a very large studio indeed to have a well-lighted wall free on which to do this, as there are still a good many other things to be fitted in.

To begin with, you will need a cupboard for your designs; and if it is to take the largest size of paper, this is bound to be a monster. Metal cabinets are the most useful. Wood ones are slightly cheaper, but in either case, since each drawer is only about 1½ inches high, and there are several of them, this is an expensive item. Papers, sketches, and pictures on paper can also be kept

Jan Vermeer van Delft: The Artist in His Studio. This splendid studio may be regarded as wishful thinking by the artist, for as far as we know he was badly off. Nor does the primitive easel fit in very well with the sumptuous surroundings

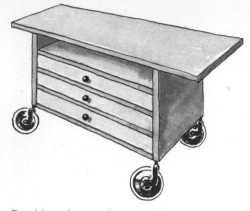

Easel-board on castors

Portable case for wet oil paintings

in portfolios, but these are eternally to be found leaning up against the walls, where they fall down, encourage the dust to settle, and jostle sensitive sheets against one another. These are always a makeshift affair. On the other hand if you have pictures which are to be looked at more often it is most useful to arrange them in a book trough, where the pages can be turned over like those of a book. The portfolios too should have thick, firm, stiff, hinged spines.

The way you store your paints, brushes, crayons, bottles of fixative, binder, and cleaning agent, as well as a thousand and one oddments, depends on what you like, what you can afford, and what you have room for. Roller-shutter cabinets are very practical, and if suitably painted over give the room a pleasant look.

If you do a lot of large-scale work, and always have a good many rolled sheets of paper lying about in the studio, it is far more convenient and economical to keep them horizontally, rather than to have them standing about in dusty corners, where the edges and exposed areas of the picture get crumpled and dirty. Various kinds of metal and wood roll-shutter cabinets are to be found, but, though practical, these are expensive. However, the most rudimentary type of bookshelf can be converted to this use if it has a curtain in front and is not less than 62 inches wide, as the largest size of paper is about 60 inches wide. Suitable rods, like those used in wardrobes, can be obtained at any furniture dealer. Slide the rolls of paper over these rods, cut to the required width. Ready-made cabinets have built-in paper cutters.

Other furniture and fittings depend on the sort of work to be done: raised platforms for models (figures in action and portraits), more tables and seating accommodation, cupboards and bookcases. It is a studio tradition to make one's platforms and seats out of chests, but as these are not sold in the shops, they have to be specially ordered. In doing this, it will be found more practical, if less usual, to order chests suitably graded to fit one into the other, rather than equal-sized coffers open on the one side, with hand-

holes. They must all be of the same height, however, to keep the platform level. Chests all of exactly the same size take up a great deal of space.

It goes without saying that every studio must have running water, and facilities for washing and rinsing. The basin for rinsing must be acid-proof, made of rust-proof steel or a suitably glazed ceramic material.

One can go much further, and make a studio delightful, as if it were a home with several rooms. However, this pre-supposes a large storage space. This makes it easier to maintain a peaceful and orderly atmosphere in the studio, without losing time over superfluous details. If you work out of doors a great deal, you must be able to improvise and set up your equipment as the occasion demands. The first Impressionist painters went into the countryside laden like packhorses. A modern, fairly successful artist will drive out in his roomy motorcar, taking with him everything he needs to make himself at home; not forgetting a large sunshade, folding table, camp stool, paint boxes, and palettes.

For a watercolorist, the most important requisite is a bottle of pure water; for an artist in any other medium, it is his easel. Recently, several models of tele-scopic tripod easels have come on the market, which are very suitable and handy. For watercolor work, a light-weight folding table will serve both as support and as a place to rest the box and palette.

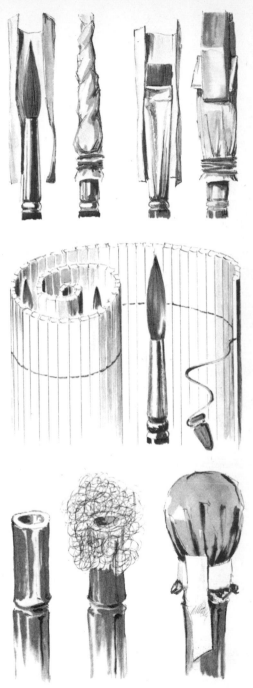

Top: Redressing a brush that has become too difficult to handle
Center: Rod-mat to carry brushes
Bottom: How to stuff a maulstick (painting stick)

The Studio and Equipment

If you paint in oils out of doors, you will want to provide your painting board or canvas with a well-fitting lid so that you can move your work while it is still wet. If you cannot buy a suitable one, fix four clamps to the edges of the support so that they project a little, and make a lid of stiff pasteboard or thin hard fiberboard.

To carry your brushes about, you should get a number of small mats, of the kind illustrated, made of little wooden slats. Make a mat yourself for your long brushes. This is the most elementary but safest way to protect brushes from dirt and damage, even if they are still wet and not thoroughly cleaned. Tie them up

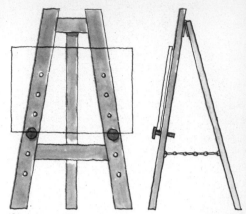

Simple studio easel with two pegs for height adjustment. The oldest but still the most useful type

tightly, and no harm can come to them.

You may find you are bothered by the light out of doors. The only answer is to use a large sunshade with a jointed stick, which will always give you shade. Never use a colored parasol, however, always a white one. Trying to paint in the blazing sun is always upsetting. The blinding light deprives you of your ability to judge colors. You may try to sit inside your car and work from there, but the windshield will get in the way and you will feel cramped, so this can be only an unsatisfactory makeshift.

This glimpse of the proper way to organize an art studio on a professional footing will give you an insight into what is needed. You cannot limit your equipment to what you would need for work in one particular medium—for instance, watercolor painting; even if you are a complete amateur, it is useful to have an idea of what is absolutely indispensable.

You may find some comfort in the thought that even the grandest and best equipped studio carries not the slightest

Fully adjustable metal folding tripod with poplar board

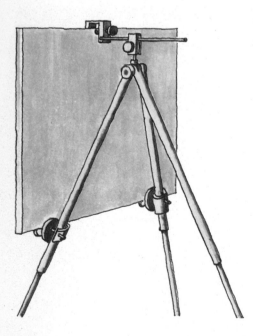

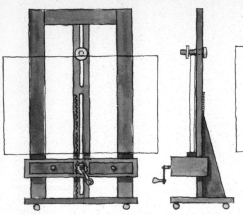

Large mobile studio easel with shelf and tool-box. Rack and pinion drive for height adjustment

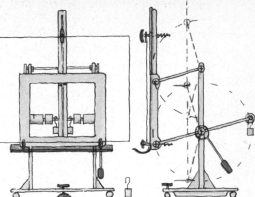

Mobile studio easel with counterbalanced weight, fitted with dragwheel and lock, grooved ledge and additional balances (designed by the author)

guarantee of success—all it can do is to lighten the task. Many a work of art has originated in the most miserable setting. Even with the most modest means at hand, given flair and imagination, somewhere to work can be found in every home. The one thing which cannot be skimped is the purchase of first-class materials.

It is simply a question of discipline always to take watercolor paint out of the pan with a perfectly clean brush. You will soon realize which colors rapidly become firm in their pans, colors such as chrome hydroxide and ivory black. Always buy these in the smallest possible quantities, while for other colors the larger sizes are more economical. The pans dry up easily once the tinfoil is removed, so always take care to close the box well; also always be sure to keep the box horizontal, as many colors which appear to be firm, such as the cobalt compounds, do in fact gradually run. Possibly it is better to buy the cobalt colors in tubes for this reason.

If you work almost daily with watercolors, it is worthwhile to place a moistened sheet of blotting paper of the right size over the pans each time you close the box. This prevents the colors from ever becoming completely hard. If you do not use your watercolors for long periods at a stretch, the constant damp will ultimately cause mildew to appear on some paints, despite the preservative. Look at them from time to time, remove any paints attacked in this way, wash off the mildew and leave them to dry.

All tubes of paint must be closed with care after use. Inside the cap there is a tiny cork disc; do not lose this, for it will enable you to re-open the tube easily. For this reason you should always leave it unscrewed by half a turn. Any paint left over will stick to the thread so hard that you will have to use force to open the tube again, and usually it gets broken in the process. It is often a help to leave oil points standing upside down in turpentine, so that both cap and thread bathe in it. It also helps if you place

size and watercolors in the same way in warm water. After the tube is closed it should always be rolled up carefully from the bottom. It is well worth the extra trouble. If you work more often in pastels, you will find that worn down and broken bits of chalk soon spoil the look of the finest pastel crayon box. Sort out these pieces and put them in a small empty box, and clean all your pastel boxes very thoroughly, so that useless left-over and broken pieces do not crumble still further and discolor the good crayons.

Usually it is the brushes which receive the worst treatment. Valuable watercolor brushes should always be cleaned only by rinsing in plenty of water; they should never be left standing in the water, as this makes them crooked. Should this happen, swirl the brush around in the water, squeeze it out, then wind a strip of thick paper around it, secured with a rubber band, and twist the ends around carefully so that they overlap. Hang it upside down to dry. Make sure it is quite clean by pressing it out with a white cloth or a scrap of cellulose. "Collars" for flat brushes may be pressed together with a clothes pin. In this way brushes which have become cross-grained can be made as good as new again.

After cleaning an oil paint brush in gasoline or a turpentine substitute, squeeze it out well, and rinse it out in pure turpentine to make sure that no cleaning agent is left on the brush. All brushes dry most speedily and satisfactorily hanging upside down.

When working in tempera colors, wash the brush thoroughly before the paint has had a chance to dry; otherwise there will be no way of removing all the binder and scraps of paint. If you are working out of doors, and cannot do this, wrap each brush in aluminum foil to keep it moist before you put it away in the brush mat. This, of course, applies equally to oil paint brushes. It is better to throw away a brush on which casein color has been allowed to dry, rather than carrying the useless object about with you. After washing casein and fresco brushes in water, rinse them out again in vinegar diluted with water in order to neutralize the alkaline, which is harmful to hairs and bristles. Leave the brushes for a while before squeezing them out, then give them a last rinse in running water before drying.

Moths appear to regard hair brushes as a delicacy, so when they are quite dry you should keep them in an airtight container or plastic bag. On no account leave them for any length of time in their jar, where they would also collect dust.

Cheap plastic palettes are not yet in mass production, so you should get a carpenter to cut you a variety of palettes from odd pieces of thin, hard fiberboard or plywood, covered in synthetic foil, to a cardboard pattern. These are no trouble at all to keep clean with ordinary household cleaners. They are a good deal better and cheaper than palettes made of expensive pear wood or plum wood, and are also more pleasant to use than tin or china. For studio work, you can also stick stiff, transparent foil to fiber boards with adhesive tape and keep this on your trolley; then, by sliding white or colored paper underneath, you will see at a glance what the shade in

question will look like against a colored ground. This practice can naturally also be extended to palettes. Foil is cheap and expendable. No attempt should be made to clean it.

For fine work and anything which calls for precise brush movements, a painting stick is indispensable. This gives you a restful support for the hand holding the brush. You will need both shorter and longer ones, and it is best to buy a number of bamboo sticks, cut them to suitable lengths, and wind cotton wool around one end fixed on with a rough material or chamois leather and bound on firmly with adhesive tape.

The beginner who goes into a shop selling artists' materials may be put off by the choice before him. Before starting, haltingly and confusedly, to buy the wares recommended, first ask to see all the sales brochures and catalogues of paint vehicles and mediums, brushes and other equipment available, preferably from several first-class firms. Go through all this literature very carefully at home, and compose a well-thought-out shopping list. When you go back, you will discover to your astonishment that now it is the salesgirl who is at a loss, for much of what you have marked as essential is not stocked at all. She may try to persuade you to buy materials that are "just as good," but you should be very wary of doing this; it is better not to give in at all, but to insist on ordering what you want. Tubes of paint should be tested before you buy them to make sure that they are still completely flexible. Tempera and size colors which have been kept a long while are especially difficult to squeeze out, and the most expensive pigments are particularly given to premature hardening.

If the day comes when you can install or even build a proper studio for professional work, you should be absolutely clear as to what you want and why. For example, studios are often placed on the top floor. But is this really practical? The older ones belong to the days when artists painted only enormous pictures; but apart from this, their ceilings were so high and the windows so unpractical, that unless the artist was constantly attending to the fire, he was bound to freeze.

We hear so much today about the "dream house." I presume in the same spirit to put forward plans for the studio of my dreams. The basic structure is very simple, and I have from the outset foregone the romantic winding stairways, dim corners, and partitions which visitors find so appealing. A light, functional room, protected against outside noises, is alone conducive to the creation of works of art, precisely because these works themselves are often so cut off from the logical and functional.

The most important thing seems to me to be the division of the studio into three parts. For my own purposes the studio must have relatively high ceilings, as I am most drawn to wall painting. There must be room for storage and preparation and a living space where one can rest, read, and write, as well as receive visitors—who, in principle, have no business in the studio, except when it is necessary for them to come and look. Nothing puts one off more than discussion of half-finished works, whether captious or flattering.

1:100

Arrangement of north wall of studio, showing large windows and recess for washing

Right above: Ground plan of the studio, with ante- and adjacent rooms

Right below: Section A-B showing arrangement of studio and living room

(Scale 1:100 expressed in meters)

I Studio, 40 sq. m. (130.4 sq. ft.)

II Adjoining room for preliminary operations, 18 sq. m. (59 sq. ft.)

III Living and reception room 21.75 sq. m. (71.30 sq. ft.)

IV Vestibule containing WC, hall cupboard, and landing with access through double doors to studio and also to private residence (V).

1 Easel with counterbalanced weight

1a Display wall

2 Easel board (see page 376)

3 Picture trough (see page 374)

4 Work table, 70 x 200 cm. (27 x 78 in.) covered in gray or green synthetic fabric or foil, about 65 cm. (25 in.) high

5 Cupboards with shutters or doors, 30 or 40 cm. (12-16 in.) deep for small items of equipment, liquids, pencils, etc., and small stretching blocks and paper

6 Cupboards or drawers for equipment such as rolls of paper, canvas, boards, stretchers, completed pictures, etc.

7 Large cupboard 80 x 130 cm. (31 x 60 in.) to hold designs and other pictures on paper

8 Bookcase with hinged flap for use as writing desk

9 Extra space, may be used as cloakroom, etc.

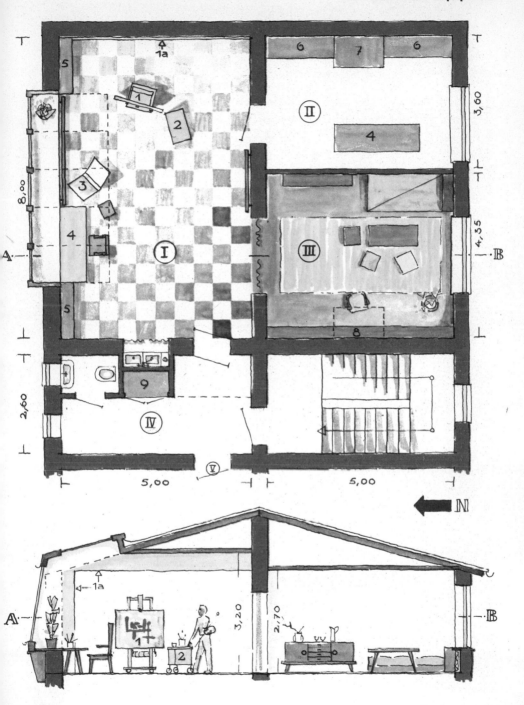

18. THE PAINTING

As a pendant to the section on The Drawing, we shall now describe how a color painting is made and how to achieve a mature and definitive work of art—to use the most ambitious term for a painting.

The extreme opposite of a painting is a drawing, in particular a sketch or impromptu study. Yet a rapid drawing is likewise the starting point for a painting. Drawing consists in fact of the division of the picture area, the composition, and later on the details. It makes no difference whether these drawings are executed with charcoal, crayon, or paints and brushes; nor does it matter whether the painting is accompanied by drawing. Color is the element from which a painting is made; but even the smallest speck of paint is also a shape and must be put down somehow. It is a question of technique, whether you begin with an outline and work up from that, or with a brush mark which you expand on all sides until it reaches the outlined shape. In any case it is a question of draftsmanship. The same is true even if the color surfaces merge with one another.

The dividing line between the individual colors is felt to be present even if it can scarcely be seen. Remember Monet's picture of Parliament in London (p. 15). Here you can hardly point out a single boundary between the buildings and the sky, but in spite of this you are fully conscious of the shapes of the buildings. It would be perfectly possible to produce a drawing without the use of color, but a colored representation cannot do without drawing. Without drawing, all that you are left with is a shapeless mass of colors running into each other. It is important to bear this point in mind, for the paragraphs which follow aim at the elaboration of a systematic procedure of universal validity. Here we have a clear distinction between line and color, which is absolutely necessary if one is to proceed in a workmanlike way.

We must be sure that we know why color always has greater impact than a black line or tinted areas. There is always something unequivocal about color. Red, after all, is red, and cannot very well be regarded as green or blue. Differences of tone between areas drawn side by side leave you at liberty to conjure up any color you wish. A patch of sky left plain white in a line drawing will be automatically felt to be in a different shade from the equally white strip of roadway—assuming that the drawing is objective and unmistakable. Now look back at the Dürer drawing opposite the Monet picture we have just referred to (p. 14) and you will see that the Dürer contains three empty spaces: sky, water, and quayside. The moment you have grasped the picture content, you assign to each identical bright surface a different color concept.

It follows from the unequivocal statement which is implicit in the use of color that every time you paint, you not only can but must express your ideas in more downright terms than when you draw.

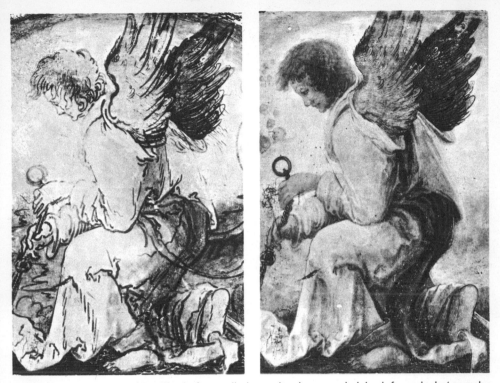

Huber, St. Anne's Altar (detail). Left: preliminary drawing revealed by infra-red photography (Photo Hans Roth)

Once you begin to paint, you begin to move towards something which, when completed, will leave little unsaid as to form, and nothing whatever as to color. If anything is left plain—if, for example, the ground is left untouched in places— the picture will always have an unfinished look. The fact that this unfinished look has a singular charm in no way affects the issue. Dürer's outline drawing, on the other hand, despite its many spaces, seems anything but unfinished. Imagine these spaces given additional treatment, filled in, perhaps, and you will see that this would not make the drawing any more "finished."

However, a mature painting will come into being only where there are a deep purpose and a clear aim. An artist must have become fully aware of the absolute limits to his attainment before he can achieve this. Naturally, these limits are narrower in drawing than they are in painting. For this reason monochrome can be said to offer greater scope to the imagination than color work. Color, the element which cannot be used in drawing, must be rendered uncompromisingly in painting, and from it there is no way back into the realm of individual imaginings.

It is also in the nature of drawing for

385

The Painting

it to say what it has to say once and for all, whereas painting gropes its way progressively toward its final form. This is simply due to the way colors affect each other. You learned long ago that a blue may at first appear correct, but appear to change when its complementary color, orange, is placed beside it. The blue will appear to be more intense; but place another blue beside it, and the first one will weaken it. The artist may, for technical reasons, occasionally endeavor to produce the definitive shade at a first attempt, relying on his imagination and experience, as in watercolor or true fresco work. As a rule, however, it will suit him better to begin by indicating his color faintly, and to arrive at his final shade step by step. It is equally important to make a workmanlike distinction between draftsmanship and painting. As a rule the painter utilizes his line drawing as a starting point, a scaffolding which

will gradually be lost to sight. He may choose to erect this scaffolding with great care, or he may prefer to sketch it in very rapidly, just enough to support the first structure. From then on he must use paint, however. Isolated masters of the craft may work without preliminary drawing of any kind. Lovis Corinth, for example, would often start with an eyebrow or a nose, and would draw on from there, or some similar feature, in color, until the portrait was done. But most artists would go aground if they tried to do this. One must have supreme command of the rules to be able to lay them completely aside. You know well enough that from a technical point of view it can never be done with impunity. The same holds good for the distribution and sequence of individual processes: depart from the well-tried rules, and you will imperil the artistic impact of your work.

Before you begin, you need to visual-

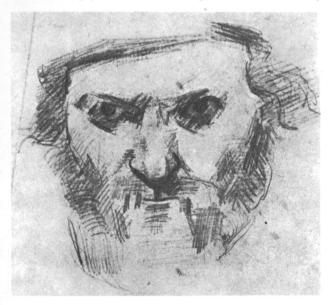

Cézanne, pencil head study

Spitzweg, The Bookworm
Right: Macro-photograph by
Hans Roth
Below: Detail, actual size

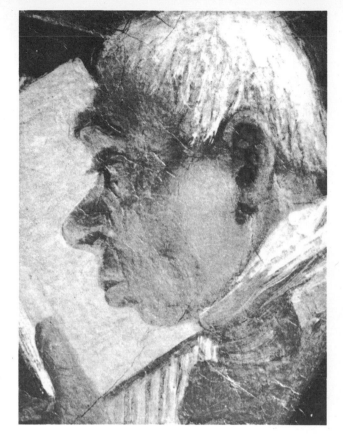

ize clearly and deliberately how you mean to put your artistic aims into effect. You will find simply that if you take whatever ground comes to hand and attempt to express an idea or a vision, however clearly you see it, without technical and workmanlike preparations, with no sketches or concentrated spadework, a true work of art cannot possibly emerge. An exceptionally skillful artist may possibly bring this off, relying on experience garnered throughout his working career, but as a rule it is precisely the greatest masters who adhere to well-tried rules of procedure, modified over the years to suit their own needs. They know only too well that this is how they will get on fastest. The accepted blueprint for the creation of a painting in its final form is to divide up all the technical and artistic processes so far as humanly possible.

At the outset of a new work, a painter must make up his mind on two fundamental points: what he wants to paint, and how he wants to paint it. Unless the idea behind the picture is a mere passing impression, in which case all the work can be done in front of the subject, and will usually be in the nature of a sketch or study, the question of

what to paint entails a lengthy process of familiarization. While it is true that, apart from some small corrections afterwards, the great Impressionist painters completed whole works at a stretch with the subject before their eyes, it should not be forgotten that what the Impressionists were interested in was after all not **what**, but **how** they painted. For the Impressionists, preparation meant grappling, incessantly and intently, but still more visually, with this question of how to paint. They painted countless studies at one sitting and the subject was a matter of relative indifference to them, so long as the color harmony or textural quality stimulated them. They might find this quality in a misty sky, a ferment of limitless greens (herbage, copse, or meadow), or the dusty glare of a hot day, with its shimmering light, which at first glance seems to be just gray and more gray, but which is in fact built up of thousands of the most subtly differentiated specks of color. They painted all this, then, as background preparation for such works as Monet's **Sunrise**, or Cézanne's **Mont Saint-Victoire**. To show how indifferent the Impressionists were to the subject of the picture—in the intellectual sense—you have only to imagine that instead of London's Parliament, Monet's painting depicted an old harbor shed down by the water. You will surely agree with me when I assert that this would make the same impression on us.

Van Gogh's attitude is in some respects the opposite of this. He is generally reckoned among the Impressionists, but he was by no means always preoccupied with the manner of his painting. To take his portrait of **Le Père Tanguy** as an

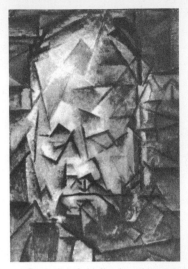

Picasso, Portrait of Vollard, painted in 1910

example: it is difficult to imagine it as Duke X, or to substitute an orchid for **Bottines**. For his sailor, Van Gogh carried out numerous detailed studies to arrive at the exact expression of the face, hands, and striding demeanor of his subject, and to discover how to set these things down finally on his canvas. So he divided his work up, concentrating one after another on little details, and went on working at them until they took their place in his idea of the picture as a whole. An artist can develop this intense preoccupation with detail to such a pitch that he sees it before his eyes and feels it in his fingers. When this stage is reached, he must carry out his final work without a single glance at the studies. This is essential, because to refer to the preliminary work now would result in copying, not creating. It is better to close one's eyes and conjure up the idea, rather than to copy what one has already painted. If you cannot do this, it means that your work was not thorough enough.

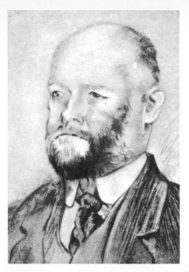

Picasso, Portrait of Vollard, painted in 1915

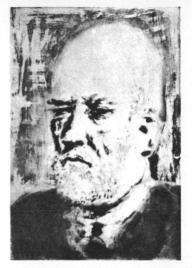

Picasso, Portrait of Vollard, painted in 1937

An actor who is not sure of his lines ceases to play his part and is reduced to mouthing the words with the help of the prompter.

To sum up, before tackling a given subject, the artist must sketch out his idea with the help of countless line and color studies. How many he must make depends on his skill in general and on the degree of difficulty of the particular motif.

Leaving aside any universal search for a new mode of expression or a new way of looking at things, as with the Impressionists, the question of how to paint also brings us to consider the craft and the technicalities of building up a picture. As a rule this is a concept which emerges clearly even as early as the first sketches, and later on, in the effort to overcome difficulties of line and color. You are well aware that in watercolor no opportunity occurs to heighten the color progressively; that the rendering of fine detail cannot help looking contrived,

that in certain cases depth of color can be achieved only by the use of glazes, and that this is not possible when using **alla prima** technique—to mention but a few such difficulties. A further factor is the degree of skill of the artist and, finally, the nature of his expression as a whole, the way he paints. All this has its technical importance even in the preliminary sketch.

For this reason, the old masters went to great pains to divide their work up properly. First, using means akin to drawing, they marked out the form their picture would take. Often this meant a monochrome underpainting, usually gray in appearance, but containing within it every detail graphically portrayed. The second process, an elaboration in color, may be understood as roughly comparable to coloring a black and white photograph. In fact, as you know, there is more to it than this. While some of the greatest masterpieces of painting were created in this way—Van Eyck's **Ma-**

donna, for instance—Rembrandt would have nothing to do with it, saying that he was a painter, not a dyer. In his eyes, his underpainting gave him a far better foundation to work on than explicit form which only needed coloring.

Rubens worked in yet another way. Neither in Van Eyck's nor in Rembrandt's work does a trace of the underpainting as such show in the finished painting. In Rubens' work, on the contrary, some hint of the hatching look of the gray primer he used shines right through to the top surfaces; thanks to the effect of color interference, this creates the wonderful mother of pearl luster seen on the skin of his female subjects. Rubens used powdered charcoal bound with size and applied it in broad sweeping strokes obliquely over the white primer, thus producing an original tinted effect. The great Flemish artist employed every process, however insignificant. We might say that he never did the same thing twice over. By virtue of his deft hand, his sovereign artistry, and, if we may be permitted to say so, his serene and nonchalant attitude to life and choice of subject, thanks too to the inner harmony of the times he lived in, from the artist's standpoint, he was spared the need to grapple agonizingly with problems of color and line. Show anyone a Rubens in an art gallery, and you will invariably see a happy smile on his face. Show the same person a Rembrandt, and his face will take on an earnest, respectful expression even before Rembrandt's most cheerful picture, the one known as **Rembrandt and Saskia**. He may be totally lacking in expertize, yet he will sense that a battle was fought over the question, "How?"

As you strive to achieve your own manner of painting, you are doing more, therefore, than studying mere techniques. Above all, your manner must come from self-knowledge. This depends on your degree of maturity, on whether you are honest and disciplined enough not to founder on the reefs of vanity, which will tempt you to strain your talents beyond their limits.

It is sheer madness to take it upon yourself "to paint like Titian," or "to paint like Kokoschka." If among the numerous paths which lead to maturity in art there is one which you feel to be particularly sympathetic, then by all means regard a painter who has already trodden a similar way as your master; but your work should never be a copy of his. If at any time you engage in that most instructive activity, copying other men's work, it should remain copying, and should be done in front of the original. This is the best way to find out what you would choose to do differently, and why.

The work of a painter whose style is markedly original reveals its manner even in sketches and studies. Their penciled lines are admittedly an indication of form, but when they come to shadow and detail, they are thinking not so much of drawing as of the color to be laid on with paint and brush. Cézanne's head studies are a case in point; essentially he was a painter, and nothing but a painter. On the other hand, Van Gogh's brush strokes are always graphic in effect, although his paintings are certainly not graphic in the sense that Toulouse-Lautrec's colored drawings are.

People often think that the spiritual

Design for a mural on light green plaster surface

greatness of a painter is more or less bound up with the size of his pictures. In a general way, this attitude may appear ridiculous, yet there is a grain of sense in it. An artist has to take a very deep breath indeed to encompass works as gigantic as those of Rubens or Makart. The majority of the historical painters of the past century failed to bring this off, as they lacked the human dimension of a Rubens or the unbelievable skill of a Makart. The second-rate fresco painters of the Baroque and Rococo periods were spurred on by the intoxicating mood of their day, and not least by the pace at which a fresco must be executed.

An artist who is not ruled by an inner apprehension of magnitude, and who works on a picture for years or decades, as oil painting will enable him to do, may all too easily find he has produced merely one square yard after another of scenes, though each one may be reasonably well painted. For this reason, every artist should discover beyond doubt what size picture suits him best, the size to which he is constitutionally suited. Even in the smallest works an

artist cannot do without a certain boldness of design and color. Leaving aside the attitude of mind which may induce a certain monumentality even in the miniaturist, this quality evinces itself in a rough and ready treatment of form and an exaggeration of the most important dimensions in the picture. It is always a surprise to see a large magnification of a miniature. The same is true of a masterpiece of small genre painting, particularly if behind a cheerfully descriptive style there lurks a gift for caricature, which is the case in the work of Spitzweg. Whereas in former days an artist's work revolved around the creation of a single style which persisted throughout his working life, there are many modern painters whose work has changed so strikingly over the years that an impartial spectator would hardly suppose works belonging to different periods of their careers to have been executed by one and the same person. Much current criticism is wrong, however, in assuming that this indicates lack of character on the part of the artist; on the contrary, a determination to gain by increased awareness is proof rather of strong-mindedness. This awareness is the fruit of a far-ranging familiarity with the work of other men and with the men themselves. Nowadays, you may read in your morning newspaper of a picture which has caused a sensation and by the same evening already have seen it, even if it is several hundred miles away. Previously, the journey alone would have taken weeks. So now that one style no longer lasts for generations, it is not to be wondered at that several may take place in one man's lifetime and may be practiced by one and the same man with a perfectly free conscience. As a most illuminating example of this, we have three portraits of Vollard by Picasso. The subject is the same in all three pictures, and although each of them shows him older than the previous one, they do demonstrate how a totally different means of expression may be used to render the same external image.

As you have seen, the **way** you paint may be determined by **what** you paint; the converse may also be true. It is equally possible for a work of art to develop without the artist having had to come to grips with the problem as such. You will seldom be able to tell how a work was created by looking at a finished product, nor can you by any means rely entirely on what you are told. What an artist records in his correspondence and diaries reveals more of the man than it does of the purely technical aspects of creation or the real motive behind it. Accordingly, I shall take the ideas underlying three of my own pictures, and with their help try to indicate a possible—but by no means the only—route from individual impulse to actual creation. At best, we can speak of hints and parallels; there are no hard-and-fast rules.

Let us assume you have learned the craft of drawing and painting, and that you set out to portray an inviting motif; a certain amount of artistic rearrangement is inevitable, and it is far from certain that your handiwork will have the compression and finality of a true work of art. You will learn nothing from the artist of genius who occasionally brings this off, however, because perfection is

inviolable and uninstructive. For this reason the designs I shall give are not completely worked out, as they would then express only a personal point of view and not be worth discussing. I would urge you rather, if you feel like trying your hand at any of the motifs, to work out your own solutions for them. The illustration on page 391 shows a design for a wall painting. It was inspired by a child's drawing, which may have conjured up some episode on a journey by its resemblance to a souvenir postcard. This by way of parenthesis. The real inspiration came from the drawing, because it showed such feeling for color and form. This, combined with the gaucherie of the representation, led me to simplify and reduce the data to the form of a mural drawing. It also meant dispensing entirely with the linear perspective which is "false" in any case, and giving the picture breadth and depth by graduating the dimensions and tone values.

The design is now ready to be transported into the mural technique, the easiest of which in this case would be a mural painting. The individual color areas could be hatched in lightly with pastel crayons, but not so as to shade into one another. Instead, local color should be laid on lightly, heavily, or more or less solidly to achieve an effect of modeling. To carry out the same design in sgraffito, you would need to restrict your colors very considerably, and the result would be more like a plaster intarsia. The simplest way to proceed would be to hollow the individual areas out of a top plaster laid on rather thicker than usual, as if doing a monochrome sgraffito. Next, use a trowel to spread the colored mortar over the hollows. There is no limit to the colors that might be used. Finally, the entire surface

Landscape in the Giant Mountains on an April morning. Pencil and watercolor (Compare illustration on page 179)

Evening in early spring in the Giant Mountains. Left above: first watercolor study. Left below: provisional version in alternating technique. Above: design for a new version in watercolor and tempera

should be treated like sgraffito plaster. The loveliest effect is obtained if—as in the design—the light background color forms a kind of linear grid.

The best way to carry out this design in mosaic form would be to assemble it out of large fragments. They should be fitted in compactly and precisely so that interrelated color areas are matched, and where joins are visible they should be made to look like lines separating colors from one another in a drawing.

This design would also look well in batik. Four shades would suffice, and the darkest tone should consist of all the colors painted one over the other.

What this means is that a single design can be realized in several different ways, and that the clearer the underlying graphic concept, the richer and more challenging these potentialities will be.

The second motif depicts an evening in early spring in the foothills of the Giant Mountains in Czechoslovakia. It is

one of a series of twelve pictures in which I endeavored to catch the culminating points of this landscape through the four seasons. The mainspring for this project lay in more than 20 years spent in these parts, and in the crucial experiences which of necessity accompany one's development from childhood to maturity. The landscape was always there in the background, and in the end it became more firmly fixed in my memory than the people or the material events concerned. When one lacks either the desire or the ability to sublimate spiritual states, events, and emotions by means of abstract expression, one finds them best expressed in the form of landscape.

At the same time I wanted to set down a permanent record of the face of this landscape, and this meant anything but a pleasant view in bright sunshine. Seen like that, the scene was much like any other in many parts of the central European uplands, and this is how it was invariably painted by those who hoped to make a profit out of the many tourists on holiday there. For me, the emphasis lay elsewhere: on the haze-shrouded day, veiled in mist, the time before sunrise in late October when the trees stand skeletal and gaunt and the pond is a smooth mirror; on afternoons in August with a storm brewing over the naked hill forest; the mornings in April, damp with rain; the quiet twilight that follows a snowstorm; on midday in June when a vapor hangs over the dusty rye fields, and so many more.

After I had been drawing for many years and produced more than a thousand sketches and studies without anything particular in mind, these were my abiding impressions. I started making deliberate studies and from them pictures which were wholly dictated by the actual scenes. At the same time this brought into play much of the technical knowledge and experience I had acquired. For instance, the color effects were unattainable except by the use of homemade paints. Many years later, seen from afar, both in the physical and intellectual sense, my attitude to it all changed. Then what I wanted to do was to leave only essential shapes and colors, and to omit entirely all the secondary emotional factors which had at one time been all too acutely bound up with my memories. Compare the first study with the "final" picture which followed, and with the design for the later **Evening in Early Spring** picture, and you will appreciate the evolution I have traced and which took the same course in all twelve pictures. If my main concern hitherto was with **what** to paint, now, while keeping to the plan, I was more concerned with **how** to paint. In **Evening in Early Spring** I sought to banish the dull brown tone entirely to make way for a cooler, more silvery rendering of the atmosphere. This was achieved by hatching lightly over a light ground with bright outlines and cool, gentle colors. My idea was to convey the feeling of twilight by keeping everything luminous, rather than by actually showing it darker. One color only, the most intense and significant of the whole picture, was to show up boldly, and that was the yellowish green of the sky. I did not attach undue importance to the formal aspect of the multiplicity of branches, placing more emphasis on

the curving lines and shapes. The plain, too, had to be stressed, giving an impression after a while of space and depth.

The intermediate stage had been a lean tempera painting on a white ground with bright grayish blue tones, but for the final version mixed technique was to be used. Naturally, neither the underpainting nor the imprimatura was to be laid on in continuous areas, but in little, short brush strokes. This was done to achieve the wavering light of dusk. There is not a sharp contour anywhere in the picture, which keeps its open, light, silvery look. The painting itself is made up chiefly of thin glazes, and the brush technique employed makes this into a well-knit fabric. This is a style which allows for the subtlest shades, the most brilliant light, as well as great depth of color without the dead weight of a—to my mind—primitively thick application of paint. The support used was not too coarse a canvas, whose natural fabric showed through the primer.

As for the third picture, this originated in a commission I was once given to do a painting of an operation. I was to make a point of doing a lifelike portrait of the operating surgeon. The whole setting was quite unfamiliar to me, so I started by doing a series of sketches and studies of other operations, to get the feel of the situation. When I first went in to look on, dressed as a doctor, I received one surprise after another. Apart from the fact that the scene was unexpectedly picturesque, I had to revise my conception of what one might call the spirit of the place. It is neither as solemn nor deadly serious as I had imagined it from what I had seen in books or films. The proceedings were matter of fact and prosaic, the atmosphere was brisk, and only after work had begun did it change to one of extreme concentration for those concerned, dictated by the need for

Study from the operating theater, watercolor

Left above: Study for the picture sketched above right. Left below: Study from the operating theater

speed. I found I quite forgot the patient, who was completely covered up. The scene of the operation might have been prepared with the aesthetic effect in mind. As a whole it had nothing of the grisly quality we associate with bleeding from a wound or even the slightest accident.

I came to the conclusion that the whole composition was made up of relatively simple shapes, but that a certain tedium in the posture of the figures was a real problem. Lighting was another matter. In the University Clinic, where I was working, the operating theaters were alll green tiled, while the overalls, caps and masks all looked a faded green, as did the cloth and covers. On the other hand, the main lamp cast a very warm light over people's faces, making them look an unreal tomato red, while the clothes looked ochre and pink, with occasional cobalt blue shadows. The light which, despite all attempts at concentration, was very scattered, combined its complementary color, green, to produce fluffy, palpable, shapes, which seemed literally to smoke with toil, heat, and smell. The contours were very vague in places. Elusive flickering lights and self-shadows everywhere. The mainstay of the composition must be the distribution of very colorful

light and the green, which, while homogeneous, contained diverse modulations.

I was lucky in that the scene portrayed in the final picture was one which could well be transferred to canvas without substantial alteration. Unfortunately, the operation (plastic surgery of the hand) did not last long, so that all I could do was to indicate the most important colors for the main figures. Altogether, however, the studies provided a satisfactory basis for the final version. I planned to do it in **alla prima** oil paint on fairly coarse canvas, with a thin layer of underpaint in broad areas on a terre verte tinted ground, the light patches laid thickly in titanium white or white lead, with a little Indian red for added emphasis. Over this coarse underpainting went a cobalt blue semi-glaze in short brush strokes for the shadows, and the reddish parts of the light in pale cadmium red, then last of all the elaboration of all the colors and details.

I hope that what I have said about the genesis and realization of these three pictures has shown that it is fruitless to wait for, or even to chase after, inspiration: methodical work, however, will always bring you nearer to your goal, and is less of a disappointment if success does not come immediately. Whatever point you reach may serve as a springboard for a new start made in the light of all the experience gained. For this reason, I should also like to advise you never to throw your work away because it seems to have gone wrong. You will often discover later on that from other points of view it is a success.

Possibly you, too, once expressed your feeling of helplessness in the face of your desire to paint or draw, in the one sentence: "I cannot draw a straight line." You now know that the reason you shied away from artistic creation was that you misunderstood it entirely, and that everyone can acquire enough technique to produce a presentable picture.

To turn this into a real work of art, no very great technical skill is needed. But what you must have is a real desire to succeed and a recognition of your particular artistic bent. Everyone has some ability. The best way to find out where your talent for drawing and painting lies is by working hard in the relevant media. The technique which really suits you will be your key to stirring achievement.

Nulla dies sine linea!

Bold type refers to pages on which the subject is discussed in detail. Figures with * refer to illustrations.